Indian-Made

CultureAmerica

Erika Doss
Philip J. Deloria
Series Editors

Karal Ann Marling
Editor Emerita

INDIAN-MADE Navajo Culture in

the Marketplace,

1868–1940

Erika Marie Bsumek

University Press of Kansas

Published by the University Press of
Kansas (Lawrence, Kansas 66045), which
was organized by the Kansas Board of
Regents and is operated and funded by
Emporia State University, Fort Hays
State University, Kansas State University,
Pittsburg State University, the University
of Kansas, and Wichita State University

Library of Congress Cataloging-in-
Publication Data

Bsumek, Erika Marie.
 Indian-made : Navajo culture in the
marketplace, 1868–1940 /
Erika Marie Bsumek.
 p. cm. — (CultureAmerica)
 Includes bibliographical references and
index.
 ISBN 978-0-7006-1595-7 (cloth : alk.
paper)
 1. Navajo Indians—Commerce. 2. Navajo
weavers—History. 3. Navajo textile
fabrics—History. 4. Trading posts—
Southwest, New—History. I. Title.
E99.N3B86 2008
979.1004′9726—dc22 2008020140

British Library Cataloguing-in-Publication
Data is available.

Printed in the United States of America
10 9 8 7 6 5 4 3 2 1

The paper used in this publication
is recycled and contains 30 percent
postconsumer waste. It is acid free and
meets the minimum requirements of
the American National Standard for
Permanence of Paper for Printed Library
Materials Z39.48 1992.

Publication made possible, in part, by a
University Co-operative Society Subvention
Grant awarded by The University of Texas
at Austin and the Charles Redd Center
for Western Studies at Brigham Young
University.

A portion of Chapter 4 was previously
published in Erika Bsumek, "Exchanging
Places: Virtual Travel, Vicarious Tourism
and the Consumption of Southwestern
Indian Artifacts," in *The Culture of Tourism,
the Tourism of Culture: Selling the Past to the
Present in the American Southwest*, ed. Hal
Rothman (Albuquerque: University of New
Mexico Press, 2003).

Part of Chapter 5 was originally published
as "The Navajos as Borrowers: Stewart
Culin and the Genesis of an Ethnographic
Theory," *New Mexico Historical Review*
79 (Summer 2004): 319–352. © 2004 by
the University of New Mexico Board of
Regents. All rights reserved.

Portions of the Epilogue were originally
published as Erika Bsumek, "Value
Added," in A. G. Hopkins, ed., *Global
History: Interactions between the Universal
and the Local*, 2006, Palgrave Macmillan,
reproduced with permission of Palgrave
Macmillan.

CONTENTS

ACKNOWLEDGMENTS

In the course of researching and writing this book, I've had the opportunity to work with a number of amazing people. Nothing pleases me more than to have this chance to thank all of those who have helped me complete this project. I am especially indebted to Peggy Pascoe, whose commitment to scholarship, students, and the craft of history make her an ideal role model. I can only aspire to be an equally dedicated, hardworking, and conscientious scholar. As a graduate student at Rutgers University, I was fortunate to work with Virginia Yans, Dee Garrison, and Susan Schrepfer. All of them provided insight and help at different times. I would especially like to thank Ginny for her efforts. Jan Lewis was also a wonderful mentor. As a fellow at the Rutgers Institute on Ethnicity, Culture, and the Modern Experience, I learned much from Clement Alexander Price, the very model of the scholar-citizen; I cannot thank him enough for his guidance and support.

Research took me to many locales and put me in contact with a number of extraordinarily helpful people. At the Huntington Library, Peter Blodgett always made time to help me locate materials that were crucial to the project; he is a generous archivist and a wonderful scholar, and I feel lucky to count him as a friend. The late Martin Ridge was always willing to read my drafts and give constructive advice. I am saddened that he did not get to see this book. I also want to acknowledge and thank Robert C. Ritchie for welcoming me into the community of scholars that he has created at the Huntington Library. He has been a wonderful mentor, and I am enormously grateful for his support. I owe thank-yous to Bill Frank and Jenny Watts for their assistance in finding material within the Huntington's rich collections and for obtaining copies of archival documents. While I was at the Center for Southwest Research, Lou Hieb not only helped me find the documents I needed, but he read various drafts of my work in its earliest stages and always offered useful advice. Librarian Mary Tsosie provided assistance at a key moment. I am also thankful for the help of Theresa Salazar and Scott Cossell at the University of Arizona. At the Hubbell Trading Post in Ganado, Arizona, Ed Chamberlain and his staff responded to queries, helped me coordinate research trips, introduced me to a number of important contacts, and made my research in the area a pleasure. At the Brooklyn Museum, Deborah Wythe and

Angie Park were as dedicated as any archivists could be and spent considerable time helping me track down the items I needed, both during the initial research and during the fact-checking stage. Jonathan Batkin, director of the Wheelwright Museum of the American Indian in Santa Fe, was an amazing resource. Not only did he direct me to material at the Wheelwright, but he shared items from his personal collection. I am also grateful to Cheri Frankenstein-Doyle for her input. I offer special thanks to scholar Willow Powers for sharing her research with me. I visited many other archival collections and would like to thank the librarians at the School for Advanced Research; the Cline Library; the National Archives and Records Administration in Laguna Niguel, California, Denver, Colorado, and College Park, Maryland; the Museum of Northern Arizona; the Montclair Art Museum; the Heye Museum of the American Indian; and the Mudd Library at Princeton University.

This project would not have been possible without generous financial support. I thank the following institutions for investing in this book: the Tanner Humanities Center at the University of Utah, the Huntington Library, the Charles Redd Center at Brigham Young University, the American Philosophical Society, the Geraldine R. Dodge Foundation, Rutgers University, and the Mudd Library at Princeton University. The University of Texas at Austin provided assistance through the Dean's Fellowship program, the Scholarly Activities Grant program, and the Special Research Grant program. I spent a semester with a reduced teaching load as a fellow at the Humanities Institute on campus, a period that I needed and very much appreciated. Finally, the university awarded me a Co-operative Subvention Grant to help with the publication costs of the manuscript, and the Charles Redd Center provided additional subvention funds. I am also grateful to the editorial and production staff at the University Press of Kansas, including Nancy Jackson, Jennifer Dropkin, and Kalyani Fernando, for shepherding this project through the publication process and to readers Leah Dilworth, Marguerite Shaffer, Erika Doss, and Phil Deloria for providing such helpful suggestions for revision. Although I only met Adrienne Harris in the editing process, I am extremely grateful to her for all of her thoughtful suggestions.

This book has also benefited from the contributions of many others. Many of my colleagues at the University of Texas and beyond read various parts of this manuscript, engaged in lively conversations, or simply provided friendship that helped me finish and improve this project. I

thank Bob Abzug, Kim Alidio, Thomas Alexander, Durwood Ball, Matt Bokovoy, Vincent Cheng, Sally Clarke, Ernesto Chavez, Cat Cocks, Janet Davis, Virginia Dominguez, Carolyn Eastman, Paul Edison, Elizabeth Englehardt, Richard Etulain, Allison Fraiser, Ariela Gross, Tiffany Gill, Frank Guridy, David Gutierrez, John Herron, Eric Hinderaker, Steven Holscher, Brian Hosmer, Madeline Hsu, Bruce Hunt, Mark Lawrence, Dana Luciano, Yolanda Leyva, Nhi Liu, Nancy Parezo, Al Martinez, Tracie Matysik, Howard Miller, Karl Miller, Kelli Mosteller, Colleen O'Neill, Bob Olwell, Hal Rothman, Michael Stoff, Michael Topp, Alan Tully, and Marsha Weisiger for their comments and suggestions. I thank David Oshinsky for taking time to provide advice. Tony Hopkins deserves special thanks for helping me flesh out the material that found its way into the book's concluding chapter. A number of people read a draft (or two) of the manuscript. As my mentor, colleague, and friend, Julie Hardwick enthusiastically worked through the entire manuscript. Neil Kamil made time to read the manuscript at a crucial stage. James Sidbury always took time out of his busy schedule to discuss my work or read and comment on it. All three have watched the project evolve, and to all three I offer my deepest thanks. I could not ask for better colleagues; this book is substantially better for their efforts. I am also indebted to Joan Neuberger for both her scholarly advice and her camaraderie. Neel Baumgardener deserves a thank you for his technical help and commitment to research. At the Huntington, Elizabeth Fenn, Carolyn Kastner, Barbara Donagan, David Igler, Clark Davis, Bill Deverell, Cheryl Koos, Natalia Molina, and Tony Thompson made the work of research less tedious and more fun. I am especially grateful to silversmiths Liz Wallace (Navajo) and Vidal Chavez (Chochiti) for deepening my understanding of silverwork and showing me some of the methods silversmiths have used over the years. I owe thanks to Zonnie Gorman for providing important information at a crucial stage. Ron Maldonado at the Navajo Nation's Office of Historic Preservation vetted the material about museums and artifacts in Chapter 5, and I thank the anonymous readers at the office who took the time to comment on the material. I am also pleased to thank traders Elijah Blair and Bruce and Virginia Burnham for taking the time to talk with me.

My family and friends have made the very long journey one travels while writing a book both pleasant and navigable. All, in their own way, have helped in a significant fashion, and I could not have completed this project without their support. Abigail Lustig and Phoebe Kropp not only

read parts of the manuscript, but they provided friendship of the highest caliber. I feel lucky to count these two wonderful women as both friends and colleagues. I thank Michael Braddick for all the conversations (and we had many) that helped me develop this project. I owe one of my largest debts to Martin Summers. His ongoing friendship is a source of support and inspiration. He not only read an entire draft of this manuscript and offered helpful suggestions, but he fielded many a phone call over the years about life in general. I appreciate all the time he's dedicated to making this book and my life better. David Isbell not only provided friendship, but he also helped in the archives. Longtime friends Susie Thomas and Rachel Borup were fixed points in my ever-changing world. Their friendship means a lot to me, and I'm grateful for their continued support. My brother, Peter Bsumek, provided unconditional support and has helped me understand the ways of academia. He also makes certain that the academic life never makes me lose sight of what's important. My aunt, Vera Campbell, deserves a big thank you as well. This project would have been much more difficult to complete without her encouraging me and cheering me on—as well as letting me use her house as a way station while I conducted research in Los Angeles. My grandparents, Albert and Vera Cuglietta and the late Edwin and Ella Bsumek, taught me the importance of history, often in sessions around the kitchen table. Their love and their interest in my work have meant more to me than I can communicate. My parents, Peter and Maria Bsumek, have provided the foundation from which everything—including this project—flows. Over many years, moves, and life changes, they have been nothing but supportive. I could not have asked for anything better as I struggled along an often-uncertain course. Daniel Hannon has endured the upheaval that comes with the academic life. I know it hasn't been easy on him, and I'm deeply indebted and extremely grateful to him for his love and support. He has helped me look beyond the past, to the future. I owe him for that and only hope I can find a way to thank him in that future. Finally, Liam Peter Hannon, my son, has helped me find balance in my life. Though I love being an academic, I love being his mother more than words can communicate. As I would say to him in one of our favorite comparative games, "I love you more than all the letters in this book." I dedicate every letter in this book to him.

Indian-Made

Navajos, the Navaho, and the Market for Indian-Made Goods

In 1901, Mr. and Mrs. Frederic Goodwin of New York City sent out an eight-page invitation to a "Navaho Indian Fiesta," an elaborate program that would include a talk by Si-wich-i-me, a "Medicine Man Driving Away the Evil Spirit" performed by Hostine Nez, a "Navaho Wedding" performed by Hostine Klish, and a "Mother Singing a Lullaby to Her Pappoose [sic]" performed by Tom-ah-no-tah. Sparing no expense, the hosts even imported food from Arizona. In the invitation, they included a pictograph (with a key) to help guests decipher the drawings within it and used a vividly colored photograph of an Indian identified as Chief Wets It on the front. The image of the chief—his face painted as if he were ready for a ceremony, wearing a blanket evocative of a striped "chief's blanket," and sporting an elaborate headdress with a red, white, and blue shield—aimed to pique the interest of potential guests. Yet Chief Wets It was not a Navajo.[1] He was not even from the Southwest. He was a member of the Assiniboine Sioux and wore the buffalo-horned headdress of a nineteenth-century Sioux warrior. His "blanket" was not a Navajo blanket but rather a *capote*, a style of coat made from a Hudson's Bay blanket and worn by Sioux men after 1850. The colorful face paint in his image had been added to an original black-and-white photograph taken by Frank A. Rinehart.[2]

Why, then, did the Goodwins call the party a Navaho Fiesta? None of the performers were Navajos. The part of the Medicine Man, Hostine Nez, was played by the budding archaeologist M. R. Harrington. The

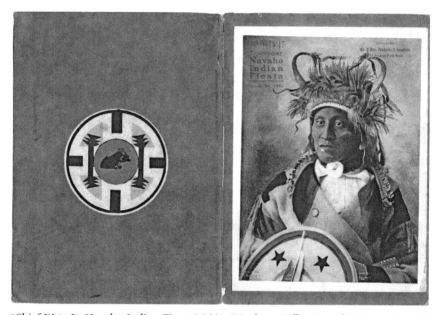

"Chief Wets It, Navaho Indian Fiesta," 1901. Warshaw Collection of Business Americana, Indians, Archives Center, National Museum of American History, Smithsonian Institution, Washington, D.C.

groom at the wedding, Ha-ta-lee Nah-tloy, was actually cycling advocate Whitfield Sammis. The bride, Nah-than Es-thon-nie, was probably the wealthy young Ohio socialite Marie Penfield, and the actress and composer Laura Sedgwick Collins played the part of the singing Navaho mother.[3] But what of the others? Hostine Klish was none other than the anthropologist George H. Pepper. A lecturer and self-designated expert on Indian culture named George Wharton James assumed the role of the evening's star speaker, Si-witch-i-me.

For the Goodwins, designating their event as a Navaho celebration invoked a dramatic and market-oriented identity more than it did a specific cultural group. Some of the guests, for example, who were assigned to "play Indian" had clear ulterior motives. George Pepper, for one, had recently returned from the Southwest where he had been working with Navajo trader Richard Wetherill as part of the Hyde Exploring Expedition.[4] Not coincidentally, the expedition's sponsors had funded a Navajo rug store on 23rd Street in New York.[5] The Goodwins promised their guests that Pepper would display—and possibly sell—his personal collection of Navajo blankets at their event. Similarly, the Goodwins noted

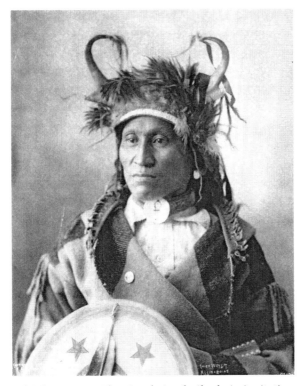

"Chief Wets It." The Goodwins built their invitation
around this photograph of a Sioux Indian. Original
photograph by F. A. Rinehart, 1898. Courtesy of the
New York Public Library.

that George Wharton James would talk about Indians and present his
own "authentic" collection of Navajo-made wares.[6] Thus, the Goodwins'
Navaho Indian Fiesta sought to present a particular kind of product, not
necessarily a specific group of people.

 This book is about how different groups—consumers, anthropologists,
government officials, traders, retailers, and cultural impresarios—came to
characterize not only Navajo-made goods but also Navajo producers and,
by extension, the Navajo population by a number of market-oriented con-
cepts that I sum up in the term *Navaho*. I use the anglicized spelling *Na-
vaho* as an umbrella concept to represent the characteristics that whites
commonly ascribed to Navajos to facilitate the sale of the blankets and
jewelry they made. Thus, the term *Navaho* speaks to whites' effacement
of important elements of Navajo culture so that they could characterize

the population as primitive and preindustrial. This process reduced the diverse Navajo population to a stereotype: that of the Navaho. Each group I cite above did its part to homogenize Navajos, each contributing a strand to the tapestry that emerged to shape the representation and consumption of Navajo-made products.

The formulation and perpetuation of the images and narratives that formed the public's understanding of the Navaho were possible because of the symbiotic nature of production and consumption. I argue that the act of consuming goods was also an act of *cultural production* that drove a chain of relationships to produce racialized objects; consuming "Indian-made" products became, in itself, a racializing practice. It produced a racialized consumer by reifying the purchasers' sense of self as "white" or "civilized," just as it created a portrait of Navahos as fundamentally different from white consumers. In other words, as a consumer-oriented concept, the Navaho was more inscriptive than descriptive: it enabled consumers to create their own narratives about the Diné as a primitive and preindustrial group while reinforcing their own identities in contrast to those qualities. *Navaho,* then, did not simply signify the particular characteristics of a racialized population; it was also a culturally based market-oriented concept. As a result, I use *Navajo* and *Diné,* often interchangeably, to discuss the diverse beliefs and actions of the Navajo population and to highlight moments when Navajo artisans were in dialogue with, diverged from, or otherwise upset the prevailing notions of "the Navaho."

By identifying the ways in which Navajo artisans were imagined, represented, and portrayed as Navahos and juxtaposing these representations with the actions of Navajos, we can uncover the ways in which Navajos related to a marketplace that seemingly offered them little room as individual actors. The origins, development, popularity, and significance of the Navaho conception in large part shaped and responded to the market for Navajo-made goods. In this book, I argue that though money lay at the heart of the market, the sale of Indian-made goods cannot be explained solely through supply and demand. Understanding the consumption of Navajo-made goods requires a careful reckoning with the multiple images and narratives that grew up around the goods themselves. Moreover, we cannot explain the consumption of Indian-made goods as the result of clever advertising campaigns that manipulated consumers into buying goods. Purchasers layered their own meanings, beliefs, and desires onto

the Navajo blankets, baskets, and jewelry they held dear. In that way, they, as much as the advertisers, helped create the Navaho.

Nor can we characterize Navajo artisans as passive victims of the marketplace. Whenever possible—and resistance frequently was possible—artists refused to play along with the images and narratives that consumers attached to the goods they made. They resisted even as marketers' representations seemed to have the power to render Navajo craftsmen invisible to consumers. In short, Navajo weavers, silversmiths, sandpainters, and basket makers—collectively and individually—were essential to the workings of the larger consumer-oriented marketplace that surrounded the goods they produced.

This book is not primarily a history of Navajo ethnogenesis, but by showing the ways in which Navajo artisans responded to market demands, negotiated trades, consumed goods, and otherwise actively participated in the modern market economy, it shows that whites' investments in the meanings of Navaho goods cannot be divorced from Navajo agency. Over the past decade or so, scholars of twentieth-century American Indian history have shifted away from treating Indians as if they existed outside the market and turned their attention instead to understanding Indian engagement with the market.[7] By examining how Navajos participated in the market economy as artisans and wage laborers, this book continues this line of inquiry. But I also look beyond the market to reveal the complicated cultural elements—ranging from the maintenance of Navajo cultural imperatives to the growing influence of consumer goods on the reservation—that affected the decisions Navajos made in relation to the forces that created the Navaho and commodified Navajo culture.

The production and consumption of Navajo-made goods intersects with another body of American Indian scholarship as well. Scholars have illuminated the ways in which white Americans routinely "imagined" and "reimagined" American Indians by "playing Indian" or "going native." These practices offered important avenues for creating national, regional, gendered, or individual identity. The scholars who have explored such phenomena have detailed the associative and ascriptive power that literature, art, film, photography, philosophy, recreation, and politics wielded in the misrepresentation of indigenous people and their history and have shown how notions of Indian-ness formed as the prevailing discourses surrounding Indians evolved.[8] This book builds on such works by examining not only the ways in which Indians were imagined but

also the ways in which Navajos responded—or attempted to respond—to such imagery within the marketplace. It also shows how Navajos were sometimes prohibited from responding to such imaginative inventions because of the way the market for their goods had come to function.

Focusing on both the production and consumption of Navaho images and narratives reveals the ways in which these representations affected Navajos, traders, scholars, consumers, and dealers of Indian-made goods. By examining two fairly specific but diverse populations (Navajo artisans and white consumers) during the important transition from a production-oriented society to a consumer-oriented one (from the 1880s to the 1930s), this book aims to shed light on both the representations and the market. This approach shows that we cannot understand the value of Indian-made goods without grappling with the structure of representations, nor can we ignore the importance of market forces to understanding what those representations were meant to convey. It was on the terrain created in the movement back and forth between cultures that Navajos and whites created their identities around "Indian-made" goods.

The processes of identity creation took place in small, unheralded, everyday places. Peeking into trading posts, curio shops, museums, living rooms, hogans, workshops, and even the Tenth Circuit Court of Appeals, this book uncovers the dynamic processes through which white middle-class Americans and Navajo artisans sought to find and express meaning in their lives through different forms of production and consumption. Rather than offering an in-depth study of a particular form of Navajo artistry like weaving or silversmithing, I demonstrate how images and narratives surrounding Navajos and their crafts were produced and consumed as well as how they affected white traders, consumers, dealers, and Navajo artisans. I explore the reasons why some of those constructed identities, like that of the vanishing Navaho, developed remarkable staying power even as they put particular strains on those producing and selling Navajo Indian-made goods. Why did traders repeatedly portray Navajos teetering on the verge of disappearance, for instance, when the Navajo population in fact continued to grow rapidly between 1900 and 1940?

By approaching the history of twentieth-century cross-cultural encounters through such questions, we find that Navajos were active participants in historical trends. As the United States changed from a production-oriented to a consumption-oriented nation, Navajos—along with other Americans—experienced the transition in unique ways;

Navajos produced goods that supposedly represented an earlier stage of U.S. economic development—the preindustrial period—yet they were concurrently becoming wage laborers and brand-conscious consumers of manufactured goods themselves. Clearly, traders sought to control the imagery associated with Navajos, concentrating consumer attention on Navajos' status as producers, not as consumers. Focusing not just on the ways in which the images and narratives surrounding Navajos emerged during the first three decades of the twentieth century but also, when possible, demonstrating the ways that Navajo and white consumers responded to, engaged with, or challenged those fabrications enables us to uncover the economic role in the social construction of identity.

To lay bare the role of economic factors in the social construction of Navajo identity, I have sought to combine themes and voices that scholars to date have largely dealt with separately. Toward that end, I have used a variety of sources. Scouring trading-post records and the papers of dealers and tourist-industry professionals has enabled me to discover the ways in which such groups marketed the Navaho. Reading such records against the grain and citing letters Navajos sent to traders has revealed the ways in which Navajos actively engaged with the market even as traders or dealers told potential consumers otherwise. Using oral histories from traders, Navajos, and silversmiths, I have investigated representations of how the Navaho were formed in the market and sought to determine how Navajos felt about the market and these representations. I have also examined museum records and the field notes of anthropologists and ethnologists to decipher the roles they played in constructing the Navaho as well as in determining the economic circumstances of Navajo artisans.

In addition, Federal Trade Commission (FTC) records have enabled me to uncover the voices of Navajos as they testified before the Tenth Circuit Court on issues related to craft production. Beyond that, FTC papers also make explicit the ways in which a Navaho identity was constructed with little or no input from Navajos themselves. Soil Conservation Service records also helped expose the economics of reservation life. I consulted Indian school records and the records of organizations like the American Association on Indian Affairs to determine the roles that such agencies played in the public presentation of Navajo arts and crafts. And, finally, I occasionally cite literature and quote literary figures who wrote about and ruminated on the meaning of "Indian-ness."

In addition to the term *Navaho,* four key terms are central to my attempt to make sense of the production and consumption of Navajo-made goods: *consumerism, the market, Indian-made,* and *primitivism.* As the engines that set the idea of the Navaho in motion, "consumerism" and "the market" became slippery concepts. What constituted consumerism? Which aspects of Navajo culture were tied to the market, and which ones escaped its pull? Within these pages, consumerism refers to the processes of buying Indian-made goods and absorbing the images associated with them. For a good majority of consumers, goods made by Indians were infused with symbolic, material, and cultural capital.[9] Navajo blankets and jewelry were prestigious in that they conveyed a set of racialized beliefs, represented a financial investment, and transmitted a series of meanings about modernity and civilization to the whites who purchased them.

I refer, generally, to the *market* or *marketplace* as the realm within which product associations were produced as well as the place where economic interactions took place. Undergirding both kinds of consumption was the hope that such transactions would yield great profit for those who successfully manipulated them. In this sense, the travel and tourist industry represented the marketplace, as did Navajo traders, gift-shop proprietors, and even museum personnel in need of public support and patronage. Anthropological texts, like those by Stewart Culin or Gladys Reichard, and fictional accounts of Navajo life, like Oliver La Farge's *Laughing Boy,* occupied a kind of middle ground. Their authors did not produce them directly for a profit-centered marketplace, but the works documented the dominant cultural ideas circulating within it, and they contributed in indirect but important ways to it. Certainly, these texts were something other than commodities produced for cultural consumption, but their authors' publication and research funds were frequently linked to a variety of market forces.

At the heart of this book is the term *Indian-made.* By the 1930s, the term had become a brand name of sorts, referring to goods that were understood to have been made by hand, infused with tradition, and produced by a primitive people—the Navaho—who supposedly lived on a "frontier," isolated from "civilization." As a result, *Indian-made* not only identified goods made by Indians but also described a world in which consumer associations and market forces loomed large. This book traces the origination of these ideas and the processes through which they created the idea of the Navaho, as well as the ways that Navajos and others contested the concept.

That Navajos navigated this developing world should be unsurprising. Yet by the 1930s, consumers seemed comfortable ignoring the Navajos' active role in the creation and contestation of the emerging "Indian-made" milieu. Equally unsurprising should be the fact that disputes about the dominant meanings of *Indian-made* occurred in the marketplace. Consumers may have thought that they understood what the term meant, but others—including Indian artisans—challenged the basic premises that had become so closely tied to the descriptor. In the early 1930s, a small group of white salesmen and manufacturers attempted to capitalize on the popularity of the "Indian-made" label while subtly shifting consumer associations in ways that would help them profit in the collapsing economic conditions of the Great Depression. In particular, they hired Navajo and Puebloan silversmiths to use machinery and to make "Indian-made" goods on an assembly line. In response, the federal government, a unified group of Navajo traders, and a Navajo silversmith instigated litigation to define the term.

One question dominated these discussions: was a product "Indian-made" if Indians made it on an assembly line? Ultimately, the consumer association of "Navajo" and "primitive" was codified into law. However, the meanings of "Indian-made" continued to change. Before the 1930s, the term evolved with government oversight in Bureau of Indian Affairs schools or federally regulated trading posts as well as within academia and among notable artists and authors. Yet because supposed consumer confusion about the term sparked the official attempts to define it, we can see that the marketplace played a significant role in crafting and codifying culturally bound ideas.

Finally, some whites evoked the concept of primitivism to bind Navajos to the production of handmade goods. Although many scholars have demonstrated that primitivism reflected a deep ambivalence about civilization among many middle-class white Americans, this book demonstrates that the concept was also at odds with, and at the center of, the market. By the 1880s, as a result of disagreements about human development and the origin of the species, educated whites often used the term *primitive* to describe non-Westernized peoples. Thus, primitivism was a Western construction that middle- and upper-class whites adopted to make sense of their world as Victorian ideology began to give way to technological modernity and aesthetic modernism. Cultural instability linked the discourses of primitivism and modernism. Movement away

from representations of "Others" as savages (meaning humans at an "early stage" of historical development) toward views of them as primitives (a more positive modern understanding of non-Westernized cultures) created a complicated mix of forces as modernism took hold.[10] The appeal of primitivism coincided with a modernist offensive against positivist Victorian epistemology. In *No Place of Grace,* Jackson Lears argues that between the 1880s and the 1920s, U.S. society underwent a dramatic transformation in which "a Protestant ethos of salvation through self denial" gave way to enchantment with "a therapeutic ideal of self-fulfillment in this world through exuberant health and intense experience."[11] Modern dissenters manifested the desire for experience as they backed away from the ethic of instrumental rationality and "groped for alternatives in . . . 'primitive' cultures." As we shall see, modernists sometimes groped for tangible items in the form of "primitive" Indian-made goods.[12]

Whereas Victorian Protestantism had been built on absolute truths and the dichotomy of civilization and savagery, modernists came to believe that primitive societies, once considered hapless victims of evolution, had the potential to redeem a world trapped by economic modernization.[13] Ironically, when applied to the Navajos, primitivism enabled Americans to express such sentiments with their pocketbooks. That the emergence of the Navaho was an expression of American primitivism reveals that primitivism was a market-oriented concept, not solely a cultural or literary one, and suggests the complex ways in which consumerism bound together different and divergent segments of U.S. society. At the center of this book is the idea that primitivism operated in different locations and in different ways, most of which were market-oriented.

Each chapter in this book examines the interconnections between representations of the Navaho and the marketplace through a different lens, always with an eye toward discerning the interplay between the economic and cultural realms in the construction of racial identity. In chapter 1, I explore not only the avenues through which Navajos engaged with the modern market economy through the travel/tourism industry but also how Navajos, and the goods they produced, became an integral part of Southwestern regional development. After some background on the development of Navajo arts and crafts and the Southwestern tourist industry, this chapter presents some of the challenges that Indians, tourist-industry professionals, traders, and anthropologists faced as they invested in both the concept of the Navaho and the notion of Navajo

labor. It details the specific difficulties Navajos encountered in trying to balance the often-competing demands of Navajo culture and a tourist-oriented economy.

Chapter 2 centers on the microcosm of the trading post, looking at how transactions took place and how various participants interpreted their encounters there. It demonstrates that specific interpretations of trading-post encounters—and the narratives surrounding them—were reflective of the period. By the 1930s, Navajos had, in many ways, become like other American consumers, yet the narratives and representations surrounding Navajo trading posts centered on the supposedly "primitive" or "frontier" aspects of reservation-based economic encounters. By paying attention not simply to what happened at trading posts but also to how traders, consumers, and retailers perceived and promoted the activities there, we can see the moments when a unified vision of the Navaho came to dominate the consumption of Indian-made goods.

Looking at the influence of advertising and promotion, chapter 3 argues that the idea of "frontier commerce" was a promotional tool for traders rather than an accurate description of trading-post encounters. Traders commonly adopted a narrative of "frontier commerce" to introduce Navajo goods to the larger market while seeking to insulate themselves from the rigors of that market; they used a rhetoric of primitivism to suspend the ordinary rules of supply and demand, thereby getting consumers to pay more for goods while accepting less choice. The engine that powered this strategy was self-promotion. As modern "frontiersmen," the traders claimed to influence all aspects of Navajo artisanry on behalf of consumers. They benefited from keeping Navajo producers anonymous and selling Navajo blankets and jewelry as the collective product of the Navaho—not as the work of individual producers. The Navajos, for their part, also maneuvered and used the market to the best of their abilities. Their actions show that they understood the ways of the market, even if they could not always control them. Acknowledging the ways in which Navajo lives were reordered as a result of demand for the goods they made allows us to expand our understanding of Navajos' interaction with the economic trends that remade America during the late nineteenth and early twentieth century.

Chapter 4 explores the world of the consumers who purchased Navajo goods. Through the papers of a well-known dealer in Indian-made goods, Grace Nicholson, we get a sense of the American consumers who

purchased Navajo rugs, jewelry, and basketry and the motivations that compelled them to spend money on "Indian-made" goods. The work of Grace Nicholson and the purchasing patterns of her consumers reveal the complicated ways in which traders and others linked images and narratives of the Navaho to ideas of spending money, consuming, and collecting. Purchasers attached value to goods, but not always in the ways that traders and tourist-industry professionals wanted them to. Married middle-class white women in particular often viewed Indian-made goods as both economic and cultural investments. Some of these consumers participated in a phenomenon I call domestic imperialism. By bringing Indian-made goods into their homes, they expressed, endorsed, or more subtly represented narratives of the white races' triumph over "primitive" Indians. Their behavior becomes critical to our understanding of how middle- to upper-class whites invented and understood the markers of race, class, and even gender through images of the Navaho and Indian-made goods.

Chapter 5 explores the realm of authentication. Ethnologists and anthropologists also created consumer-oriented representations of the Navaho, albeit for a distinct kind of consumption: the transmission and reception of knowledge about the American Southwest and the indigenous people who lived there. The chapter looks at the activities of Stewart Culin, curator of ethnological collections at the Brooklyn Museum in the early twentieth century, suggesting that he helped produce and present another characteristic of the Navahos: their cultural borrowing. In representing Navaho culture as both primitive and derivative, we can see how Culin constructed Navaho identity for the market, on the one hand, and was in many ways, at the mercy of the marketplace, on the other. With a background in retail, the museum's director expected Culin to create exhibits that would appeal to the public. Thus, the market influenced the "authenticating" processes, adding a layer of culturally infused value to the Navaho and the goods that came to represent them.

As we see in chapter 6, by 1932, as the U.S. government stepped in to regulate the trade in "Indian-made" goods and to devise a legal definition of the term *Indian-made*, the philosophies of the major players in the market for Navaho goods had become increasingly apparent. As part of its mission to protect businesses from unfair competition and consumers from fraudulent advertising practices, the FTC spearheaded an effort to codify the term. Reservation-based traders and a few Indian silversmiths

Creating the Navaho

In the spring of 1905, a pregnant fifteen-year-old Navajo weaver named Adjiba sat weaving beautiful rugs in Fred Harvey's Indian Room at Albuquerque's Alvarado Hotel, the most famous of all southwestern tourist destinations. Beside her worked her silversmith husband, Ya'otza biye', or Miguelito, and her mother, Maria Antonia, a skilled weaver who also happened to be Miguelito's first wife. To observe Adjiba and her family at their work, the middle- and upper-class tourists who stepped off the Atchison, Topeka & Santa Fe (AT&SF) trains need only wander into the Indian Room during their forty-minute stopover or few days' stay. Many were transfixed by this opportunity to watch Adjiba and other Native American artisans produce coveted authentic "Indian-made" wares.

Indeed, the hotel's parent company, the Fred Harvey Company, worked hard to create a dramatic and entertaining setting for tourists to view American Indian life as it supposedly was lived on the region's reservations. John Frederick Huckle, co-owner of the Harvey enterprise, sought to enable the "hundreds of thousands of tourists a year who never thought of visiting reservations . . . [to] see Indians at work." He and manager Herman Schweizer also assembled model interiors to show consumers how they might use Navajo-made decorations as "interior decorations" in their homes.[1] Yet personal tragedy loomed over this picturesque scene. By the end of July, the youthful Adjiba was dead, the victim of a difficult birth and mismanaged health care. The circumstances surrounding Adjiba's

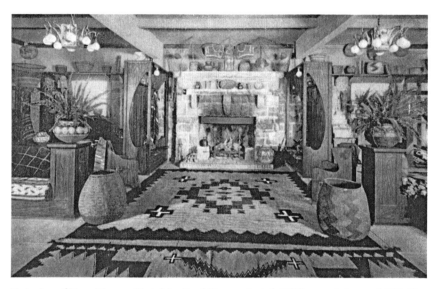

"Interior of Fray Marcos Hotel," a Fred Harvey hotel, Williams, Arizona, 1908. The Harvey Company used Indian-made objects as decorative accessories to demonstrate how tourists might use them in their homes. Grace Nicholson Collection. Used by permission of the Henry E. Huntington Library, San Marino, California.

premature death, and her husband's attempts to avoid it, brought Navajo producers, tourist-industry personnel, marketers, and consumers together and cast into stark relief the complicated relationship between Navajos and those who mediated and profited from their skills, showing how Navajo artisans embraced the market while trying to preserve their culture.

Setting the Stage

By the early 1900s, Navajo weavers and silversmiths were participating in the production of wares and the display of Indian life because they could earn much-needed income at a time when employment options for American Indians were extremely limited. Miguelito, Adjiba, and Maria Antonia were no exceptions. While Miguelito drew a salary from the Fred Harvey Company, working both as a silversmith and as a storeroom clerk, the two women were compensated for the sale of their rugs in the hotel's gift shop or in direct transactions with consumers. After only a few years of employment at a number of Harvey Company venues,

Miguelito and his family had saved their wages, paid off debts, and invested in livestock.[2]

While Adjiba and her family made the most of this employment, the Harvey Company had its own agenda. In creating the Indian Room, the company sought to stage authenticity while stoking consumer desires. Central to this vision of "authentic" Navajo life and culture was the Indians' so-called primitiveness. Thus, the hotel placed weavers and silversmiths like Adjiba, Maria Antonia, and Miguelito in an environment meant to simulate life on the reservation—complete with regional vegetation to lend authenticity to the scene. By presenting Navajos as "primitives" who engaged in preindustrial forms of production, executives believed they created "a tremendous stimulant to the demand of Indian products."[3] Their Navahos were primitives, and primitives brought profits.

Though Miguelito in particular assumed roles other than that of preindustrial artisan—he was both a wage laborer and family representative—the company repeatedly focused attention on his more "primitive" qualities. Company officials often downplayed his familial roles or made note of them only when doing so offered useful ways to highlight his "primitivism." In fact, they often went to great lengths to emphasize this quality over the more complex relationships Miguelito maintained in his life and with the company. This attitude is evident in a description of Miguelito's response to Adjiba's death by noted anthropologist Gladys Reichard in *Navajo Medicine Man: Sandpaintings and Legends of Miguelito,* a book funded and published by the Harvey Company in 1939. According to Reichard, Miguelito and his family were

> in Albuquerque when [Adjiba] was about to give birth to [Miguelito's] child. Although he had many contacts with whites, Miguelito had not accepted any of their treatments for illness or any of their religious beliefs. . . . Consequently he did what was natural for him to do. He took his young wife to an isolated place on the Rio Grande where he built a shade for her and sang as the Navajo used to do to aid childbirth. His efforts were however unavailing and the girl died. Whereupon Miguelito, with the Navajo fear of the dead and a possible feeling of guilt at having taken too much responsibility upon himself, came for help to Mr. Schweizer, who by this time had become his staunch friend. . . . Miguelito showed his love and respect for the girl by giving over all of her silver and turquoise to be buried with her.[4]

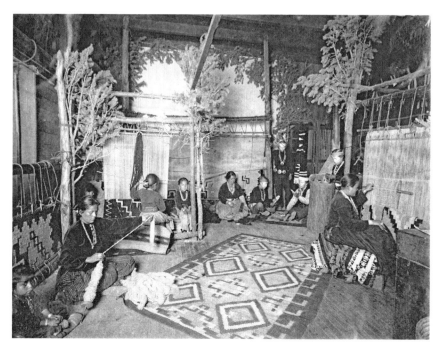

"Navajo Room, Alvarado Hotel," Albuquerque, ca. 1910. Navajo artisans demonstrated their skills in the Navajo Room. The Harvey Company staged such exhibitions to fuel demand for Navajo-made rugs and jewelry. Harvey Collection. Courtesy of the University of Arizona Library Collection.

In this one-sided account of Adjiba's death, about which we'll learn more later, Reichard accentuated Miguelito's "primitive" belief system by noting his rejection of white medical treatments and his decision to treat his wife as "the Navajo used to do" during childbirth. Likewise, her mention of Miguelito's "fear of the dead" underscored his superstitious nature. An earlier mention of Miguelito's polygamy further distanced the silversmith from white, "civilized" society. Yet the behavior of Miguelito and his family members, along with that of other Navajo artisans, suggests a rational economic motivation that belies, or at least complicates, Reichard's primitivist representations. And though Miguelito and his family realized at least some financial gains from craft work, a closer look at the circumstances surrounding Adjiba's death reveal that their participation in the modern market economy also had unforeseen and unfortunate consequences.

The incident reveals the pressure Navajos were under to fulfill white expectations of a certain picturesque, primitive "Indian-ness." However,

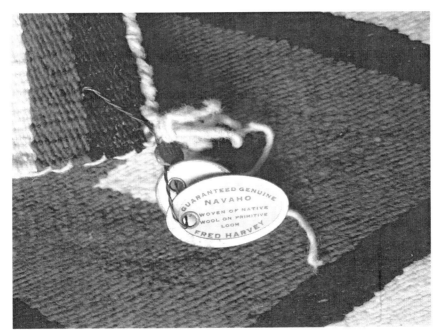

Rug and label, ca. 1930–1950, unknown weaver. Collection of the author.

it also demonstrates that they were important participants in an economic system that was deeply entrenched in the larger modern market economy. Navajos were producers of highly desired commodities, they were wage laborers who sought to support their families, and they were contributors to the creation of a tourist economy. Moreover, the popularity of tourism bound together eastern white travelers, distant consumers, and Navajo producers. An investigation of Adjiba's death demonstrates this connection and shows that there was much more than met the tourist's eye in the Harvey Company's depictions of Navaho Indian primitiveness.

Adjiba and the Harvey Company

According to Navajo custom, Miguelito had married Adjiba, Maria Antonia's daughter from a previous relationship, when she was deemed mature enough to be a wife. In dealing with his young wife's crisis, he clearly sought a path between adhering to his Navajo beliefs and appeasing

his employers. Equally clearly, Reichard's 1939 account of Adjiba's death is misleading and demonstrates the company's conscious desire to maintain the iconography of the "primitive" Navaho over time. Internal and confidential Harvey Company correspondence in 1905 presents a story vastly different from the account the company offered through Reichard. The correspondence between Harvey Company representatives and John Lorenzo Hubbell, the Navajo trader who gave Ya'otza biye' the name of Miguelito and facilitated the family's employment in Albuquerque, suggests that Miguelito did not simply respond to events as they unfolded around him—attempting to control the circumstances surrounding his child's birth in accordance with common Navajo practice—and intentionally placed himself at odds with the Harvey Company's desire to preserve its exhibition of Navajo weavers. For instance, in mid-May 1905, Miguelito informed his "friend" and employer, Herman Schweizer, manager of the Harvey House chain, that Adjiba was approximately six months' pregnant, and the couple wanted to leave Albuquerque in "30 to 40 days" so that Adjiba could have the baby on the Navajo Reservation. The couple's desire to return to the reservation reflected the fact that birth and death were, and are, sacred events among Navajos.[5]

Ultimately, however, their employer delayed the couple's departure until the company could find another family to take their place. John Frederick Huckle summarized the situation in a letter to trader J. L. Hubbell:

> Referring to my letter . . . in reference to Meguelito [sic] and his
> family returning to the reservation: As per our understanding of this
> matter, you expect, I believe, to send us some other Indians to take
> the place of Meguelito's [sic] family. We would not like to have
> Albuquerque out of Indians, if possible . . . Mr. Schweizer tells me . . .
> (h)e . . . would like at least two women weavers and a good man.
> Of course, two or three children would be an attraction too.[6]

Adjiba and her mother's weaving attracted the attention of tourists, and the company did not want to relinquish one of their most successful displays. Hubbell, who coordinated work agreements between reservation Indians and the company, had the task of finding a weaver and a silversmith to replace the family. In spite of Miguelito's salary and the money Adjiba and her mother earned by selling their blankets, the family remained dependent upon Hubbell's ability to find replacements and

the Harvey Company's willingness to release the three from their labor agreement. Only Hubbell or a Harvey executive could authorize the family's travel back to the reservation.[7]

The company had several reasons for delaying the couple's return. Huckle may have wanted Adjiba to have her baby in Albuquerque. In the summer and fall of 1905, he asked Hubbell to try to persuade Navajo artists to bring their children with them to tourist venues because they were "one of the chief attractions of the traveling public."[8] Because Indian children of school age were being sent to government boarding schools, most of the Indian children at tourist attractions were toddlers or infants. The prospect of adding another child to the overall display might have appealed to the company. Huckle was also reluctant to release the couple because he believed Miguelito was "earning a pretty fair salary and his squaws are doing well." But the success of the overall Navaho display seemed to be more important to the company than the artisans' well-being. So essential was the performance of "primitive" Indian production methods that one company official asserted that it stimulated regional tourism by creating "a world-wide interest . . . in the land of Pueblos and Navajos." Despite Miguelito's efforts to select the place where their child would be born, the couple was still in Albuquerque in late June when Adjiba went into labor.[9]

Because childbirth is hazardous, we cannot know how the scenario might have played out had the family been allowed to return to the reservation. We do know, however, that Adjiba and her baby survived the birth but immediately became dangerously ill. Ironically, as Adjiba's condition worsened, her return to the reservation took on sudden urgency for Harvey Company officials. Whereas the Harvey Company had previously blocked the couple's return to the reservation so that it could satisfy consumer demand, the events of midsummer motivated company representatives to try to send the new parents back to the reservation.

By early July, Huckle suspected that the death of either Adjiba or her baby would disrupt the life and work routines of other Navajo employees at the Alvarado. He confided to Hubbell, "If this baby should die at Albuquerque or if Agippa [sic] should get very ill there the Indians might think it was on account of their living there [at the Alvarado]."[10] Huckle probably, and Hubbell certainly, understood the strong cultural beliefs surrounding the death of a Navajo. When Reichard noted that Miguelito appealed to Schweizer to take over Adjiba's burial, for instance, it reflected

the fact that whites who had lived and worked near Navajos were familiar with Navajo death taboos—and had been for decades.[11] Huckle's fear that other Navajos would abandon the hotel complex was very likely a result of his understanding of Navajo culture.

This selective understanding of Navajo customs did not help weaver, silversmith, or baby. After considerable debate about Adjiba's health, hotel staff members arranged for the young weaver to be transported from the Alvarado to a hospital in Albuquerque. Still, Huckle remained anxious: "If we insisted on keeping her in the hospital," he wrote, and Adjiba were to die, Miguelito "might think that it is due to the white man's treatment." He suggested letting Miguelito take the "matter in his own hands." In a turn of reasoning, Huckle blamed Miguelito for Adjiba's state, telling Schweizer that "[Miguelito] has brought this trouble about himself by his trying to doctor the Indian woman in the first place." Huckle could not refrain from commenting on the character of the Navajo even as the situation became increasingly desperate: "My feeling is that all of us should do everything we could to save the life of an ignorant person like this."[12] Acting on his own beliefs, and—intentionally or unintentionally—following Huckle's directive, Miguelito had Adjiba discharged from the hospital and took her to a grove of cottonwood trees on the banks of the Rio Grande, where, despite Miguelito's best efforts, she ultimately died. Schweizer did assist Miguelito by arranging for Adjiba to be interred in Albuquerque's Fairview Cemetery.[13] Miguelito and Maria Antonia mourned and finally returned, albeit temporarily, to the reservation.

As Adjiba's story indicates, Navajo artists played more complex roles in the Southwest than that of symbolic "primitives" for white audiences. As wage workers, as artisans, and as performers in a regional drama that cast whites' vision of their culture in a starring role, Navajos occupied unique positions in the burgeoning industrial economy of the turn of the twentieth century. However, literary, artistic, and ethnographic visions of American Indians continuously put forth a romanticized, fictitious form of regional identity and Indian life.[14] Such image making provided Indian artists with work but also forced them to maneuver between their roles as producers and as icons as they made their way in the rapidly changing American economy.

To unravel the strands in the narrative of Miguelito's life and Adjiba's death, and to extend the lessons to the larger theme of this book, we must look at the factors that led the family to the Alvarado Hotel in the first

place. This search takes us back in time to look at how U.S.-Navajo relations evolved in the nineteenth century as well as how the skilled crafts of Navajo weaving and silversmithing had changed over an even broader span of time.

Development of the Navajo Reservation and Navajo Craft Production

The standard non-Navajo interpretation of Navajo prehistory goes as follows: The Navajos entered what is now the American Southwest sometime between 1200 and 1400 A.D.[15] They migrated, perhaps, from the Pacific Northwest and have linguistic links to the Apache as well as other Athapaskan peoples of Alaska and Canada. After arriving in the region, they came into contact with an array of southwestern Pueblo Indian groups who were mostly sedentary farmers but who had already established long-range trade networks. At this time, according to anthropologists, the Apaches and Navajos, or the Southern Athapaskan speakers, split into separate groups. Whereas the Apaches maintained a hunting-and-gathering lifestyle, Navajos "began to incorporate many of the subsistence features and cultural features of their new [Pueblo] neighbors."[16] They began to herd livestock, weave with reeds and cotton, and then finally with wool, after they acquired sheep from the Spanish and Puebloan peoples.

Because Navajos were neither unified nor entirely sedentary and existed on the eastern periphery of what became New Spain, determining what contact occurred between the Navajos and the Spanish is difficult. But conflict existed between the two groups, especially during the fifteenth and sixteenth centuries when the Spanish took Navajos as slaves. Raids on Navajo settlements like Canyon del Muerto continued into the nineteenth century, such as the infamous one in 1805, in which Spanish soldiers led by Antonio Narbona massacred hundreds of Navajos. Despite such violence, Navajos did acquire sheep, horses, and livestock either directly or indirectly through the Spanish. A distinctive Navajo culture developed, in part, around livestock, religion, craft production, and trade. Intermarriage, raiding, and trade with local and distant Puebloan and Spanish populations facilitated this development.[17]

By the 1840s, as the United States began to integrate the New Mexican territory into the nation, Navajo contact with the U.S. government had

become fraught with conflict. When the Treaty of Guadalupe Hidalgo was signed in 1848, the U.S. government initially gave little consideration to the Navajos. From 1848 to 1860, Navajo raiding and the perception of Navajo "savagery" against local settlements increased, and tension between the federal government and the Navajos intensified. By 1860, army officials argued that the raids justified a major military effort to force Navajos to submit to federal authority. In 1862, General James Carlton, who sought to end conflict with Navajos, instituted a program of removal and relocation. His plan called for sending Navajos and Apaches living in Utah, Arizona, and New Mexico to a site called Bosque Redondo in east-central New Mexico while other indigenous peoples of the region, the Pueblos, Zunis, and Hopis, remained free. Carlton selected Kit Carson, a trapper and explorer, to oversee his plan and kill any Navajos who resisted relocation. In one of many such episodes, Carson and his troops marched through Cañon de Chelly, the spiritual and agricultural center of Navajo country, spoiling wells, burning cornfields, destroying peach orchards, slaughtering cattle and sheep, and killing resisters.[18]

Between 1863 and 1867, Carson forced almost the entire Navajo population of New Mexico, Arizona, and Utah to walk to Fort Sumner at Bosque Redondo, or Hwéeldi—as it was known among the Diné. Navajos call these years those of the Long Walk.[19] By 1865, 8,000 Navajos had endured the brutal trek to Fort Sumner. Approximately one-quarter of the Navajo population perished along the way. Having endured starvation, freezing temperatures, and imprisonment for four years, Navajo leaders negotiated their first treaty with federal officials in June 1868, which established the initial boundaries of the Navajo Reservation. The reservation, 3.5 million acres of land in northeastern Arizona and northwestern New Mexico, included only about a quarter of the traditional Navajo territory. The treaty also provided Navajos with white teachers, agricultural supplies, 15,000 sheep and goats, and 500 head of cattle. Navajos, in turn, consented to the construction of railroads or roads through the reservation and the building of military posts within the reservation, and they agreed to stop raiding white settlements.[20] By 1880, despite the effects of their confinement at Hwéeldi and loss of a large part of their land and property, Navajos had rebounded to become one of the most populous Native peoples in the United States with 25,000 to 30,000 members living on the Navajo Reservation and surrounding areas.[21] They also managed to preserve their history as well as traditional religious ceremonies, social

organizations, work patterns, and crafts such as weaving—which were inseparable concepts.

Weaving

Navajo weaving is a common theme in both Navajo cosmology and history. In Navajo origin stories, the disorder of the subterranean worlds propel the Navajo ancestors to emerge onto the earth's surface, leaving the Earth Surface People (or the Nihookáá Dine'é) dependent upon the Holy Ones to teach them to survive. Changing Woman, the most important of the Holy People, tells the Nihookáá Dine'é where to live—the area marked by the four sacred mountain ranges of the Navajo homeland—while other Holy People establish rules of conduct and teach the Earth Surface People the skills they need to survive.[22]

To help ensure the people's survival, Spider Woman, another of the Holy People, teaches Navajo women how to weave.[23] According to oral tradition, when two Navajo women sought Spider Woman's assistance in subsisting in their new world, she cast her web to lift the weary women up to the summit of her home. Spider Woman then built the women a loom and taught them how to shear sheep and to turn the wool into yarn that they could then dye with colors from local plants and other organic materials. Finally, she instructed the weavers to hold beautiful thoughts in their minds and devote themselves to their work. At the time, the women were not sure why Spider Woman wanted to teach them how to weave, but they respected her and learned the craft. Still, they wondered how they would benefit from weaving. In an act of individual assertion, which stemmed in part from a misunderstanding of Spider Woman's true intentions, the women created a flaw in their designs, leaving an opening in the textiles so that, if necessary, "their souls could escape" and return to their loved ones.[24]

Creation accounts contend that Spider Woman first responded with anger, which was quickly tempered by compassion, and sent the women home. Upon leaving, they felt that they had failed at their primary task: to help their people survive. Yet, wanting to give something to their people, they began to teach the other women, just as Spider Woman had taught them. As time passed, Navajo women, and men who wished to learn, learned to create beautiful textiles that kept them warm in the winter and provided a commodity item to trade for food and other necessities.

Non-Navajo scholars have a different understanding of the history of Navajo weaving and contend that in the mid- to late 1600s, as the Navajo integrated sheepherding into their daily activities, wool became the primary material for Navajo textiles. In turn, the textiles were "transformed from a purely utilitarian practice into an art" when they were traded with their neighbors to the south for Mexican serapes, blankets, and floor coverings.[25] The craft changed again when factory-made cloth, such as European-made bayeta red cloth, became available to Navajo weavers through long-distance trade. The weavers used the cloth in distinctive ways by unraveling it and incorporating the reddish thread into their textiles.

Scholars of Navajo textiles agree that the classic period of Navajo textile production was between 1650 and 1868. Global processes, especially trade between divergent local communities, such as European cloth manufacturers, Mexican traders, and Navajo weavers, occurred during this period and came together in the textile trade, often in ironic ways. For instance, Navajo weavers welcomed the brighter-colored material from Spain as a contrasting hue to the muted shades they made using vegetable-based dyes. Ironically, the bayeta came to the Navajos through a circuitous route; the Europeans made bayeta cloth from cochineal, a beetle parasite extract they imported from Mexico; the bayeta cloth was then transported back to Mexico and to the Navajos.[26] Scholars often point to the textiles from this period, like the bayeta weavings, to illustrate interactions between the Spanish, the indigenous people of Mexico, and the Navajos.

The so-called transitional period that followed lasted from 1868 to 1890. During those years, the market for Navajo blankets, in which Natives had been the primary consumers, shifted to a tourist-dominated business.[27] Like other populations within the United States, Navajos were affected by national trends like industrialization and the growth of a consumption-oriented society. They obtained brighter, chemically dyed yarns from textile-manufacturing hubs like Germantown, Pennsylvania, and started to weave rugs instead of saddle blankets and articles of clothing. They also began experimenting with new geometric patterns and color combinations.

The influential agents of change in the transitional period were the reservation-based traders, who reportedly instructed weavers in producing rugs in the sizes, colors, and designs that would appeal to non-Indian consumers.[28] For instance, in the 1870s and 1880s, traders began selling

the Germantown dyes and yarns to Navajo weavers. Traders claimed that these new yarns enabled Navajo weavers to improve their skills because the materials were of finer quality than the hand-carded and dyed yarn the artisans had been using. Accordingly, Navajos began experimenting with patterns, designs, and styles, inventing new patterns such as the bold eyedazzler, which wove together contrasting colors in interlocking geometric designs.[29] When muted colors became more popular in decorative schemes, traders responded to market demands by placing orders for vegetable-dyed rugs from weavers, and the Germantown rugs fell out of fashion.

Interpreters of Navajo weaving commonly highlight the influence of traders in the alteration of design and material. Certainly, toward the end of the nineteenth century, Navajo traders, the best known of whom include John Lorenzo Hubbell and John Bradford Moore, encouraged local weavers to use certain kinds of yarn, integrate design elements from Persian and Turkish textiles, and alter the patterns of rugs in various other ways to fit the demands of tourists, interior decorators, and other consumers who desired Indian-made rugs.[30] Yet noting the modifications that traders encouraged does not provide a complete picture of how Navajos and traders interacted in their commercial exchanges in the late nineteenth and early twentieth centuries. Nor, as we shall see in subsequent chapters, does it explain why Navajo craft work was such an important component—both culturally and economically—on the reservation, at trading-posts, and for tourist economies.

Silversmithing

Like the history of weaving, the history of Navajo silversmithing illustrates the cultural interplay that existed in the Southwest before and after the Long Walk period. Although Spanish metalsmiths and Navajos may have had some contact, many artists, anthropologists, and historians agree that Navajos changed their approach to metalworking—beginning to see the craft as an artistic endeavor rather than a utilitarian occupation—relatively quickly after they saw the work of neighboring Mexican bridle makers sometime between 1850 and 1860. The first Navajo to smith silver was Atsidi Sani, or Old Smith, who learned to work iron from Nakai Tsosi, or the Thin Mexican. Sani then taught others such as Grey Mustache of Sunrise Springs, Arizona. Atsidi Sani, like those who would follow, first mastered ironwork and then advanced to working with semiprecious

silver. According to Grey Mustache, Atsidi Sani was initially attracted to metalwork because "in those days the Navajo bought all their bridles from the Mexicans, and [he] thought that if he learned how to make them the Navajo would buy them from him."[31] From there, silversmiths branched out, making bracelets, belts, and buttons from coin silver to trade with each other and those around them. So, early on, Navajos knew that metalwork had artistic merit and market value.

From the beginning, the manufacture of silver jewelry had special social and cultural meaning. By the time silver was readily available in the form of American coins and Mexican pesos in the early 1880s, Navajos had become quite skillful at working silver into bracelets, conchas (belts with silver disks), bridles, earrings, and purses—either by melting and then casting the silver or by pounding prepressed silver, like coins, into the desired shape. Items of finely crafted silver, noted for their hefty weight and bold designs, became important indicators of wealth, status, and artistic ability among Navajos. Like weavers, Navajo silversmiths imbued the goods they made with beauty. The amalgamation of Navajo products and Navajo culture was evident at all stages of production. Holding beautiful thoughts in mind during the production of textiles and silver jewelry was, and is, a key cultural element of Navajo life—a reflection of reverence for the concept of *hózhó*, or beauty. *Hózhó* expresses a "unity of experience" that connects spiritual, economic, intellectual, and aesthetic endeavors. As anthropologist Gary Witherspoon has shown, "Navajo life and culture are based on . . . the creation, maintenance, and restoration of hózhó." *Hózhó* is expressed through creation, not "through perception and preservation" in the way of Euro-Americans. In this way, beauty is not "so much a perceptual experience as it is a conceptual one." Witherspoon sees the Navajo willingness to sell beautiful Navajo-made goods to outsiders as consistent with this concept.[32]

Even as Navajos sold or traded the items they made, they valued the skill and artistry that went into producing jewelry, seeing the items they produced as expressions of cultural or ethnic pride as well as wealth. We see evidence of such pride in economic interactions between Navajos. In 1938, Navajo silversmith Isadore Burnside described the process in which two Navajos bartered for jewelry: One Navajo might admire a nice bracelet that a silversmith was wearing and inquire about its cost. The silversmith would then ask how much the curious party would pay to own the item. If the admirer were to offer $20 for the bracelet, the craftsman

would immediately make a counteroffer, explaining how long he had worked to make the bracelet "and what a hard job it was." Then the silversmith would name his price—$30 in this hypothetical instance—to account for the time and materials he had invested. The buyer's acceptance of the revised price reflected recognition of the skill that went into the production of the bracelet. The appropriate response, according to Burnside, would be "I will pay you what you want because you know what you are talking about and [I] don't want to spoil the work of my people by offering less than the price called for."[33] To Burnside, the ability to secure a higher price legitimized the cultural and social status of silversmithing. The work was valued not only by the artisans as a craft that had income-earning potential but also by Navajo consumers as an expression of their culture. Not only did Navajos prize jewelry for its artistry, but they also often acquired and wore their jewelry to demonstrate individual affluence. As late as 1938, Grey Mustache refused to have his photograph taken when he wasn't wearing his jewelry on the grounds that "without my turquoise and silver on, the people who saw it would say that Navajo doesn't have anything at all." As an asset made from semiprecious metal, culturally prized jewelry could also serve as collateral when Navajos needed loans from traders.[34]

Beyond its culturally enriching properties, silversmithing also provided an important source of income for artisans employed by traders in specific parts of the reservation. Beginning in the 1890s, Harvey Company promoters not only hired Indians like Miguelito to make jewelry in the Navajo Room, they also purchased silver jewelry from traders to meet the tourist demand. Throughout the early twentieth century, demand for lightweight silver jewelry increased, and traders employed numerous silversmiths to produce piecework on a regular basis. Occasionally, the Harvey Company even provided traders with the silver and stones that the silversmiths would need to make jewelry. Trader Charles Newcomb of Coolidge, New Mexico, steadily employed a group of silversmiths from the early 1910s into the 1940s to produce jewelry for the Harvey Company.[35] Thus, like weaving, silverwork gained monetary and cultural significance both within and beyond the reservation in the early twentieth century. The production and sale of silver jewelry provided an important source of income for Navajos, traders, tourist-industry personnel, and curio-store owners. White consumers deemed them artistic creations and culturally valuable representations of "primitive" peoples.

In fact, Navajo craft production and consumption were among the main conduits of the multifaceted exchanges between Navajo and non-Navajo people. Indeed, these exchanges marked a remarkably swift reorientation of the relationship, from the punitive demands of the Long Walk era to the market demand for Navajo products. The Harvey Company was a critical catalyst in this process through its ability to inspire tourists to visit New Mexico and Arizona after the turn of the century. To understand both the Harvey Company's preeminence and the importance it lent to Indian-made goods, we must trace how the Southwest became a tourist destination and how the tourist industry evolved to become an influential force in the region. Although Navajos had long inhabited land beyond the borders of New Mexico, the story of the territory's development nicely illustrates the importance of tourism to the region.

New Mexico as a Tourist Destination

New Mexico became part of the United States in 1848 with the signing of the Treaty of Guadalupe Hidalgo. Over the next sixty years, prospects for statehood seemed grim, despite the territory's ability to meet the basic population requirements. According to Mark Simmons, politicians in Washington seemed to think that residents of a territory "so unlike the rest of the United States seemed to have a poor chance of adjusting to the militant demands of American patriotism and economic nationalism."[36] As other scholars have demonstrated, Washington power brokers' conclusion that New Mexicans would have difficulty "adjusting" stemmed from the fact that few Mexican nationals, American Indians, and locally born Hispanics living in the territory had rushed to join the larger nationalized economic system. In turn, white settlers and Washington senators alike were loath to include the local Navajo, Apache, and Puebloan Indians or the Spanish-speaking "Nuevo Mexicanos" in their tally of "American" residents needed to qualify the territory for statehood.[37]

The railroad, more than any other force, nationalized New Mexico through economic development. The Atchison, Topeka & Santa Fe, the Denver & Rio Grande and the Southern Pacific railroads arrived in New Mexico in the early 1880s. By 1887, the AT&SF had become the largest railway system in the world. In the process, the railway stimulated southwestern markets for fuel and building materials and greatly increased

western access to eastern and European markets. Over the next fifty years, railway-related industries—shipping, logging, mining, and tourism— altered New Mexico's economy, its landscape, and its population. For example, the railroad brought almost 10,000 new Euro-American residents to Albuquerque between 1880 and 1893. Most were from the East and were attracted by the area's commercial possibilities.[38] By drawing new residents to New Mexico, creating its own markets and opening new ones, the railroad solidified the region's connections with the nation and its system of industrial capitalism. Such changes altered the ways in which native and non-native New Mexicans of all ethnic backgrounds worked, lived, and understood their place in American society according to economic, social, and racial hierarchies.

From 1880 to 1896, the AT&SF railway relied primarily on shipping for its revenue. But the economic depression of the 1890s financially devastated the railroad and forced it to reorganize. During that reorganization, railroad executives realized that the line could not survive solely on its shipping income. As a result, the AT&SF sought to open new markets.[39] One of the markets the AT&SF cultivated was the travel and tourist industry. Beginning in the 1890s, the railroad initiated its first attempt to attract eastern and European tourists to New Mexico and the Southwest. In 1896, the railway spent millions of dollars on an advertising campaign of unprecedented size and scope.[40] Under the supervision of William Allen White, editor of the *Emporia Gazette,* the AT&SF railway bought the rights to Thomas Moran's portrait of the Grand Canyon and had lithographic reprints made of it. White had these prints "framed in handsome gilt frames and then sent them out, first by the hundreds and then by the thousands" to offices, libraries, hotels, schools—basically to "almost anywhere that there was a fair chance of the picture bringing in business."[41] Through such promotional efforts, the Railway attempted to make the Southwest appealing to middle- and upper-class travelers.

By 1900, the railroad had effectively combined economic booster rhetoric with romanticized visions of American Indian life in its effort to stimulate southwestern tourism. Under the tourist gaze, the stereotype of Navajos decisively and quickly shifted from that of "savage" plunderers to "primitive" artists, a more dramatic change than that in the image of the Puebloan peoples, who had never been at war with the United States.[42] Beginning in the 1890s and continuing into the 1930s, the railway and affiliated tourist industries created a romanticized vision of the Navajos as

nonviolent, naturally talented, innocent, and beautiful "primitives," the so-called Navahos. For example, Marjorie Helen Thomas's 1909 painting *Navajo Indians at Desert Water Hole* features two Navajos quietly watering their horses. The railroad added the following caption: "Then, too, in much of our western landscape we need the Indian in the same way that a finely wrought piece of gold needs a jewel to set off its beauty in a piece of jewelry."[43] By comparing people to jewelry, this caption underscored the Navahos' value to Euro-Americans: they accessorized the region's naturally beautiful landscape. The association of Navajos with jewelry would not have been lost on tourists and consumers who purchased finely wrought silver, and such depictions of the Navahos, as Anglo-Americans were encouraged to imagine them, were becoming commonplace.

The railroad wrote the script and then cast the Navahos as premodern actors in a modern drama. For example, it commissioned Thomas's work and distributed it in the same way it had distributed Moran's painting of the Grand Canyon.[44] The railroad followed the lead of the government, which had essentialized the Navajo decades earlier. Before 1870, popular portrayals depicted Navajos as savage, wild, nomadic, and sinister. This image was especially prominent in the 1860s, when the government portrayed the entire population as threatening and "savage" enough to justify its forced internment at Fort Sumner.[45] The vision of the Navaho that emerged in the 1880s and 1890s reflected the elasticity of public-image construction. The railroad chose to market Navajos as primitive people despite, or perhaps because of, the fact that they had once been portrayed as savage.

Meanwhile, William Allen White, a middle-class impresario, realized that travelers could be enticed to see "primitives" but did not want to be treated like them. As a result, the AT&SF worked in conjunction with hotel operator and restaurateur Fred Harvey. Harvey hotels allowed travelers to "continue their tours without first outfitting a medicine chest and adding to their life insurance."[46] They dotted the Santa Fe rail line from Kansas to California, yet New Mexico and Arizona's Grand Canyon were the favored destinations. Harvey, capitalizing on this popularity, built eight establishments in New Mexico alone. Among them were four large (100-plus-room) hotels: La Fonda in Santa Fe, El Navajo in Gallup, the Montezuma in Las Vegas, and the Alvarado in Albuquerque. The Alvarado, built in 1902, was the largest and most elegant, with 169 rooms, and Harvey was proud when it became the social center of the territory. The

company recruited Navajos from Alamo, Cañoncito, and Gallup, New Mexico, as well as from the region surrounding Ganado, Arizona—where Adjiba and Miguelito lived—to weave and work with silver in the Alvarado's Navajo Room, in the large Indian and Mexican Building, while tourists watched. Navajo artisans not only worked at the Alvarado, but they also lived there, in adjacent hogans, or traditional Navajo dwellings, that Harvey built for them.[47]

The hotels, hogans, American Indian artists, and skilled craft labor supplemented railway-produced images that made a southwestern tour seem safe, luxurious, adventurous, and exotic to easterners. The railroad also published its own texts that not only presented the Native peoples of the Southwest as "primitives" but also offered a glimpse of ancient times, making a southwestern tour the educational equivalent of a tour of Greece or Rome. The AT&SF identified tourism as an economic lifeline and worked tirelessly to reshape the image of the Southwest and the interpretation of the people who lived there—all in the service of improving its profitability. Depiction of the Navaho as exotic, artistic, and peaceful was part of the strategy to make the Southwest more marketable. Railway executives suggested that the Southwest offered tourists the chance to see living "primitives" who were more interesting, animated, and accessible than the marble remnants of past civilizations in Europe.[48] As we shall see in subsequent chapters, hundreds of thousands of white men and women in eastern cities responded by flocking to New Mexico and Arizona or by collecting Navajo-made objects.

Silversmiths and the "Indian-Made" Economy

While Adjiba, Miguelito, and Maria Antonia found work in tourist venues, over the years many other Navajos across the reservation felt the industries' pull. To meet the rising demand for souvenirs, curios, and collectibles, Navajo traders provided silver, turquoise, wool, and other supplies to artisans. They, in turn, supplied traders with a steady stream of rugs and jewelry. In 1940, one trader, Bill Stewart, explained the finer points of "lending" silver to Navajos to anthropologist John Adair. Stewart claimed that patience was the key to success in such relationships; otherwise, silversmiths would produce "a lot of junk." Traders who wanted high-quality

jewelry had to wait for silversmiths to produce it. Thus, he linked time with quality: "The better the silversmith, the slower he is."[49]

The production of silver jewelry took a variety of forms that ranged from home to shop work and from pure handwork to the integration of light machinery in an assembly-line atmosphere—and everything in between. Some traders hired Navajos to work in well-supplied workshops. Others, like Stewart, "lent" silver to smiths who worked at home and then brought him the finished articles. By 1940, the trader at Pine Springs, Arizona, consistently purchased jewelry from 12 silversmiths; the trader at Navajo Lake had 13 silversmiths working directly for him; and the trader at Pinedale purchased goods from over 40 local silversmiths. During the winter of 1939–1940, the trader at Smith Lake employed between 78 and 104 silversmiths in a jewelry shop behind his trading post and paid them by the ounce. On a visit to the shop, Adair marveled at the efficiency of the operation, with its 5-foot tank of gas attached to twenty-five anvils via a series of rubber hoses.[50]

In 1940, Mike Kirk, the trader at Manuelito, New Mexico, employed as many as 100 smiths at a time. Kirk's business had rapidly expanded over the years. According to Adair, Kirk claimed "that when he first started a silver business, some thirty years ago, there were only two silversmiths that could turn out decent silver. Now there are over a hundred (who work for him) not counting the free-lance smiths." The quality of the jewelry produced at Kirk's varied, and Adair reported that much of it was not of high-quality. He noted, for instance, that the majority of the items that Kirk commissioned were "awful looking novelty stuff: butterflies, lizards, goats heads, cows heads, bucking horses, horsehead watch fobs."[51] Shipping large quantities of silverwork was possible because many of the traders, like Kirk, worked in areas that were either close to Gallup or offered access to the railroad, so they could easily ship merchandise to curio stores throughout the nation. Traders tapped into such markets by mass-producing catalogs that enabled store owners to see photographs of available merchandise and place orders for various quantities.

In the spring of 2006, ninety-three-year-old Vidal Chavez [Cochiti], who worked alongside Navajo silversmiths in the 1930s at an off-reservation commercial operation called Julius Gans's Southwest Arts and Crafts Store and "trading post" in Santa Fe, explained how this process worked. He recalled that traveling salesmen would show curio-store owners a catalog of "Indian-made" jewelry. Owners would then place an order for a dozen

or so of each bracelet or pendant they wanted. Chavez, along with ten to twenty other Navajo or Pueblo silversmiths, then manufactured the pieces to fulfill these orders. According to Chavez, he and the other silversmiths did all the work by hand and took great pride in their work.[52] Not all the reports of the time, however, agree with Chavez's description of the work.

In 1935, anthropologist, novelist, and Indian activist Oliver La Farge lamented that smiths at Gans's shop were "working as if the devil himself were standing over them." From his perspective as president of the American Association of Indian Affairs, La Farge saw Gans's operation as a "sweat shop" in which Indians were poorly compensated for their labor, earning only about 28 cents per hour. Even though such wages were meager, Chavez claimed that he and his fellow silversmiths were grateful for the work during this period of the Great Depression. Chavez described Gans as "tight" but said that the money that he earned enabled him to feed his growing family.[53] In the 1930s, low wages were better than no wages, according to the superintendent of the Southern Navajo Agency, who advised silversmith Haske Burnside to retain his job at Maisel's Trading Post in Albuquerque if possible.[54] Burnside saw things differently and quit.

Men like Chavez and Burnside knew that making jewelry was only one part of their job. Chavez recalled that in Gans's shop, the workbench at which the Navajo and Pueblo smiths labored was visible to the public. In Maisel's shop, tourists watched some silversmiths through a window, whereas other smiths, like Burnside, worked behind a partition. Then, as now, tourists or visitors to Albuquerque and Santa Fe wanted to see silversmiths performing their craft and then to purchase the items that they had watched being made. The Harvey Company initiated this practice of public performance, and other business owners quickly followed suit.

Through advertising and investment in local communities, the AT&SF, the Harvey Company, and the tourists they attracted helped transform New Mexico from a distant territory cluttered with supposedly foreign elements to an American state organized around the products and performances of colorfully "primitive" American people. The railroad sponsored the incorporation of Navajos into the United States as primitives—as Navahos—and enrolled them in the industrial economy. The tensions inherent in being cast as primitives divorced from the modern market economy while actually living and working in close conjunction with modern railroad-related industries undercut the seamless harmony that the Harvey Company depicted in its brochures.

Navajo Silversmiths and the Navaho

As the market for silver jewelry grew, the jewelry sold, manufactured, and advertised as "Indian-made" became increasingly synonymous with the Navaho who supposedly made it. In part, the association between silversmiths and Navajos occurred not because Navajos were the only skilled silversmiths in the Southwest, but because traders, booster literature, and curio-store circulars routinely depicted silversmiths making wares in Navajo hogans or portrayed silversmiths—be they Pueblo or Navajo—wearing the familiar Navajo headwrap. As curio shops across the country sold Navajo jewelry of different grades, ranging from the heavy "old pawn" associated with early Navajo silversmithing to the newer-style, lighter tourist-oriented products, critics of the jewelry business emerged. These critics asserted that when consumers purchased items like lightweight silver watch fobs or poorly decorated bracelets made by wage-earning Navajos, they undermined the core aspects of Navajo silversmithing that these "experts" as well as run-of-the-mill consumers associated with the Navaho.

Oliver La Farge objected to the type of workshop run by Gans and worked to preserve the "primitive" and "traditional" character of production methods by establishing "standards of genuineness" and a government-run Indian Arts and Crafts Board in the 1930s. In a memo published by the National Association of Indian Affairs, of which he was president, La Farge claimed that the public clearly associated silver Indian jewelry with Navajo producers. The preservation of traditional Navajo work patterns—such as home and hogan production—was therefore important to consumers, many of whom had been influenced by representations of lone silversmiths working in hogans. Consumers clearly believed that Indians were unfamiliar with methods of mechanical production, even as mechanized buffers and gas blowtorches became more common among silversmiths who provided goods to traders. La Farge also argued that home production allowed Navajos to make more money than they could make in poorly compensated wage labor, thus improving their basic standard of living.[55] Yet even Navajo silversmiths working at home used modern tools like blowtorches.

La Farge was not alone in objecting to the production of "Indian-made" goods using supposedly "nontraditional" methods. Anthropologist and regional promoter Edgar Hewitt; authors Mary Austin, Mabel Dodge

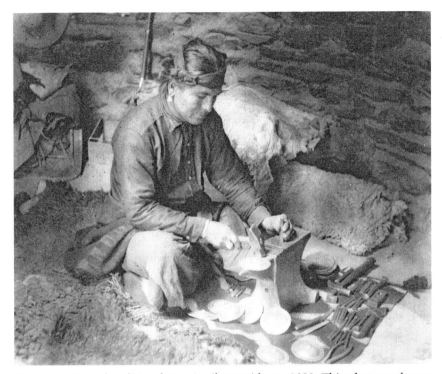

Representation of traditional Navajo silversmith, ca. 1920. This photograph captures the dominant characteristics that consumers came to associate with Navajo silversmiths. The craftsman in the photo is working at home in a primitive setting and is not using a workbench or any kind of modern machinery. Photographer unknown. Courtesy of the Center for Southwest Studies, Kimball Collection.

Luhan, Ruth Bunzel, Elizabeth De Huff, and D. H. Lawrence; artist John Sloan; and many others in the southwestern intelligentsia advocated the preservation of indigenous production methods to save "primitive" cultures. Elitist proponents of "traditional" silversmithing would have been hard pressed to define the exact nature of "traditional" methods, for nineteenth-century silversmiths on the reservation had commonly used manufactured scissors as well as handcrafted molds and bellows. Production unsullied by modernity existed only in promotional texts, not on the Navajo reservation.[56]

The elite who supported the maintenance of American Indian craft "traditions" believed, as historian Margaret Jacobs has demonstrated, that "owning expensive, hand-made Indian arts heightened their status in an increasingly standardized society." A select few openly asserted that the

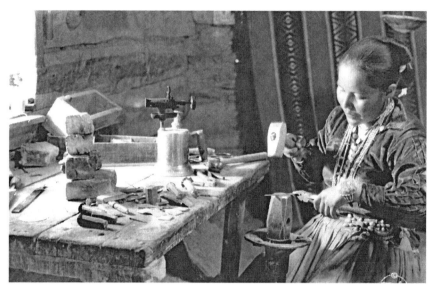

"Navajo Indian Maiden Silversmith, 'Little Hunter's Grand Daughter.'" Frasher Foto Collection, Pomona Public Library, California.

consumption of cheap "Indian-made" souvenirs allowed a working and middle-class white consumer to "parade as a member of the elite." The outspokenly elitist Mary Austin even suggested that when consumers purchased "badly chosen souvenirs," they reinforced their own social "unimportance."[57]

Austin believed that people derived status from their role as connoisseurs of "Indian-made" goods. She feared that the cultural cachet of owning such goods would decline as the production and brash consumerism of "tourist-quality" goods overtook those made for indigenous or other well-informed buyers. Meanwhile, La Farge was concerned about the standing of the goods themselves, asserting that "the making of a few, poor, debased objects . . . will also bolster the present tendency in the country to believe that Indian products are interesting only as curios and not as valuable objet's d'art [sic] in their own right."[58] Moreover, La Farge worried that superficial interest in Indian-made objects would spur Americans to devalue "traditional" American Indian culture, especially Navajo culture.

By the mid-1930s, the meaning of terms like *tradition* and *value* had become a matter of perspective: traders, tourist-industry personnel, silversmiths, consumers, writers, artists, philanthropists, and federal authorities

had differing opinions. Not surprisingly, a number of reservation-based traders who hired Indian silversmiths disagreed with Adair's and La Farge's view that goods manufactured in a workshop atmosphere cheapened the trade and tarnished the image of Navajo silversmiths. Ruth Kirk, of the McAdams Trading Post in Gallup, claimed that the silversmiths her husband hired used "only the finest quality turquoise" in classically Navajo styles. The "highest standards of craftsmanship were encouraged."[59]

Savvy retailers like the Fred Harvey Company sold both tourist-oriented and "classic" Indian-made goods. As early as 1902, Huckle instructed Hubbell to send a shipment of silver spoons to sell to tourists, reminding the trader that most tourists preferred lighter, and therefore more moderately priced, items. Huckle realized, however, that people also wanted to see, and some wanted to buy, the type of goods Navajos themselves were said to prefer. Thus, he ordered "old pawn," requesting "classical" goods that had specific cultural associations like "bridal buttons" that whites could use "as belt buckles."[60] The mystique of silverwork may have derived from its association with the Navaho and primitive production methods, but an appreciation of goods was not fixed to any one style.

Like others, Adair lamented the declining quality of Navajo silverwork, yet he and La Farge were among the few to focus attention on the economic conditions facing Navajo silversmiths. In his research journals, Adair showed that the demand for tourist-quality jewelry had provided Navajos with an important source of income during the economically desperate 1930s. Soil Conservation Service figures verify Adair's claim. By 1940, thirteen of the twenty-four silversmiths working in the vicinity of Two Wells were earning $360 to $750 per year, and the other eleven were earning between $25 and $350 per year. Most smiths from this area sold their jewelry either to local traders or to the Gallup Mercantile, which acted as a wholesaler and supplier to curio stores across America. One such silversmith was twenty-eight-year-old James Begay, who lived with his wife, sister-in-law, and two children on the reservation. In 1939, he sold $200 worth of silver to trader Mike Wallace. Though the family earned an additional $85 by selling wool and livestock, the sale of Begay's silverwork accounted for the bulk of the household's limited but meaningful income. Another family in the same region earned even more, selling $500 worth of silver jewelry to Wallace.[61] Additional surveys confirm that traders paid silversmiths between $45 and $50 dollars per month to

work either at home or in their shops in 1939.[62] Although we do not know how specific artists felt about the "quality" of the goods they produced for the tourist market, they likely valued the production of beautiful items as an expression of *hózhó* as well as a source of income.

In addition to its culturally enriching properties, silversmithing was an important source of revenue for traders and silversmiths, especially in areas of the reservation that were adjacent to major roads or to the railroad, and for Navajos who left the reservation and found employment in tourist destinations like the Alvarado Hotel or the Grand Canyon. As Colleen O'Neill has demonstrated, by 1940, Navajos in the Gallup/Two Wells region derived 32 percent of their household income from silver- smithing and 19 percent from the production of rugs.[63] Yet in the first three decades of the twentieth century, employment at trading posts or the production of commissioned piecework was not the only option for a talented Navajo silversmith. Miguelito, Adjiba, Maria Antonia, and count- less others worked directly for the tourist and travel industry. Artisans were popular at Harvey's venues because Schweizer and Huckle knew that tourists not only wanted to buy Navajo-made jewelry and rugs as souvenirs, they also wanted to see silversmiths making the jewelry or weavers creating their stylized blankets. The ability to see the artisans at work authenticated tourists' experiences and purchases.

Navajo silverwork and textiles were so popular with tourists and so important to the tourist industry that the Harvey Company continued to play on the iconic image of the Navahos as primitive artisans. In 1922, the company spent over $750,000 to build the El Navajo Hotel in Gallup. This hotel, built adjacent to Gallup's train station, was the jumping-off point for tours of Cañon de Chelly, a popular tourist attraction, and became a favorite place to buy Navajo-made souvenirs.[64] The construction of El Navajo perhaps marked the culmination of a remarkable shift in non- Indians' understanding of the Navaho and their cultural products.

Navajos and the Navaho at the Crossroads

Before moving on to analyze the multidimensional impact of the shifting in views of the Navaho—the story that forms the heart of this book—let us return briefly to Miguelito, who by the 1920s had become a prominent medicine man and artist. A later chapter of his life offers a revealing

example of many themes that will come into play in the analysis to follow. For it was none other than Miguelito who oversaw the production of sacred Navajo sandpaintings on the interior walls of the El Navajo hotel. How can we account for Miguelito's willingness to participate in the creation of permanent sandpaintings, going against the Navajo practice at the time of routinely destroying the works after their creation? In 1939, Reichard attributed Miguelito's departure from tradition to his upbringing, which allowed him to see "that certain Navajo rules decreed in ancient times must naturally break down upon the impact of a culture like ours."[65] Reichard also saw the influence of Roman Hubbell, Lorenzo Hubbell's son, in Miguelito's decision.

Whether Roman Hubbell's influence was indeed responsible for Miguelito's participation in the sandpainting project, the medicine man clearly continued to face challenges as a result of his engagement with the tourist industry. In an effort to preserve Navajo culture, Schweizer wanted Miguelito to reproduce ceremonial images and record ceremonial chants. Miguelito had to find a way to overcome the taboos against medicine men's "giving up" of all they knew to outsiders. Miguelito's solution, according to Reichard, was the result of his essential honesty and rationalization. He was "accepting a fee for his compromise and should therefore deliver the goods." In addition, he had promised Roman Hubbell that he would complete the job. "Besides," wrote Reichard, "there was Mr. Schweizer checking him daily and spurring him on." As a result, Miguelito relied on "prayer and purification" to "atone for the sin of breaking the rules."[66] No doubt, Miguelito found the $200 he received useful. Again we see Miguelito trying to negotiate his way in a new market economy that valued his culture, and paid for his labor to "reproduce" it, but simultaneously devalued the premium that Navajos put on sacrosanct directives. Although we do not know what Miguelito thought about this process, and our account of it is filtered through Reichard, we do know that Miguelito guided the creation of El Navajo's sandpaintings as well as many others that Schweizer archived in the 1920s and Reichard collected in the 1930s, in part because his knowledge enabled him to earn cash.[67]

As the tension surrounding Adjiba's premature death in 1905 shows, the tourist industry placed white and Navajo cultures at odds. This tension between Navajo culture and white industry reappeared during Miguelito's production of sandpaintings for Schweizer in the 1920s. At the time, executives reported that Miguelito's reputation as a medicine

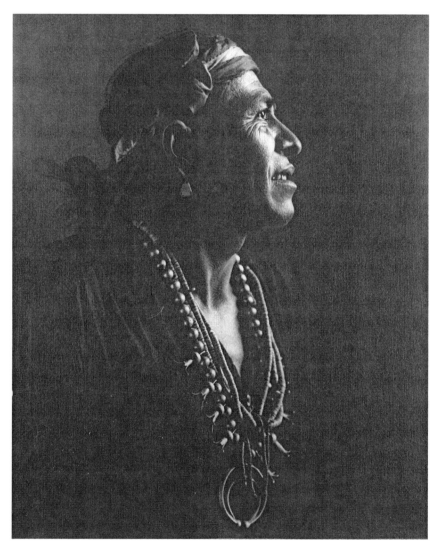

Portrait of Miguelito by Carl Moon, ca. 1905. Photographer Carl Moon worked with the Harvey Company to create salable visions of the Southwest. His portrait of Miguelito became the iconic representation of a Navajo man and Navajo jewelry. Used by permission of the Henry E. Huntington Library, San Marino, California.

man on the reservation was destroyed when "the Medicine Man who had assisted Miguelito went back to the reservation and told the Navajos that Miguelito had given away the secrets of sacred legends and ceremonies." At this point, Schweizer reportedly interceded to help his friend.

"Miguelito at the El Navajo Hotel," ca. 1922. Miguelito contin-
ued to work for the Harvey Company into the 1920s. Here he
is shown standing next to one of the sandpaintings he made
to decorate the El Navajo Hotel in Gallup. Harvey Collection.
Courtesy of the University of Arizona Collection.

According to Reichard, Schweizer persuaded the Navajos who had been
most critical of Miguelito's actions that they should "feel that their pres-
tige had been enhanced by the interest which the white men were be-
ginning to take in their Sand Paintings." As a result, "Miguelito . . . was
held in high esteem for the work he had done."[68] In relating the details of
Adjiba's death or Miguelito's sandpaintings, the Harvey Company contin-
ued to construct a narrative that emphasized the "primitive" qualities of
Indians in relation to the rational motivations of white businessmen.

The tensions between business concerns and individual ones continued into the 1930s, sometimes in very personal ways. On October 11, 1936, Roman Hubbell wrote to Reichard to inform her of Miguelito's death. A few days earlier, Miguelito had returned from a trip to Fort Worth, Texas, which Hubbell had organized. Although we do not know for certain, given Miguelito's history, he likely made the trip to record, create, or otherwise perform some aspect of Navajo culture. By the time Roman went to visit him at his home in White Sands, he found him to be "a pretty sick man." Upon this discovery, and with Miguelito's consent, he went to a local ranch to phone a white doctor. Meanwhile, Miguelito's children followed a different course of action and traveled to Gallup to "get some things for a sing to be held over Miguelito." When Miguelito's family returned, Hubbell "scolded them a little for leaving [Miguelito] alone." His daughter, Marie, in turn complained that Miguelito would not have become so sick if Roman had not insisted he do so much traveling. Hubbell responded that Miguelito had gone of his own free will. In Hubbell's words, "No one had been compelled to go or do what they had not wanted to."[69] After defending his actions, Hubbell left to pick up the doctor, but before he could get him, Miguelito's son-in-law intercepted the trader "at the crossroads" between Ganado and White Sands and informed him that the medicine man had died.

Although he died at his home on the reservation, Miguelito had spent a good deal of his life negotiating the crossroads where Navajos came into contact with the Navaho and all that the concept entailed. As a skilled artist and noted medicine man, Miguelito tried to balance the demands of Navajo culture with those of the tourist-oriented economy. He worked with white traders, anthropologists, and businessmen so that he could provide for his family, but he also worked to maintain his reputation on the reservation, his religion, his cultural traditions, and his family and community. The Harvey Company invested time, money, and cultural capital in Miguelito's presentation of Navajo culture, but in doing so, it focused on a form of Navaho primitivism that it could market. Being both Navaho and Navajo forced Miguelito to navigate between competing demands.

In the time between Adjiba's and Miguelito's deaths, the human drama of the sale, production, representation, and promotion of Navajo "Indian-made" goods continued at full bore. Yet if we return to the circumstances of Adjiba's brief working life, we see how many parties invested both in

her labor and in her representation of the Navaho. In Adjiba's case, her industry and the income it generated were important to her family. But many others mediated, participated in, controlled, or otherwise influenced the employment of Navajo artisans. Adjiba's story demonstrates the close-knit ties between Navajo traders and tourist-industry representatives. It reveals that traders handpicked Navajo producers and then coordinated the work arrangements between artisans and outside venues. Once work agreements were in place and Navajos were integrated into the modern market economy, Navajos became subject to the constraints imposed by their employers. As in Miguelito and Adjiba's case, Navajos might agree when work would commence, but they then might have difficulty terminating their employment. The Harvey Company relied on the performances by Indian artisans to sell the goods, images, and authenticity of the region, and the travelers to whom the company sought to appeal contributed to the corporation's bottom line when they consumed vast quantities of "Indian-made" goods along with images and displays. Thus, both the production of images and the consumption of them helped white Americans think of Navajos not as a modern American population but as the Navahos, a preindustrial and premodern people.

Ethnologists and anthropologists who observed, endorsed, and wrote about Navajo displays of "primitive" peoples contributed to the power of such concepts. Reichard, like many other noted anthropologists of the time, accepted research and publication funds from the Fred Harvey Company.[70] Even she, a student of Franz Boas, who embraced the idea of cultural relativism, published commercially driven assessments of American Indian primitivism in her publications. In the end, the skills of Adjiba, Maria Antonia, and Miguelito were the elements that attracted Hubbell's, Huckle's, and Reichard's attention, enabling the family to enter the market economy and winning them the appreciation of outsiders. Ironically, however, and from the very beginning, the representation of these artisans' expertise became so important to tourist-related industries and pursuits that it limited Maria Antonia's and Miguelito's ability to negotiate with the company for Adjiba's return to the reservation.

Still, as the possession, representation, and display of Navaho culture became products for white consumption, the role of Navajo artisans expanded. Navajos produced goods for the growing consumer economy even as they supposedly embodied a precapitalist exchange system representative of America's preindustrial past. In turn, if not always in the

same ways, individuals from different social, cultural, and economic realms relied on the production of Navajo goods and invested meaning in the image of Navaho artisans. In this sense, Navajo-made goods were not the Navajo reservation's largest export, yet because they came bundled with an expansive set of cultural meanings, the goods gained importance beyond their numbers. The ideas evoked by Navajo production methods, textiles, and jewelry not only influenced the type of work available to Navajo artisans; they had a profound effect on the ways that Americans off the reservation understood Navajo culture as a whole. If tourists and their guides chose to emphasize the appearance of primitiveness in these products, theirs was a selective vision. It obscured the fact that Navajo-made goods were at the fulcrum of a dense set of cultural and economic beliefs and exchanges in which Navajos tried their best to balance their need for income with their desire to maintain their culture and participate in the representation of their culture.

The popularity of the Navaho, Navajo-made goods, and the performance of Navaho labor stemmed from the tourist trade, which in turn grew out of efforts by scholars, artists, and authors, along with traders and tourist-industry executives, to feed the growing craze for all things "primitive." For the most part, however, consumers did not need an education in anthropology or a fat pocketbook to appreciate or obtain Navajo-made goods. Traders made certain that a wide range of Navajo-made goods were available, accessible, and affordable. Traders learned about Navajo culture because they traded and lived among Navajos, but they also wanted, and needed, that knowledge if they were to reap profits from "Indian-made" commerce. As the demand for blankets and jewelry grew among American consumers, traders across the reservation expanded their options by selling Navajo goods to a growing number of stores, including large department stores like Macy's in New York, or by marketing them directly to consumers through catalogs. We know that Navajos themselves continued to value the artistic, cultural, and economic aspects of the goods they made, but we know relatively little about how they interacted with traders as the demand for their textiles and jewelry increased and the idea of the Navaho took hold in the American imagination. To understand the form and import of trade interactions, we need to take up the history of Navajo trading posts and examine how posts linked Navajo exchange practices with white business principles.

Negotiating the Navajo Trading Post, Navigating the National Economy

In 1935, Navajo weaver Louisa Alcott wrote to Lorenzo Hubbell Jr. requesting aid to help her through an illness. She reminded Hubbell of their long-standing, mutually beneficial economic relationship. "Whenever I make a Navaho rug," wrote Alcott, "I always take it to your store in Tenebito." Noting the quality of her rugs, she chided him for occasionally undervaluing her work: "Sometimes the price [paid for the rugs] is so low I do not get much out of what I weaved." In need of groceries, Alcott asserted that Hubbell owed her help not simply because he had underpaid her for rugs in the past but also because "I do much for you" and "I help you all the time." In her view, a mutually beneficial trade relationship hinged upon the parties' willingness to help each other. She concluded her letter by placing an order for flour, coffee, sugar, and baking powder. Hubbell provided Alcott with the goods she requested because he too recognized the importance of keeping his customers and workers alive and happy.[1] As Alcott's letter suggests, trading relationships at the time were complex affairs, not easily reduced to economic formulas and principles. Hubbell purchased Alcott's rugs because much of his business depended on his having a stock of Navajo products to sell. In turn, Navajos needed the products that traders stocked, a fact that gave Hubbell social and economic standing on the reservation. Even so, exchange relationships extended beyond individual economic transactions.

As we saw in Chapter 1, connections between Navajo artisans and traders provided a steady stock of Navajo-made items to tourist venues, curio shops, ethnic-art dealers, anthropologists and ethnologists, and American consumers across the nation. This chapter looks at the evolution of Navajo trading posts—including the participants' strategies in exchanges and the narratives that gave life to the market—to help us see how the "Indian-made" marketplace took shape. As Alcott's request demonstrates, although exchanges between Navajos and traders were part of the modern economy, they did not always conform to strict economic guidelines and did not necessarily end once goods and services changed hands. The exchanges depended on mutual understanding of cultural mores as well as economic give and take. As Alcott pointed out, social accountability had a role in the business of trading.

Except for brief periods in American history, cross-cultural trade relationships between American Indians and non-Indians have suffered from miscommunication, uneven power relations, and Euro-Americans' seemingly unyielding demand for the natural resources held by indigenous peoples. Most scholars who have documented such encounters have focused on Indian-white trade relations during the time of early contact and the colonial era.[2] Yet trade between American Indians and non-Indians continued well into the twentieth century. The escalation of industrialization, the growth of vast transportation systems, and the rise of a consumption-oriented American public influenced trade relationships between Navajos and non-Navajos. Navajos, as producers and as consumers, and traders, as business-minded individuals, conducted their transactions within this larger context. Moreover, from the 1890s through the 1930s, both the national demand for Navajo-made products and the popular representation of Navaho producers as "primitive" artists played a part in this apparently localized trade. Examination of the microcosm of Navajo trading posts reveals this influence.

Trading posts were at the center of Navajos' and traders' economic lives. There, Navajos learned of American consumer demand for their products, and many had their first exposure to a consumption-driven marketplace. Trading posts were their entrée to the modern industrial economy. For traders, trading posts were a launchpad for shipping the majority of Navajo-made goods across the nation. In acknowledgment of Navajo trading posts' unique and significant status, two contemporary narratives quickly came to dominate analysts' explanations of the

business conducted there. One powerful narrative described a world of "frontier commerce" in which nonmonetary exchanges at trading posts were peripheral to the modern marketplace. The other suggested that the end result of trading practice was economic dependency. Both narratives focused attention on the destruction of Navajo culture, but the second detailed the more coercive aspects of trade encounters. Although neither narrative adequately conveyed the complexity of the economic interactions between Navajos and traders, the two interpretations reveal how non-Indians imagined and understood Navajo market engagement at the time. Not only did these interpretations obscure Navajos' participation in the marketplace, they also cast Navajos as victims. By uncovering the form, function, and interpretation of exchanges between traders and Navajos underneath these narratives, we can chart a more complex view of this cross-cultural trade. A close look at Navajo trading practices can help us understand how Navajos viewed the marketplace, attempted to temper uneven power relations within it, integrated new economic rationales into their own and traders' daily routines, and maintained their culture even when economic and power relationships were skewed to favor non-Indian players. A look at the notions of frontier commerce and dependency can lay the groundwork for exploring gaps in these narratives and determining why these views found willing audiences among scholars and the public in the first four decades of the twentieth century.

The Roots of Trading-Post Narratives

By the late nineteenth century, the term *Indian trader* described a non-Indian (usually a Euro-American or Hispanic) who exchanged manufactured goods with American Indians for raw materials or handmade crafts on an Indian reservation. By the early twentieth century, some businessmen, like Julius Gans of Santa Fe and Maurice Maisel of Albuquerque, had co-opted the term for their own purposes, recognizing that it had come to signify not only an occupation but also a mythologized lifestyle.[3] By 1900, the trading post had become a key economic center and had come to symbolize Indian-white encounters.

Two fundamental changes in the Navajo economy paved the way for commerce between Navajos and traders on the reservation. First, the reservation system regulated the movement of Navajos and strictly limited

the hunting practices and trade networks that had been a way of life before 1867. In addition, the Bureau of Indian Affairs outlawed intertribal raiding, a centuries-old method of acquisition among the once seminomadic Navajos.[4] As a result, Navajos developed new subsistence, agricultural, and survival skills that revolved around trading posts. As Navajos manufactured goods to meet non-Navajo demand, they also consumed the staples available at the trading posts, such as calico and velvet, canned milk, peaches and tomatoes, and sewing machines, hammers, and hoes. In doing so, they became linked to a larger economic network. Not surprisingly, both Navajos and traders attempted to negotiate trades that served their self-interest. Thus, Navajos accrued both credit and debt at trading posts. Some debts were seasonal in nature; others could last for years.

By sponsoring ceremonies, accommodating tourists, trading with Navajos, and selling to external markets, traders like the Hubbells of Arizona created a year-round market in an area known for its seasonal business cycles. When trade with Navajos slowed in the late summer and early fall, the traders would turn to tourism. John Lorenzo Hubbell, the proprietor of over thirty posts in New Mexico and Arizona, hosted thousands of tourists per year at Ganado and Oraibi. When the tourist season ended, Navajos again provided the bulk of the business into the winter months. Curio stores and other retailers placed large orders for Navajo-made jewelry and blankets in November and early December to stock up for the holiday season. Then, in the lean winter season, traders again relied on Navajos, who gathered wood, pine nuts, and other resources that were needed at the posts or were in demand in specialty markets. By early spring, traders would have acquired lambs for trade. In this way, the Hubbells and Navajos forged an economic cycle based on the buying and selling of sheep and wool.[5] Cash rarely changed hands between trading partners. Cyclical buying seasons were supplemented by yearlong patterns, with Navajos bringing in rugs, jewelry, or raw materials to trade for staple items or to obtain payment in scrip. Traders also accepted pawn, which helped ensure that Navajos would continue to patronize their stores.

This cycle of extending credit and increasing Navajo debts in a cash-poor economy spawned the two narratives that dominated the early literature about trading posts. By the 1930s, popular and academic portrayals of transactions between Navajos and whites were suggesting that a form

of frontier commerce drove trading-post exchanges. The term empha-
sized the more rough-hewn qualities of Navajo-white trade relationships,
especially the ways that "primitive" Indians and "civilized" traders bar-
tered with each other on an isolated landscape. Other portrayals focused
not so much on the form of trading-post economies as their function.
The latter interpretations held that institutions, along with federal poli-
cies, forced Navajos into economic dependency or debt peonage. Both
frontier commerce and dependency fostered the idea of the Navaho, and
both were distinct elements of a larger discourse about the relationship
between the Navajo and capitalism.

By the 1930s, narratives of frontier commerce and economic depen-
dency circulated throughout the nation, influencing governmental and
nongovernmental assessments of trading posts. In 1935, for instance, the
principal agricultural economist of the Office of Experiment Stations in
the U.S. Department of Agriculture, identified only as B. Youngblood,
drew together the two interpretations in a report detailing the effects
of Navajo trading "in relation to Navajo economy and life." At the time,
the department was considering a proposal to expand its controversial
program of livestock reduction, and Youngblood and his staff were in-
vestigating ways to halt soil erosion and reduce the Navajo economy's
dependence on sheep, horses, and goats. The agency's stated goal was to
make Navajos less dependent on the practices of credit and pawn in the
trading-post system. Youngblood reported that Navajos routinely paid for
high-priced manufactured goods by either selling "cheap raw materials"
or "buying in a protected market and selling in an unprotected market."
In a system of frontier commerce, he noted, Navajos were rarely able to
subsist beyond the most basic standard of living and were almost wholly
dependent upon the traders as a result.[6]

Youngblood invoked the term *frontier commerce* to explain the anach-
ronistic qualities of trading posts. Posts were not only oppressive eco-
nomic institutions, but "trading as conducted in the Navajo country is
probably our best remaining example of frontier commerce." Youngblood
noted the long history of cross-cultural relations between American Indi-
ans and Europeans: "Trade with Indians began with the first settlements
along the seaboard and served as the vanguard of European penetration
into the interior in the struggle for supremacy on the North American
continent." Subsequent waves of European and American "adventurers"
moved through "Indian country" by boat, horse, or wagon, exchanging

merchandise for Indian products. Most trades took the form of barter and other nonmonetary exchanges. Yet, though the kinds of products that whites and Indians exchanged had changed over time, Youngblood reported that the practice of trading remained the same: "Navajo trading is carried on today in much the same fashion as in former times." He drew upon a well-entrenched idea that, like their eastern seaboard cohort of days gone by, Navajos and traders lived, worked, and traded on a "frontier." He favored either revising the older functions of trading posts or creating a different kind of lending institution altogether.[7]

Although other observers were less interested in transforming the trading-post economy, many agreed with Youngblood's assessment of trading-post life, sometimes almost word for word. Anthropologists Clyde Kluckhohn and Dorothea Leighton, who studied the Navajos in the 1930s and 1940s, probably consulted Youngblood's report for their research. They claimed in their seminal text, *The Navajo,* that the trading post "has been well characterized as 'the best remaining example of frontier commerce'" in America.[8] For Leighton and Kluckhohn, the word *frontier* implied both a geographical region and a type of commerce in which the trading posts functioned "as did the general store in white society a generation ago." As a result, some "traders, foolhardy or unscrupulous, have granted credit so liberally as to keep families in perpetual debt," thereby reducing Navajos to "a state of peonage dependency." In another reiteration of the Youngblood report, Leighton and Kluckhohn reported that the general economic dependency was a direct result of an outdated and unfair system: "The [Navajo] People are exchanging raw materials or simple craft products for costly manufactured articles, they labor under the continual disadvantage of buying in a protected, and selling in an unprotected, market."[9] Although the anthropologists acknowledged that by the 1940s Navajos commonly purchased manufactured goods, they claimed that Navajos had gained a "closer acquaintance with the white economy" only as a result of World War II.

Even if both interpretations were accurate in some aspects—and both still find their way into contemporary literature—neither the frontier commerce narrative nor the dependency narrative effectively communicate or describe the complex power and trade relationships at Navajo trading posts. For today's scholars, the explanations are largely useful as expressions of the era and as indications of non-Navajos' view of Navajos not as modern economic actors but as Navahos. And one way to test the

accuracy of these narratives is to examine how and why Navajo trading posts and practices developed the way they did.

The Evolution of Posts and Practices

The first exchanges between Europeans and indigenous peoples occurred during colonization. Spanish, English, French, and Dutch colonizers bartered with American Indians for survival. As colonial survival became more secure, colonists began trading with Native Americans for furs, skins, and a variety of natural resources that they could sell in Europe. Native American communities also traded with each other. In 1630, for instance, Spanish colonizers reported that Pueblo and Navajo peoples exchanged buffalo hides and deerskins for corn and cotton mantles. Such transactions took place at large celebrations that could last for days.[10]

Government-regulated trading outposts developed relatively late in the eighteenth century. In 1795, George Washington appealed to Congress to establish government-controlled trading posts to supervise trade with American Indians.[11] From their inception, then, trading posts were supposed to be sites of controlled interaction between American Indians and Euro-Americans. Federal regulation of trade began when Congress passed the Indian Trader Bill, which controlled exchanges between whites and American Indians in so-called frontier territories. The Indian Trader Bill made trade between American Indians and non-Indians a federal concern. The first trading posts, called factories, aimed to provide a buffer zone between rural settlers and indigenous peoples. The federal government attempted to regulate the trade of raw materials, and later of manufactured goods, by limiting traders' markup to one-third of the wholesale price.[12]

Trading houses were supervised by the Department of Public Supplies until 1806, when they became the domain of a single superintendent of Indian trade. The superintendent oversaw and controlled trade from his headquarters in a warehouse on the outskirts of Washington, D.C.[13] However, his distance from the posts impeded his efforts to regulate trade. As a result, in 1822, Congress passed legislation discontinuing federal trading houses. Instead of trying to oversee operations, the federal government began to license individuals who wished to trade. Between the years before the Mexican War and 1876, traders in the Southwest were

appointed by federal Indian agents. After 1877, the commissioner of Indian affairs appointed and licensed traders.[14]

George A. Richardson was the first federally licensed trader to build a post in Navajo country, and he did so just before the Navajos were released in 1868–1869 from internment at Fort Sumner, Bosque Redondo.[15] Upon the Navajos' release, the federal government provided them with 15,000 head of sheep and goats. By 1885, federal agents reported that Navajos owned more than 500,000 sheep and goats. As a result of this remarkable growth of livestock on the reservation, more and more individuals rushed to trade with the Diné. The first exchanges between federally licensed Euro-American traders and Navajos involved livestock. However, historian Richard White warns against overstating the commercial prospects of sheep. Sheep trading was a "byproduct of sheep raising," not the primary goal of Navajo herders. In addition, by the 1880s, as the government minimized its role in the area, many traders saw an opportunity to profit from the rapidly increasing Navajo population by providing the Indians with staples.[16]

Many traders were financially successful. A federal ruling in 1886 limited traders' profits to 25 percent of the price at which they sold an article, but despite this profit ceiling, at least two traders grossed more than $4,000 that year.[17] By 1889, Indian agent C. E. Vandever counted nine traders living on the Navajo Reservation and more than thirty trading posts surrounding Navajo land.[18]

As in other exchanges, Navajo culture influenced trading-post practices. Timeworn Navajo traditions such as gift giving, which were fraught with symbolic and economic intent, greatly influenced exchanges between Navajos and traders. Gift exchanges had long influenced traditional Navajo trading processes. When trading with Hopis, Apaches, or Utes, a Navajo would find a member of the other tribe who had a bond with the Navajo community. "In the early days," Richard White has noted, Navajos "gave gifts of hides or baskets to this 'friend'; later the gift was almost always blankets." In return, "the friend reciprocated by giving horses if they were Ute, or foodstuffs, pots, or turquoise if he was a Pueblo."[19] Gift exchanges and, therefore, indigenous trading relationships persisted for generations. As traders moved onto the reservation in the 1880s and began to deal with Navajos, they quickly realized that if they wanted to succeed they would have to embrace local Navajo market practices alongside more contemporary national business norms.

Once licensed, the most successful traders in the late nineteenth century and beyond were those who respected culturally based economic practices. Exchanges between Navajos and traders blended symbolic and material components. For example, the willingness of a medicine man (healer) or his family members to exchange a medicine bag (*jish*) for credit indicated that they trusted the trader. Traders offered credit, cash, or goods in exchange for ceremonial pouches even though they knew that if the owners of such collateral did not reclaim the items within the designated time, the traders should not sell them. If traders failed to understand the cultural value of the pouches and tried to sell them, they could lose favor with medicine men—and all those under their influence. Thus, the real value of the medicine pouch was as a symbol of cultural understanding and mutual trust. Violation of trust or "goodwill" on either part threatened the viability of future exchanges or might lead to violence.[20] As a result, traders gradually learned the particularities of the trade or were forced out of the business.

One especially important lesson that traders had to learn was that they had to overcome any local hostility if they were to establish a Navajo clientele. Traders who failed to respect Navajo terms could be driven out of the business. Some occasionally lost their lives. For instance, Pat Smith was killed at Tucker's trading post in 1918. Smith had closed the post during an Enemy Way Sing ceremony taking place a few miles from the trading post. When Smith refused to open the post so that two young Navajos could shop, the two would-be shoppers reportedly killed him, set the trading post aflame, and proceeded to the ceremony.[21] The assailants had desired to stock up on supplies before proceeding to the ceremony and perceived Smith's refusal to open the post as a cultural affront.

Smith was not the first trader who faced dire consequences when he neglected to take the demands of his clients seriously. Eight years before, Richard Wetherill (or Anasazi, as the Navajos called him), the trader at Chaco Canyon, New Mexico, suffered a similar fate at the hands of a group of six Navajos. The triggerman, Chis-Chilling-Begay, lived nearby and did not like the way that Wetherill had "carried" him on the books. Begay expressed his wrath by shooting Wetherill point-blank in the head. Wetherill's killing was a sign of broader tensions between Navajos and whites that lingered as a result of the racial and national conflicts that had arisen with the Long Walk, but Begay's breaking point was the development of an unsatisfactory trade relationship with Wetherill. Although

racial difference and power relationships often figured into strained tensions between Navajos and whites, Begay dealt peacefully with other white traders. In fact, just before murdering Wetherill, Begay had pawned a silver concha belt with trader George Blake in order to buy two boxes of cartridges for his rifle. After shooting Wetherill, Begay returned to Blake and asked for his advice about surrender. Begay obviously trusted Blake and particularly disliked the way that Wetherill treated him. That five other men accompanied Begay suggests that Wetherill's trading practices had angered a number of the trader's patrons.[22]

How did traders navigate Navajo cultural and economic practices and successfully merge them with their own profit-driven motives? The most effective traders were those who, from the beginning, were able to temper cross-cultural mistrust and were aware of their responsibilities to the Navajos with whom they dealt. For instance, during her work on the Navajo Reservation in the late 1930s and early 1940s, Ruth Underhill noted that "the trader's life" and livelihood was contingent upon his or her "ability to please the Navajos." Successful traders learned the Navajo language, or when language barriers arose, offered "a friendly smile." Likewise, successful traders had to be patient while Navajo consumers "inspected every article in the store." Oral histories with traders confirm Underhill's claim. Traders told interviewers that they felt they had to at least make a pretense of respecting Navajo trading preferences. Most traders routinely offered Navajos gifts of coffee, canned goods, tobacco, or candy as a way of acknowledging the Navajos' culturally ingrained approach to trading.[23]

Traders had to be consumers of Navajo culture, as well as goods, to nurture fledgling businesses. Traders like Samuel Day and his son Charles, J. L. Hubbell and his sons, and many others learned to speak a form of "trader Navajo." Hubbell's oldest son, Lorenzo Hubbell Jr., was reportedly fluent in Navajo, was respected by Navajos, and had a reputation as a man who "thought like a Navajo" (though most such descriptions came from whites). At least some Navajos also remembered the elder Hubbell with a degree of fondness. Navajo Ailema Benally stated that Hubbell was "a friend not a foe of the Navajos."[24] Samuel Day Jr. became personally involved with Navajos and married a Navajo woman, Kate Roanhorse. Day's son described his father as "a student of Navajo ceremonies."[25] Day was not alone in his desire to learn from Navajos. Sallie and Bill Lippencott, who ran the trading post at Wide Ruins, Arizona, in the late 1930s and early 1940s, had trained as anthropologists at the University

of Chicago and viewed trade with the Navajo as a potentially profitable form of "fieldwork."

The Days, Hubbells, and Lippencotts adapted to Navajo life as a matter of personal effort, business acumen, and intellectual exercise, but whatever their motivations, traders also had to immerse themselves in Navajo culture and purchase Navajo-made products to safeguard their financial success. According to government officials and anthropologists, these traders were conducting their business on the periphery of civilized society—on the "frontier." Traders agreed and took on the task of interpreting Navajo culture for outsiders as a means of increasing their profit margins and perpetuating Navajo trade.[26]

As part of that interpretive process, and following the lead of the railroad, some traders facilitated tourism to the reservation. To enable travelers, tourists, and dealers to experience a different culture and see the wide array of goods available for purchase, Hubbell opened his home to visitors. He and his wife, Lina, had lavishly decorated the more public areas with baskets, blankets, and other Navajo crafts. Like other traders, Hubbell hosted ceremonies and celebrations near his trading posts and coordinated tours into "Indian country" from Ganado.[27] These efforts paid off. Stella Preston, a Hopi woman who worked as domestic help for the Hubbells in the 1920s and 1930s, reported that "thousands" of tourists often showed up at the trading post. She said that the area around the post was "filled with cars" and that "many people used to come to see him [Hubbell] from near and far." Around the time of the Hopi Snake Dance, an especially popular tourist attraction, J. L. Hubbell and his son Lorenzo welcomed many travelers. According to Preston, Hubbell took visitors to the dance and then put them up for the night. Because he had limited space in his home, Hubbell gave tourists space on the floor of the elaborately decorated house or post and offered them handmade Navajo blankets off the shelves—the merchandise—to sleep on. In addition, he provided food and drinks to visitors for a small fee. For a dollar, the Hubbells provided roast beef, chili, vegetables, and pies to hungry tourists. Buying a Navajo blanket became part of a tourist's authentic experience at the reservation. Thus, despite the difficulty of playing host to so many individuals, Hubbell built a customer base through this tourism. His sons continued to host tourists after their father's death in 1930.[28]

How did traders cultivate their roles as part of a supposedly commercial frontier? As Don Lorenzo Hubbell demonstrated, traders would cast

Interior of Hubbell House, ca. 1902. Don Lorenzo Hubbell sits amid his Indian collection. Photo provided by National Park Service, Hubbell Trading Post National Historic Site.

themselves as the embodiment of the cross-cultural encounter. By displaying Navajo-made goods in a familiar domestic setting, traders could demonstrate that Navajo-made items could be integrated into any household décor. But traders also underscored their distance from urban areas by focusing attention on the remoteness of the Navajo Reservation and the primitiveness of the Navaho and the artifacts they manufactured. This strategy explains why observers could not resist using the term *frontier* in referring to trading posts. Similarly, outsiders' assumptions about Navajos' dependency rested upon the belief that traders would come out on the better end of the deal because of their innate racial qualities or characteristics. In reality, the fact that the traders had to accommodate their lives and their businesses to Navajo culture countermanded neat portraits of white racial superiority or frontier iconography. Traders had no guarantee that they would come out ahead in economic exchanges, especially because they were, in many ways, dependent upon their Navajo partners. As a result, traders typically sought to offer trading terms and conditions that Navajos would accept—even though Navajos could not control the terms directly. Although the Navajo Reservation stood apart from urban areas in many ways, both traders and Navajos understood

Interior of Hubbell House, dining room, August 18, 1909. Hubbell entertained tourists and "showcased" Navajo-made wares in his home. Photo provided by National Park Service, Hubbell Trading Post National Historic Site.

modern market trends and practices and were tied to the rest of the nation by the railroad.

Forms of Exchange

For traders like Lorenzo Hubbell to build solid businesses, they had to develop a somewhat mutually beneficial trade system with Navajos. Hubbell, like other traders, used three basic business practices to establish a reputation for fairness and a consistent trading relationship with Navajos: barter, overstocking, and pawnbroking. Barter was the primary feature of frontier commerce that supposedly defined exchanges between traders and Navajos as "primitive." Overstocking resulted from Navajos' insistence that traders buy more stock than the market demanded if they wanted to maintain long-term trade relationships. Pawnbroking incorporated Navajo assets into the expanding economic network that linked

the reservation-based market to the national economy. Like bartered exchanges and overstocking, pawn gave Navajos some, albeit limited, room to influence exchanges in the trading process, especially as these practices were mitigated by Navajo custom. Even so, Navajos like Alcott understood that white consumers' appetite for Navajo rugs and jewelry could grease the wheels of all three means of trading-post exchanges.

Barter

If barter was one of the key features of commerce that marked the trading post as a frontier, we have to explore its evolution, its ultimate purpose, and its rules of engagement. As we have seen, trade was not a new concept to Navajos. The two items that Navajos most commonly traded with other American Indians, according to Navajo John Charlie, were "hides and food."[29] Such exchanges required little bartering and mostly took the form of gift giving. When Navajos did have to barter, as in their interactions with Puebloan peoples, they disliked it and thought their partners stingy.[30] Bartering and bargaining, however, became central features in trading-post exchanges, mostly because the idea of bartering for goods made more sense to traders than did the process of "gift exchange," which they did not fully comprehend. Still, although Navajos supposedly disliked bartered exchanges and did not always trust the traders, a mutually understood trade relationship developed relatively quickly. At least at the beginning, the form of barter that took place on the trading posts incorporated elements of gift giving, with traders initiating or closing exchanges by presenting Navajos with small gifts such as coffee, tobacco, or candy.

By the 1920s, bartered exchanges had developed a pattern. For Sallie Lippencott of the Wide Ruins Trading Post, "patience was needed when dickering for a rug." A weaver would enter the store with "a rug neatly wrapped in a flour sack" and then stand "inside the door for a few minutes greeting particular friends with a touching of hands." For Navajos, claimed Lippencott, a visit to the trading post was "an event." Only after the social aspects of the visit had been fulfilled would the weaver let the trader know that she was ready to barter. (Most weavers were women, but a few Navajo men also worked as weavers.) Traders knew not to rush through the encounter. First, a trader would admire and assess the aesthetics of the rug. Then, "with the weaver trailing along," wrote Lippencott, "we would take the rug into a back room of the store, spread it

Interior of Hubbell House, dining room, August 18, 1909. Hubbell entertained tourists and "showcased" Navajo-made wares in his home. Photo provided by National Park Service, Hubbell Trading Post National Historic Site.

modern market trends and practices and were tied to the rest of the nation by the railroad.

Forms of Exchange

For traders like Lorenzo Hubbell to build solid businesses, they had to develop a somewhat mutually beneficial trade system with Navajos. Hubbell, like other traders, used three basic business practices to establish a reputation for fairness and a consistent trading relationship with Navajos: barter, overstocking, and pawnbroking. Barter was the primary feature of frontier commerce that supposedly defined exchanges between traders and Navajos as "primitive." Overstocking resulted from Navajos' insistence that traders buy more stock than the market demanded if they wanted to maintain long-term trade relationships. Pawnbroking incorporated Navajo assets into the expanding economic network that linked

the reservation-based market to the national economy. Like bartered exchanges and overstocking, pawn gave Navajos some, albeit limited, room to influence exchanges in the trading process, especially as these practices were mitigated by Navajo custom. Even so, Navajos like Alcott understood that white consumers' appetite for Navajo rugs and jewelry could grease the wheels of all three means of trading-post exchanges.

Barter

If barter was one of the key features of commerce that marked the trading post as a frontier, we have to explore its evolution, its ultimate purpose, and its rules of engagement. As we have seen, trade was not a new concept to Navajos. The two items that Navajos most commonly traded with other American Indians, according to Navajo John Charlie, were "hides and food."[29] Such exchanges required little bartering and mostly took the form of gift giving. When Navajos did have to barter, as in their interactions with Puebloan peoples, they disliked it and thought their partners stingy.[30] Bartering and bargaining, however, became central features in trading-post exchanges, mostly because the idea of bartering for goods made more sense to traders than did the process of "gift exchange," which they did not fully comprehend. Still, although Navajos supposedly disliked bartered exchanges and did not always trust the traders, a mutually understood trade relationship developed relatively quickly. At least at the beginning, the form of barter that took place on the trading posts incorporated elements of gift giving, with traders initiating or closing exchanges by presenting Navajos with small gifts such as coffee, tobacco, or candy.

By the 1920s, bartered exchanges had developed a pattern. For Sallie Lippencott of the Wide Ruins Trading Post, "patience was needed when dickering for a rug." A weaver would enter the store with "a rug neatly wrapped in a flour sack" and then stand "inside the door for a few minutes greeting particular friends with a touching of hands." For Navajos, claimed Lippencott, a visit to the trading post was "an event." Only after the social aspects of the visit had been fulfilled would the weaver let the trader know that she was ready to barter. (Most weavers were women, but a few Navajo men also worked as weavers.) Traders knew not to rush through the encounter. First, a trader would admire and assess the aesthetics of the rug. Then, "with the weaver trailing along," wrote Lippencott, "we would take the rug into a back room of the store, spread it

out, and point out the good points and the occasional bad ones."[31] The bargaining followed.

Bartered exchanges involved cultural manipulations on both sides of the counter. One weaver in particular, Mrs. Glish, seemed to understand how to use Anglo-American gender norms to her advantage. Mrs. Glish wove beautiful rugs but, according to Lippencott, was such a tough barterer that it was difficult "for the men behind the counter . . . to deal with her." Bill Lippencott especially had a hard time bargaining with the weaver because she had a tendency to weep. In contrast, Sallie Lippencott claimed to have the higher hand and asserted that she was not fooled by Mrs. Glish's tears and would not pay an elevated price when the weaver cried.[32] These reports reveal the key elements of the exchanges between traders and Navajos: personal interaction, the pursuit of mutual self-interest, and the manipulation of cultural mores.

Lippencott also mentioned other common features of the bartering process. Weavers used trading posts to exchange news and to trade. They waited until they commanded the full attention of the trader. Traders started the transaction by naming a price. Weavers took their time and carefully summed up the traders' thoughts. Then, and only then, did the serious haggling begin. Traders reported that weavers used a variety of strategies to increase the price. A strategy like weeping had specific gendered overtones. Once the two parties agreed on a price, however, weavers conducted additional business with traders by obtaining goods. Traders reciprocated by providing something extra, usually canned tomatoes or peaches, to maintain goodwill.

The incorporation of gift giving into the bartering process did not completely eradicate mutual suspicion. Because traders purchased wool and sometimes rugs by the pound, Navajos knew that traders might lower prices or underweigh sacks of wool or rugs. In turn, Navajos occasionally loaded bags of wool with rocks, sand, or other material to increase the weight before bringing them to traders. Mary Baily, whose parents ran the trading post at Piñon in the 1920s, remembered how even strained trade relations might be both friendly and competitive—at least from the trader's perspective. She remembered her father's reaction to one Navajo who had fooled him. Her father "looked up on this [bill of lading chart] to see what Joe Benally's sack had in it." He found that Benally had wrapped up "a mattress . . . real, real, tight, and then padded [the rest of the sack] with wool." Her father took this with a grain of salt. He "could hardly wait

to do something for him someday. . . . It was really, really funny."[33] Wool wholesalers sometimes accused traders of tampering with exports, and whether the traders had learned their tricks from Navajos or the other way around is difficult to say. For instance, a German trader named Fritz reportedly instructed one of his employees to "sand the wool, sand the blankets, sand the hides" before shipping them to the wholesaler, Babbitt Brothers, in Flagstaff.[34]

Bartering was not simply a cross-cultural exchange that created or quelled tensions, it was an economic practice that reflected traders' desire to manipulate trade and build a steady clientele. Although wool was probably the most commonly bartered item at trading posts, the trade in blankets demonstrates how closely traders had to work with Navajos if they wanted to expand their businesses. The trade in blankets steadily increased from 1890 to the 1910s. During this time, the buying of blankets grew at a rate disproportionate to the purchase of raw materials. In 1892, Hubbell reported that he had purchased only $364 worth of Navajo blankets at his trading posts, but by 1909, he reported buying, through bartered exchange, $27,558 worth of blankets. This growth was remarkable, even given inflation, price fluctuations, and the addition of new trading posts to Hubbell's circle. Trade for other items remained level. For instance, Hubbell traded for $625 worth of goatskins in 1892 and saw this business increase to only $890 by 1909. Figures for goatskins and blankets show that the terms of trade between Navajos and traders remained constant, meaning that Navajos and Hubbell had developed some form of mutually acceptable behavior and that certain items became more desirable as traders tapped into preexisting markets or created new ones. At the same time, traders continued to trade for items that had little external market value, bartering for items such as goatskins, because Navajos demanded that they do so. Hubbell's business records indicate that between 1891 and 1909, he consistently bartered for wool, blankets, pelts, skins, pine nuts, and jewelry—buying more than he needed and at least putting up the pretense of paying high market prices so that Navajos would continue to patronize his stores.[35] This technique was effective. In 1926 alone, J. L. Hubbell reported to the commissioner of Indian affairs that he had purchased $19,000 worth of Navajo rugs, $7,000 worth of cattle, $35,000 worth of Navajo wool, $16,000 worth of pine nuts, and $18,000 worth of sheep.[36] While trading posts that were closer to the railroad invested their time and resources into developing the silver trade, Hubbell

fostered the blanket trade. Yet, throughout his years as a businessman, Hubbell clearly established a bond between himself and area artists.

In theory, the success of bartered exchanges helped both traders and Navajos. The Annual reports of the Commission of Indian Affairs documented that in 1913, "The Navajo blanket industry continues to be the most important and remunerative of the native industries in which [all] Indians engage." This statement was based upon the fact that "Navajo Indians derive from this source about $700,000 a year." This figure is startling given that only two years earlier, the commission reported that only 1,000 Navajo women were engaged in weaving.[37] Clearly, Navajo women were making rugs and selling them to traders. Traders, in turn, were selling the rugs to tourists, curio stores, dealers, and consumers directly bound for home. However, we cannot necessarily conclude that weavers received adequate compensation or that only 1,000 of Navajo women were weavers. As Alcott conveyed in her letter to Lorenzo Hubbell Jr., weavers often believed that they did not receive enough for the products of their labor—even when bartering—indicating they knew the market value of their labor and their products. Unfortunately, such knowledge did not make traders and Navajos equal trading partners. Bartering for goods served a specific function for traders: it enabled them to get the best price for goods that they thought they could sell off-reservation and enabled them to pay lower prices for goods not in demand.

Overstocking

A look at the practice of overstocking goods enables us to test the features and workability of the frontier-commerce and dependency narratives. Overstocking was one of the key features of trading-post life and yet it almost never receives mention in the dominant narratives. More than any other practice, overstocking demonstrates the importance traders placed on maintaining trade with Navajos—to the point that they were willing to burden themselves with excess stock of one sort or another. In 1912 and 1913, for instance, though Hubbell's trading posts were well stocked with Navajo blankets, he and his staff purchased over 50,000 pounds of Navajo-made blankets.[38] Yet Hubbell expected that Navajo blankets were "going to be a drag in the market, except the fine blankets." He told his brother, Charles, who ran one of his trading posts, to buy accordingly and to recognize that the "medium grades and common blankets you [will] have to buy cheap for we will lose money on them."[39]

Hubbell knew he had to continue to buy these goods even though he believed they would be difficult to sell. In 1913, Lorenzo Hubbell Jr. explained to his father that in general "trade seems to be keeping up pretty good; but I am going crazy on blankets again . . . [but] if I don't buy blankets, I'll have no business."[40] He was following his father's credo: "Use your judgment as to the price you pay, but as you know my rule, get the business no matter what the cost."[41] Traders overstocked raw wool, blankets, rugs, goatskins, pine nuts, and silver jewelry not only because they wanted large inventories of such items but because trade on the reservation was seasonal. Even well-off Navajo families needed credit during some months of the year, and traders had to buy stock when the artisans offered it to keep area Navajos supplied with goods.[42]

On one level, the function of overstocking is obvious. Traders needed to keep Navajos trading for their businesses to stay afloat. Yet this practice also had a cultural dimension that illustrates that both traders and Navajos were aware of external national economic fluctuations. Like the unstated rules that governed the practice of barter, overstocking helped traders earn the trust of Navajos. Traders earned Navajo trust by at least appearing to pay fair market prices for Navajo goods. Hubbell instructed his representatives to establish a reputation for fairness by purchasing blankets or wool when he already had plenty in stock. He told his trading-post managers "to be sure to pay the indians [*sic*] a good price." "It is best," he stated, "to pay more than the market price" during crucial periods in order to ensure future business.[43] Clearly, Navajo awareness of the national marketplace influenced traders.

Even as Hubbell worked to establish trustworthiness and acknowledged a degree of interdependence between Navajos and traders, he was also a savvy businessman and not above manipulating his Navajo clientele. Hubbell knew Navajos needed to *think* they were receiving the best market prices for the products they had to sell. As a result, he advised Lorenzo Jr., who was running the trading post at Keams Canyon, "By all means do not permit the Indians to go away from your place of business with the *idea* that you are not paying the highest market price."[44] In the same letter, he explained, "At the beginning of the trade it is always necessary to have the Indians go out with the report that you pay a good price." He cautioned his son, "Watch the buying of the wool and make sure that there is no mistake in the price of weight." Vigilance could pay off, whereas a misjudgment or intentional tampering could have long-term

financial repercussions. "A mistake being less than what an Indian ought to get," wrote Hubbell, "might cost us a large amount of our trade."[45] Clearly, Hubbell was responding to Navajo producers. He needed their business, recognized that they followed market pricing, and developed strategies that he thought would allow him to profit from exchanges.

Such maneuvering required long-term planning. In September 1912, at the beginning of the trading season, Hubbell advised those working for him to pay approximately 15 cents a pound for fine wool. But he also advised buyers to make sure that the wool they purchased was "clean" and to pay an average price of 13.5 cents per pound over the season.[46] Hubbell's business records show that he purchased 250,000 pounds of wool from Navajos for just over $25,000 that year. Thus, Hubbell's buyers followed his advice and in the end paid an average price of just over 10 cents per pound of wool. At the same time, Hubbell believed he could sell the wool for 14 to 15 cents per pound. The fact that Hubbell advised his buyers to pay the retail price at the beginning of the trading season suggests that Navajos knew the market value of the wool. As Navajos became increasingly tied to his trading posts, Hubbell's actions reveal that he knew he had to at least put up the pretense of paying market value to maintain trade before they could drive a hard bargain.[47]

Not everyone approved of Hubbell's strategies. In June 1913, for instance, C. N. Cotton of Gallup, New Mexico, wrote a terse letter to Hubbell questioning Hubbell's policy of "buying this stuff at exaggerated prices" from the "bloody Indians." According to Cotton, Hubbell's buying strategy was "all foolishness" given that Navajos had relatively few avenues for contesting coercive practices.[48] Cotton knew that if Navajos had to travel the sometimes-lengthy distance to Gallup to sell their wool, rugs, jewelry, or pine nuts, they would be more inclined to accept whatever Cotton offered and would then probably spend their profit at Cotton's store. When Hubbell offered better prices than Cotton did, Hubbell effectively kept business local. Thus, Hubbell's strategy sought both to frustrate his town-based competition and to earn Navajo business.

Why would Hubbell and other traders attempt to create a perception of fairness if Navajos were as dependent on them as observers suggested? First, Hubbell needed to offer a seemingly fair deal to Navajos because traders were dependent on daily trade with Navajos. Lester Williams, C. N. Cotton's grandson, clearly stated the reason behind Hubbell's behavior and revealed one possible reason for Cotton's frustration: "Traders

had to buy what the Indians produced because this income was what the Indians then used to buy goods from the trader."[49] If Hubbell paid a high price and word got out, even a town-based trader like Cotton would have to do the same to keep his business steady. Traders like Hubbell and Cotton counted upon the acquisition of Navajo-made goods and raw materials for their survival. The stability of their businesses depended on the rock bed of Navajo trading and thus had to be balanced against the stock they traded for. Traders also had to compete for business while creating an off-reservation market for Navajo wool, blankets, jewelry, pine nuts, and other goods.

One reason why the frontier-commerce narrative may have overlooked the practice of overstocking is that the practice illustrated that Navajos had some knowledge of market conditions and leverage in trade relations. Such agency was incompatible with the one-dimensional portrayal of the Navaho. Hubbell purchased more rugs than the market demanded partly in response to poor economic conditions on the reservation. YaNaBa Winker moved to Ganado in 1901 as a small girl and spent the rest of her life there. She recalled in an interview in 1971 that "there were many (women) weaving for him because there was hunger." Weaving and trading a rug could bring immediate relief from the "many hardships" such as poverty and disease that Navajos faced. Winker explained the effects of rug weaving: "The rugs were finished in one day and taken to the store in exchange for food. The wool was from him [Hubbell] and for that reason we lived for quite some time."[50] On a macro level, Navajos were subject to unfair economic conditions that undervalued their labor, land, and resources. On a micro level, Navajos understood the marketplace and worked within it to the best of their ability, largely by pressuring traders to buy goods and extend credit or aid so that they could feed themselves and their families.

Though weaving provided immediate relief from hunger, Winker and others wove their rugs to meet the desires of Hubbell's customers. For example, Hubbell had artists such as E. A. Burbank paint cards of "old" and popular Navajo rug styles to facilitate sales of his rugs. Weavers supplied, more or less and in addition to their own contemporary styles, the designs that Hubbell told them were most popular. As a result, Hubbell had a steady supply, if not the occasional glut, of marketable rugs. In the process, the rugs became a kind of currency for the weavers and an asset for traders.[51] As Winker explained, "After we finished weaving these

rugs we turned them in for exchange for merchandise."[52] Demand for the blankets from consumers, curio shops, retail stores, hotel gift shops, and museums enabled Hubbell's business to endure economic downturns. Not surprisingly, as we shall see in Chapter 3, Hubbell and other traders invested time and money to ensure that Navajo products would be prized by American consumers.

Overstocking not only forced traders to buy wool from Indians; it also enabled Navajos to shop around for the best price. Those who contend that the Navajos were wholly dependent on the traders overlook the fact that Navajos had at least some power to maneuver in the marketplace because the business of Indian trading was competitive. As early as 1886, John Bowman, one of the first Indian agents, noted that despite difficult traveling conditions, Navajos sought out fair traders and equitable prices. "The Indians are well aware of the value of the wool, and if the offered price is not up to their expectations, they will seek another trader."[53] Edward Hall also noted that Navajos would journey great distances to trade with reputable traders and that traders vied for business.[54] Evidence from Hubbell's trading posts also shows that Navajos traded with more than one trader and reveals that Hubbell's fear that he could lose Navajo business to competitors was justified. In 1913, Hubbell had to compete with another trader to keep the business of Nashshoshi Bitzoi at Ganado. He wrote to Nelson Gorman at Chinle: "There is an Indian by the name of Nashshoshi Bitzoi who pawned a string of silver beads with you when there was a Chicken Pull there for twelve dollars or twelve dollars and a half. . . . The stove that he bought from you he does not want as he has bought one from me." He concluded by asking Gorman to "send over the beads" and promised to pay off Bitzoi's debt in return. Hubbell kept Bitzoi's business at Ganado by providing the same product as that of his competitor and then assuming Bitzoi's debt.[55]

A review of the practice of overstocking reveals that traders were expected to exchange small gifts, provide a semblance of a fair price when bartering for goods, buy what Navajos had to sell when they needed to sell, and provide additional aid during hard times. This system existed, and was perpetuated, because of consumer demand for products and Navajo knowledge of market demands and practices. Along with Alcott's request, Bitzoi's attempt to play traders off of each other reveals that some degree of give and take took place between Navajos and traders—a fact that was often overlooked in frontier-commerce and economic-dependency

narratives that focused primarily on Navajo victimization. Navajos had some influence in trade relationships through their reconfiguration of indigenous trading patterns. In the end, such reconfigurations were not culturally incompatible with industrial patterns.

Pawnbroking

Pawnbroking was probably the most controversial of the practices at trading posts. When Navajos like Bitzoi or Winker had nothing of value to sell, they pawned items for credit. By the late 1880s, pawnbroking had become such a potentially coercive practice that the government attempted to eradicate it. However, both Navajos and traders formally protested.[56] By 1887, the government had issued official regulations for pawn. Guidelines stipulated that traders had to keep an item for at least six months before it went "dead" and could be sold. Traders were required to tag each pawned item with the owner's name, the date they had taken the item in pawn, and the amount of money they had lent the owner for the item. At the end of the imposed six-month holding period, traders would take the item from the "pawn room" and place it in a visible spot in the store for at least one month. If, at the end of that time, it remained unclaimed, traders could sell such goods to the public. Navajos, in turn, could make payments in the form of cash, livestock, jewelry, or blankets to return items to the pawn room.[57] The most commonly pawned items were concha belts, bracelets, rings, silver bridles, squash-blossom necklaces, and rugs.

As in other commercial transactions, a number of cultural and economic objectives could be achieved through pawn. For instance, pawn was a way for traders to prove to Navajos that they could be trusted and that they trusted their clientele. Trader Mary Baily, whose parents ran the Piñon trading post in the 1920s, recalled an incident witnessed by a tourist from New York who was a banker. Some Navajos "had come in [to the post] and wanted to borrow their pawn." Her father retrieved the goods from the pawn room, which he had already shown the banker. He returned with the pieces that the Navajos had requested and "sent them on their way" without requiring them to redeem them. The banker responded with horror and "nearly died!" He asked Baily's father, "'How in God's world can you ever make a profit?!'" The trader responded, "You have to know your customers . . . they're honest as the day is long, and they'll be back, and they'll bring it back in." Thus, the interactions

surrounding pawn rested on cultural expectations as well as economic rules. Navajos expected to have access to pawned goods; traders expected Navajos to return the pawned items when they were no longer needed. Baily's father fared well as a result of such exchanges. She recalled, "Daddy always managed to make money with his rugs and with the trading post—it always made a profit. Like I say, he was a shrewd trader and he knew how to do it."[58]

Cultural expectations influenced other sorts of behavior as well. Traders knew that "if something were of particular value" to a Navajo that it should be kept "indefinitely." Others reported that if they sold pawn prematurely, Navajos could decide to cut off trade. Sallie Lippencott explained yet another reason why pawn was an important institution. "The Indians' possessions were their savings accounts, and once gone, they were gone forever. If redeemed, they were money in the bank and could be drawn upon again and again."[59] Oral histories of other traders reiterate Lippencott's claim, but to equate pawn to a bank account is inaccurate. Indians appeared to use pawn rooms less like interest-earning bank accounts than like safe-deposit boxes. For instance, traders usually kept valuable jewelry in locked safes or locked cases. Many Navajos believed that priceless, dear, and expensive items were safer in the trading post's safe than in unlocked hogans that were often unoccupied while families gathered wood, tended sheep, attended ceremonials, or worked for wages.[60] Because Navajos *paid* interest on their pawn, the values associated with the exchange were not on par with the market value of the goods. Nevertheless, the exchanges were both economically and culturally important because of the expectation that traders would provide a service beyond that of the initial loan.

Indians could redeem pawn in several ways. Sometimes they "traded out" items of equal or greater value for the pawned goods. For example, Hosteen Glish, a weaver who commonly traded at Wide Ruins Trading Post, brought a rug to Sallie Lippencott and received $80 worth of credit in trade. First, the Lippencotts deducted the amount of credit they had already extended for the promise of the rug. She then "took one of her bracelets out of pawn." According to Lippencott, Glish subsequently "toyed with the idea of taking a necklace and another bracelet or two out." Her motivation for redeeming the pawned bracelets seemed clear to Lippencott: the weaver wanted "to cut a swath at a curing ceremony" that would start the next day. Instead of buying velvet for a new blouse or

new jewelry, which she apparently considered, the weaver realized that first she needed to buy necessities. She purchased "a sack of flour and its accompanying can of baking powder, a sack of sugar and a package of shortening, so essential for making fried bread." Glish also invested in 25 cents' worth of oranges and half a bale of hay, some candy for the children, and other "fripperies," in Lippencott's words.[61] The encounter between Glish and Lippencott had elements of all three of the economic practices that marked exchanges between traders and Navajos. This exchange shows that traders bought what Navajos had to sell, illustrates that Navajos might pawn the same materials over and over again, and shows that Navajos were ultimately paid in goods, not cash.

Although Navajos like Hosteen Glish tried to use the institution of pawn to their benefit, some traders took advantage of the system, charging exorbitant interest rates, loaning only small amounts for very valuable items, and sometimes selling items before the expiration of the pawn contract. Traders determined and rationalized pawn values in several ways. Wagner claimed that despite the seemingly self-serving aspects, she and her husband actually undervalued goods because they believed Navajos would have difficulty earning enough money to redeem items for larger amounts. Such practices may have had other rationales as well. As anthropologist Willow Roberts Powers has documented for business reasons, traders could not afford to give more than the wholesale value of an item in the event that they would later be in a position to sell it.[62]

Either way, traders made money on pawn. Regardless of the amount of credit they gave for a pawned item, they could charge a high interest rate on the transaction, which turned out to be a sort of short-term loan.[63] Unfortunately, we have more trader accounts dealing with the issue than accounts from Navajos. Most traders, however, seem to concur that jewelry represented mobile wealth and that Navajos saw the trading post as a "safe" place to store their goods.[64] If true, Navajos developed their own set of expectations for pawn, which reflected their knowledge of the value of their goods, the kind of compensation they wanted, and the degree of leverage they thought they could muster within the ever-expanding marketplace. In other words, Navajos understood that they were at a disadvantage in the marketplace, and they relied on social and cultural expectations to manipulate trades—whenever and in whatever way possible—to their benefit.

"Sallie and Bill Lippencott in Living Room at Wide Ruins," ça. 1938–1950. Traders unfolded rugs before they began to negotiate for them. Sallie and her husband, Bill, spread out a prize-winning rug to assess its value. Photo provided by the School for American Research.

The reverse is also true. Whereas Navajos acknowledged the cultural implications of pawn, traders had specific economic concerns. Traders, claiming they were cash poor, often gave Navajos the "cash value" of the goods they pawned in tin money or scrip. For example, cash flow was unpredictable at Hubbell's posts. One manager at Hubbell Trading Post reported, "I am afraid that the money on the books is a hard proposition (and) I do not think I will collect 10 percent." Paying out cash that they did not have caused traders to come up with alternative methods of exchange. For example, at Hubbell's Ganado post, according to Winker, "Tin money was all he [Hubbell] ever gave and not whatever [groceries] we wanted . . . we used it to buy what we want [sic] with it."[65] Navajos at Hubbell's trading post used the tin money they received to purchase goods. They may have accepted scrip not only because they had little choice in the matter but also because it had some small benefit for them. Many were illiterate and did not trust traders' accounting systems.[66] Yet the use of tin money had some coercive aspects. Traders could use it to limit competition because it essentially fixed Navajo trade to a particular post.

Thus, pawn had multiple meanings and values in a society that was cash poor and offered limited work opportunities. YaNaBa Winker remembered that wage work was difficult to come by in the 1920s and 1930s and that when Navajos received payment in cash, they got between 50 cents and a dollar a day—roughly the same price that tourists paid for a single meal at Ganado. When Navajos could not afford to buy what they needed with their limited paychecks, they bartered for goods or pawned valuables.[67] Under such conditions, one can see why pawn became such an essential part of both the trading post and the Navajo economy and created an economic system that forced Navajos into debt peonage. Still, though the practice was coercive, it did not completely strip Navajos of their economic agency.

Like overstocking, pawn enabled Navajos to obtain the goods they needed during lean months, and it benefited both producers and traders during heavy trading periods when raw materials and crafts were exchanged for pawned goods. Through the practice, Navajos could take individual action within a competitive marketplace. Their behavior demonstrates that they had a well-developed sense of wealth and understood the market value of the silver and wool products that they pawned. Skilled craft work—like weaving and silversmithing—were especially important. Navajos used their creations to express both social and economic worth. According to Father Bernard Haile, who lived and worked among the Navajos in the first half of the twentieth century, "The art of weaving and silversmithing, leather work and modern trades like building or coal mining distinguish the individual in the community and increase his possibilities of acquiring material property."[68] As a result, Navajo women raised livestock (mainly sheep and goats) and wove blankets. Sometimes they worked silver. Meanwhile men made silver jewelry and worked for wages when they could.[69] Navajos generally knew the value of their labor and the goods they produced. As a result, Navajos like Alcott knew that they did not always receive fair compensation for their work. This knowledge helped shape the strategies and expectations of Navajos and traders.

Even in the face of a powerful national market, Navajos influenced general trading practices by forcing traders to honor their cultural expectations. Pawn established long-term bonds based on honor and trust between the two groups. Overstocking enabled traders like Hubbell to pay Navajos just what they needed when they needed it. It also enabled Hubbell to supply blankets to consumers whenever demand arose. Gift

giving became part of the bartered exchange process because Navajos expected and demanded it. Thus, the forms and functions that dominated trading-post exchanges grew out of disparate economic needs and cultural knowledge. Exchanges were tempered by Navajo culture and influenced not only by the specific type of transfer but also by the evolution of trading-post culture and external market demands. Traders acquired goods or lent Navajos money because they thought they could dispose of products off the reservation. Economic dependency existed in the sense that Navajos came to depend on the goods available at trading posts, and the traders who sold them, but it did not portend the eradication of Navajo culture. Without consumer and tourist demand, traders would not have been able to overstock goods or pay silversmiths wages for jewelry. Still, markets outside of the trading post heavily influenced the values ascribed to Navajo products and culture.

Navajos/Navahos within the National Economy

Navajos may have been bound to the trading-post economy—or even dependent upon it at times—but the trading-post economy was also part of, and dependent upon, the larger national economy. In the frontier-commerce thesis, references to "protected" and "unprotected" markets hinged on the idea that manufactured goods coming into trading posts were subject to regulation whereas the prices traders paid for Navajo-made products—the wool, rugs, and jewelry—were not. In effect, however, both manufactured imports and hand-made exports were regulated by demand. For instance, traders who bought larger amounts of stock had a degree of purchasing power and paid lower amounts for manufactured goods as a result. Traders—like Hubbell—with ties to an external clientele could afford to pay a higher price than some other traders for the goods of individual Navajos—at least at strategic moments—because they successfully manipulated market demand. In general, the idea of market "protection" does not take us very far toward understanding the supposedly "frontierlike" trading-post economy because the majority of buying and selling that occurred at trading posts were subject to national price fluctuations. Both Indians and traders were aware of market trends. However, this fact did not make traders and Indians equals in such

exchanges. Rather the idea of frontier commerce miscast Indians in the role of Navahos consigned to be the ignorant trading partners of supposedly savvy whites.

By the end of the twentieth century, Navajo dependency had become a standard way of explaining the declining conditions of Navajos across the reservation. Generally, it does describe the fate of the Navajos, especially after stock reduction in the 1940s. But if we put it aside as an all-encompassing macro interpretation and look at the cultural work and assumptions that such interpretative narratives embodied what kind of picture emerges? Here, concepts such as *independent* and *dependent* did not so much represent a scale that one might slide up or down but served as discourses that were subject to the sway of cultural understandings, racial hierarchies, and the economic marketplace. It is not that those terms had no meaning at the level of the trading post but that the various parties constructed their meanings in particular ways and thus did not base them on an external objective barometer of conditions.

That Navajos like Alcott turned to traders when in need is not surprising. What is surprising is how contemporary narratives deliberately perpetuated or created myths about the character of the Navaho. An interpretation of trading posts as points of cross-cultural contact—or the centers of so-called frontier commerce—makes sense in some ways. Traders and Navajos did come into contact at posts. They exchanged goods and accommodated each other's cultural values. However, the appeal of frontier commerce as a general label explains much more about the promotion of the "Indian-made" market than it does the forms and functions of Navajo trading itself.

What neither the frontier commerce nor the dependency narrative account for, however, was the behavior of Navajos. Trading posts became regular stops in the lives of Navajos. There, the Indians sold the products they made, purchased the goods they needed to survive, and obtained the items that they wanted. In this sense, trading posts functioned much like urban grocery stores. Navajos were becoming like other Americans, buying the brand-name products of the era. Yet few observers described immigrants in New York or Chicago as a fringe or frontier element when they used store credit or haggled over prices with the grocer. Trading-post life looks a little less exotic when we think about Navajos purchasing coffee, wagon parts, sewing machines, peaches, evaporated milk—either on credit or with scrip. How does our understanding of Navajo-white

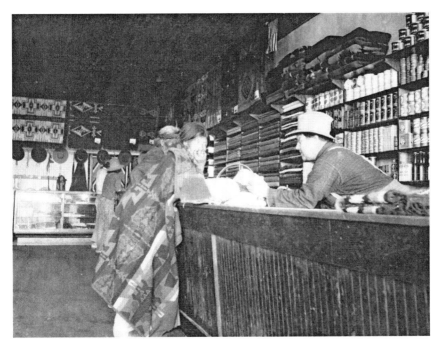

Interior of trading post, ca. 1930. A trader leans over to talk and trade with Navajos. Note the tremendous selection of canned and manufactured goods in the background. Photograph by Laura Armer. Provided by the Wheelwright Museum of the American Indian, Santa Fe, New Mexico.

relationships change when we look at Navajos' understanding and participation in the economic trends that remade America in the late nineteenth and early twentieth centuries? Neither frontier commerce nor dependency accounts for this side of the equation: Navajos were learning to navigate the American marketplace alongside other Americans at the turn of the century and beyond. Let us, then, explore why the narrative of frontier commerce focused so much attention on the role of the traders and so little on the Navajos with whom they traded.

Marketing the Navaho through Frontier Commerce

In her 1964 book about growing up on the Navajo Reservation, Navajo Kay Bennett recalls an occasion on which her mother, Chischillie, went to the Red Lake Trading Post to sell a rug she had recently woven. A keen observer, Bennett watched her mother walk from their wagon with "her rug under her arm" and enter the post. Chischillie communicated her desire to sell the rug to the trader by placing it on the counter. However, instead of rushing to complete the trade, Chischillie then went to "shake hands and to exchange gossip with the other Navajos who had come to the store to look and shop." Despite her mother's apparent lack of interest, Bennett remembered how her watchful eyes "never wandered from her rug." Only after her mother finished socializing and exchanging news with neighbors and relatives did she turn to the business of selling the rug. Chischillie and the trader retreated to a back room, where the trader spread the textile out on the floor, "so he could see the tightness of the weaving and the pattern." Chischillie's "sharp eyes followed every move of the trader."[1]

Bennett reports that her mother was well aware she had not presented her best work and watched the trader to see if he noticed any flaws. Bennett's mother and the trader agreed upon a price of $46 for the rug. Per common practice, she took half the purchase price in silver dollars and traded out the other half for essentials such as flour, coffee, sugar, lard, milk, salt pork, and shoes for her children. As a luxury, she spent part of

the money on candy. Finally, according to a mutually understood trading etiquette, the trader demonstrated respect for the weaver by providing Chischillie with a gift of "a bag of crackers and a can of pears" for lunch.[2]

Billie Yost, daughter of William Franklin Williams, who ran the Red Lake Trading Post in Arizona from 1914 to 1929, recalled her first encounter with the trading process in 1914 when she was about ten years old, about the same age as Kay Bennett when she witnessed her mother's exchange: "The Indian woman came in . . . She carried a Navajo rug she had woven and offered it to Father. He weighed it first, then inspected it carefully, noting the design and making sure it was all wool, woof and warp and then said, 'As-dla-a-gah' ('fifteen dollars'). During the next few minutes," stated Yost, " I learned my first lesson in how to be a shrewd and wise trader." According to Yost, her father knew the rug was worth $18 and intended to pay that much for it but claimed he also knew "squaw psychology."[3]

In Yost's account, the bargaining process unfolded in dramatic style. The unnamed weaver "would demand twenty dollars." Yost's father would refuse. The weaver "would go off in a corner and sulk." Yost's father "would take care of other customers." The trader then raised his price to $16.50. The weaver would "look disgusted" and then would "start to leave saying she would go to another trading post." But the weaver got only as far as the door. She then stopped, turned, and launched a dramatic counteroffer this time announcing she wanted at least $18. Yost's father then feigned reluctance and supposedly gave in to the weaver's demand. Yost gave her interpretation of the weaver's thoughts: "Her 'yahti!' ('Good!') when she put out her hand to receive the money, was ample proof that she was happy and convinced she was a smart bargainer. Hadn't she forced Willie the trader to raise his price?"[4]

These two young girls' observations of Navajo trading, written thirty years apart, highlight divergent perspectives of cross-cultural yet inherently economic encounters. The differences and similarities in Bennett's and Yost's accounts are telling. Both women learned the finer points of trading-post encounters as children, both accounts featured a Navajo woman trading at the Red Lake Trading Post—one of the oldest trading posts on the reservation—and both focused on the ways in which Navajo women attempted to get the most from their labor. Yet the differences are significant. In Bennett's account, her mother acts as a knowledgeable and

calm trading partner. She knows what her rug is worth, flaws and all, and patiently works to control the exchange so that she can obtain the price she wants. In Yost's account, the Navajo weaver is demanding, sulks, acts disgusted, and is overly emotional. The trader's reactions to her behavior aim to control it. Traders often relied on the stock image of the irrational Indian in such accounts while portraying themselves as restrained and successful negotiators.

In Bennett's memoir, her mother exhibits assertive rational economic behavior. However, at the time of this exchange, and in the tens of thousands of exchanges between Navajo weavers and traders that preceded it, few accounts showed Navajo agency, control, and balanced actions. Most of what we know about trade encounters comes from traders' accounts, which reflect the period in which their authors' lived, the region in which they worked, and the culture they helped to create. The images of trading-post culture that went out to white consumers of Indian-made goods conjured life on the "frontier" and depicted business dealings with a "primitive" and premodern people. In such representations, Navahos were usually unfamiliar with modern market trends and practices.

For example, Yost depicts her father consciously using a form of psychological manipulation. He barters and then fakes reluctance to pay the weaver's price, even though he intended to pay that amount from the beginning of the transaction. Thus, by his daughters' account, he "allowed" the Navajo woman to "feel" like she had outsmarted the trader even though he directed the exchange. In describing the events for external consumption, Yost depicted the traders as uniquely qualified to direct economic activity between Navajos and whites because of their ability to work with irrational Indians. The image of the weaver she presented bolstered this claim. In contrast, Bennett's account demonstrates that Navajos were more than one-dimensional subjects and were in control of their emotions in their business dealings. For example, Bennett indicates that Navajo weavers, like her mother, knew the value of their wares and based their decisions to sell or not to sell a rug on whether they believed a trader was offering the best price they could get. In all probability, the weaver in Yost's account also knew all along what price she would accept for her rug.

The two accounts provide a glimpse of the everyday practice of exchange at trading posts. As we have seen, Indians and traders each negotiated for the best possible price, and each understood that the item at

hand had value. Traders determined the value of a rug by how badly they needed to trade with Navajos and by their estimate of how much they could sell the rug off reservation. Thus, they were always concerned with the ways in which impersonal market forces (the price of rugs) could alter or enhance economic conditions. Weavers, and other Navajo artisans, were aware that the products they brought to trade had value as commodities that would generate immediate income in the form of cash, scrip, credit, or consumables at the post—and then later as commodities for the traders themselves. Weavers also prized their rugs as expressions of their Navajo culture and identity. Yet in traders' accounts of trade encounters, they commonly downplayed or ignored signs that Navajo producers were knowledgeable, focusing instead on the supposedly innate and primitive characteristics of the Navaho, their production methods, and their appreciation of rugs and jewelry.

At a time when few middle-class American consumers were still producing "handmade" goods, the fact that Navajos hand manufactured the products they traded only underscored the idea that Indian producers practiced "primitive" modes of production. Thus, Navajos were cast as significantly different from the urbanized Americans who either worked in factories or purchased the goods that workers made there. The representation of the Navaho as a premodern producer or economic actor was powerful because it highlighted the differences between the so-called primitive Indians and their supposedly civilized counterparts, modern white middle- and working-class American consumers. Traders in Navajo goods worked hard to create and then bridge the distance between these two parties, in reality and through the marketing of "Indian-made" goods. As we have seen, and will see, curio-store owners, tourist-industry promoters, dealers in Indian-made goods, and ethnologists who created displays for museums all used similar techniques to create and promote the idea of the Navaho.

Traders produced a vision that cast the diverse Navajo population under the singular moniker of the Navaho. They promulgated this vision through descriptions of Indian-white interactions in advertisements and sales circulars, in catalogs and magazine articles, and in their assessments of the Navajo found in promotional literature describing the practices they claimed one needed to become a successful trader to the Navajos. In contrast to Kay Bennett's account, which draws our attention to the active role that Navajos played in the trading process, accounts

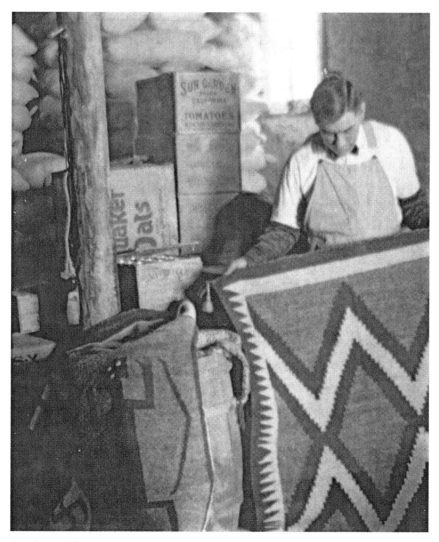

"Trader Holding Rug," ca. 1930. A trader examines a rug in the supply room with crates of products like Quaker Oats and Sun Garden Tomatoes in the background. Photograph by Laura Armer. Provided by the Wheelwright Museum of the American Indian, Santa Fe, New Mexico.

written by traders and their kin routinely highlighted the more dramatic primitive and "premodern" behaviors of Navaho producers.

This chapter examines four themes that traders played on to create an overarching representation of the Navaho through a narrative of frontier commerce: the very idea of what constituted a frontier; the view of Navajos

as a primitive people, and even a "vanishing race"; traders' self-representation as experts and their efforts to sell their expertise; and the commodification of the Navajos as the Navaho. Traders incorporated these themes in their marketing to attract white consumers and grow their businesses.

The Frontier and the Navaho

As I show in the previous chapter, the term *frontier commerce* does not fully reveal the complexity of trading practices on the Navajo Reservation. Nonetheless, the concept influenced contemporary cultural ideas, including the formulation of Navaho identity. In particular, traders combined the ideas of the frontier (the perception that the Navajo Reservation was a place where "civilization" had not yet completely taken hold) and commerce (the buying and selling of goods and services) to represent a specific kind of economic interaction between Navajo Indians and white traders. Such creations typically cast Navajos as primitive producers (Navahos) and unsophisticated trading partners and, of course, depicted the traders as civilized entrepreneurs.

The Roots of Frontier Commerce

The cultural production of frontier commerce became as powerful as it was largely because of events off of the reservation. The idea developed within the political and economic context of the American West in the late nineteenth and early twentieth centuries.[5] The long history of depicting American Indians in a one-dimensional fashion to fit specific national dramas culminated in the late nineteenth century. While politicians of that era, like Theodore Roosevelt, romanticized the "frontier" as central to the American spirit and expansionism, showmen like Buffalo Bill Cody played fast and loose with the facts of the Indian Wars, making Indians—even those who performed in his shows—appear to be part of a world that was rapidly passing away. Similarly, photographer Edward Curtis depicted Navajos literally as a "vanishing race," and ethnologists, like Lewis Henry Morgan, publicly expressed doubt that indigenous populations, in general, could transcend "upper savagery" and become "civilized" before they became extinct.[6]

In 1893, historian Frederick Jackson Turner celebrated the role of the West in creating American culture and institutions. He responded to the

census bureau's 1890 report by claiming that the American frontier was "closed." His and others' interpretations obscured the fact that American Indians still lived in this mythologized territory while celebrating the role of adventurous white settlers, including Indian traders. Sometimes overt and sometimes subtle, the cultural and political overtones of the era were fertile ground in which presentations of frontier commerce could thrive. The idea of the frontier affected local Navajos and traders as well as distant middle-class, eastern, white consumers.[7]

Navajos had been forced onto a reservation just twenty-five years before Turner's pronouncements. Ironically, the fact that Navajos lived on a reservation strengthened the idea that they lived on a frontier. To some degree, this view stemmed from the Indian service's official vision of reservations as uncivilized spaces in which the government could implement a program of incremental assimilation.[8] Since the 1830s, the U.S. government had periodically set aside lands for the use of indigenous peoples. President Andrew Jackson ordered the relocation of southeastern American Indians from their native lands to a "permanent Indian frontier" west of the Mississippi River. Yet, even as the government's brutal removal of over 100,000 Indians wound down, white settlers demanded the land that had been promised to Indians. In the 1860s, the government reneged on its promises to maintain a permanent space for Indians. Yet even as Indian reservations became smaller and government oversight increased, the public continued to conflate Indian reservations with American frontier lands into the twentieth century.[9]

Whites commonly viewed Navajos, who were forced onto a reservation barely thirty years after the brutal removal of the Cherokees, as frontier residents. By the 1890s, as Navajos living on their reservation struggled to reconfigure their economy and to retain their culture, many Americans—scholars and the public alike—were likening American Indians and Indian reservations to "uncivilized" peoples and "untamed" lands. The fact that the three territories that housed the Navajo Reservation all had difficulty becoming states reinforced the notion that the Southwest remained less developed than the rest of the country. Utah gained statehood only in 1896, and both Arizona and New Mexico had to wait until 1912. References that cast the Navajo Reservation as a frontier territory continued well into the twentieth century. A 1933 article in *National Republic*, "Glimpse of the Navajo Indian," made such connections clear: "In the northwestern part of New Mexico and the northeastern part

"The Vanishing Race," 1904. This photograph by Edward Curtis was perhaps the best-known and iconic photograph of Navajos in the early twentieth century. Courtesy of Northwestern University Library, Evanston, Illinois.

of Arizona is a vast tract of land known as the Navajo Indian Reservation. On this vast acreage of desert lands resides the Navajo Indian, one of the last tribes to succumb to the advances of civilization."[10] The western frontier that eastern Americans imagined and romanticized was more than a place where civilization had yet to take hold; it was also a space linked to the national narratives of social, economic, and political development. For example, both Theodore Roosevelt and Frederick Jackson Turner linked the frontier with democratic ideals.

The concept of the frontier in America was also linked to other processes, such as shifting production methods and consumption patterns. Nineteenth-century America witnessed dramatic transitions in methods of production. As more and more goods were mass-produced in factories, American consumers found that buying such goods was cheaper and easier than making them. As historians of business, advertising, and marketing have demonstrated, the American West was a central force in this process. Large-scale businesses, like the AT&SF railroad, made the

region's lumber, coal, and agricultural resources available to all Americans. In turn, as the region's population grew, it created new markets for manufactured goods. By the early twentieth century, both nationally based and regionally specific retailers and consumers were seeking to keep pace with the rapidly expanding economy. Indian traders' work with Navajos evolved in this context. Traders endeavored to make the pine nuts Navajos harvested, the wool they sheared, and the blankets and jewelry they made accessible to consumers within the larger American marketplace, from Los Angeles to New York and from Saint Paul to Providence. Although the depiction of the Navajo Reservation as a frontier region was an inaccurate portrayal of Navajo-white relations, it was spot-on in other respects: it helped traders sell such goods.

The Role of Advertising

To increase sales of Navajo-made rugs and jewelry, traders realized that products had to make their way into the stockrooms of curio shops, ethnic-art dealers, and department stores across the country. To achieve this goal, the traders used the same marketing approaches that larger companies used: advertising. They advertised in regional and national newspapers and in widely circulated magazines and gazettes. They mailed out their own sales circulars to potential customers and retailers. They publicized their shops, themselves, and the behavior of the Indians with whom they worked. They paid to be mentioned in books as reliable dealers of Navajo textiles. In all these venues, they emphasized the ways in which their businesses were unique in the American marketplace— namely, in working with exotic trading partners such as the Navahos and in offering goods created through primitive production methods. By portraying themselves negotiating on an economic and cultural frontier, traders bolstered these claims.

Traders claimed that the creation and exchange of goods on a frontier added value to the goods they sold. They used contemporary marketing strategies to convey this idea—a fact that tied them and the Navajos with whom they worked into the modern marketplace even as the vision they created suggested otherwise. As Jackson Lears has demonstrated, early twentieth-century advertising professionals sought to create a society of mass consumers through a unique blend of promotional salesmanship and condescension.[11] Such advertisers sold mass-produced goods by persuading customers to value the reliability that came with standardization.

Traders used the same promotional techniques but inverted the narrative. They contended that the value of Indian-made goods hinged on their unique status as nonstandardized goods made by a noncivilized frontier population in the age of mass production.

Ambitious traders, like John Lorenzo Hubbell and John Bradford Moore of Crystal, New Mexico, aggressively promoted the sale of Navajo rugs through magazine advertisements, catalogs, and promotional literature. This literature focused consumers' attention on the behavior of primitive Navaho artisans as well as on the goods and services traders were selling. Beginning in 1900, Hubbell and Moore each published and distributed a series of catalogs filled with expensive color reproductions of Navaho rugs.[12] In their catalogs, Moore and Hubbell accentuated their personal relationship with native weavers and their involvement in the development of rug patterns. The implication was that Navahos needed direction.

Both Moore and Hubbell asserted that they did more than simply trade goods for rugs. Hubbell told readers of his catalog that he had "been at great pains to perpetuate the old patterns, colors and weaves, now so rapidly passing out of existence even in the memory of the best weavers."[13] Suggesting that he had had even more direct participation, he claimed, "I have even at times unraveled some of the old genuine Navajo blankets to show these modern weavers how the pattern was made."[14] Moore also claimed involvement in the production of rugs—albeit in a managerial capacity: "In the beginning I had stubborn and conservative workers in these Navajo women," yet under his personal direction, their "stubborn, hurtful and senseless opposition . . . has given place to cheerful cooperation, good natured rivalry and friendly strife for excellence in their work." Moore also described the behavior of Navajo weavers. They were "stubborn," and they resisted his initial attempts to improve their industry. But they also yielded to the suggestions of the right kind of mentor. Moore's message was simple: as a primitive people, Navahos were capable of making fine wares, but they needed the assistance of a savvy white man to direct their talent. Perhaps this attitude explains why Moore felt he could claim at least partial ownership of the rugs he was selling: "My fine rugs are let to plead their own case."[15] Numerous traders and their wives, including the Moores, the Hubbells, the Wetherills, the Lippencotts, and the Newcombs all claimed to have both directed and created markets for Navajo-made goods.[16]

Catalogue and Price List

Navajo Blankets
& Indian Curios

J. L. HUBBELL
INDIAN TRADER

Ganado, Apache County, *Arizona*
Branch Store: Keam's Cañon, Arizona

Hubbell Trading Post Catalogue. The cover of Hubbell's rug catalog depicts a weaver at work. Grace Nicholson Collection. Used by permission of the Henry E. Huntington Library, San Marino, California.

Popular magazines reinforced the idea that rugs made by a primitive and remote people were intrinsically valuable. Periodicals like *House Beautiful, Red Book, Primitive Man,* and *Franciscan Missions of the Southwest* featured articles on Navajo weaving and Navajo trading. Traders sometimes wrote or contributed interviews to such articles.[17] Magazine articles often reiterated the points that traders told customers in their circulars. They said that Navahos were uncivilized and that consumers needed to employ the services of a knowledgeable trader if they wanted to buy a Navajo rug. In his 1902 catalog, Hubbell lamented that once eastern customers began buying rugs, "there sprung up such a demand for them that unscrupulous dealers took advantage of the ignorance of those desiring to purchase such goods." As a result, "cheap and gaudy blankets, loosely put together . . . have been sold Unless one has given study to this matter it is easy to be deceived."[18] In 1929, *House Beautiful* was still circulating this information. Author Hazel Cumin advised customers either to learn the finer points of Navajo weaving or to use the services of traders. In past years, she told her readers, "the markets became flooded with badly woven articles made of greasy, unwashed and loosely spun" wool. Traders would work to rectify the situation, she said; they encouraged weavers to do "their best" work.[19]

Magazines often placed advertisements strategically next to articles on Navajo rugs or treatises on Navajo culture, art, games, and leisure. In 1912, *Outwest* magazine published an extensive article on Navajos, "Bedouins of the Southwest." In it, author John L. Cowan exclaimed, "Of all products of aboriginal art and industry, the only one that has won for itself an enduring place in modern civilized life is the Navajo blanket." The article featured multiple illustrations of the rugs and of Navajo Indians making and wearing Navajo blankets. But it also featured an illustration of a "trading store," its walls lavishly decorated with Navajo textiles. The author informed readers that J. L. Hubbell operated the largest as well as the most reputable store on the Navajo Reservation. Readers also got a glimpse of life on the reservation; there, traders "exchanged white man's goods for the wool, blankets and jewelry of the redskins," and weavers worked on "crude and primitive" looms to fashion their "prehistoric" designs into textiles. Instructions on how to purchase rugs, and how to use them in home decoration schemes, followed. Not surprisingly, Hubbell placed an advertisement in the magazine offering to sell Navajo rugs "at wholesale" to the public.[20]

The connection between informational articles on the primitive be-
havior of the Navaho and strategically placed advertisements was so
common that it transcended strictly commercial periodicals. *Franciscan
Missions of the Southwest (FMSW)*, which described itself as an "annual
published in the interest of the Franciscan Branch of the (Cincinnati,
Ohio) Preservation Society," commonly featured articles on Navajo de-
signs, spiritual practices, myths, and games alongside conversion per-
centages. In 1918, a Franciscan missionary, Father Leopold Ostermann,
wrote "The Navajo Indian Blanket," an eleven-page article for the yearly
edition of the magazine. Ostermann provided a lengthy history of the
craft, asserting that Navajo weavers learned from Pueblos but rapidly
became the more skilled artisans of the two groups. Navajos then "stole"
bayeta cloth from the Spanish and incorporated it into their weaving. But
he also emphasized the uniqueness of the manufactured items: "The Na-
vajo blanket is the only thing of its kind in the world." He also compared
the Navajo weavers to their Persian counterparts: "The squaw does her
spinning, as also her weaving, and in fact all her work . . . sitting, or rather
squatting, Turk fashion upon the ground." He also praised the "semi-bar-
baric beauty" and "life-time durability" of Navajo rugs. Yet he suspected
that his audience already knew that his claims were true. Many Cincin-
nati readers possessed "one or more samples of this unique product of
the textile art."[21] Missionaries not only gave detailed information about
the "primitive" Navajos with whom they worked while attempting to raise
money to fund their schools and missions, they also vouched for traders,
mentioning them by name, recommending their stores in articles, or call-
ing them friends.[22]

Novice or veteran customers interested in purchasing a Navajo rug
could peruse the advertising section of the publication. In the ads Hubbell
placed in *FMSW*, he mourned that "the Old Blankets are passing away in
the nature of things" but then reassured readers that "I can supply Genu-
ine REPRODUCTIONS of the OLD WEAVES." Traders Matchin and Board-
man from Lukachukai advertised to Cincinnati readers that "A delightful
Indian Blanket for your Home" with its "soft blending of colors" would
be the perfect addition to any "Porch, Auto or Den."[23] Such ads routinely
appeared in issues along with articles titled "On Navajo Myths and Super-
stitions," "Navajo Houses," "Navajo Names," "The Navajo Indian Blanket,"
and the "Origin, Characteristics and Costume of the Navajo Indian."[24]
The placement of advertisements in a wide range of publications—from

missionary reports to regional promotional publications and home-furnishing magazines—illustrates that traders understood, and commonly employed, the techniques of modern marketing to sell the "primitive" goods that Navahos made to American consumers.

Primitive Behavior and the "Vanishing Race"

The use of the marker *primitive* to describe the Indians of the Southwest has a long history. As Leah Dilworth has shown, the travel and tourism industry drew upon the work of noted American writers and artists to create popular images of southwestern Indians, especially the Puebloan peoples, casting them as the region's most distinctive primitive population. Art historian Jackson Rushing has shown that artists used the supposed primitivism of southwestern Indian peoples to critique urbanism.[25] Beyond such works, there is little in the scholarship to help us understand how "primitivism" writ large influenced, or was influenced by, economic factors. In particular, little, if any, scholarship examines how Navajos, traders, and consumers responded to the simultaneous pressures of cultural trends and market conditions. Analysis of frontier commerce can help in this regard.

Traders and other promoters of Navajo rugs not only described the products of Navajo labor as "primitive" in their promotion of trading posts, but they went a step further and characterized the posts as institutions on the margins of the U.S. economy. Discussions of Navajo behavior were central to this claim. As in Yost's portrayal of Navajo trading practices, traders presented Indians in myriad ways that supposedly demonstrated the most fundamental and primitive characteristics of Navajo culture.

For example, traders touted the fact that Navajos bartered as proof positive that Navajo Indians were a primitive people. By the 1930s, Americans viewed bartering largely as the epitome of primitive exchange practices and irrational economic activity. Fifty years earlier, modern department store giant John Wanamaker had promised his customers a "civilized" shopping experience, one devoid of this element of premodern commerce. In the 1870s, Wanamaker had introduced the modern retail system of fixed prices, store hours, and return policies. For modern consumers, set prices had become an expression of civilization.[26]

To middle- and upper-class urban dwellers in early twentieth-century America, the distance between modern and premodern, civilized and primitive, and set prices and bartered exchange seemed as far away as the industrialized city seemed to those on the Navajo Reservation. American consumers generally understood that bartering was an important phase of the nation's economic development. Yet, precisely because many middle-class Americans remembered seeing their parents or grandparents barter, or knew that the behavior persisted within immigrant communities, this distancing strategy proved effective. Only those living on the fringes of the American economy, like first-generation immigrants, bargained and bartered.[27] Those in the center, like Wanamaker's customers, who had a vision of a "civilized" shopping experience, viewed bartering as an activity that belonged, or should belong, to the past.

Depictions of specific trade practices, like bartering, were an important means of creating the idea of frontier commerce, and they were easy to work into the overriding portrayal of Navahos simply because Navajos *did* barter for goods. However, the fact that Navajos bartered does not mean that the practice was central to Navajo trading before the population's contact with Euro-American culture. Thus, both the portrayal and the practice of Navajo exchange patterns mattered. As we have seen, Navajos honed their bartering skills through their contact with Europeans and white Americans. Thereafter, bartering served a function beyond the exchange of goods. Traders used the practice as evidence that Navajos were, in both the social and the evolutionary sense, primitives. Social scientists of the time supported this view and reinforced the links between primitive behavior and the frontier. In 1893, Frederick Jackson Turner claimed, for instance, that the "barter" economy was one of the defining features of frontier life. Turner was not alone: he based his ideas on Richard Ely's 1889 edition of *An Introduction to Political Economy*.[28] In short, the ways that traders depicted Navajo economic practices did not occur in a vacuum; they gained traction because of the larger national context of expansionism and conquest.

Traders also took advantage of a larger cultural and market trend: demand for hand-crafted goods. In the United States, demand for "tribal" rugs began in the early nineteenth century. Most of the "exotic" rugs sold during the first part of the century came from Persia and were purchased by America's elite families. The popularity of Navajo rugs at the end of the century took place within a widespread "carpet boom."[29] Because Navajo

rugs were cheaper than Persian or Oriental rugs, they were more widely available for middle-class consumption. In addition, the fact that the rugs were made by an indigenous domestic population gave them value as symbols of American expansionism. Navajo rugs became emblematic of contact, however distanced it might have been, with a uniquely American and supposedly primitive society.

Traders hoped to cash in on the rug boom by making direct comparisons between Navajo and Far Eastern rugs. Whereas Father Ostermann noted that Navajos wove "Turk" style, Hubbell made the connection more explicit: "No fabrics produced by Native peoples in any portion of the world surpass the genuine Navajo blankets in richness, beauty and durability. The finest Persian and (East) Indian rugs, although perhaps more dainty and exquisite, possess no greater strength of design and no greater durability or suitability to the purposes for which the fabric was intended."[30] As had Ostermann in his 1918 article on Navajo rugs, Hubbell used code words like "suitability" and "durability" to signal that he understood middle-class standards. Consumers integrated the association with Persian rugs into their requests, asking to buy rugs that were made from "Turkish Red."[31] Such tactics served Hubbell well. Between 1899 and 1930, his rug trade increased five- to sixfold, from $50,000 per year to between $280,000 and $350,000.[32] Rug sales continued to increase steadily over the next twenty years.

Beyond tapping into the popularity of Persian rugs, the narrative of frontier commerce was rooted in its era in other ways. In particular, trading posts were part of an evolving national and global economy that integrated indigenous peoples in a specific fashion. Beginning in the 1870s, the strategy of labeling American Indians as premodern and primitive worked because non-Indians expected Indians, Navajos in this case, to be separate from modern economic trends and technological innovations. As Philip Deloria has demonstrated, "Whether racially marked or evolutionarily backward, their rural reservations far from the modernity of the cities, Indians (many non-Indians assumed) could not comprehend, much less appreciate, invention, innovation, or technological advance."[33] Pairing traders with civilized conduct and Navajos with primitive behavior set up an oppositional relationship. Once traders established that the Navahos were primitive people who inhabited a mythic economic and technologically challenged hinterland, images of the reservation could easily become synonymous with a more territorially bound frontier in consumer consciousness.

In addition to commercial representations, artistic and literary portrayals of Navaho primitivism circulated throughout the nation. Painters in Santa Fe and Taos often created sympathetic and romantic portraits of Navajos. Authors like Mary Austin, D. H. Lawrence, Mabel Dodge Luhan, and Oliver La Farge created southwestern Indian characters who were pure because of their "primitivism."[34] Such artistic expressions may have reflected cultural instability in the face of modernism, yet an examination of frontier commerce demonstrates that primitivism also had a material component. In fact, primitivism was not simply a characteristic of frontier commerce; it was a key feature of it. Discussions of primitivism appeared in assessments of Navajo production methods as well as in more artistic renderings. Navahos, for instance, were "primitive" not only because they needed the direction of a white manager but also because they worked in isolation. Traders commonly used an image of a solitary Navajo weaver or silversmith on their stationery. As historian Jennifer Nez Denetdale has shown, such images reinforced stereotypes of Navajo weavers. In this case, they were shown working in isolation.[35] Postcards, advertisements, and promotional photo spreads depicted individual silversmiths and weavers working alone and squatting next to an anvil, forge, or loom, their tools scattered about with radiant sunsets flooding the barren landscape. Placed in the southwestern landscape, this kind of imagery highlighted the distance between civilized consumers and their primitive counterparts. In contrast to other American employees who worked alongside each other in factories, the appearance that Navajos worked alone without the assistance of machinery made their production methods seem a thing of the past.

American consumers were repeatedly exposed to this aspect of primitivism. George Wharton James, author of the era's best-known book on Navajo weaving, published in 1914, reported that a solitary weaver produced one rug at a time, working from beginning to end before starting the next project. Traders, and authors like James who consulted them, told consumers that isolation and individual inspiration were the keys to the creation of Navajo designs. In fact, weaving often involved an entire Navajo family. Husbands or sons built looms, daughters helped shear sheep and collect plants for dyes, and weavers had daughters, cousins, or nieces watch and assist them to learn the craft. Navajo jewelers used similar strategies. But James, and the traders whom he consulted, knew that American consumers would be attracted to the idea of the lone Navajo

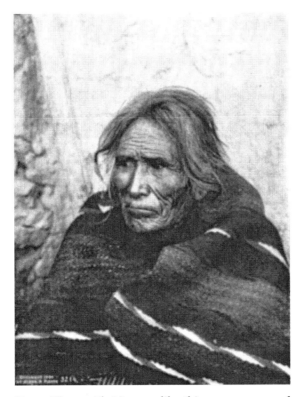

"Lone Silversmith." Images like this one encouraged viewers to focus on the age of artisans and their craft as well as the fact that they supposedly work alone. Pennington Photos, from the Tom O. and Lucille Kimball Indian Collection. Used by permission of Fort Lewis College, Center for Southwest Studies, Fort Lewis, Colorado.

producer, so the traders who could have corrected James chose not to do so. Instead, they worked with him. Hubbell even paid him $150 to name him as a trustworthy dealer of Navajo rugs in his publications.[36]

Observers also assessed the sustainability of Navajo production methods in modern America, which in turn added the idea of the "vanishing Indian" to the frontier-commerce narrative. Traders, especially after the final episodes of the so-called Indian Wars in the early 1890s, played on the image of the vanishing Indian to create a market for the goods that they had to sell, a neat trick given that the Navajo population was actually growing. As historians Brian Dippie and Coll Thrush have shown, the

idea that American Indians were "a vanishing race" had little to do with historical reality. From 1868 through the 1940s, the Navajo population steadily increased from approximately 7,000 to 65,000. In all likelihood, the number of Navajo producers was also increasing as a result, yet traders continually asserted that weaving and, to a lesser degree, silversmithing were skills that belonged more to the past than the present.[37]

Other social impulses of the era reinforced the idea that Navajos were a marginal or fragile "frontier" population that might not survive into the twentieth century. From 1890 to 1920, missionary societies and reformers concluded that America's Native populations needed help. Some organizations, like the Indian Industries League, wanted both to assist and to assimilate Navajos through the promotion of Indian arts. Others, like author Mary Austin, ethnologist Oliver La Farge, and reformer John Collier, all of whom belonged to the American Association of Indian Affairs, promoted the sale and protection of "authentic" Indian arts and crafts to help the Navajos maintain their "traditional" culture.[38] The attention that such individuals lavished on the idea of Indian arts and crafts sent a clear message to consumers: Navajo-made items had value as tokens of a culture that was likely to disappear. Traders managed to fit this rendering of the Navahos into their promotion of Navajo arts and crafts.

Traders linked the concept of the frontier, the primitivism of the Navaho, and the idea of the vanishing race in their commercial endeavors. Recall that J. L. Hubbell told readers of his catalog that the "old blankets are passing away, in the nature of things."[39] More importantly, however, Hubbell and his sons often referred to Navajo textiles simply as "Navajos." Thus, when Hubbell asserted that Navajos were disappearing, he could have meant the rugs or the people. Either way, he indicated that the artists and their products were becoming increasingly uncommon—even as he was overloaded with stock. Similarly, J. B. Moore spoke of his apparently tireless work to resurrect the "dying" art of Navajo weaving.[40]

If we look at the idea of the vanishing race within the conceit of frontier commerce, we can see that representations of vanishing sought to promote the sale of rugs. More importantly, the fear that Navajo arts and crafts were the product of a "vanishing race" enabled traders like Hubbell and Moore to publicize their roles as central to the crafts' existence in modern-day America. Hubbell, for example, claimed he was instrumental in the "reproduction" of older styles.[41]

Another thread woven in the discourse of the vanishing race focused on Navajos as consumers of modern manufactured products. In 1920, Julius Gans, who owned a curio shop in Santa Fe and described himself as a trader of "Indian-made" goods, explained why Navajos consumed machine-made Pendleton blankets in his Southwest arts and crafts catalog, *The Indian As Artist:* "Less and less does the Navajo wear the beautiful blankets his women weave, when the value of the wool in one of his blankets will buy several manufactured blankets from the trader."[42] Navajos did consume manufactured goods as status symbols and markers of wealth. American manufacturers like the Pendleton Woolen Mills, the Capps Indian Blanket Company, Oregon City Woolen Mills, and Racine Woolen Mills met and cultivated the demand for these goods by creating specific designs to appeal to Indian populations. Pendleton Woolen Mills developed the center-point design rug to appeal to Navajos. Its design features were based on those of a hand-woven Navajo Center point rug.[43] Yet knowledge of the Navajo demand for manufactured blankets actually reinforced the basic ideas of frontier commerce among white consumers. Having been barraged by frontier-oriented propaganda, consumers were well versed in the idea that as the frontier became civilized, Navajos would either disappear or assimilate. In either depiction of Navajos, as a dying race or as an assimilated people, they were apparently a "vanishing race."

Cast as a group of primitive producers divorced from the modern American economy in one variation of frontier commerce, how could Navajos be contemporary consumers of manufactured goods in another? Essentially, traders crafted a vision of the Navaho that enabled seemingly contradictory images to coexist in the minds of consumers. In actuality, Navajos were aware of modernization and industrialization through wage labor, travel, consumption patterns, and contact with the dominant culture at trading posts and beyond.[44] When promoting Navajo-made products, however, traders paid little attention to such realities, instead drawing on and developing the rhetoric of frontier commerce. Purveyors of frontier commerce used the idea of vanishing to persuade consumers that as a preindustrial people, the Navaho, and their traditional arts and crafts, could not survive in the face of widespread industrialization. As either modern consumers or primitive producers, the Navaho that consumers knew would cease to exist.

In truth, rather than leading to their demise, the desire to consume manufactured goods drew Navajos, and the products they manufactured, into the modern market economy. Navajos did, as Gans indicated, buy manufactured goods. But they purchased far more than Pendleton blankets. From 1900 through the 1930s, Navajos came to depend on the staples available at the trading posts.[45] As Navajos exchanged handmade goods at trading posts, they integrated preprocessed flour, coffee, and sugar into their daily routines; they savored canned tomatoes, pears, Vienna sausages, sardines, and evaporated milk; they adorned themselves with manufactured calico cloth, velvet, and blankets; and they used manufactured tools, saddles, and machines that made cooking, making clothing, and farming easier and more efficient.[46]

Not surprisingly, Navajo consumers quickly developed a fondness for specific brands. Trader Tobe Turpen reported that around the Pine Springs area, Navajos were especially fond of Kool Aid. Invented in 1921, Kool Aid had become a staple, at least at the Pine Springs Trading Post, by the 1940s.[47] Other traders reported that Blue Bird flour, Arbuckle's coffee, Orange Crush soda, Levi's jeans, Coleman lights and fuel, Wheaties cereal, PET condensed milk, Del Monte tomatoes, and Buster Brown shoes were favored brands across the reservation.[48] So deeply were such products woven into Navajo life that they sometimes appeared in Navajo textiles. Elijah Blair, a trader for over fifty years, kept a Navajo rug that illustrates this point. When Navajos entered the confines of a trading post, not only did they mingle with neighbors, exchange news, and prepare to trade sheep, blankets, wool, jewelry, or goats with traders, they also took the opportunity to develop and channel their own consumerist desires toward the goods they wanted.

Rather than leading to a decline in the production of Navajo blankets, as traders predicted in their publications, the demand for manufactured goods actually spurred the production of Navajo rugs and jewelry. A 1930s survey of Navajo income, wealth, and debt reveals that Navajos commonly purchased manufactured saddles, bridles, pots, wagons, flour, coffee, shawls, jewelry, shoes, and clothing at trading posts.[49] Navajos usually acquired such items through wage work, the sale of livestock or livestock-related products—such as wool or rugs—or the production of jewelry. For instance, Dineh-Tso; his wife, Etseh-Telli; and their four children acquired a plow, a scraper, two wagons, five saddles, and two harnesses primarily through the sale of "rugs, wool, [and] sheep" to traders.[50]

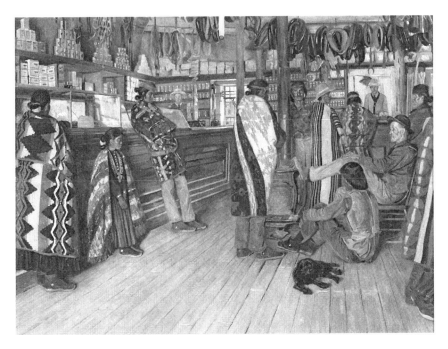

"Ganado, Arizona, 1908." Interior of the Hubbell Trading Post, including the grocery store. This painting by E. A. Burbank portrays Navajos' sociability inside Hubbell's trading post. Few of the Indians seem to be actively trading, but all are wearing Pendleton blankets, and they are surrounded by the commercial goods that Hubbell kept on his shelves to meet local demand. Provided by National Park Service, Hubbell Trading Post National Historic Site.

Other families in the vicinity owned similar items. Hastin Natani; his wife, Bah; and members of their extended family collectively owned a plow, four scrapers, two wagons, two saddles, two harnesses, a sewing machine, four shovels, two axes, and two hoes. The four female household members, Bah (age forty-one) and her daughter Ah-son-nes (age twenty-seven), along with two other female relatives, contributed to the family's income by weaving rugs. In fact, the census lists them as the only income earners, suggesting that the family most likely acquired the machine-made articles they desired through the production of rugs. This information shows how supposedly primitive production and modern consumption were intertwined on the reservation.[51] As Navajos shopped, they sought to lay claim to their place in the consumer-oriented economy, a place where the imagined "primitive" Navaho producer and the "modern" American consumer were one and the same.

"Day's Store at St. Michaels. Charley and Willie Day," 1905. A wide variety of manufactured consumer goods were available at trading posts like this one. Used by permission of the Brooklyn Museum Archives, Culin Archival Collection.

The two trade encounters I describe at the beginning of this chapter gave us a glimpse of Navajo producers who wanted to receive fair pay for their labor. We can also see that Navajos engaged in straightforward economic exchanges. As consumers of manufactured goods and products, Navajos expressed more than agency; they exhibited their familiarity with the American marketplace. In each case, and the many other trade encounters that occurred on the reservation, Navajos were modern economic actors. Traders knew this fact and worked with Navajos, providing them with goods *and* meeting their expectations. Only after they had negotiated such exchanges did traders evoke the narrative of frontier commerce to broadcast an image of the primitive, preindustrial, vanishing Navaho beyond the confines of the reservation.

Traders' Self-Representation

The role traders played on the reservation was also a key feature of frontier commerce. Traders cast themselves as individuals who bridged two very different economic systems: the premodern, irrational, bartered exchange practices of Indians; and the modern industrial capitalism

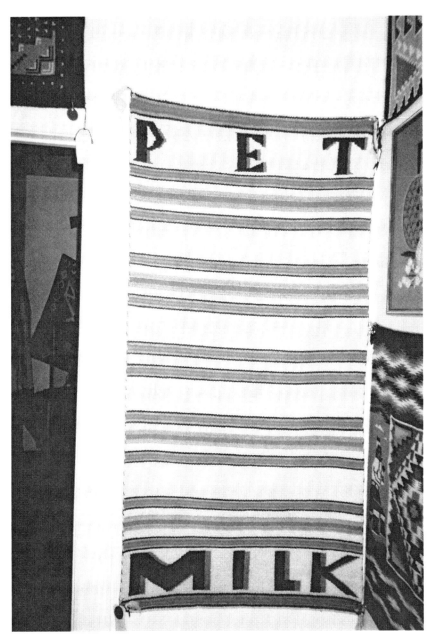

PET rug, ca. 1940s. This rug demonstrates Navajo weavers' familiarity with brand-name goods. According to Elijah Blair, Navajos bought only PET evaporated milk and spurned Carnation milk, explaining to him that milk comes from animals, not flowers. Elijah Blair's Indian Trading Post Museum, Page, Arizona. Collection of the author.

supposedly practiced only by modern American consumers. They used advertising and publicity to craft a profile of their profession just as they did in promoting a view of the Navaho. The perceived racial identity and commercial behavior of the traders were important parts of the overall narrative. Traders focused on what they had in common with other businessmen and white consumers, and they pointed out how different they were from the "primitive" Indians with whom they interacted. No individual represents the self-promotional dimension of frontier commerce better than the prolific John Lorenzo Hubbell.

John Lorenzo Hubbell: A Case Study
in Self-Representation

Although earlier chapters examined Hubbell's participation in the travel and tourist industry and his interactions with Indians, a more thorough portrait of Hubbell can improve our understanding of frontier commerce. In many ways, the life of John Lorenzo Hubbell (1853–1930) shows in microcosm how Navajo traders created, participated in, and perpetuated frontier commerce.[52] Shortly before his death in 1930, Hubbell, then the proprietor of, or investor in, five Navajo and Hopi trading posts in the American Southwest, described his job as an Indian trader to readers of the popular magazine *Touring Topics:*

> During my numerous visits to Washington, New York and other eastern cities people have often asked me what business I follow. When I have told them I'm an Indian trader I've usually found myself visualized as some sort of Sir Thomas Lipton, for east of the Mississippi River the popular conception of an Indian trader is a fellow who bases in Bombay or Benares, Colombo or Calcutta; and makes piles of money out of tea or teak, jute, jewels or other products of the Orient. . . .
>
> Out here in the west, an Indian trader is an entirely different hombre . . . The dictionary defines him as one who has isolated himself from members of his race for the purpose of establishing trade relations with the American Indians. . . . Out here in this country the Indian trader is everything from merchant to father confessor, justice of the peace, judge, jury, court of appeal and chief medicine man, and de facto czar of the domain over which he presides.[53]

Traders assumed such roles because relatively few non-Indian settlements existed around the reservation, enabling them to portray the

reservation as a frontier. Hubbell also emphasized the importance of his multifaceted role by proclaiming to be regional royalty: "For nearly half a century, I've been known locally as The King of Northern Arizona."[54] Thus, he carefully fashioned his own image for the tourists and consumers who were interested in the Navajos. To do so, he focused attention on the ways in which he lived on the edge of society, yet he also retained the status and authority of a successful businessman.

The fact that Hubbell was one of the more successful brokers of Navajo crafts and southwestern Indian culture makes his behavior all the more noteworthy. In some ways, his personal history and ethnicity made him unique in the world of southwestern commercial interests. He was born in 1853 in Pajarito, New Mexico. His father was a transplant to the Southwest from Connecticut, and Hubbell bragged that his father had been a "Connecticut Yankee." His mother, Juliana Gutiérrez, was a granddaughter of one of the first governors of New Mexico while still under Mexican rule. As he matured, Hubbell began his professional life by working in the Albuquerque post office. He later went to work for traders at Fort Wingate in the territory of New Mexico and then in Kanab, a small Mormon enclave in the territory of Utah. During these years, Hubbell traveled extensively throughout the region. In 1874, he took a post at the Navajo Agency at Fort Defiance, Arizona.[55]

The details of Hubbell's career at the Navajo Agency are unclear, but he did establish ties with Navajos—sometimes intervening with local and national authorities on their behalf—that would help him throughout his life. He also mediated disputes between Texas cattlemen and Hispanic settlers in St. John's, Arizona, where he ran a trading post and rented rooms to travelers. In the 1880s, Hubbell expanded his enterprises, and his influence in the area grew. He was elected sheriff of Apache County in Arizona in 1882. A year later, he opened the Hubbell Trading Post in Ganado, Arizona, which eventually became his most famous and profitable endeavor. In 1884, while serving as sheriff, Hubbell established a partnership with C. N. Cotton. In 1885, Cotton bought Hubbell's share of the post and launched a major marketing effort to promote the sale of Navajo-made blankets and silver jewelry.[56] A few years later, Cotton left the area and moved to Gallup, though he retained an interest in selling Navajo goods. According to Charles Amsden, Cotton "got hold of a mimeograph outfit and directories of various eastern cities, and proceeded to circularize the 'whole country'" with catalogs that featured Navajo-made goods.[57]

Hubbell renewed his involvement in trading at Ganado by opening a wholesale house that furnished supplies to other regional traders. By the 1890s, Hubbell entered the most significant phase of his career as a Navajo trader and marketer of Navajo-made products. In 1895, he purchased the Ganado Trading Post back from C. N. Cotton. Undoubtedly, Hubbell was influenced by Cotton's promotional savvy. After he received a special governmental exemption allowing him to claim land that was actually part of the Navajo Reservation, he developed a 160-acre homestead adjacent to the post at Ganado in 1908.[58] Hubbell then established a freighting business, farmed part of the 160 acres, constructed a blacksmith shop to support the homestead, served other traders and Indians, honed a business philosophy that advocated self-sufficiency, and started to develop a business strategy that would enable him to maintain an income year-round. Hubbell facilitated business by hiring area residents and local Navajos in times of drought, economic depression, and family crisis. These business practices allowed Hubbell's trading post to thrive while the efforts of his competitors waxed and waned. Traders Thomas Keam of Keams Canyon, J. B. Moore of Crystal, New Mexico, Richard Wetherill of Chaco Canyon, and many others all entered and left the Indian trading business in Hubbell's lifetime.[59]

Even while Hubbell spoke generally about the life of the Indian trader, he also referenced internationally known figures. In the *Touring Topics* article, he acknowledged that white tourists and consumers were as curious about the men and women who owned and operated trading posts as they were about Navajos. To show potential consumers exactly what he did, Hubbell compared his occupational heritage with that of the celebrated East Indian trader and businessman Sir Thomas Lipton. Lipton was a successful self-made businessman who earned a fortune in the grocery business and owned and managed tea plantations throughout the East Indies.[60] In comparing himself to Lipton, Hubbell adopted the rhetorical image of the entrepreneurial, successful, adventurous, and self-made man. Clearly, Hubbell and his contemporaries gave considerable thought to how they wanted to be perceived in worldly urban areas. Such rhetoric resonated with Americans who believed that the American West, as had the East Indies previously, could provide endless economic opportunities to those brave enough to face the uncertainty of building a business in remote or supposedly frontier areas.[61]

By using such strategies, Hubbell sought not only to sell Navajo goods but also to sell a region, a personality, and a character. For instance, he

highlighted his ethnic background and the geographical proximity of the southwestern United States to foreign borders by referring to himself and his fellow traders as "hombres." In comparing himself to Lipton, Hubbell conveyed to the readers of *Touring Topics* that he had successfully merged the risk taker with the rational businessman. He also attempted to capitalize on the fact that many middle-class white Americans would expect him to feel a sense of ethnic isolation as a non-Indian living in a primarily non-English-speaking part of the country.

Hubbell commonly evoked the theme of isolation in his publications to conjure life on the "frontier." He also referenced the theme of remoteness when speaking of himself or the Indians with whom he traded. In his sales catalog, he claimed that Navajo silversmiths were "primitive" and wrote of the remote location of the Navajo Reservation. This approach added drama to the commercial transactions between producers and traders. Even as Hubbell claimed that the two secluded populations needed each other to survive economically, the imagery of isolation helped lend worth to goods he was selling. Goods from frontier areas were valuable because of the perception that they were difficult for urban consumers to obtain.

In reality, Hubbell overstated his isolation from more urban populations and locations. Neither he nor the Navajos were completely isolated from Euro-Americans. Though conditions on the reservation often made travel—between posts and settlements—in the area difficult, it was not impossible. From the 1900s through the 1930s, for instance, Hubbell and his sons served a broad clientele of travelers, tourist-industry professionals, anthropologists, artists, writers, and politicians. These visitors included artists E. A. Burbank and Maynard Dixon; photographers A. C. Vorman, Edward Curtis, and Carl Moon; anthropologists Stewart Culin, Oliver La Farge, and Gladys Reichard; writers William Allen White, Charles Lummis, and Dane Coolidge; as well as President Theodore Roosevelt and a steady stream of newspaper reporters and "tin-can" tourists. Hubbell also spent a considerable amount of time "off-reservation," traveling in New York, Washington, D.C., and Philadelphia, especially in the 1910s and 1920s.

Selling Expertise: Hubbell and Other Traders

Although almost all the traders influenced the development of Navajo products and participated in the construction of frontier commerce and of the Navaho, Hubbell was one of the first traders to devote substantial

time and energy to marketing Navajo-made goods off-reservation. After observing Cotton and Santa Fe railway executives, Hubbell devoted a considerable amount of time, energy, and money writing letters to curio stores and businesses to stimulate interest in Navajo-made goods. He usually wrote these solicitation letters on his distinctive stationery, which proclaimed Hubbell a "dealer in Navajo blankets and silverware" and featured elaborate illustrations of either a Navajo weaver at her loom or the head of a Hopi maiden. In the body of the text, Hubbell focused on his personal relationship with Indian producers, the longevity of his trade with them, and his expertise as a skilled negotiator with Indians.

The letters all began with the same formal introduction: "May I take a little of your time to bring to your consideration the Navajo Indian Rug, a hand made Indian product of native material, no two of which are alike?" Hubbell then described the history of weaving and the "peculiar characteristics" of the Indians' designs and production methods as well as those of the artists themselves. He peppered his correspondence with information that lent authority to his claim that he ran a legitimate operation and sold only authentic Navajo rugs. "We have been dealing with these Indians for over fifty years, know quality and can sell at value."[62] By using the circular format and legitimizing his business by referencing its age, Hubbell showed his familiarity with contemporary business and marketing practices. Yet he noted the unique aspects of the products he was selling in his mass-produced catalogs: they were nonstandardized goods.

To illustrate the nonstandardized aspects of the goods he was selling, Hubbell informed retailers that Navajo artisans were deeply influenced by their primitive belief system—one that tourists might find compelling. He suggested that Navajo-made products were representative of the Navaho and their superstitions as well as their connection to the natural world. For example, he told Mr. Connolly, of Connolly Brothers Saddlery in Livingston, Montana, "The zig-zag figures represent lightning, and the squares usually clouds, the straight bars rain or rainbows; if a string from near the center runs through the border, it is the pathway of purification" or an outlet for "evil spirits." This letter was well timed: Hubbell solicited Connolly just as "Dude Season" was approaching, and Hubbell knew that incoming tourists would want souvenirs of their western vacation.[63] By presenting Navajo culture as a symbolic culture throughout his career, Hubbell played up the primitivism of the Navaho and parlayed such images to the retailers who dealt with the public. In the images Hubbell

created, the Navaho were a premodern people who communicated not through arts and letters but through nature and symbols.

As textile sales became an essential part of Hubbell's livelihood, the images he evoked to sell Navajo-made products took on added significance. As early as 1891, Hubbell was deriving approximately 10 percent of his gross sales from textiles. By 1897, that figure had increased to 49 percent.[64] Although no exact figures exist, Hubbell's business records indicate that he shipped more than $40,000 worth of Navajo blankets a year during the 1910s. In just two days in 1913, Hubbell shipped 36,000 pounds of blankets to retailers, consumers, and dealers.[65] The growth of rug sales continued throughout the 1920s, and Hubbell devoted a considerable amount of time and attention to this facet of his business until his death in 1930. Hubbell's use of frontier commerce to market Indian-made goods was a matter of business sense. An important example illustrates one of the many ways that Hubbell attempted to guide retailers of Navajo blankets so that he could boost his own sales figures. In 1913, Hubbell informed the manager of Mandel Brothers Department Store in Chicago that he was not only sending the number of Navajo blankets that the manager had ordered but "I am sending you somewhat more than you ordered . . . for in order to make the assortment complete . . . from the best to the cheapest quality . . . I was obliged to alter your order." To reassure Mandel Brothers that he was not cheating them, he added, "I do not hesitate to say that your order is much better than could be procured from another trader in Indian blankets, for I had a stock of blankets from which to select this assortment, the value of which was more than thirty thousand dollars."[66] Beyond sending more than the retailer had ordered, Hubbell offered some suggestions on how to sell the items he had shipped.

In the same letter, Hubbell also advised the clerks at the department store to mark up the blankets by only 50 percent. Why did he suggest such a course of action when other retailers routinely marked up goods by 100 to 600 percent? Once "you have established your blanket trade . . . the public will patronize . . . and you could then make your prices more extravagant."[67] Thus, Hubbell's expectation that demand would increase enabled him to rationalize his practice of augmenting orders. He justified any further "alterations" in orders to clients by stating that because the supply of Navajo blankets was often uncertain, he tried to provide as big a selection as possible when he had inventory on hand. Retailers were always free to return, at Hubbell's cost, those goods they did not wish to keep.

As with the Mandel Brothers, Hubbell routinely supplemented his commercial exchanges by offering retailers free advice on how to price blankets and on which consumer groups would find specific color or design schemes appealing. Thus, he acted as advertising executive, business consultant, and Indian trader in his efforts to dump excess merchandise on the market. In 1909, he informed retailer C. B. Fenton of [M]ackinac, Michigan, that "the grey and black blankets sell to the very wealthiest people in the country." He explained that he was also sending "a selection of a good many blankets with a good deal of white, that generally do not sell where there is coal used." Hubbell knew that dust from the kind of wood-burning heaters that were popular in Michigan would not mar the coloring of the rugs.[68] Finally, Hubbell always gave both store owners and individual customers the assurance that he had, and would continue to have, one of the best selections of Navajo rugs in stock. As we saw in Chapter 2, he could provide this selection, and had to do so, because of his practice of overbuying stock from Indians. As Hubbell's reputation for manipulating market demand grew, his role solidified as a cultural intermediary who served both primitive and civilized clienteles.

With this reputation, Hubbell was often called upon to ease the tensions that arose when consumers made specific demands. As non-Indians began to use Navajo rugs as floor coverings, wall hangings, portieres (doorway dividers), couch throws, and pillowcases, as well as to use smaller Navajo saddle blankets for automobile-seat covers, they developed very specific needs, and the rugs for sale, although noted for their integrity and uniqueness, did not always match consumers' pragmatic concerns. For instance, Alfred Hardy, a dealer in Indian-made goods from Long Beach, California, informed Hubbell that the most popular Indian blankets were the ones that middle-class women could easily launder. He wanted "Navajo rugs: *un*-dyed—no matter what the *weavers* think. I have been asked time and time again for these as they can be easily cleaned." The undyed blankets were more desirable because "*They* could be sent to a good laundry."[69] As Hardy suggested, the demands of domestic use often determined what consumers would buy. Carefully crafted representations of the Navaho might spur demand for goods, but consumers' practical concerns still influenced the market. Thus, the management and manipulation of the "Indian-made" market required constant vigilance by retailers and the traders on whom they depended.[70]

Hubbell kept widening his field of vision as he sought to monitor market trends. The perspective he gained enabled him to use frontier commerce to appeal to potential buyers beyond individual consumers or retailers. Given his vast stock and his need to increase the demand for Navajo rugs, Hubbell attempted to persuade automobile dealers and manufacturers to use Navajo blankets as car-seat covers. This effort was a logical step, because many people already ordered blankets directly from Hubbell for that purpose, and he could use evidence of prior sales to appeal to the Franklin Motor Car Company. Beyond pointing to the demand among modern consumers, he emphasized the distinctive characteristics of the blankets and their creators. He informed company representatives that "no two [Navajo rugs] are alike" but also pointed out that the rugs were "very durable, all wool, hand carded, hand spun, and hand woven by the Navajo squaw."[71] At this time of increasing standardization within the automobile industry, Hubbell interestingly used virtually the same rhetoric to sell car-seat covers to a large company that he did to sell them to a resident of Philadelphia. In both cases, Hubbell was selling a product, but he was also selling an image of the Navaho as a preindustrial population. Even while asserting that Navajo rugs had a place in modern American homes or cars, Hubbell never let on to the public that Navajos might be as market savvy and accustomed to driving automobiles as his customers were. He wanted consumers to see Navajo-made products as symbolic of a particular kind of frontier life, Navaho life. This representation effectively distanced Indian people from technology in American consciousness. As scholar Philip Deloria has demonstrated, tropes that separated Indians and technology were part and parcel of the misrepresentation of Indians in the early twentieth century.[72]

As a businessman, Hubbell capitalized on images of the frontier on which he supposedly lived and the kind of commerce in which he purportedly engaged. In this view, the Navahos, as a remote population, were unique, as were the products of their labor. Weavers still preserved time-honored traditions. They turned hand-carded wool into finely woven blankets fit for any modern car or home. As part of the narrative of frontier commerce, they clearly belonged to a nonstandardized, nonindustrial world characterized by hand labor. Accordingly, Hubbell presented Navajo weavers as "Squaws" who engaged in handwork, not as keen negotiators. Trading-post owners went to great lengths to point out

that the work patterns of Navajo women were not similar to those of the average assembly-line worker. Such characterizations of both the goods and the people reinforced the idea that Navahos were pastoral and preindustrial workers. Nor did traders convey that their relationships with the Navajos were interdependent, that Navajos followed market trends, or that they had to modify their business practices to fit the needs and desires of Navajo consumers. Hubbell and other traders also neglected to advertise the more coercive aspects of trading.

Hubbell may have been one of the most successful traders, but the business practices he used were by no means inimitable. Invoking the themes common to a narrative of frontier commerce, other traders also touted their unique personality traits presenting themselves as rational businessmen and women who worked with an economically irrational population. J. B. Moore not only focused on the ways that he worked to change Navajo personality traits in his description of the Navaho, he also asserted that a trader had to be willing to "buy any and everything the Navajo has to sell: his wool and pelts [that] his farm produced when he has any, the surplus of his flocks . . . any and everything that he has which he wants to turn into cash." According to Moore, the Navajo seemingly knew or cared little about external markets. It was "up to [the trader] to find a market for" whatever the Navajo wanted to sell. This task took perseverance, innovative thinking, recognition of the trading partner's general disposition, and hard work. Accordingly, Moore informed potential consumers that the trader "must be on the job all the time, and see to it that he is not outmatched by as clever a people as ever worked their way up from savagery." Although the Navaho label no longer referred to Navahos as savages, traders played up the difficulty of establishing trade in a cultural and economic hinterland by casting themselves as rational businessmen dealing with trading partners who were "primitive" producers.[73]

As we have seen, descriptions of the Navaho as economically premodern and culturally primitive focused on a range of behaviors, including the Navajo preference for bartering, the use of symbols, and the Indians' emotional outbursts. Traders reinforced the idea of economic primitivism when they told white consumers that the Navahos had no concept of monetary wealth and therefore measured value in material goods, not cash. For instance, in describing the pawn system, they reported that Indians would keep items in a trader's vault for safe-keeping but would

continually return to the post to borrow against an item—at least until they wanted to wear it to a dance or ceremony. The Navahos would then expect the trader to allow them to use the object. This expectation was not rational in an economic transaction, said the traders, but they had to meet it if they wanted to continue trading on the reservation. By bridging rational and irrational business practices, traders claimed to map the frontier in which the premodern Navajo producers lived and worked. In reality, the frontier commerce narrative enabled traders to sustain their businesses over the long term. It helped Hubbell and Moore enhance their reputations and fortify their businesses' financial success.

If seasonal patterns like buying goods from Navajos at the time they needed to sell them sustained reservation-based trade relations, traders' ties to national markets were the factor that stimulated the use of frontier commerce. Hubbell and other traders used the discourse of frontier commerce to promote the aspects of their business that they believed made them unique in the minds of white consumers: the remoteness of the reservation, the isolation of the post, their role as mediators, their unmatched supply of blankets, their identity as a representative of the "civilized" race, and the characteristics of their Navaho trading partners. Moreover, they put forth the idea of frontier commerce in the larger context of early twentieth-century America, when society's fascination with the frontier, American Indians, and national commerce converged.

Frontier Commerce and the Commodification of the Navaho

Commerce and primitivism were intertwined in the character of the Navaho. And this fact lets us see that primitivism not only operated as a critique of dislocations of urban life, as other scholars have argued, but also as a tool of the market—the same market that drove modernity and industrialization.[74] Despite trader fanfare to the contrary, by the time rugs or jewelry reached consumers, the items had passed through a variety of hands as part of the modern market economy. Paradoxically, the market value of the rugs and silverwork depended in part on the perception that they were not produced under modern market conditions but were expressions of frontier commerce. An indication of this, and perhaps part of the appeal of the rugs to the consumer, was the unpredictability of the

rug market, which consumers were made to accept. Moore, Hubbell, and other traders stressed that customers would have to accept the risk and uncertainty of buying Indian-made goods sight unseen. Moore informed buyers, "We are always glad to have your preferences as to colors and patterns . . . but we cannot promise to follow instructions exactly. . . . We will send you just what you order if we can, but if we cannot, will send the nearest like it."[75] This risk may have been part of the appeal of the rugs, underlining their preindustrial and "primitive" nature and underscoring that their producers had scant allegiance to standardization and mass production. "Primitive" here signified nonstandard and variable form in the rugs but not in the practices of the traders who sold them.

For the most part, the promotion seemed to work. Navajo rugs, like other Indian-made items, became increasingly popular among American consumers during the first half of the twentieth century.[76] Hubbell, and other traders, worked to satisfy the demand for Navajo rugs. By 1930, the trade in Navajo weavings may have been worth more than $1 million.[77] This figure is especially impressive if we consider the amount of weavers' labor necessary to generate this level of sales. Weaving is labor-intensive. Navajo women had to fit it in with other daily activities such as sheepherding, wage work, and caring for families. In the first part of the century, weavers were usually paid according to weight (by the pound), design, type of material, and desirability. They typically received between $1 and $25 per rug, depending on the size, in the early 1900s and between $5 and $75 by 1929. Trader markup remained consistent during the entire period and ranged from 100 percent to 600 percent.[78]

Trading-post culture and practices carried a number of ambiguities that reveal broader cultural phenomena. Economic relationships between traders, Navajos, and consumers operated according to a distinctive rationale, reflecting the traders' need to establish a secure trading relationship with Navajos. Traders represented themselves to Navajos in terms that Navajos understood and accepted. Negotiating a legitimate position on the reservation and in the larger consumer society was not easy for either traders or Navajo artisans. The narrative of frontier commerce developed as a result.

As traders worked to broker between these worlds, they accentuated the paradoxes of creating a market for primitive, preindustrial, Navajo-made goods. Their experience sheds light on the relations between Euro-American traders and American Indian worlds in a period of accelerating

marketization, as well as the responses of a new consumer class to that process. For instance, the popularity of Navajo rugs and the development and manipulation of the market for them affected Navajo weavers in distinct ways. As central figures in the production of the rugs, Navajo weavers were cast as primitive, preindustrial artisans who created unique individual products. Traders, however, managed to eclipse the import of the weaver in circulars and other advertisements by promoting their own role in the trading process. In doing so, they defined a market that seemed to have no room for Navajos' direct participation. A narrative of frontier commerce made the weavers liminal to the retailing of their manufactures—existing in promotions as inhabitants on the threshold of disappearing or as the missing link between past and present. Yet they were central to the production of goods and thus to the traders' livelihoods.

As modern markets connected East and West, and whites and Navajos, more intimately than during the nineteenth century, purchasers of Navajo rugs could have become closer to the weavers, but the way in which the market developed actually enlarged rather than collapsed the distance between the two. This distance was expressed in dichotomies between, for example, frontier and civilization, primitive and modern, Indian and white, and handmade and machine made. Indeed, it became a critical part of the appeal of the goods. By helping to create this distance, traders effectively sold their role as intermediaries while increasing the demand for cultural brokers such as themselves. In this sense, self-promotion, if successful, could bring them financial well being.

Frontier commerce, then, had both a cultural and an economic reality. Consumers' image of frontier commerce was more important to the trade than the reality of conditions at the posts, and the traders were anxious to draw attention to the particularities of the conditions in which they conducted their business. Chapter 4 explores the next stage of the trade: the consumption of "Indian-made" goods by affluent white consumers, the majority of whom belonged to the professional and educated middle class.

Although frontier commerce communicated specific messages about the Navaho to white audiences and consumers, Navajos were not passive participants in trade encounters. In reality, as well as in representation, as long as the idea of frontier commerce stimulated a market for Indian-made goods, it provided both opportunities and challenges to Navajos

like Chischillie, Adjiba, Miguelito, Maria Antonia, and Louisa Alcott. Navajos produced products as part of their cultural heritage but also to obtain much-needed cash, credit, and commodities at the nearest trading post. Navajos were sometimes, but not always, at the mercy of unscrupulous traders who cheated them or took advantage of their lack of transportation. Yet even when Navajo artisans successfully negotiated such ground, they were represented as premodern economic actors. As producers, however, they understood that the rugs, the car-seat covers, the concha belts, and the cigarette cases they made were being sold to non-Indian consumers outside of the reservation, and they wanted, and desperately needed, a piece of the economic pie.

Navajos navigated the trading-post system to the best of their ability, sometimes gaining from exchanges and sometimes not, but they were always aware of whatever power they had and used it when necessary. One way they flexed economic muscle was to seek out traders who paid the best prices, and traders were acutely aware of this fact. For instance, in 1931, Lorenzo Hubbell Jr. warned his cousin Charlie, another trader, to reduce the price he was paying weavers for rugs. "You should know," warned Lorenzo, "the Indians are taking you rugs that have never taken you rugs before, and it's because they are getting the best of you."[79] In such ways, Navajo weavers and silversmiths deftly attempted to control the outcome of day-to-day trading-post exchanges, even if they could do little to alter their emerging image as economically premodern and culturally primitive actors.

In the end, then, frontier commerce was not just an expression of cultural apprehension about standardization, the end of the frontier era, or a disappearing race. In the promotion of Navajo-made rugs, jewelry, baskets, and the occasional piece of pottery, the dynamic representation of Navajo artisans engaged in frontier commerce worked mainly to popularize the role of the traders while turning attention away from Navajos as the economic actors they actually were. This strategy located the qualities of the Navahos more in the commodities controlled by the traders than in consumers' understanding of Navajos as a people with the power to shape their own identities. In modern marketing terms, "Navaho" became a brand. The agent of transmission, the trader, attached his or her name to the goods to lend authenticity to this brand. Clearly, casting Navajos in the exclusive role of preindustrial producers and whites in the role of civilized traders and consumers was a market strategy. Given what

we know about Navajos, however, the artificiality of such distinctions is obvious. But the promotion of Indian-made goods was only one part of a larger economic process, so we need to look beyond the actions of the traders. In fact, we need to look at the consumption of Indian-made goods in the context of the phenomenon that Warren Susman has identified as the shift from a world that foregrounded production to a new collective focus on consumption.[80] Thus, the next chapter looks at the concerns and behaviors of consumers, as well as the dealers who facilitated their consumption, and demonstrates that traders were not the only ones with reasons to endorse the concept of the Navaho.

Dealing in and Consuming
the Navaho, 1890–1940

In 1921, when Lorenzo Hubbell Jr. decided to open a retail outlet called the Arizona Navajo Indian Rug Company in Long Beach, California, he put his cousin Forrest Parker in charge of the operation. In May, Parker informed Lorenzo, "It looks as if we are going to have a nice business if inquiries are any criterion. There have been dozens of people inquiring when we would open. Especially women. They all say they have long wanted a nice Navajo rug and as soon as we open would be in for one."[1] To facilitate the sale of Navajo rugs and jewelry, Parker hired an attractive widow who came highly recommended by Long Beach's most notable bankers, businessmen, and club women. Parker's new sales clerk was active in a variety of national women's clubs and was "a great church worker," affiliations Parker believed would get his "business up to the best women of Long Beach" more effectively than "all the advertising I could do."[2] Parker's elation at finding such an employee revealed what few traders so openly articulated but many obviously knew: married, well-to-do women were in charge of home decorating, so they were the key consumers of Navajo rugs and jewelry. This truism may have had wide acceptance, but the question remains, why exactly were the "best women of Long Beach" beating down Hubbell's doors for a nice Navajo rug, and what did their purchases mean to them?

As earlier chapters have demonstrated, Navajo producers, traders, and tourist-industry personnel associated different sets of meanings with the

goods Navajos made. Producers strove to feed families, acquire goods, develop new skills, and maintain cultural traditions. Tourist-industry personnel linked the concept of the Navaho with primitivism to attract tourists to the Southwest and to sell a romanticized vision of the region. For traders, primitivism was a tool for highlighting their role in the marketplace, and most used it to sell existing stock and to create a steady demand for the goods they acquired from Navajos. For consumers, like those Parker wanted to attract, primitivism took tangible form. It came as a Navajo rug or silver bracelet—and it was both an economic investment and an artifact to display on one's person or in one's living room or den. What did a piece of Navajo jewelry mean to the person who wore it, and what did a Navajo rug mean to the person who hung it on his or her living-room wall? What message were white buyers trying to communicate by associating themselves with Indian creations?

Part of the answer lies in recognizing that consumers participated in a cyclical process that simultaneously subjugated and celebrated Navahos and the handmade, preindustrial, and "primitive" items they produced. As we have seen, tourist- and travel-industry personnel and Navajo traders portrayed the Navaho as a frontier population who remained heroically untainted by the wider effects of civilization but would soon vanish in its shadow. The implication was that as the celebrated southwestern Indian culture disappeared, so too would the production of the Indians' handmade wares. The ever-present danger of scarcity made Indian-made goods valuable to consumers. Many consumers believed that the path of objects would mirror that of indigenous cultures: handmade objects would be overpowered by machine-made products, just as primitive people had been subdued by civilized societies.

Beyond the pursuit of rarity, three primary reasons explain why items made by indigenous populations became popular decorative accessories and investments among American consumers. First, dealers doubled as interior-design consultants and financial advisors and helped middle- and upper-class women invest in the kind of Navajo-made goods that would increase their net worth and express their appreciation for primitive cultures. Next, cast as the artifacts of a primitive race in a civilized world, American Indian wares carried a certain symbolic status as embodiments of the frontier, which itself represented society at an earlier social and evolutionary stage. On a scale of "man's material existence," Indian-made products were perceived to be one developmental stage

away from the goods in the "early American home" and yet centuries re-
moved from "'the age of electric lights, radios, automobiles and refrigera-
tors.'"[3] White consumers, especially women, evoked popular evolutionary
hierarchies, by placing Navajo-made objects in their living rooms or dens.
The straightforward display of Indian-made goods in households was one
way in which consumers symbolically domesticated primitive peoples
in the confines of the modern home. This use of Indian-made goods re-
veals how the dynamics of race and power played out in intimate spaces
where people came into contact with the objects. Although not as direct
or coercive as other forms of imperialism, the acquisition and personal
use of Indian-made goods enabled women to express their class status
and racial authority in a form of domestic imperialism.[4]

Finally, female consumers not only celebrated their status and em-
braced racial hierarchies through their purchases, they also used them
to reinforce, and communicate their frustration with, contemporary gen-
der roles. By embracing primitivism through interior-design schemes,
women could invest household funds in ways that they hoped would
guarantee their financial security, solidify their class status and social
rank, and, if only vicariously, escape the confinement of the domestic
sphere. Thus, women bought more than Indian-made goods when they
made their purchases. Consuming Indian-made items objectified expe-
riences they wanted to have but were unable to realize: independence
from spouses, financial security, emotional gratification, or travel and
adventure. In turn, we must eventually ask what many Navajo women
and men were doing when they became consumers of modern domes-
tic wares like sewing machines, canned goods, kitchen appliances, and
machine-made tools and cloth.

Production, Consumption, and Nostalgia
in America

By 1900, well-to-do women had more social influence as consumers than
as producers, and buying Navajo-made goods was one way they attempted
to wield this power. White middle-class women no longer had to labor at
home for the same long hours that their grandmothers had, and this so-
cial evolution freed them to buy, rather than make, goods. Major retailers
encouraged these women's shopping by portraying department stores as

the epitome of civilization. Department stores like Wanamaker's, Macy's, and Marshall Field's made their stores into social spaces where women came into contact with finely appointed sales clerks, stylish furnishings, and their peers while shopping for affordable goods. John Wanamaker, owner of Philadelphia's largest department store, designed displays that would help Americans learn about fashion, art, and style. His innovations helped turn department stores, as scholar Neil Harris has demonstrated, into American institutions. By forging a uniquely American establishment, John Wanamaker was optimistic that commercial institutions like his had the power to civilize society.[5] Most women of the era realized, however, that their grandmothers had been producers of goods for the household long before the latest generation was able to become society's key consumers of household items.

Handmade, preindustrial, frontier, or other seemingly "primitive" goods reminded contemporary buyers that they had evolved from producers to consumers of handmade wares, fortifying popular beliefs about work, progress, and civilization. From the colonial period to the beginning of the nineteenth century, women often made the basic necessities of the American household, such as clothing, rugs, blankets, sheets, pillowcases, curtains, pottery, and utensils. By the mid-nineteenth century, industrialization had changed traditional modes of production. Before 1820, for example, most manufacturing took the form of home or small-business production that served local markets. As late as 1820, women fashioned two-thirds of all the clothing made in the United States within their homes.[6] By 1860, as the national marketplace matured, the growing demand for finished household goods was met by manufacturing processes in factories, often by immigrant women who worked as wage laborers. Because household goods like clothing and textiles could be produced more cheaply in factories, middle-class white women no longer needed to produce household goods on the same scale. Instead, they could buy them. This shift corresponded with an increase in leisure time. The mass production of goods and growth in leisure activities proceeded at a startling clip into the early twentieth century. During this era, shopping became both a form of leisure and a refining experience.[7]

To understand domestic imperialism, we have to acknowledge that the consumption of goods made by Navahos and other supposedly primitive populations corresponded with Wanamaker's confidence in the civilizing effects of consumerism as much as it did with Hubbell's faith in the

marketability of frontier commerce. As large department stores across the United States sought to capitalize on Navajo rugs, the consumption of primitivism became part of the early twentieth-century shopping experience. Wanamaker's was one of the first to integrate supposedly primitive Indians into the civilized space of the department store. In 1909, Rodman Wanamaker hired Dr. Joseph Dixon to lead an "educational expedition" to "Indian country," where he was to hold flag-raising ceremonies to civilize Indians and make them into patriotic Americans. After the expedition, the store not only published a primer on Indian life and culture and distributed it to public and private schools in the region, but Wanamaker also displayed photographs of the American Indians the expedition had encountered throughout his emporium. In doing so, he positioned Indians within the structure of American consumerism. In the 1910s, Bullock's in Los Angeles coordinated elaborate displays of Navajo rugs and "generic" Indians to draw consumers into the store. By the 1930s, Macy's in New York was still mounting such displays to appeal to consumers, expecting the displays to generate sales. In the spring of 1934, the store's home-furnishings department had even ordered over 1,000 Navajo rugs of the "subdued type" to complement the type of "modern furniture used in the East."[8] These marketing efforts placed representations of so-called primitive Indians in the midst of modern shoppers.[9] Still, even though Indians and Indian-made goods found their way into modern department stores, the sale of machine-made goods dominated the marketplace. Retailers clearly believed that Indians would be part of the modern market economy, not as consumers but as representatives of a bygone, or rapidly disappearing, frontier era. They showcased Indians as keepers of the lost skills and arts of hand production.

The decline of hand-tooled products—along with the communities that supported them and the values they represented—became, for many, a lamentable aspect of modern development.[10] In 1900, Stewart Culin, director of ethnology at the Brooklyn Museum in New York and a noted collector of Navajo arts and crafts, waxed nostalgic about the loss of the symbolic and aesthetic traditions of American craftsmen to industrialized commercial production:

> Enter one of our great department stores, and examine the fabrications. . . . Visit any of our art schools; the majority of the students are preparing themselves, not as disciples of Velasquez and Raphael,

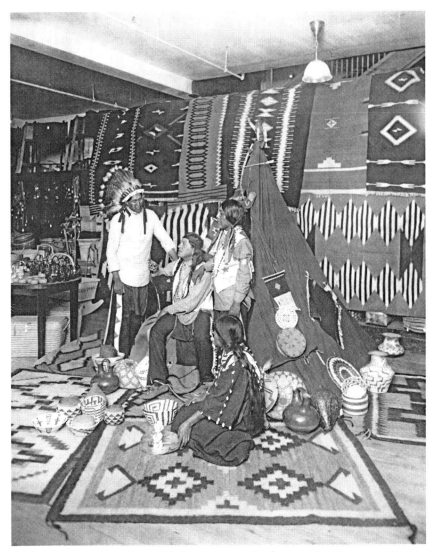

"Indians in Department Store," Bullock's Indian display, ca. 1915. Department stores often created elaborate displays featuring American Indians and Navajo rugs. Used by permission of the Henry E. Huntington Library, San Marino, California.

but to make designs for carpets or knife-handles. The mechanical processes of reproduction have of late enormously increased these tendencies. . . . Our modern designs, while they chiefly repeat the past, are so mixed and conventionalized that it is often difficult to analyze them satisfactorily.[11]

"Mechanical processes of reproduction" stripped white American artisans of the more traditional aspects of their culture and forced them, according to Culin, to meet commercial demands for machine-manufactured goods. In Culin's eyes, finely crafted decorative products were more than pleasing or attractive items; they were expressions of an essential American culture and identity. As a result, he suggested that American consumers preserve artisanal culture by turning their attention to the "crafts of primitive man." Culin took his own advice to heart. He visited the Alvarado Hotel in Albuquerque, met the director of the Indian Building, had trader J. L. Hubbell arrange a trip to the Navajo Reservation, and collected a wide array of Indian-made goods—including prayer sticks, buckskin costumes, jewelry, and rugs—which he used in a display of "traditional" Indian culture in the Brooklyn Museum.[12]

Upon returning to the East Coast, Culin lectured audiences on the cultural significance of Indian-made goods and contributed articles to *Women's Wear Daily* that praised the rough attractiveness of "primitive" clothing and decorative accessories. In publications and public presentations, he encouraged white urbanites to look to "primitive" cultures, such as Navahos, as "the personal conservator of all the wisdom and experience of mankind."[13] In a world dominated by machine-made goods, Culin said, products made by preindustrial people were especially meaningful. Like many of his contemporaries, Culin suggested that even the feelings of dislocation resulting from rapidly changing production patterns could be alleviated by connecting historic artisanal practices with the contemporary craft traditions of primitive people.[14] Authority figures like Culin reinforced the connection between the white past and the Navaho present, and the temporal distance between primitive and civilized peoples, by encouraging consumers to embrace goods made by groups like the Navahos. Consumers who patronized department stores or Navajo traders had only to give up a few dollars to buy into such ideas.

The ascendancy of mass production in America slowed down the production of goods manufactured within middle-class households, but consumers of both machine-made and "primitive" hand-made goods benefited from the wide-scale distribution systems that enabled department stores to offer a wide selection of goods at competitive prices. By 1890, machine-made clothing, blankets, shoes, and other household items were commonly produced in urban areas and then sold throughout the country via catalogs, local shops, or large department stores. Canals and

railroads made the shipment of goods from factory to department store easy and cost-efficient. Dealers of southwestern Indian artifacts used catalogs and railroad shipping to acquire stock and then ship goods to consumers across the country. As participants in this integrated marketplace, female consumers received mixed messages: they should buy machine-made items to make their lives easier, yet they should also appreciate objects made by a supposedly dying race of "primitive" people to reinforce their identity as civilized members of society. They could buy both types of goods in catalogs or department stores. By purchasing Navajo-made goods, women conveyed their appreciation for the role primitivism played in their lives. Not all women, however, found the Indian-made objects they desired in an urban department store or in the pages of a catalog.

The Role of Dealers

Within the potentially homogenizing milieu of the industrial marketplace, dealers of American Indian– and Navajo-made goods had to find a niche. To compete with merchants, big and small, who attempted to eliminate the need for their services by stocking Navajo rugs and jewelry in their stores and using catalogs and circulars, dealers first had to make themselves known and then had to make themselves invaluable to their customers. They did both by assuming a number of complementary roles. As interior decorators, dealers advised consumers on household purchases; as travelers who conveyed their experiences to clients, they sold the adventure of the Southwest; as negotiators, they coordinated exchanges between Native Americans and whites; as promoters, they tapped into prevailing advertising and marketing trends; and as friends—and sometime confidants—they helped individual buyers express their personal tastes and styles. The business of selling, and the acts of buying, goods made by Navajos effectively commodified these objects. Dealers and consumers of Native American products carefully molded the image of American Indians in general, and the Navahos in particular, as carefully as Hubbell and Moore did by creating the narratives of frontier commerce.

Grace Nicholson was one such dealer. Although she did not deal exclusively in Navajo-made articles, she did influence and perpetuate the exchanges between Navajo producers and white consumers. As a successful

dealer of American Indian artifacts, Nicholson was apparently good at building a strong clientele while concealing much of her personal life. Indeed, we know relatively little about her. Born in Philadelphia on December 31, 1877, she moved to California in 1901, where she worked as a stenographer and developed an interest in Native American baskets. Early in 1901, she began purchasing Indian-made baskets and other Native American artifacts for resale to museums and private parties. Around that time, Nicholson traveled around California and to Washington, Oregon, Arizona, and New Mexico on buying trips. She sold the goods she purchased out of her Pasadena home, eventually turning her house into an elaborately designed retail space—which by 1909 covered over 5,000 square feet. She also ran an extensive mail-order business and employed a family friend, Carol Hartman, as an assistant from 1902 until his death in 1933.[15]

Gender complicated Nicholson's attempts to make her mark in the male-dominated professions of ethnology and business, but it also helped her understand the needs and desires of her primary clientele: well-to-do women. She was a skilled decorator and took advantage of the fact that the domestic sphere was the domain of women. To meet the needs of her primary clientele, Nicholson rarely went out of her way to stock goods—like weaponry and implements of war—that might appeal more to men than to women. She even refused to purchase an impressive lot of skulls, war clubs, bows and arrows, and Sitting Bull's buckskin coat.[16]

Men did buy from Nicholson, but most of her male clients were primarily professional ethnologists, anthropologists, or writers who represented institutions or local business interests.[17] These men made careers out of their interest in Indians, whereas other middle-class boys and men celebrated Native American culture by joining clubs like the Sons of Daniel Boone or the Woodcraft Indians. In contrast, Nicholson's female clients demonstrated their appreciation or fascination with Indians by purchasing decorative accessories for their homes, integrating more domestically inclined items, like Navajo textiles, silver spoons, and wedding baskets, into living rooms with lace curtains.[18]

Nicholson helped her female clients express their preferences and personalities by coordinating their acquisition of Indian goods. Like other dealers, Nicholson traveled to Arizona and New Mexico. She dealt directly with Navajo traders, American Indians, and the buying public, keeping extensive business records on her sales and promotion of American

"Charles, Brother, and Myself," ca. 1905. Men and women tended to use Navajo rugs differently. This photograph demonstrates that men used Navajo rugs along with skulls to reinforce white masculinity. The swastika is a Navajo symbol that weavers stopped using during World War II. Nicholson referred to herself as the skull. Grace Nicholson Collection, Photo Postcard Collection. Used by permission of the Henry E. Huntington Library, San Marino, California.

Indian–made goods. She displayed items in her home/business in "interior displays" so that customers could envision the goods in their own living rooms.[19] Nicholson's sales records reveal much about consumers' perceptions of Indian-made goods as well as the ways in which the discourse of primitivism became linked to self-reflective behavior in the national marketplace.

Between 1909 and 1929, Nicholson worked hard to promote her skill as a collector by building a professional profile. For instance, her reputation grew when, at twenty-nine, she won a silver medal for a 1909 ethnological exhibit she coordinated at the Yukon-Pacific Exposition in Seattle. In 1913, she reinforced her community standing by lending a large collection of Navajo jewelry and Indian baskets to the Los Angeles County Museum. She continued to loan and donate items to museums throughout her career. In 1931, to alleviate a Depression-era tax burden, she donated the bulk of her estate, valued at over $200,000 to the construction fund of the Pasadena Art Institute. She also endowed a scholarship at Scripps College to be awarded to young women art students.

Nicholson's shop, interior view, ca. 1900–1910. Nicholson used her home as her shop and decorated rooms to appeal to her female clientele. She, like the Fred Harvey Company, created displays that consumers could replicate at home. Grace Nicholson Collection. Used by permission of the Henry E. Huntington Library, San Marino, California.

Grace Nicholson's prosperity—even when it ebbed and flowed—partially grew out of her success at self-promotion. After making these donations, Nicholson remained in business as a successful dealer in ethno artifacts until the 1940s.[20]

Other cultural mediators were important to her success as a dealer. She courted traders like Lorenzo Hubbell by paying them top dollar for high-quality items. She also cultivated relationships with anthropologists like Matilda Cox Stevenson, William Henry Holmes, and Alfred Kroeber. Early in her career, she solicited goods from the Hyde Exploring Expedition (HEE), a speculative archaeological expedition funded by the heirs of the Babbitt Soap Company whose charge was to excavate "ancient" southwestern sites from 1896 to 1900. Navajo trader Richard Wetherill worked closely with the expedition's lead archaeologist, George Pepper. On the side, Wetherill and Pepper facilitated the sale of jewelry and blankets made by local Navajos to dealers, museums, and interested private parties.[21] Because the Hyde and Wanamaker expeditions blurred the line

between scholarly and commercial endeavors, Nicholson took the opportunity to build her own business by requesting Navajo rugs from the HEE. The expedition could easily accommodate such requests. By 1900, Wetherill and the HEE operated twelve Indian trading posts around Chaco Canyon and had acquired over $100,000 dollars worth of goods, including tens of thousands of pounds of Navajo rugs.[22]

Beyond her dealings with the HEE, Nicholson participated in a larger regional group of mostly male writers, artists, and photographers, such as George Wharton James, Charles Lummis, and Joseph Henry Sharp, who publicized and depicted indigenous peoples of the Southwest as primitives. Sometimes she worked with these men in order to promote her store. In 1902–1903, for instance, Nicholson stocked James's books on Indian handicrafts and sold items from his personal collection on commission.[23] In 1937, she sponsored an exhibition of forty years of Sharp's Indian paintings. Her relationship with Sharp stretched back to 1918, when she had purchased Sharp's extensive and well-regarded collection of Navajo and Puebloan Indian material, including many museum-quality Navajo rugs. Among the items she acquired were "about 15 Navajo—3 or 4 old Chief [blankets] . . . exquisite in color and design." Nicholson profited from this relationship, but so did Sharp. In purchasing Sharp's collection, Nicholson helped the artist dispose of goods that he no longer wanted or needed to use as props in his paintings—even though he considered them "the treasures I love [most] next to my wife and doggie!"[24] Yet Nicholson was different from Sharp and her other male colleagues who painted, wrote extensively about, lectured on, and became famous for their representations of American Indians. Nicholson found a more intimate way to address the public's fascination with things Indian: buying and selling Indian-made goods for use in domestic spaces.

"The Realities of Life": Consumers, Commodities, and Financial Security

Women consumers invested Indian-made goods with different meanings than did male artists and ethnologists. Nicholson not only worked with well-known men like Sharp, she also earned the trust of a wide array of female collectors by making the fact known that she was sympathetic to women and would pay a fair price for any Indian-made goods they might

sell. When such women experienced a major life-changing event or ran into financial trouble, they turned to Nicholson. Nicholson acquired a good deal of stock and obtained some of her most important items from women in need. Unlike Sharp, who made a living painting and representing Indians and used the rugs he collected as props, middle-class women used their purchases to ensure their financial security in case they found themselves without adequate spousal support. For instance, upon her husband's death in 1901, Mrs. Comstock of Ventura, California, offered to sell Nicholson her extensive collection of Indian baskets for $3,000. Comstock and her husband, a local doctor, had spent a good deal of their adult lives building the collection. Mrs. Comstock told Nicholson that her husband's recent death left her no choice but to part with her beloved baskets. She compared herself to "a mother with her children . . . as I love all [the baskets] and they are almost part of my life," but her emotional attachment could not compete with her need for cash. In this case, not only did Comstock refer to the Indian-made items in her collection as her children, but her language indicates the important position the items assumed in her home and in her life. Comstock, like many a hopeful parent, saw her "children" as an investment in her financial future.[25] Nicholson assumed responsibility for Comstock's progeny by purchasing at least $1,100 worth of Indian-made goods from the widow, easing Mrs. Comstock's fiscal crisis and supplementing her own stock of Indian-made goods in the process. In Comstock's words and actions, we get a sense that both maternalism and materialism were part of domestic imperialism.

Mrs. Comstock was not the only widow who cited financial insecurity as the key reason for selling Indian-made collections to Nicholson. In 1916, Mrs. William F. Dermont of Berkeley, California, offered Nicholson a large collection of California and southwestern Indian artifacts that she had accumulated over the previous thirty years. She revealed that she needed to part with her Indian-made goods because of her husband's recent death. Although the collection was appraised at $10,000, Dermont offered the entire lot to Nicholson for $8,000. Nicholson's answer is unknown, but Dermont's proposal reveals that women, especially married women, assembled Indian-made items in their homes because they viewed baskets, blankets, pottery, jewelry, and carvings as personally significant, culturally important, and economically valuable assets that they could sell if they had to.[26]

The women who asked Nicholson to purchase items viewed Indian-made goods in general, and Navajo items in particular, as material assets layered with personal meaning and social significance. In this sense, the death of a spouse was not the only reason women might want to turn their collections into currency. One of Nicholson's clients, identified only as P.K.T., expressed her reason plainly: "My sweetheart and I are getting old and I want the realities of life—not material traditions." As evidence that her advanced age was driving her decision to cash in her collection, P.K.T. offered to sell Nicholson, among other things, an "ancient" Navajo blanket that had been in her husband's family since 1837. P.K.T. knew exactly how to appeal to Nicholson. She documented the provenance of the item, especially the details that reflected her family's role in the expansion of the nation. P.K.T.'s father-in-law had acquired the blanket in the Southwest when the area was still part of Mexico. He had carried it "across the plains to Missouri in an Ox wagon . . . over the Old Santa Fe trail at a time when relationships between Indians and whites were tense." This journey had been especially difficult, and some "of the party were scalped by the roaming Indians." So strong was the seller's desire for funds that she was willing to part with an object that she even associated with her wedding in 1866.[27] At the least, P.K.T. smartly wrapped her blanket in both a stirring historical story and a deeply personal one.

In her letter, P.K.T. emphasized the aesthetic qualities of the blanket that made it valuable even though it was less than beautiful to its owner. P.K.T. asserted that the "Hideos [sic] . . . colors cannot be produced now." She then described how the blanket's nonwhite owners had used it. It had "a slip in the center which I sewed up—it was called a 'rain proof' Pouncha [sic]." For P.K.T., this Navajo textile was, literally, a security blanket, and Nicholson paid $35 for it. What was "hideous" to one person might be beautiful to another—especially to women of a different generation. Nicholson likely suspected that to her younger clients, the blanket would carry currency as a symbol of the triumph of white Americans through manifest destiny and national expansion.

As an object, the blanket had value because it represented the Navahos and their role in the nation's history. In addition, it would be easy to incorporate into personal decorating schemes. Even so, Nicholson suspected that whereas consumers would appreciate the blanket's ability to evoke the drama of America's expansion, they would pay little attention to the violence that might have attended its story. For instance,

Nicholson knew that women shied away from adorning their walls and cozy corners with war clubs and skulls, preferring to decorate with blankets that Navajos had made at a time when they lived on Spanish or Mexican, not American, soil.[28] The details P.K.T. provided may have verified the object's authenticity, but Nicholson did not necessarily use the more gruesome aspects of the blanket's history to sell it to her female clients. Had she been trying to appeal to men, she might have used them. Male collectors, in contrast, did use Navajo bones, skulls, and spears in their displays even when they used Navajo rugs as background material.

Nicholson used her personal relationships not only to acquire rare goods and interesting reminders of national expansion but also to acquire ethnographic details about the items she sold. She often used the connections she had made through women's organizations and missionary societies. For example, after Nicholson purchased a collection of Navajo baskets from Bertha Little, a teacher at the Navajo Indian School in Liberty, New Mexico, she asked Little to provide information regarding the use and cultural significance of the "rare" Navajo marriage basket. Little lived on the reservation, but she was not engaged in ethnographic research. Still, at Nicholson's insistence, she promised to scour Washington Matthew's 1897 publication, *Navajo Legends,* to gather more information about the baskets. In the meantime, Nicholson could assure her "customers that . . . [the baskets] have all been used at singings."[29] When Bertha Little obtained goods for Nicholson, she earned a profit for herself and became part of Nicholson's network.

As Little became better acquainted with Navajo basketry, she passed on valuable information to Nicholson, who relayed it to her consumers. In 1908, Little told Nicholson, "The ceremonial baskets are very scarce on the reservation and twice last year the Indians came to borrow my baskets for their singings."[30] From the Yei-bi-chi Dance she witnessed, she carried away "an impression of the flickering lights, rich color, grotesque costumes" and vision of how Navajos used their baskets: "As the twelve dancers with painted bodies and gay trapping filed into the 'arena' they were met by a medicine man from the lodge, carrying a 'marriage basket' in which was an oblation of meal or possibly pollen." The dance "was very simple, resembling somewhat the—Virginia Reel."[31] For Nicholson, proof of use and the narrative of "disappearance" added a great deal of value to the goods she was selling.

Domestic Settings and Networks
of Consumption

Women's integration of Indian-made goods into their home decor corre-
sponded with rising interest in the indigenous peoples of the American
West and the growing appeal of interior design and decoration as both an
occupation and a modern necessity for well-to-do white women.[32] For in-
stance, from the 1900s to the 1930s, articles about Navajo-made products
began to appear in *Good Housekeeping, House Beautiful, Good Furniture
Magazine, Scribner's, Outlook, Cosmopolitan, Travel, National Geographic*,
and a host of other periodicals that targeted, and were popular among,
middle- to upper-class American readers.[33] As Nicholson did in her own
home, many interior-design–oriented consumers used Indian blankets,
baskets, jewelry, and pottery in "cozy corners." Because Navajo-made
items were readily available and easily transportable, they became a sta-
ple in such displays. Cozy corners came into popularity as the stark and
confining space of the Victorian parlor gave way to the more open space
of the modern living room. According to proscriptive literature, contem-
porary living rooms differed from Victorian parlors because they were sup-
posed to be "lived in." A key feature of the modern residence was the per-
sonality of the woman of the house. Interior-design experts encouraged
women to display fewer items in their living rooms than their mothers
had placed in their parlors but advised them that whatever they displayed
should have personal significance and reveal their character.[34]

By coordinating decorative displays, helping women present their
personalities, tapping into social and professional networks, buying en-
tire collections from women in financial need, and rejecting items that
women rarely used in their domestic displays—like skulls or war clubs—
Nicholson came up with business strategies that were designed for profit.
By 1916, Nicholson claimed to have sold at least 20,000 Indian-made ob-
jects, most of which went to private parties. She continued to sell such
artifacts until 1929, when she switched the primary focus of her business
from American Indian items to Asian artifacts. From that point on, she
still sold Indian-made goods, but not exclusively.[35] We know a little about
the conditions that prompted women to sell their collections to Nichol-
son, but what circumstances prompted women to buy goods from her
store?

Examination of the strategies and networks that Nicholson drew upon to sell her stock and please her clientele lays bare the fact that consumers used Indian-made goods to comment on their domestic circumstances and social lives. In 1918, Mary C. Jones of Pittsburgh, Pennsylvania, wrote to Nicholson expressing affection for the dealer and asking to employ her talents. But she also took the opportunity to comment on a key source of tension between Jones and her husband: shopping. After informing Nicholson that she was planning a trip to California, she told the dealer that she would change her itinerary if they conflicted with Nicholson's travel plans. In part, she wanted to be able to call on her friend and visit her shop, but a bigger motivation was her desire for some autonomy, specifically when shopping. "I don't care to say bluntly that I don't wish Mr. Jones' company." She explained that her husband lacked "sympathy" for her choices, at least "until he sees the articles at home and arranged." Only then did he seem "pleased and proud" of Jones's decorative taste. Jones fully expected Nicholson to respect and sympathize with her need to get away—and to commiserate about her husband's lack of imagination.[36]

Regardless of their personal connection, Mary Jones took the business of buying Indian-made goods seriously: shopping for Indian-made goods was an avocation that brightened her day and enhanced her personal space. So that Nicholson might better serve her, Jones informed the dealer that she had recently purchased a Navajo silver necklace from another dealer of Indian-made goods in Miami. This purchase had ended a three-year hunt that started when Jones failed to acquire a similar item "from an Indian at the exposition in San Francisco a few years ago." Initially, Jones had seriously considered simply sending Nicholson an order "for a [Navajo] rug for my Indian room," but she had then decided to travel to California instead. Because her husband would not approve of a shopping trip, Jones was going to tell her husband that she was going to attend a meeting of the Theosophical Society. In reality, she planned to visit Nicholson's store. So that Nicholson might prepare for her visit, she described the display cases that housed her Indian collection. She wanted Nicholson to locate a Navajo rug that she could place between her 7-foot-long display case and her living-room door.[37] Jones's appreciation for Navajo goods went beyond her desire to pursue specific goods, decorate her home, or adorn her person. Toward the end of a long letter relating news to Nicholson, she informed Grace that the dreary winter weather had

given her the "blues." Planning a shopping trip to visit her trusted friend and respected dealer/decorator to buy a Navajo rug cheered her up. She valued Navajo necklaces and rugs not only for their decorative capacity. The objects could lift her spirits and provide a sense of independence.

Most women, like Jones, purchased goods from Nicholson that they expected to use in their homes. From 1901 through the 1930s, a network of middle- to upper-class white women wrote to Nicholson requesting baskets for use in cozy corners and family bathrooms, silverwork and pottery to decorate their Indian rooms or mantelpieces, and Indian blankets to hang in their dens or use in a variety of other ways. For example, in 1921, Anita Baldwin, the daughter of the notorious and wealthy businessman E. J. "Lucky" Baldwin, asked Nicholson for "two Indian sadle [sic] blanket [sic] to use as small curtains," most likely for use in her highly publicized Indian room.[38] Other clients expected Nicholson, as a woman, to understand their decorating sensibilities and meet their needs accordingly. Jones praised Nicholson's decorating ability: "You always seem to know intuitively what will please [me]."[39] If her clients did not directly state how they wanted to use blankets, jewelry, or pottery, Nicholson suggested ways in which they could display the items in their homes, much as Hubbell often advised stores on how to merchandise Navajo blankets. This comparison is revealing. Like Hubbell, Nicholson received many requests for Navajo blankets to use as pillow covers, drapes, couch covers, and, of course, living-room rugs. Hubbell might promote the frontier qualities of the goods or advise retailers on the best way to market Navajo rugs, but rarely, if ever, did his clients expect him to tell them how they might ultimately use their purchases. Still, both Hubbell and Nicholson understood that the majority of Navajo rugs were destined to decorate middle-class homes.[40]

Especially among Nicholson's married clients, the desire for and display of ethnoartifacts clearly reflected a multiplicity of domestic conditions and sentiments. For instance, in addition to serving as cheerful decorative accessories, personal expressions, or conversation pieces, Navajo and other Indian-made products might also communicate more complex and symbolic dynamics: the desire to domesticate Indians, to experience the excitement of the search for a prized object, and to display an adventurous attitude. As a result, the fact that the majority of the women Nicholson dealt with were married is important. Like Jones, married women often had difficulty making arrangements to travel. Some

were unable to journey alone to Indian reservations or to California be-
cause of household responsibilities, including child rearing, care for fam-
ily members, or social and church work.[41] In fact, the majority of the
clients listed in Nicholson's letterbooks were married.

Just as Hubbell hoped his consumers would latch onto the idea of
frontier commerce, Nicholson hoped her clients would value the authen-
ticating details that she collected while in the Southwest gathering her
stock. Most letters that customers sent to Nicholson were similar to that
of Mrs. Frank S. Ford, who in 1912, requested a large collection of south-
western American Indian artifacts as well as information authenticating
their use and their acquisition. In the end, Mrs. Ford paid $498 for a col-
lection of forty-two artifacts made by Navajo, Hopi, and Pueblo Indians,
sight unseen. Grace Nicholson legitimated one of the Navajo baskets she
sent to Mrs. Ford by providing the following information: "This basket is
known as the medicine basket The little black dots at the ends . . .
are supposed to represent the various home [sic] of the spiderwoman,
who according to Navajo lore is responsible for the population of the
world."[42] Details that conveyed religious significance or baskets that con-
tained traces of ceremonial corn meal, like those that Nicholson pur-
chased from Little, conveyed the authenticity of the goods, signaled the
primitivism of their makers, and channeled the excitement associated
with their acquisition.

Like Jones, Comstock, Little, and Baldwin, women across the country
were linked into Nicholson's network. As the *Pasadena Star* newspaper
noted in 1915, Nicholson's shop was famous throughout the country, and
"thousands of tourists visited her museum yearly." Networks played an
essential role: "Most of them [the tourists] are sent by friends, and there is
much privacy attached to the business as though the purchaser called on
Miss Nicholson in her home."[43] Those who could not personally visit Miss
Nicholson used the postal service as a proxy. Mrs. Jesse Metcalf of Provi-
dence, Rhode Island, also shopped via mail in 1913. Nicholson sent Mrs.
Metcalf a large collection of Navajo silver jewelry, noting "The workman-
ship is very different by comparison with the modern stuff made for tour-
ists."[44] Nicholson had other clients in Providence as well. Mrs. W. S. Radeke
found out about Nicholson from Mrs. William G. Baker. Such connections
helped Grace Nicholson establish a growing network of clients looking to
find something unusual or rare for themselves or their homes.

Nicholson tried her best to fulfill consumer desires. She sent Mrs. Radeke seven Navajo bracelets whose prices ranged from $6 to $10, as well as concha belts, necklaces, earrings, rings, and Navajo blankets. In the end, Radeke purchased over $300 worth of goods. Because Radeke was buying them sight unseen, Nicholson attempted to persuade her not to return any of the items. She told Radeke that if she did not wish to keep everything Nicholson sent, Mrs. Baker, the woman who had introduced Nicholson and Radeke, would donate unwanted goods to a local museum or art school. This statement, along with the fact that she informed her client that the items were very "scarce," spoke of their cultural and economic value. As if to underscore the worth of the items, Nicholson added, "[The] old Navajo [blanket I] selected to send you on account of variety of design used" and "The silver is all genuine old Navajo Indian make."[45] By focusing on the uniqueness of the goods, Nicholson validated their social, cultural, and financial worth. In referring to a blanket as a "Navajo," she revealed the social value women placed on goods. Blankets were more than textiles; they were Navahos. Moreover, these "old" or "primitive" representative items had the potential to yield financial security for their "modern" or "civilized" owners.

The assemblage, sale, and consumption of Indian-made materials were part of a layered interaction in which the main participants, the dealer and the consumer, invented meanings around primitive Navahos to fit specific domestic purposes. For example, Nicholson sold, and most of her clients bought, "old," "scarce," "lost," and "rare" museum-quality pieces—pieces that women could not easily obtain even if they were to go on a southwestern tour—for the obvious reason that she could charge more for such items and because the difficulty of obtaining such goods verified their value. Nicholson had financial reasons to control the image of the goods she was selling. Like Navajo traders, Nicholson needed to ensure that individuals valued her role in the process as much as the goods she was selling. As a result, Nicholson continually worked to establish her expertise. Given that she had no formal training in the burgeoning fields of anthropology or ethnology and could not claim authority through living on a "frontier," Nicholson had to sell her talents. Still, her skill as a dealer, her network building, and her willingness to go into the field to buy from reservation-based sources and study Native American culture meant nothing without her effective management of her reputation.[46]

Hubbell did not have to go to the same lengths to validate his role as an expert on Indian life and culture because he lived adjacent to the Navajo Reservation. He merely used his proximity to Indians and a narrative of frontier commerce to promote an image of himself and his services. Hubbell's clients, as a result, purchased directly from Hubbell because they perceived him as part of reservation life. But once his son Lorenzo opened a store in Long Beach, effectively distancing the sale of Navajo rugs from the Navajo Reservation, Hubbell needed someone like Nicholson—hence Parker's employment of a well-appointed salesclerk— to establish ties within the community and navigate social networks.

Vicarious Travel and Virtual Tourism

Although Hubbell marketed his persona along with his goods, Grace Nicholson offered a more personal connection to the goods and services she sold. Nicholson traveled extensively almost every summer looking for objects to sell in her store. To promote herself, she also chronicled her adventures as a dealer in exotica. These travels, both as verification of authenticity and as adventures, pleased one of Nicholson's wealthiest clients, Florence Osgood Rand Lang (1862–1945) of Montclair, New Jersey. Lang was both the ultimate consumer and a serious collector. At the urging of her mother, she purchased tens of thousands of dollars worth of southwestern Indian-made artifacts. Eventually, Lang turned her private collection into a public exhibit, donating it to the Montclair Art Museum in 1931 in memory of her mother, Annie V. Rand.[47]

Nicholson carefully noted any details that enhanced the authenticity of the artifacts as well as the encounters she had while acquiring them. When she sent Lang some Navajo silverware in October 1912, she told her client that the items had been "secured direct from Navajos, who live far away from the Railroad," and she had "spent the last two months of my trip in New Mexico, and Arizona, visiting nearly every out the way trading post and crossing and re-crossing the Navajo Reservation a number of times." Photographs of the Navajo craftswomen and -men who made the items helped eliminate any question about their authenticity and allowed Lang to travel vicariously to the Southwest. Lang did travel extensively to Europe for vacation, to Nantucket for the summer, and back to Pasadena for the winter, but the only way she

"Nicholson on Donkey," ca. 1900–1910. Used by permission of the Henry E. Huntington Library, San Marino, California.

experienced the adventure of the Southwest was by patronizing Grace Nicholson's shop.

Nicholson's employee Carol Hartman also evoked the theme of adventurous travel. He filled his reports to Nicholson with details that would help meet consumers' expectations of the Navaho. In 1902, Hartman informed Nicholson that he was extending a trip so that he could see some upcoming "rare Navajo ceremonies in this region." Besides witnessing "a day of genuine old fashioned Navajo sports," Hartman planned to stay and watch an exorcism, a rarely performed ritual: "These dusky sons of the desert" believed that the devil had "honored himself for a year past by taking up his abode in the body of an ailing [Navajo] woman." Hartman's trip to collect silver from the primitive Navaho to sell to Nicholson's winter clientele was proving to be a successful adventure. In turn, Nicholson could pass on Hartman's stories to her clients as proof of the character of the Navaho and of the extra effort one might have to make to obtain Indian-made goods.[48]

Themes of adventure and authenticity appeared in various forms: in Nicholson's claims that she secured items directly from American Indians; in her extensive documentation of the myths and stories associated with the baskets, blankets, and jewelry she amassed for sale; and

especially in the stories she told her clients of her experiences while collecting material. Often she used adventure as an overt selling point, inquiring of Miss Livermore of Morristown, New Jersey, "May I hear what interests you?" and then attempting to entice her with her stock of "over 40,000 object [sic]" that she had "personally collected" on trips "full of adventures."[49] To entice customers, Nicholson and Hartman reported camping, hiking, viewing ceremonial dances, participating in Indian rituals, and crisscrossing large sections of the West. Like Nicholson, Hartman was keenly aware of how he represented himself and knew that images of travel and adventure verified his credibility as a collector of ethnoartifacts. In the end, he was pleased with his work and, under Nicholson's decorative eye, expected the materials he collected to bring in a good profit. In fact, Hartman believed that once the goods he collected were displayed on "our old walls," they would enable Nicholson's business to compete with other larger retailers. "I cannot see that any place in Los Angeles or Pasadena shall have so excellent material for an appeal to the public and I am certain that in the matter of Indian curios our oasis will stand quite alone in the peculiar and meritorious pack of the goods having their own advertisers." But in his correspondence with Nicholson, Hartman revealed more than his sense of adventure on the job. Periodically, he observed that Navajos were consumers of American goods—and brand-conscious ones at that. During one break during his travels to Navajo ceremonies, he wrote Nicholson, "Picture me astride an empty coffee box (Arbuckle brand, of course) against a sunlit adobe wall, my writing on my knee." As traders and dealers alike acknowledged, Navajos preferred Arbuckle's coffee to any other brand.[50]

The drama of Nicholson's and Hartman's collecting experiences and interactions with indigenous craftsmen and -women played out, as Hartman's letter indicates, on both the sunlit walls of reservation adobes and the walls of the Pasadena store. As Hartman indicated, Nicholson ran her "shop of treasures" out of her Pasadena home. There, she displayed photographs of Indians, a vast array of goods, and even on occasion featured native artisans making goods in the yard. In doing so, she copied the marketing techniques of the Fred Harvey Company's Indian and Mexican Building—which sought to appeal to middle-class consumers.

Nicholson's attempt to sell adventure was, like traders' promotion of frontier commerce, a marketing strategy, but Nicholson had to manipulate it to meet the needs of her clientele. Hubbell also sold adventure, but

he rested his claim on the fact that he, unlike Nicholson, lived among the Navajos and Hopis. Hubbell arranged to take travelers to dances and ceremonials, and he led tours of Navajo country.[51] Because Hubbell's home was also a "guest house," he prominently displayed Indian products there to encourage visitors to buy the goods they could find next door in the trading post. Hubbell also built up his persona as a colorful regional character and expert on Navajo jewelry and rugs by coordinating adventures for tourists and promoting Indian-made products. He reassured buyers that he carried the widest selection of Navajo goods in the United States. Nicholson used business techniques similar to Hubbell's. She repeatedly played the role of knowledgeable adventurer. For each set of Navajo artifacts, she assembled the kind of information she knew her customers desired. Lest anyone forget the nature of her business, however, Nicholson reminded potential consumers that Navajo Indian rugs were made for use in homes, especially living rooms. Although Hubbell and Nicholson used similar business techniques, their businesses created different challenges. Hubbell traded directly with Navajos every day, so his expertise in Navajo products was beyond question. However, though he attended to trends in home decoration and placed ads in home-furnishing magazines, his customers never viewed him as an interior decorator. Nicholson, in contrast, was a trusted decorator but had to prove her expertise in Navajo goods.

Both dealers' clients wanted rugs, jewelry, or baskets for their living rooms and a vague engagement with Indian adventure, but few expressed interest in the graphic details of Indian life. Nicholson transformed the lived experiences of the Navajo, as she did with other ethnic groups, into a narrative for clients, but like the narrative of frontier commerce, her presentation hid as much as it revealed. She frequently insisted that the design of the Navajo medicine basket "was symbolic" or detailed how Navajos made such baskets or used them in ceremonials, but she failed to mention the more pedestrian circumstances of her business trips in the Southwest and life on American Indian reservations.

Thus, Nicholson heavily edited the narrative she constructed for clients. She described the places where she bought particular pieces but didn't mention the drudgery of traveling to those places. When writing to Alice Phromm, a close personal friend, Nicholson shared the kinds of experiences she withheld from clients:

Between you and I this has been one of the hardest trips I've made this summer. Lost in weight . . . Mr. H. [Hartman] and I wanted to

visit the adjoining Pueblos so went to Oraibi with a one armed gov-
ernment official and he succeeded in getting us accommodated at
the Government building—en route we killed an enormous rattle
snake, and I have the 8 tailfins. . . . [I] was disappointed with the
Pueblo as it is so filthy and the Indians are in dreadful shape with
trachoma . . . a serious contagious eye trouble.[52]

News of health problems in Indian country could create anxiety among
potential clients, so Nicholson often bathed baskets and rugs in gasoline
to prevent diseases from spreading via goods.

Nicholson also assiduously fashioned a fictional, safe, exotic experience
for her clients by neglecting to tell them about the difficulty she some-
times faced, as a woman, in establishing trade with indigenous peoples.
After attending a "disappointing" Flute Dance, Nicholson's party traveled
18 miles to attend the same ceremony at Wishangnovi and Shipanlovi. At
Shipanlovi, she told Phromm, she had a frightening experience:

On this trip I'd been wearing my Thubehon turquoise necklace. It
has caught the Indians' eye and is often a means of opening conver-
sation. Mr. Ladd was in some house and Mr. H. was near taking pic-
tures. A young Indian admired my necklace and went in the door-
way of his house and beckoned me. I had been inquiring for some
small katchina baskets. He said he had some and pointed to the west
room—I entered and was about to pass him when I noticed the room
darken. He had closed the door quietly and fastened it inside with a
nail. I gave him one look and demanded that he open the door. I tell
you I hunted up my party in a jiffy.[53]

Although Nicholson passed on American Indian lore and described
production techniques to consumers, she never mentioned the poverty
and disease she witnessed or the threats she faced. As a businesswoman,
she selected details that would enhance the value of Indian-made goods
in general. A narrative of safe adventure and verifiable authenticity en-
hanced an item's appeal. Danger, disease, and despair did not. In this
sense, the details Nicholson and Hubbell included with purchases as-
sured consumers that they were buying authentic, hand-crafted items
made by nonthreatening, healthy preindustrial peoples: a people who
may have been subdued through American imperialism, but who—be
they Navaho or Puebloan—had yet to become identifiably civilized.

That these edited versions of collecting experiences helped sell American Indian material raises questions: Why were authenticity and adventure so important to consumers? What does this fact tell us about developing middle-class ideology, the personalities of consumers, and the power behind domestic imperialism? Perhaps the representation of self—both by Nicholson and by her consumers—became a kind of social theater. One set of actors—consumers—wished to locate social authority, authenticity, adventure—perhaps even manifest destiny—in the activity of shopping. By hiring stand-ins, like Nicholson and Hartman, consumers acquired Indian-made goods both as investments and as beautiful objects. Clients bought accessories from these entrepreneurs to fuse the identities of homebody and adventurer. In this sense, clients cared less whether the goods were made by Navahos or by other southwestern people as long as they believed that the makers of the goods they acquired were "primitive." Dealers like Nicholson helped them narrow the distance between their role as married housewives who, in Mary Jones's words, participated in the "fad" of collecting Navajo-made goods and the adventurous professionals who helped them locate the items over which they would preside in their homes.[54]

Primitivism, Consumerism, and the Navaho

Beyond examining women's attempts to transcend the domestic sphere, a look at the context and processes surrounding the consumption of southwestern Indian artifacts enables us to explore the paradoxes of associating the Navajos with primitivism. By consuming supposedly preindustrial, primitive Indian artifacts, middle-class white women could challenge the physical limitations of the home simply by shopping, an activity that was socially acceptable and befitting to women. Such behavior fits with historian Alice Kessler Harris's description of the "complex ways in which social organization of gender constructs relations of power and simultaneously obscures them so that they appear to be natural/invisible."[55] When Anita Baldwin draped the Navajo rugs she purchased from Nicholson over her windows, she altered the physical space around her. She also made a statement to passersby. Baldwin's house displayed something unusual, exotic, and adventurous: Navajo blankets. White female consumers literally grasped at adventure, traveled vicariously, and

domesticated representations of the Navaho as a way of transcending the limitations of their surroundings. The consumption of artifacts made by Navajo Indians was accepted (even expected) because the artifacts were used in the home, women's "natural" place.

To many collectors, the display of ethnoartifacts in their homes also confirmed their class status and racial superiority. For many middle- and upper-class women, American Indian artifacts represented not only vicarious adventure but also racial difference.[56] In fact, women who used Indian-made arts and crafts in home displays or as interior decorations expressed as much about their personal identities as about the domestication of the Navaho. Attaching tribal affiliations to items objectified producers and served to underscore the specific identity of the consumer. Placing items that celebrated subjugated characters in their modern home displays enabled collectors to celebrate their own status.

The popularity of displaying "primitive" artifacts reveals some American consumers' beliefs about Navahos' place in social and cultural hierarchies. As American Indian goods appeared in ad campaigns, magazine articles, and store displays, Navahos' handmade products became welcome additions to the homes of well-heeled Americans in a way that Navajos themselves would not have been. As long as Navahos remained characters rather than individuals to white collectors, their separateness or distinctiveness justified their subordinate position in American society.[57]

The celebration of Navaho primitivism through consumption reflected the romantic conviction of many whites that "civilized" society could learn something from preindustrial people. Romantic primitivism conjured up a vision of the Navaho who stood in contrast not only to civilized Americans but also to the effects of civilization: the sterile, sanitized, and culturally barren urban environments. In 1931, M. L. Woodard, a newspaperman from Lincoln, Nebraska, and later from Gallup, New Mexico, chronicled the transmission of "the appeal and spirit of the Southwest to the effete East." In "The Navajo Goes East," he summarized the journey of Navajo sandpainter Chili Betsua, "girl weaver" Yil Habah, and silversmith Kinnie Begay from New Mexico to Boston, where they introduced the modern world to their preindustrial lifeways: "More and more select easterners marveled as they saw the remarkable artistic ability of this primitive tribe and heard of the wonders of the Southwest."[58] More than 35,000 easterners witnessed a series of demonstrations in

which the Navajo artists herded sheep through the ballroom of the Hotel Statler, built a typical Navajo hogan (the traditional Navajo dwelling), and performed chants and sacred ceremonies. The radio station WBZ broadcast during the daily exhibition of rugs, sandpaintings, and silver jewelry. The popularity of this affair prompted the making of an educational film distributed by the Pathe Corporation. Many similar trips followed.[59] Although Woodard pointed out that society's "elite" attended such events, the size of the daily crowds—and the scope of the project—reveals its broad appeal.

Such staged events, alongside the aggressive Harvey Company/Atchison, Topeka & Santa Fe advertising campaign and the promotional literature and activities of traders and dealers, shows that amazingly similar representations of the Navaho occurred on a number of levels, among different groups, and in a variety of geographical localities and forums. As a result, one cannot easily support the argument that primitivism was soley the creation of the era's avant-garde and activist artists, intellectuals, and authors.[60] The promotion and consumption of the Navaho was part of the larger economic shifts that accompanied industrialization. White women reinforced traditional gender roles by shopping, but some expressed frustration with their domestic arrangements by buying Navajo-made goods. In both cases, consumers asserted their racial authority by domesticating the Navaho in cozy corners.

Women like Jones, Radeke, and Lang were not the only ones to consume Navajo-made goods, but they represented an influential group that contributed to the growth of the flourishing market for Navajo-made goods from 1900 to 1930. For instance, in 1890, the U.S. Department of the Interior reported sales of $25,000 worth of Navajo blankets nationwide. In 1931, the Bureau of Indian Affairs reported forty times that amount.[61] Silver earrings, bracelets, and necklaces were similarly popular with women, especially in the 1920s. Although sales figures for these goods are questionable given traders' and dealers' reporting methods, trade in Navajo goods remained steady throughout the 1920s. As a result, Navajos began to rely on the income generated by their industries to buy the manufactured goods they both desired and needed to survive. By the early 1930s, nearly one-third or more of Navajo family income came from craft industries.[62] Navajos' consumption of manufactured products and brand names raises another set of questions about domestic imperialism. What can we conclude from Navajos' willingness to bring manufactured

goods into their homes, demand specific brands from traders, and produce goods that carried their name? Did they intend to subvert white dominance by ruling over the machine-made products they purchased at trading posts? Did their actions justify the assertions that they were cultural borrowers and that their culture was fundamentally derivative? Or was an even larger form of domestic imperialism at work—one driven by manufacturers' desires to place their brands in every American home? The effects of whites' *and* Navajos' consumption extended beyond the walls of craftsmen's bungalows and traditional hogans—sometimes even to the hallowed halls of the nation's museums.

Authenticating the Navaho

Although shopping for Navajo goods was a popular activity, it was not the only way in which the concept of the Navaho was produced and consumed. In some cases, the concept was appropriated for entertainment. "After fourteen sleeps, in the third moon of the civilized year 1901, you are commanded to turn your footsteps in the direction of 467, on the West Side of Central Park." So Mr. and Mrs. Frederic S. Goodwin directed the guests they had invited to their "Navaho Indian Fiesta." By describing their home as a "hogan" and reporting that "members of their own tribe, and all visiting Indians" were invited to the gathering—while also lightheartedly threatening "your scalp . . . if you fail to appear"—the Goodwins played Navaho. Yet, beyond using a Navajo word or two and emphasizing the symbolism that so many whites associated with Indians, what made the Goodwins' party a Navaho event?

In part, the feature presenter, George Wharton James, provided the necessary cachet. By 1901, George Wharton James was well-known for his lectures on the Navaho and other indigenous peoples. He had taken a very odd path toward becoming a self-designated Indian expert. Once a Methodist minister in California, James fled the state after his wife charged him with adultery and incest in 1889. Because he was persona non grata in California, he sought solace in the greater Southwest, living and camping among several indigenous populations. Intrigued by Indians, James reinvented himself as an expert on American Indian culture,

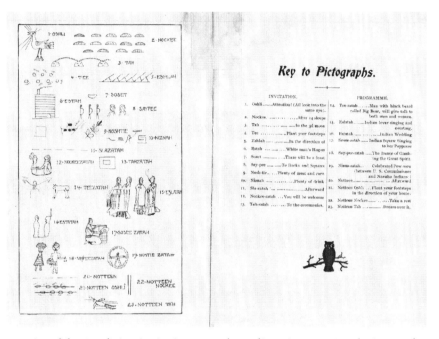

Interior of the Goodwins' invitation, "Navaho Indian Fiesta," 1901. Playing up the primitive qualities of Navahos, the Goodwins used a pictograph to invite their guests to the party. They also included a "key" so that their "civilized" guests could easily decode the message. Warshaw Collection of Business Americana, Indians, Archives Center, National Museum of American History, Smithsonian Institution, Washington, D.C.

especially the Navahos, and traveled throughout midwestern and eastern cities giving popular lectures celebrating the Southwest and the American Indians who lived there.[1] Given the interest James drummed up, it is not surprising that the Goodwins placed him at the center of the evening's program. Invoking James's Indian name, the Goodwins informed invitees that the highlight of the party would be "when the Pellicana (white man) with the black beard, called 'Big Bear,' known as George Wharton James, will talk to all the people both men and women."[2] James was there to provide an educational and entertaining lecture on the Navahos.

The Goodwins also announced that "'Hostine Klish,' the Snake Man, otherwise George H. Pepper, from the [American] Museum [of Natural History]" would be present. Though the anthropologist was not scheduled to talk, Pepper's presence conferred scholarly legitimacy on what promised to be a dramatic party, featuring a "Navaho wedding" and a "Squaw"

dance performed by the hosts and a few of their friends. Almost as an afterthought, however, the Goodwins noted that the only "Bo-nah Fi-dah Indians" attending the party would be from the Iroquois, Blackfeet, and Onondaga tribes. If any aspect of the party was authentic, it had little to do with Navajos themselves. Only one Navajo seemed to participate, an unnamed woman whom the invitation described only as someone who lived "forty miles from the railroad station of Arizona." Her role was to make bread and ship it to the Goodwins to serve to their guests.[3]

Navajo fry bread was not the only thing partygoers could consume that evening. In the past, both James and Pepper had been known to peddle Navajo goods alongside their dramatic or scholarly representations of Indians. James, for instance, almost always brought his personal collection of Navajo rugs to sell when he lectured audiences. Similarly, Pepper, who at the time was just finishing a stint with the Hyde Exploring Expedition (HEE), also knew a good business opportunity when he saw one. Before the HEE folded because of mismanagement of funds, Pepper regularly purchased Navajo blankets from Navajos with whom he worked with the hope of reselling them for profit—sometimes even to the HEE's New York Navajo rug store on 23rd Street. For both men, the Goodwins' fiesta was the perfect place to sell their personal collections of "Navaho blankets, squaw dresses, baskets, water jars, and gambling implements." As a scholar, Pepper was there to market and authenticate Navajo-made goods.[4]

The Goodwins' Navaho Indian Fiesta reveals as much about the connection between those who studied Navajos and those who sold Navajo-made goods as it does about the consumers who attended such events or the Navajos that they supposedly represented. The concept of the Navaho had roots in both scholarly and commercial circles, and its use in the Goodwins' party foreshadows the symbiotic link between the two influences that would persist for years to come.

Thirty-two years after the Goodwins' party, for instance, scholarly and commercial interests in the Navaho were still intertwined. In the 1930s, the Brooklyn Museum hosted a touring show featuring Pueblo and Navajo "Craftsmen at Work." Instead of bringing a scholar to a private space like the Goodwins' home, the museum invited a Navajo trader, Wick Miller, to set up shop in its courtyard. Miller's role was to help the public see that Indians were "true artists."[5] Whereas individuals like Fred Harvey, Lorenzo Hubbell, and Grace Nicholson worked hard to promote the use of Navajo-made rugs and jewelry in the American home and

consumers participated in domestic imperialism or played Indian inside their homes, museums fleshed out the notion of Navaho primitivism in the public realm. Through displays that presented various takes on primitivism, ethnographers considered whether or not the Navajos were at risk of losing their authenticity and their standing as a distinctive people. At issue was their behavior as "cultural borrowers." What were the implications of Navajos' borrowing, if they indeed were borrowers, and why should anyone care if they were? Moreover, how did the notion of cultural borrowing help construct Navajos as Navahos?

In the pages of the *Brooklyn Museum Quarterly* [BMQ], we can see that the museum, by furthering the idea of the Navaho as cultural borrowers, helped legitimize whites' construction and racialization of Navajo identity. Jean Reed, who authored a *BMQ* piece that supplemented Miller's exhibition, argued that Navajo and Puebloan peoples represented two distinct evolutionary phases in human adaptation to the "snow capped mountains, plateaus, deep canyons and lava capped mesas" of the Southwest. Both groups were "primitive peoples," but they were not identical. Puebloan peoples "innovated," whereas Navajos "borrowed."[6] The idea that, as a race, Navajos had a propensity to borrow goods, skills, and ceremonies from their neighbors predated the Brooklyn Museum's 1932 demonstration. Scholars like Washington Matthews and Hubert Howe Bancroft had made similar claims as early as the 1870s. But these scholars' claims had little commercial value at the time they made them.[7] A few decades later, traders had become invested in the idea of borrowing. They used it to justify their oversight of the designs Navajos wove into their rugs and the styles of silver jewelry the artisans made. Though not as blunt or market driven as were the traders, Stewart Culin, the curator of ethnological collections at the Brooklyn Museum in New York from 1903 to 1929, also used the idea with the market in mind. He used it to build the public's receptivity to displays of Navaho culture.

In Culin's hands, portrayals of Navaho borrowers had more than intellectual influence. Like department stores, museums sought to sell an experience. Unlike department stores, however, museums also had the mission of educating patrons.[8] Still, stores and museums used similar practices. For example, Wick Miller set up demonstrations of Indian artists at Marshall Field's in Chicago, L. S. Ayers and Company in Indianapolis, and the Emporium in San Francisco as well as at museums. Though his was a clearly commercial endeavor, Miller cautioned all his clients

against confusing his displays with circuslike performances. Rather, probably because he hoped to draw on the popularity of the Exposition of Indian Tribal Arts that swept New York in 1931, he characterized his outfit as an "exposition" of a "group of Indian craftsmen making silverware, sandpaintings, pottery, beads, [and] blankets" whose aim was to educate consumers about Indians and the products they made.[9]

Long before Miller conceived of such an event, Stewart Culin had been a prime mover in the evolution of the Brooklyn Museum's permanent collection and overall mission. In many ways, Culin's "Indian" displays mirrored what the public wanted to believe about Indians as much as they revealed ethnographers' pursuit of scientific knowledge. In Culin's hands, a narrative that cast Navajos as borrowers became not only an ethnographic explanation but also a justification for his collection strategies, a tool for educational enhancement and diverting entertainment, and, ultimately, a rationale for assembling "traditional" objects. For Culin, museum displays should reflect Native American identities and should respond to the audience's desires. Ironically, through Culin's collection of "old," "rare," and "ceremonial" Navajo objects, he conveyed that the assimilation of the Navajos was a virtual inevitability. How did Culin, with his specific subject position, help produce and consume a paradigm that portrayed Navajo culture as simultaneously unique and derivative? The first step in answering this question is to understand the cultural context in which he developed his views of the Navahos.

Shifting Perspectives on Navajos and the Presentation of the Navaho

The borrower theory emerged during a period of changing perceptions of Navajos in American society. Between the end of the Indian Wars in the 1890s and the early 1900s, federal and scholarly assessments of Navajos began to move away from casting them as the unrefined "savage" foes of other American Indians, settlers, and the federal government and instead presented them as strong-willed "nomadic" and "semiprimitive" people who could adapt to a variety of circumstances. This change occurred partly because American intellectuals and policy makers had never known what to make of the raiding seminomadic Navajos. As other scholars have noted, many Americans could more easily understand and

even admire the pastoral, agricultural life of the Puebloan peoples.[10] The complex culture of the scattered and sometimes contentious Navajos who lived on the Pueblos' western periphery was more alien to the public and to the government—especially in the period directly before and after they were interned at Fort Sumner in 1868. As William Lyon has noted, from 1868 until the 1880s, "the few Americans who observed the Navajos" during that time "saw them as fierce, aggressive, cunning, plucky."[11]

In the 1890s, depictions of Navajos began to shift in the public consciousness, prompting considerable disagreement about the group's fundamental characteristics. Popular magazines, for instance, presented the public with a host of contradictory images. In 1890, William Edwardy asserted in *Harper's Magazine* that the Navajos had almost exclusively "fierce and warlike natures" and that they harbored a "deep-seated and well-founded hatred for the white man" so intense that "no white man or party of white men can safely pass through Navajo country alone."[12] In contrast, Michael J. Riordan, writing for *Overland Monthly*, also in 1890, observed, "[The] Navajos have always been a law-abiding, industrious people (with the exception of one occasion many years ago, when they gave the government some little trouble), and hence they have never been placed before the public in the light of savage and unconquerqable [sic] warriors."[13] In Riordan's estimation, the Navajos were "a race capable of great intellectual development, and of having qualities of mind and body that, if rightly dictated, would in time make of them a frugal, industrious, and intelligent people."[14] Although Riordan did not yet use the word *borrowing,* his article provided a sense that Navajos had become Navahos and that, as a singular racialized group, they were capable of change.

In the 1890s, the debate about the fundamental character of the Navajo race did not always fully articulate or incorporate the idea that Navajos were cultural borrowers. Yet by the late 1920s and early 1930s, the idea of cultural borrowing saturated popular and scholarly representations alike. For instance, in a 1929 informational article on Navajo rugs in *House Beautiful,* Hazel Cumin suggested that the weavers had learned their craft from the Pueblos, whom she called "an unaggressive and industrious people upon whom [Navajos] proceeded to wage [a] ceaseless pilfering warfare, appropriating as they went along whatever Pueblo customs, manners, property, art, religion, or anything else they deemed worth having."[15] For Cumin, Navajo appropriation was not just the result of warfare but its goal.

Scholars, institutional authorities, and those with whom they worked also commonly put forth the idea of Navajo borrowing in the early first three decades of the twentieth century. Under Culin's direction, the Brooklyn Museum introduced visitors to the borrower label twenty-five years before Miller set up shop in the museum's courtyard.[16] According to Culin, Navajos had "been influenced by the Pueblos, from whom they have borrowed many of their arts and ceremonies."[17] According to Jean Reed's 1932 *Brooklyn Museum Quarterly* article, Navajos had also "borrowed" weaving techniques, sheep, and silver from the Spanish upon their arrival in the Southwest. Such representations had the effect of diminishing the distinctiveness of Navajo achievements, making them seem essentially derivative. They derided the Pueblo as well, portraying them as weak and hopelessly bound together with the borrowing Navahos.[18]

The edition of *BMQ* that accompanied the Miller exposition explained that cultural and material borrowing among the Navahos was not just behavioral; it was one of their core characteristics. Navahos had "always been a borrowing people, often excelling their teachers at their own work."[19] Culin's successor, Herbert Spinden, articulated similar sentiments in an article on the Exposition of Indian Tribal Arts in 1931, claiming, "The Navajos wove no cloth until after they had acquired Spanish sheep. A generation later they were producing splendid fabrics."[20] By the 1930s, mid-nineteenth-century notions of Navaho "savagery" had by and large disappeared, and new depictions of the Navahos as a primitive and borrowing race had taken their place. The rise of the narrative of borrowing had helped form the American public's image of the Navahos; more importantly, it was deeply connected to the development of the profession of anthropology.

The emergence and development of the borrower theory corresponded with two key historical moments that were of great importance to American Indians, professional anthropologists, and the general public. First, a turn in anthropological theory influenced Culin and his peers. By 1900, the influence of Lewis Henry Morgan's evolutionary scheme that plotted a straight line from savagery to barbarism to civilization was diminishing while the theories of diffusion and cultural relativism advocated by Franz Boas were on the rise. Culin, who began his career working as a merchant and who had no formal training as an anthropologist, felt free to bridge these strains of thought in his professional life by perpetuating the idea that the contemporary circumstances, and future state of Navahos, were

directly affected by their behavior as cultural borrowers. Next, although Americans had heard otherwise for decades, census records showed that Navajos were not likely to "vanish." Between 1860 and 1940, the Navajo population rose from approximately 10,000 to 40,000.[21] By casting Navajos as accomplished cultural borrowers, Culin could tell museum visitors that the Navaho Indians might yet disappear. His presentation suggested that the Navahos would have the capacity to assimilate easily as the century wore on.

Anthropological Theories and the Borrower Theory

In the early 1900s, ethnologists and anthropologists began to reexamine the characteristics of indigenous peoples in light of new debates about race, social evolutionism, and cultural relativism. In the 1870s, anthropologist Lewis Henry Morgan had developed a way to understand Native American life and culture by postulating three sequential stages of social evolution: savagery, barbarism, and civilization. Called the "backbone of late nineteenth-century anthropology," this theory provided a way for museums and universities to classify cultures by their degree of so-called civilization. Such classifications enabled curators to group like artifacts from distant locations in their displays. The theory was also popular because it promoted the belief that white "civilization" would naturally triumph. According to such logic, the conquest of American Indians was the inevitable outcome of colonial endeavors.[22]

Morgan's theory of social evolution also drove federal Indian policy, including the Dawes Act of 1887. According to Morgan, American Indians were trapped in the stage of "barbarism" and needed assistance if they were to evolve beyond it. Morgan's ethnocentric evolutionary ladder created a scientific rationale for politicians to blame American Indians for their inability to assimilate. Unless American Indians could be persuaded to give up their traditional ways and assimilate once and for all, they would be doomed to extinction because of their supposed biological inferiority.[23] Morgan's colleague Alice Fletcher even suggested that Indians could not transcend their so-called barbarism if they were continually bound by the reservation system. Fletcher strongly believed that as long as indigenous peoples were tied to their traditional territories, they

would cling to tribalism. She contended that destruction of the cultural connection between indigenous peoples and their land was necessary if American Indians were ever to emulate the model of "civilized" whites and become independent land-owning farmers.[24] Thus, assimilation was Congress's goal in passing the Dawes Act of 1887, which instituted a policy of allotment that significantly reduced the amount of land held by tribes under the reservation system and further eroded the financial security of a number of tribes.

Morgan's theory dominated anthropological thinking and governmental policy until Franz Boas revised it in the 1890s. By 1904, in an article outlining the history of the discipline, Boas described anthropology as "partly" a branch of biology and "partly a branch of the mental sciences." People interested in biological questions had been influenced by "the great zoologists of the eighteenth century," who focused on the "general systematic tendencies of the times." As a result, scholars like Morgan had been interested in "a classification of the races of man" as well as the "discovery of valid characteristics by means of which the races could be described as varieties of one species or as distinct species."[25] Meanwhile, Boas had developed an interest in the "mental" phenomena and studied "language, invention, art, religion, social organization and law" as a result.[26]

Boas's scholarship rested on the fundamental idea that grouping people according to predetermined schematics hindered real understanding of distinct populations. Instead, he advocated "actual investigation into the individual history" to learn more about human history and psychology. His theory of cultural relativism grew out of his belief that the study of "even the poorest tribe can throw light upon the history of mankind."[27] In addition, he asserted that cultural development is marked by variance and diversity. Because cultures exchange material and ideas when they come into contact, one cannot prove the workability of a single, progressive evolutionary scheme that values one culture over another. Boas's idea became known as diffusion.[28] Boas noted that contemporary ethnologists had begun to incorporate such ideas into their work and had started to study "the distribution and history of customs and beliefs with care so as to ascertain whether they are spontaneous creations or whether they are borrowed or adapted."[29] Boas's ideas and professional influence grew over time. His students included Elsie Clews Parsons, Ruth Benedict, and Margaret Mead. Gladys Reichard, one of Boas's students at Columbia University in the 1920s, was committed to Boasian "salvage

ethnography" and structured her work on Navajo language, weaving, and religion accordingly.[30]

Boas extended his ideas of cultural relativism beyond the classroom. He thought that museum displays and curators should reflect changing professional ideas, and he pushed for individual displays that featured specific tribal peoples. Such displays were a significant departure from exhibits that grouped objects or peoples in sequences that supposedly represented cultural evolution and racial hierarchy. In the same way that he encouraged an early form of "field work" among his students, he also advocated the use of "life group" displays that featured life-sized replicas of indigenous peoples posed as "a family of several members of a tribe, dressed in their native costume and engaged in some characteristic work or art illustrative of their life."[31] Culin's displays reflected Boasian thought in this respect.

Even as Culin molded exhibits after Boasian thought, he, like the public, was intrigued by the question of whether American Indians were disappearing. Before the twentieth century, museums and fairs presented American Indians as a vanishing race who stood in contrast to the growing ranks of industrialized Americans. Frederick Ward Putnam, director of Harvard's Peabody Museum, said that the 1893 World's Columbian Exposition displayed American Indians as object lessons—to give modern Americans a glimpse of a fleeting past—because "these people, as great nations, have about vanished into history, and now is the last opportunity for the world to see them and to realize what their condition, their life, their customs, their arts were four centuries ago."[32] In contrast to Putnam's assessment, the view that not all American Indian populations were going to fade into history, and that white Americans might have something to learn from diverse cultures, was beginning to circulate within the profession. By 1900, museums and curators were likely to present either viewpoint to the public. According to scholar David Jenkins, by the turn of the century, museums were collecting and displaying different cultures "either as living representatives of vanishing races or as lifelike mannequins intended to demonstrate cultural diversity."[33]

Taking yet another approach, Culin tied together the seemingly competing strands of social evolutionary thought, cultural relativism, and the trope of the "vanishing race" with the idea of presenting a complex tapestry of cultural and anthropological thought to museum patrons. Weaving this idiosyncratic ethnographic pattern was possible because of

his personal background and the important role of curators at the time. Curators' personal interpretations and inclinations not only determined the kinds of material culture that museums collected but obviously also influenced their display.[34] As he used a combination of professional approaches to delineate the place of American Indians within American society, Culin's version of the Navahos and their borrowing, with its particular racializing bent, slowly evolved along with his displays of southwestern Indians.

Stewart Culin: Background and Influences

Stewart Culin's career as curator of ethnology at the Brooklyn Museum spanned more than a quarter century, from 1903 to 1929, and left an indelible imprint on the institution's collection of American Indian material culture.[35] As the first curator of ethnology, Culin was almost wholly responsible for determining the museum's ethnographic mission, developing its reputation in the field of ethnography, and fabricating its displays of cultural artifacts.[36] Culin joined the Brooklyn Museum in 1903 as curator and head of the newly founded Department of Ethnology, at which point he immediately began to build on the organization's existing collection.

Culin's background helped him develop the skills that later informed his museum work. One of seven children, Stewart Culin was born on July 13, 1858, in Philadelphia, where his father worked as a merchant. He was educated at Nazareth Hall, in Nazareth, Pennsylvania. As a young man, Culin joined his father's mercantile company, in which he honed his bargaining skills and began to build a sense of the types of products that appealed to consumers. In the 1880s, he developed an amateur interest in ethnology, exploring the games and culture of Philadelphia's Chinese immigrant population, and he eventually became an expert on Chinese games. By 1890, he had served as the secretary of the University of Pennsylvania's Archaeological Association, though no evidence exists that he ever formally attended university. He left the mercantile world in 1892 to work at the University of Pennsylvania's museum, where he assisted in the display of the Haggard Collection, a major collection of southwestern Indian artifacts. While working with the Haggard Collection, Culin was mentored by a unique group of individuals who reflected his diverse

interests. For instance, he was befriended by John Wanamaker, the famed department-store owner known for his stores' striking displays and his interest in Native American culture. Wanamaker also helped fund Culin's endeavors at the university museum. Anthropologist Daniel Brinton, an adherent of Morgan's evolutionary thesis, also mentored Culin.[37] Although Culin was self-taught, he took charge of the university museum's exhibit of American archaeology and ethnology at the 1893 World's Columbian Exposition in Chicago. Culin's displays consisted of games from around the world and objects illustrating the history of religions.[38] Thereafter, Culin's work merged his growing knowledge of professional social science with his experience in crafting and satisfying consumer taste.

Culin also sought to promote the confluence of "industrial" and "primitive" design influences. He viewed the art of "primitive" cultures as rejuvenating and sensuous. He hoped that modern industrial designers would not shy away from putting "the primitive" into the products they constructed. As a result, he opened a design study room in the museum in 1918 and "filled it with thousands of the primitive and peasant artifacts he had gathered on trips." Culin envisioned the study room as a "laboratory of taste." Clothing manufacturers and designers consulted Culin's collection of materials. According to historian William Leach, the creation of this room demonstrates the type of "consumer populism" that Culin sought to nurture through his displays of "primitive" goods and is consistent with his desire to appeal to broad sections of society.[39]

Long before Culin opened the design study room, he had developed an interest in the Southwest. As a result, he was one of a select group of ethnographers who introduced large audiences to Navajo and Zuni material while interpreting those populations' cultures for the public. Cementing Culin's interest in the Southwest was a chance meeting at the 1893 exposition with the controversial Frank Hamilton Cushing, who had spent considerable time living among the Zunis in the 1880s. The two men became friends and even planned to coauthor a publication, *Games of the North American Indian,* though Culin had to complete and publish the work on his own after Cushing's untimely death in 1900.[40] Cushing's influence on Culin was obvious. Culin hired Thomas Eakins to paint a life-sized portrait of his friend and used Cushing's likeness at the museum as a backdrop for a display of material from the Southwest from 1905 until well into the 1910s.[41] During the 1890s, Culin also met and befriended distinguished anthropologists George Dorsey and Franz

Boas himself. These prominent contacts facilitated Culin's success in the profession and stimulated his interest in the American Indians of the Southwest.

Even before Culin's arrival, the Brooklyn Museum had begun building a permanent ethnological collection. When the museum opened in 1897, it announced a grand plan to become a first-class institution devoted to art and science. It hired Culin as the curator of ethnography six years later. His initial task was to assemble the first major ethnological collection of American Indian artifacts to surpass that of the Brooklyn Museum's primary rival: the American Museum of Natural History. When Culin assumed his post, he rallied the board of trustees of the Brooklyn Institute of Arts and Sciences, the body that oversaw the Brooklyn Museum, to support collecting endeavors in the Southwest, which was becoming an increasingly popular tourist destination. That popularity, he explained, would help fund the museum's important contributions to the field of ethnology. The southwestern tribes also met three practical criteria. They were "nearest at hand," "of the greatest scientific importance," and "of general interest" to the public.[42] Franklin Hooper, director of the Brooklyn Institute of Arts and Sciences, needed little convincing, for the institution, along with hundreds of thousands of Americans, had already developed an interest in the Southwest. Stewart Culin, along with many contemporary collectors, drew on the public's desire to learn about southwestern Indians as living examples of the human past to justify the widespread accumulation of Indian material from the region.

At first, the Brooklyn Museum's collecting policy focused on sheer quantity. Before Culin's arrival, the ethnological and archaeological divisions had acquired a substantial collection of ancient pottery from the Southwest.[43] Upon his arrival, Culin moved these and similar items from the Department of Natural History to the newly founded Department of Ethnology. To make the Brooklyn Museum a top-flight ethnological institution, Culin sought to build on its existing collection of southwestern Indian material culture. From March to September of 1903, Culin traveled extensively in the Southwest and had great success in obtaining Navajo and Zuni artifacts. During this foray, he reportedly collected 1,560 "specimens" for the museum's permanent collection. Over time, and through successive trips to acquire new materials, Culin developed a more scientific approach to acquisition and crafted his methods for scientifically presenting information to the public about southwestern tribes. In the

resulting exhibits, he increasingly focused on the characteristics that he believed were the defining features of various American Indian groups.

By most accounts, Culin was successful and earned praise from the public and his contemporaries for his displays. By 1913, George Dorsey considered Culin an ethnologist of the highest stature. Dorsey wrote that whereas ethnologists at "Regular Museums" were "happiest in museums, . . . using themselves as center posts" and gathering about them "big cases filled with small objects badly arranged," Culin was a well-informed consumer who went off into the field with only "car fare, . . . a set of ideas and a smile." According to Dorsey, Culin returned with the same grin and ideas, but he also carted ethnological booty that he transformed into "sweet, attractive exhibition halls where one may breathe the very air of Arizona, or California, or Alaska or Japan" or any of the places that had reportedly willingly given up its treasures to Culin, the "museum magician."[44]

Collection Strategies and Emerging Philosophies

In his effort to build his ethnographic collection in a relatively short time, Culin adopted three interwoven collecting strategies. First, to compete with rival collectors, ethnologists, and institutions and to assemble a unique and scientifically valuable exhibit, Culin purchased "Indian collections" from whites—usually traders—who had settled in the Southwest. Second, he relied on his ideas about the vanishing-race theory and the discipline of ethnology in making his collection choices. Third, he viewed items with an eye to their suitability for public display at the museum. The nascent strains of Culin's ethnographic philosophies on "borrowing" and "innovation" were evident in these strategies. Culin believed that purchasing collections of artifacts from regionally based non-Indians was the best way to acquire complete collections of interconnected items with a clear provenance.

Reflecting his belief that American Indians were "vanishing," Culin thought that non-Indian traders were often closest to the tribes in question, especially those indigenous peoples whose cultural traditions appeared to be faltering in the modern world. This reasoning helped Culin find unique items off the beaten path—items that fit into, and helped him

develop, his interpretations of Zuni and Navajo cultures. In August 1903, for instance, Culin met Andrew Vanderwagen, a former Christian missionary turned Indian trader, who had amassed a large collection of Zuni artifacts. Culin wrote to director Franklin Hooper that based on "what is occurring on other reservations and in other towns, the sale of this material marks the breaking up of old Zuni, and the dissolution—from one point of view—of the most interesting villages in the Southwest."[45] Culin reported that conditions at Zuni were especially bad. Although he described the Zuni people he met as "agreeable" and "hospitable, kind and affectionate to their children," he also reported that they lived in a state of self-aware "degradation," with disease and poverty menacing the population. "The process of disintegration, now started, will progress rapidly, and old Zuñi as it exists today, will soon disappear."[46] Culin believed that the purchase of the Vanderwagen collection would raise the Brooklyn Museum's reputation within the professional community, so he nabbed the collection before the museum's cross-town rival in New York City had the chance. His successful work with trading-post owners such as Vanderwagen enabled him to compete with other institutions for indigenous materials that he believed would not survive much longer.[47]

Like Putnam and other ethnologists, Culin clearly viewed the Zuni Indians as "vanishing" peoples—a tribe that would eventually cease to exist. Like others within his profession, he sought to acquire as many artifacts as he could before the traditional customs, games, and crafts disappeared—a process of disappearance to which, ironically, collectors contributed. Culin's expedition journals reveal that the Brooklyn Museum was not immune from the sentiments that fueled Euro-American mining of indigenous cultures. In October 1903, at the end of his first expedition to the Southwest, Hooper urged the new curator of ethnology to plan another expedition the following year, for it "would appear that Arizona and New Mexico will be exhausted of good material within a few years, and. . . unless your work is continued the coming year, your opportunities to secure valuable collections will be greatly decreased."[48] Hooper supported Culin's collection strategies not only because the Zuni were disappearing but because he also foresaw that the rare southwestern Indian artifacts Culin brought in could easily be transformed into visual commodities—products people could consume with their eyes if not with their wallets—while also earning the museum modest revenues through admission fees and enhancing the institution's reputation.

In Culin's mind, however, the idea of the vanishing race was not a fixed concept. Some populations would cease to exist; others would survive but shed aspects of their culture in successive waves of expansion and assimilation. Culin believed that at least one indigenous group, Navajos, would endure indefinitely. He reported that they were one of the most numerous American Indian tribes in the nation, with over 28,500 members living in Arizona, Utah, and New Mexico.[49] Yet he also recognized that Navajos' use of their "traditional" goods was changing. Thus, he modified the vanishing-race theory to fit his field observations and the museum's need. He posited that the "old" Navajo artifacts and customs were indeed disappearing in the face of such changes and would be popular public draws.

Culin personally witnessed the ways in which material borrowing contributed to cultural borrowing, noting that the "Navajo blanket, which was formerly exclusively worn" had become "discarded as an article of dress." In place of their own manufactures, Culin asserted, "the [Navajo] Indians buy Pendleton blankets at the traders [sic]." In addition, he noted that Navajo "men ride Mexican or California saddles" and that only the women, the weavers who made the popular Navajo blankets, could still be "seen with old Navajo saddles with a high peak, but without the horn."[50] While traveling in the Southwest and visiting with trader Lorenzo Hubbell, he had witnessed Navajos incorporating American manufactured goods and white people's styles into their daily lives. Whereas the Puebloan people were "dying out," Culin believed that Navajos' consumerism mirrored their propensity for cultural borrowing and assimilation. Culin saw this practice as their attempt to survive in the modern world. Still, this kind of borrowing pushed "traditional" customs toward dissolution and ultimately influenced Culin's slowly developing ideas about the future course of the Navajo Indians.

In contrast, Culin viewed Zuni culture as unaltered by contact with outsiders. He had made his initial visit to Zuni country in 1902, tracing the footsteps of Frank Hamilton Cushing. At the time, he reported that only 1,540 Zunis were living in the Southwest and that he expected "to find the people much modified and changed by contact with whites, but in this I was mistaken."[51] Despite the fact that the Zunis lived "on a well traveled road, with numerous visitors, both traders and sightseers," Culin reported that the tribe "remains essentially the same as it was in the preceding two centuries."[52] These observations did not seem to influence his

opinion that the Zuni would not survive. By collecting Navajo material culture for distant exhibit cases and noting that Navajos had been influenced by a diversity of cultures while Zunis had not, Culin drew upon parts of Boas's diffusionist theory in holding that Navajo borrowing was linked to the tribe's cultural and racial evolution. Yet Culin also relied on older classification schemes and influences.

Like many others who contributed to the representation of the Navahos as a singular population, Culin relied on traders to provide context and meaning for the goods he collected. He took a different path from that of contemporaries like Franz Boas and Edward Sapir, who learned indigenous languages and collected the stories that indigenous peoples associated with objects. Like many contemporary American consumers, Culin collected the goods traders sold him and gathered the stories they shared with him for the purpose of display. The tales were dramatic and emphasized the antiquity of the people. For instance, Culin acquired his first major group of Navajo artifacts from trader Charles Day, who called himself the "custodian of Cañon de Chelly and del Muerto" on the Navajo Indian reservation.[53] During his first collecting tour for the museum, Culin purchased an impressive collection of Navajo "cliff dweller" material from Day. This collection primarily consisted of the remains of a large Navajo party supposedly massacred by Mexicans around 1800.[54] Culin reported that the traders had gathered the Navajos' artifacts, bones, and household objects from Cañon del Muerto, in the majestic Cañon de Chelly—a site of great importance to the Navajos. Culin explained his acquisition of "bleached out bones" and domestic items by placing the tragedy within Day's understanding of historical relations between Navajos and Mexicans.

According to Day's account, the story of the Cañon was both historically important and exciting. He reportedly told Culin that in "the early days of the Southwest, the Mexicans and the Navajos were constantly making raids on each other, to secure slaves and to steal stock." If Navajos raided a Mexican encampment, "Mexicans would retaliate." The cycle of raiding, according to Culin's retelling of Day's tale, led Navajos to seek a way of protecting the women and children when the men were absent. As a result, they established "a partially fortified cave on the side of the wall."[55] At some point during one of the retaliatory battles, Navajo women, children, and old men attempted to hide in the cave. As Culin heard the tale, "The Mexicans passed below and would not have noticed the

Navajo, but a hysterical woman, who could not control herself, screamed and attracted their attention." In another version of the story, an "old man, fancying his party secure, whooped and taunted the Mexicans." The Mexicans responded by launching a ground offensive and then climbing the wall to club the women and children to death. Supposedly, "one old man, whose body was covered," was "taken for dead and escaped to tell the story."[56] Day claimed Navajos had told him this story of the Cañon del Muerto. Culin then reproduced it in his expedition report, making it available for public consultation. More recent sources date the massacre to 1805, when the Spanish militia, led by Lieutenant Narbona, attempted to subdue the Navajos. Narbona found a group of Navajo women and children in their hiding place and killed them in a brutal and deadly assault. Today, the cave is known as Massacre Cave. According to author Campbell Grant, the "Navajo have touched nothing since the massacre, but curious whites have removed all the skulls and perishable material."[57] Although Culin was once removed from the pilfering of these goods, he is nonetheless one of those who acquired the remnants of the cave.

Culin was particularly pleased with the Day collection and the narrative of how the remains came to be in the cliff. He reported to museum personnel that, as of 1903, there was "no recording in New Mexico, nor has any account of the tragedy appeared in print." Not only did the century-old bones, weapons, and clothing illustrate that Navajos were "ancient," the items also made clear that Navajos had an intriguing and violent past. By comparing the Day material with more contemporary visions of the nomadic, borrowing Navajos in lectures or exhibit cases, Culin could convey to New Yorkers how much Navajos had changed in the time since the massacre. And Culin's narrative did illustrate the history of the Navajo Indians as well as differentiate them from the peaceful, agricultural, and unchanging Zunis.[58]

The lore also served Culin's professional goals of entertaining and educating the public. The story of the Massacre Cave enhanced the "primitive" and haunting character of the Navaho exhibits at the Brooklyn Museum. In general, the story of the Cañon del Muerto massacre fit neatly with Culin's professional protocol and his eagerness to dramatize the history of the Southwest. As in other instances, Culin kept extensive notes on his experiences, using them in public lectures and signs on museum display cases.[59] Why did he think the bones and household items from the canyon

would draw the attention of the public? Perhaps he thought the items had graphic appeal: they horrified but also intrigued the public. According to Culin, when displayed alongside other "cliff dweller" material, "pottery, stone, bone, textiles" provided a "source of information concerning the Indian before a time of white contact" and "an insight into the everyday life of the people."[60] The previously warlike Navajos had fought with their enemies and could therefore be differentiated from the Puebloan peoples, but they also, at that point, shared a history with them; both populations had attempted to survive in the face of successive waves of Spanish, Mexican, and American colonization. As with Nicholson's consumers, Culin's belief in the disappearance of the Southwest's indigenous peoples fueled his desire for "rare" Navajo and Zuni items, deeming such items to be the most valuable from an ethnographic standpoint. And, like Nicholson, in acquiring these items, he stripped important cultural artifacts from reservations, ironically ensuring their value as "rare" artifacts. In other cases, he collected artifacts and stories from traders for practicable reasons; such exchanges were relatively easy because he and the traders shared a language, English, and a culture of commercial transactions. Culin needed to create dramatic displays for public consumption, and he was generally successful in obtaining such materials because he used his professional status and the museum's deep pockets to endear himself to his primary suppliers, traders like Vanderwagen and Day, who conducted a steady business with Navajos and Zunis—or took the time to "excavate" ancient archaeological sites like the Massacre Cave.

Culin's purchases also reflected the multidimensional process of racialization. Culin bought goods and made his own observations, but he also consumed the meanings that traders attributed to items. Culin wove these strands together to manufacture his own interpretation of Navaho behavior, characteristics, and identity. The Navahos might survive in sheer numbers, but they would lose their culture in the process. Culin could impart the meanings of "racial" objects—those that most clearly represented "traditional" Navaho culture—to the museum's visitors and to lecture audiences, who would consume Navaho identity and reify their own social position in the process. Yet the ethnologist did not rely solely on other anthropologists or traders to formulate his theories. He also crafted his vision of the Navaho race from the encounters he had with individual Navajos.

Dealings with Indigenous Peoples

Despite the limited amount of time Culin had in the Southwest, he tried to deal directly with indigenous people when possible. Such exchanges, in addition to being difficult and draining for all parties, also led the ethnologist to develop particular ideas about the general character of borrowing, especially the role of Navajo medicine men in Navajo culture. Culin was often suspicious of his Navajo trading partners. As a result, he tried to circumvent the will of the potential seller or asked white traders to act as intermediaries when negotiations became difficult. More than anything, however, these interactions influenced Culin's displays.

Culin focused attention on Navajo medicine men, sometimes even exploiting their fears to obtain objects from them. At one point, for example, Culin desperately wanted a medicine man's outfit, complete with curing and ceremonial implements, for a museum display. Following the Boasian idea of "life group" displays, Culin even commissioned Father Dumarest, a Franciscan priest at St. Michaels, Arizona, to make a plaster cast of the head and hand of "an old Navajo" for his planned medicine man mannequin.[61] Culin wished to clothe a Navajo figure in the appropriate deerskin costume and display a curing outfit alongside it in the museum's exhibition hall. Samuel Edward Shoemaker, one of Culin's contacts, had a lead on one such outfit, informing him that a "'Singer' named Cha Yadezi Bidy, 'Crooked Hat's Son' . . . had a valuable outfit which he had offered . . . for sale at a very modest price."[62] Culin sought out this man and "after the customary smoke," he began to barter with the singer. His notes reveal that Bidy was a reluctant seller. According to Culin, Bidy initially claimed that "he was not a medicine man and had no such outfit." After some pushing by Culin, the man admitted that "he had some things," but "he declared he did not want to sell them" nor would he show them to the curator. To persuade Cha Yadezi Bidy to show him the items, Culin told him that he was "from Washington," whereupon the singer expressed fear that the ethnologist had been "sent by the Government to take away his medicine."[63] Culin did nothing to ease these fears. In fact, to bolster his authority on the reservation and increase the odds of obtaining the items, he allowed Bidy to believe that he was a government representative.

Culin's next encounter with Bidy, at which he was accompanied by a local headman named Sandoval, revealed much about Culin's skill as an ethnographer, demonstrated his collection tactics, and exposed occasional failures in bargaining. Bidy worried that should he sell the outfit,

he would cease to be a medicine man. Such worries were not without precedent. Anthropologist Charlotte Frisbie reports occasions on which misfortune, decrease in social status, or worse attended a medicine man's loss of medicine bundles, or *jish*.[64] Culin pressured Bidy to consult with "Sandoval, who was the head of the particular society of medicine men to which he belonged."[65] In the process of negotiating for the outfit, Culin was able to garner extensive and valuable information about Bidy's items. Over the course of the negotiations, Sandoval "went into a long explanation of the character and value of the collection." Of particular worth were two cranes' heads—one female, the other male—with their plumage fully intact. Equally important, the two birds had not been shot but rather "caught without injuring them by means of a lasso." Sandoval also described at length how the deerskin leggings and tunic had been acquired and made.[66] Sandoval and Culin tried to reach an agreeable price for the entire package. Culin balked at the price Sandoval proposed, about "800 head of sheep or the equivalent of $1600.00," and Culin countered with an offer of $60.[67] Not surprisingly, negotiations with Sandoval broke down—which may have been his intention all along.[68] Still, Culin demonstrated his ethnographic acumen; he obtained valuable cultural information even if he lost the sale.

Culin walked away from the encounter with more than ethnographic information. He had formed an opinion of Navajo medicine men. Culin believed, for instance, that the sale fell through in part because of Sandoval's interference and devious character, which Culin linked to his role as a medicine man. Culin's notes about the meeting describe Sandoval as "a man of lighter complexion . . . than most Navajo."[69] This mention of skin tone was relatively unusual for Culin. In these observations, written well after the singer had blocked the sale, Culin claimed that despite Sandoval's seemingly "tawny yellow" skin color, his general "countenance" reflected a supposedly "cunning and untrustworthy character."[70] In this case, Culin used racial features to suggest Sandoval's character. Culin found it curious and maddening that although Sandoval may have looked more "white" than "red," he still prized traditional cultural artifacts for their inherent value to the larger Navajo community over Culin's desire to use them in a display featuring the Navaho. Culin viewed Sandoval as a skilled negotiator who managed to keep the cherished and sacred items out of the hands of an accomplished collector. This interaction with Sandoval, along with prior and subsequent encounters with Navajo

medicine men, colored Culin's perception of the singers and influenced his assessment of the tribe as a whole, contributing to his slowly developing borrower theory.

Undeterred by his failure to obtain Bidy's medicine-man outfit, the ardent Culin turned, as was his habit, to non-Indian collaborators for assistance. This time, he used the controversial pawn system to his advantage. He explained to the museum directors that the poverty of Navajo Indians had led them to pawn cultural wealth in the form of silver jewelry, beads, guns, saddles, buckskin, blankets, and medicine bundles. The traders supposedly made "liberal advances" against such items. According to Culin, Navajos "recently had agreed among themselves not to buy each others [sic] pawned stuff."[71] Culin ignored their collective decision; their misfortune became his good fortune. "In consequence," he reported to the museum director, "I was able, as an outsider, to make many excellent purchases on unredeemed pledges." One trader, Joe Wilkin, told Culin he had "a medicine bag containing two cranes' heads," which Culin endeavored to buy.[72] Others helped Culin obtain a Navajo tunic with buckskin fringe.[73] Eventually, Culin ordered the manufacture of items he could not purchase from either medicine men or traders for a display featuring a model of a Navajo medicine man. The practice of relying on traders either to provide material culture or to intervene when negotiations with Navajos failed illustrates that Culin implicitly placed his trust in non-Indians as authorities.

Like Grace Nicholson, Culin preferred to purchase goods from traders rather than spend an extended amount of time living with, getting to know, and bargaining with members of specific American Indian nations. Instead, he relied on Vanderwagen, Day, Shoemaker, Wilkin, Hubbell, and others. When it was opportune, he did turn to informants who were willing to sell him old goods. Yet Culin was particular about his purchases, and when he could not find specific items for sale, he had copies made. For instance, he commissioned a Navajo silversmith named Little Singer to reproduce copies of old costumes, games, and fetishes that proved difficult to find on the reservation.[74] This reproduction of material was a somewhat controversial practice among ethnologists, who debated whether facsimiles lacked cultural authenticity. In museum exhibitions, however, Culin was more interested in creating composite cultures than in presenting strictly authentic ones. As in department stores, ethnographic art shops, and tourist venues, the need for a dramatic display

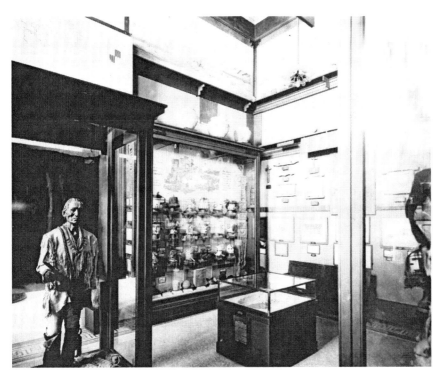

"Southwestern Indian Hall." The Southwestern Hall featured a mannequin dressed as a Navaho medicine man or singer. This kind of display enhanced the museum's reputation as an ethnographic institution, but by creating a stagnant portrait of Navaho medicine men, Stewart Culin conveyed a message about their role in Navaho culture. They were part of the past, not the future. Brooklyn Museum, 1910. Used by permission of the Brooklyn Museum Archives, Photograph Collection.

that evoked a particular population was more important than a drive for authenticity. Culin's reproduction of artifacts is one of the most significant examples of the influence of his background in retail sales in his acquisition strategies.

Clearly, Culin envisioned displays before he returned to the museum and did not overly worry about the integrity of reproduced items. As a museum curator with no students studying for advanced degrees, he focused primarily on public education. Culin was dedicated to gathering the largest collection of artifacts representative of the Navaho ever assembled in a museum. In his pursuit of this goal, as the Sandoval/Bidy encounter reveals, he formulated his ideas about the cultural personality

of the Navaho. He let Navaho items "speak" to the public, but his was the voice behind the curtain.

Direct or indirect contact with Navajo medicine men was part of the process of assembling an expansive collection of Navajo material. Whenever Culin came across old or ceremonial Navajo goods, he was eager to buy them. In one instance at Charles Day's trading post, Culin noticed three Navajo medicine bags: "Two of these bags had been placed in pawn and not redeemed." The other "had belonged to a singer Tseyine Yazhe, from whom it had passed at his death to his brother, who not knowing the songs, had pledged it with Mr. Day."[75] Before belonging to Tseyine Yazhe, "it had been the property of Qastquin Tse bak'a'e, 'He on the Rock.'" The provenance gave the medicine bag immediate value in Culin's estimation, especially because Day believed that "it had been made long before the Navajo went to Bosque [Redondo] in 186[4]" and that the Navajos had taken the medicine bag with them during their forced internment. This item was a remarkable discovery for Culin, who knew that "such objects were not ordinarily sold" but passed down from one generation of singers to the next.[76]

The fact that the bag had passed into Day's hands only reinforced Culin's belief that as long as medicine men did not interfere with the unfolding of history, the disappearance of certain legacies was only natural. Moreover, he believed that Navajos' reliance on the singers and chanters actually hindered their adaptation to and survival in modern American society, a process he articulated in the borrower theory. On a trip in 1902, he had been impressed with certain aspects of the "Navajo character," which included the ability to borrow and, eventually, to assimilate. He reported that Navajos worked hard, used the knowledge and techniques of their neighbors to their benefit, and had developed sophisticated weaving and silversmithing traditions as a result. Successive cultural improvements would occur, Culin claimed, provided the Indians had the opportunities "to do real work on the railroads, ditches, and in agriculture, to become valuable members of the community."[77] Accordingly, he reported that the Navajos he encountered were eager to work "to improve themselves" and that when given the opportunity for employment alongside whites, they rapidly acquired "a knowledge of the English language and of American customs."[78] Culin's comments signaled his desire to see Navajo Indians drawn into American culture by their mimicking of white culture, especially by adopting white Americans' work patterns

and language skills, and this perspective influenced his representation of Navajos as the Navaho.

The main problem Culin had with Navajo medicine men was that they actively discouraged certain forms of borrowing and rejected assimilation into white American culture as a cultural goal. Indeed, the "domination of medicine men" kept Navajos from fully absorbing the trappings of white culture, according to Culin. He hoped their influence, especially their tendency to discourage their patients from seeking "medical advice more than anything else from whites," would cease over time.[79] "Any change in [Navajo] belief," stated Culin, "must be preceded by a change in their habits of living which may be accomplished when they have an opportunity to work like white people."[80]

In Culin's pragmatic approach to Navaho primitivism, assimilation would have the added benefit of civilizing a corrupt and untrustworthy people. "In spite of their many fine qualities, for they are a strong and virile people, the Navajo is immoral, even from an Indian standpoint. . . . Almost without exception they are liars and thieves . . . As to their sexual moral[s], chastity is esteemed no virtue, incontinence being regarded as an evidence of strength among men, while female morality rests upon a strict commercial basis."[81] By voicing these concerns, he claimed to echo the widely held sentiment that the grip of the medicine men had to loosen before any changes could occur. "All agree," reported Culin, "that the 'Singers' or medicine men are the curse of these Indians, impoverishing them without benefitting [sic] them in any way."[82]

Ironically, Culin's wish that the singers' influence would die out seemed to reinforce his desire for items associated with them. In 1903, he reported obtaining a "Yeibichai [sic] Outfit" that a Navajo singer named Laughing Doctor had committed to trader J. B. Moore's care to sell to the highest bidder.[83] Culin reported that the seller, like Bidy, was not eager to sell the outfit. "Mr. Moore, to the last moment, was afraid that the Doctor would back out of his bargain." According to Culin, "the Laughing Doctor was one of a family of 'Singers'," and the outfit he acquired had been passed down along the male line, from father to son. Moore collected the ethnological details of the outfit and explained to Culin, "The deer from which the skins were obtained, had all been rundown and strangled without other injury."[84] Laughing Doctor then required Moore, who was acting as Culin's intermediary, to tell him "stories of our civilization," suggesting that Culin and Moore were not the only ones collecting ethnological details of another culture.

In one pointed exchange, Culin noted that the singer used his newly obtained knowledge to make a salient point about assimilation. Laughing Doctor was especially alarmed at how quickly the government expected Navajo children to integrate the ideas and customs they had learned in schools run by the Bureau of Indian Affairs. "The Doctor, after hearing about the Old World, asked how long its history extended." Moore purportedly replied, "Some six or seven thousand years." The Doctor "reflected" and said, "'Well, these things that took you people so long to learn you are trying to teach our poor children in a few months in your schools.'"[85] Laughing Doctor's comments speak to the pace of change. Navajos may well have integrated resources and skills into their culture, but they did so over the long course of history, controlling the features they adopted and the pace at which they incorporated change. Clearly, for Navajos like Laughing Doctor, assimilation, which was often forced upon Navajos and other indigenous peoples through various government programs, represented coercion, and many attempted to resist the pressure for full cultural transformation.[86] In contrast, Culin saw the history of Navajo borrowing as consistent with Morgan's theory of evolution. Through the promotion of the borrower theory and his assertion that the medicine men's influence should cease, Culin advocated and naturalized the idea that the primitive Navaho were prime candidates for assimilation because of their borrowing.

As a scholar, educator, and showman with a mission, Culin had relatively little time in the Southwest. In that short period, he was expected to amass enough material to create the foundation of an unparalleled collection of Navajo and Zuni artifacts for the Southwestern Indian Hall. As a result, he had to marry his skills as a professional ethnologist with those of a competitor, educator, and purveyor of consumer taste. In response, Culin wed his understanding of social evolution and cultural relativism/diffusion to his "geographical or 'ethnic' approach" to ethnology.[87] As he developed this style, each of his displays featured a specific group of American Indians that supposedly represented the historical circumstances, contemporary conditions, and fundamental racial characteristics of the indigenous peoples of the Southwest. In these displays, Culin developed and expressed his theory of the Navaho borrower and sought to convey it to others. In particular, Culin viewed the collection of goods as a way to hasten a "natural" evolutionary process: the removal of traditional items would spawn the adoption of new ones. Thus, "traditional"

items were valuable not only because of their age, their significance, or their function in the past but also because of their ability to foster change among Navajos on the reservation.

Public Displays and Lectures

As Culin collected material, he kept in mind each item's potential use in public displays, for educational purposes, or for entertainment. In his displays in the Southwestern Indian Hall, Culin used a comparative approach, juxtaposing the material culture of Zuni and Navajo Indians and adding smaller displays of other southwestern Indian populations to round out the exhibit.[88] Working from his ethnological field journals, Culin also developed a series of public lectures in which he defined ethnology as "the science of races." This definition embodied his ideas about the Navaho in a time of great change as well as his thoughts about the field of anthropology and the cultural atmosphere in which he worked.[89]

During lectures, Culin seemingly took a page from Morgan's evolutionary scheme, telling audience members that the ethnologists' job was "to collect, classify and compare the information concerning the traits and customs of the different races of man."[90] Then, drawing on a very Boasian idea, he informed his audience that the goal of this work was to throw "light upon the origin and migration of man and upon the principles which underlie the development of human society and civilization."[91] Culin told lecture attendees that he had picked "the Zuni to represent the Pueblo peoples in our Museum" and had "in the same manner selected the Navajos as the principal object of my study among the nomadic tribes."[92] Culin selected Navajo and Zuni material for display for both pragmatic and educational reasons. He opted for the Zuni display because of the availability of the material, Cushing's influence, and his own belief that the population represented an open field of study.[93] Similarly, he decided to devote energy to collecting Navajo artifacts because they had not yet had a showing in a major museum, and artifacts were readily available from traders.

Taking his audience members on an imaginary journey to the Southwest, Culin described the view from the window of an Atchison, Topeka & Santa Fe railway car. Travelers to the Southwest would see "everywhere a vast treeless expanse, covered with sage brush or mesquite, a succession of high mesas or table lands, broken by innumerable valleys and dry watercourses, with everywhere the same tints of ochre and brown."[94] Into

this landscape, Culin thrust his cast of characters: Mexicans, Puebloan peoples, Navajos, Apaches, white traders, and religious missionaries. He described each group in detail but turned most of his attention to indigenous peoples. According to Culin, by studying "primitive man, we discover people whose development has been continuous and uninterrupted through many ages, tribes who have escaped the general commingling and inter-fusion, at once the cause and the result of modern civilization."[95] Culin was obviously referring to the Puebloan people, such as the Hopis and Zunis, whom he also described as peaceful and pure. Meanwhile, he cast Navajos as "the antithesis of the gentle, peace-loving, Pueblos."[96] Because they had not resisted "inter-fusion," Culin saw the potential for them to evolve toward "modern civilization."

Using adjectives like "fierce," "cruel," and "revengeful," Culin also described the Navajos in singular, masculine, racialized terms. A Navajo, stated Culin, was "more of a man, both physically and morally" than a Puebloan Indian.[97] Culin relied on a Morgan-like schematic when he asserted that the Navajo deserved "to be accorded a high place among our native peoples."[98] Still, he drew upon timeworn stereotypes when he warned audience members that "the Navajos are more robust, but their code is that of savagery." By way of explanation, he stated that they observed a "blood feud," demanded "a life for a life," and were known "to kill old women who become burdensome, or defenseless traders who tempt their cupidity."[99] The flip side of such behavior, in Culin's view, was the Navaho's "capacity for hard, unremitting work," which distinguished him from other Indians and would enable him to survive in the future.[100] The Navajos' craft production illustrated this work ethic. Calling the women "industrious weavers," he noted that the "men only need an opportunity for profitable labor." In his presentation of Navaho primitivism, Culin demonstrated that Navajos had the capacity for both savagery and civilization. For them, primitivism was a way station on the road to their destiny.

In his assessment of Indian peoples, Culin came to view the Pueblos, especially the Zunis, as the cultural torchbearers, and rightful heirs, of the mysterious pre-Puebloan or "Anasazi" peoples who had developed many of the advances that made life sustainable in the region and lived lives relatively unchanged by contact with other indigenous people or whites. Paradoxically, following Culin's logic, this "innovation" would ultimately lead them, as it had the "Anasazi," to their demise. They faced an invisible cap on their advancement. Culin did not see the Puebloan

people moving beyond primitivism; they had reached this stage and could not move beyond it. Adhering to Morgan's ideas that linked race and evolution, Puebloan peoples were automatically doomed by their supposed biological inferiority. By comparison, he came to think of the Navahos as a people "anxious to improve themselves" and adopt, as they had many times before, new materials and customs into their daily lives. In essence, they were a people who had the ability, even a predisposition, to assimilate.[101] Hence, Culin naturalized the idea that the Navaho would integrate into the American mainstream by connecting the goal of assimilation to their history of borrowing. The outcome, however, would be the destruction of their traditional culture.

Navaho Borrowers and the Market for Indian-Made Goods

From the Goodwins' party to the halls of the Brooklyn Museum, anthropologists and ethnologists played important roles in the appropriation of the Navaho. In Stewart Culin's hands, the borrower theory justified the collection of sacred artifacts and shaped the ways in which the museum displayed them to the public. It also advocated loosening the hold of medicine men over the minds of Navajos while elevating the archaic culture of the medicine men. The sooner the Navajos stopped venerating the medicine men, the sooner the larger Navajo population would speak English and become honest laborers—in other words, the sooner they would assimilate. The museum-going public could thus both enjoy seeing the authentic vanishing rarities that represented the primitive Navaho and absorb the idea of assimilation, effectively soothing concerns about the disappearance of traditional Navajo artifacts from the reservation. Unlike the Zunis, who would disappear in Culin's racialized scheme, Navahos would absorb new skills and materials that would allow them to survive, and in so doing, they would be expressing their "traditional" predisposition to borrow from other cultures. Assimilation was not only desirable, it was inevitable.

The borrower theory also bolstered beliefs in white superiority, in the guise of anthropological cultural relativism. By drawing on the prominent anthropological theories of the day, Culin formulated his own brand of ethnographic understanding of a people. The ideological construction

of the borrower theory, for instance, used social evolutionary thought to cast the Navahos as metaphorical middlemen, standing halfway between peaceful primitive Puebloan peoples and urban civilized white Americans. This representation of the Navaho effectively established a racial hierarchy that positioned whites at the top, the Navahos somewhere in the middle, and romanticized Puebloan people at the bottom. Culin's unique form of cultural relativism emerged alongside this hierarchy, for those at the top and bottom of this spectrum had cultures that were valued for their own sake—as evidenced by Culin's spatial distribution of artifacts. For instance, the museum's exhibition of Navajo material flanked the Zuni collection.[102] In the end, the borrower label, as Culin developed it in the early 1900s, made the idea of Navajo assimilation seem completely natural—even "traditional"—to the museum-going public.

Yet if we return to the museum's courtyard in 1932 and Wick Miller's exposition, we can see how the borrower thesis presented a dilemma for those who profited from it. Even as Miller paid homage to Culin's vision of the Navahos as borrowers, he sought to revise the concept to maintain his business of selling Navajo rugs and jewelry. In short, he had to convince consumers that the Navahos had not yet assimilated but had maintained their craft traditions.[103] In an effort to reconfigure the concept to fit contemporary market concerns, he and a group of traders began to ask whether borrowing and the maintenance of tradition had to be mutually exclusive. Questions surfaced from other quarters as well. If borrowing was a key feature of Navaho identity, could one see it as a tradition in and of itself? In the end, the economic insecurity arising from the Great Depression pushed these questions outside the academy and into the realm of law. When off-reservation traders began hiring Navajos to use machinery in the production of their jewelry and then sought to sell the jewelry as "Indian-made," a controversy arose about the nature of authenticity and tradition. Was a piece of silver jewelry "Indian-made" if a Navajo used machinery in its production? Did increased use of machinery signal the death of Navajo traditional silversmithing practices or the culmination of Navaho borrowing? Few Navajo voices received a hearing in this debate, but the traders and anthropologists who spoke up reflected whites' marketable vision of the Navaho. The idea that the Navahos were borrowers became central to legal disputes and to the scholarly assessment of Navaho culture. This process not only shaped Navajo engagement with the market but helped set their place in history.

Perhaps no individual recognized the tensions and fissures that emerged in the debate more than the novelist, anthropologist, and Indian-rights activist Oliver La Farge. As the argument unfolded about what constituted authentic "Indian-made" Navajo jewelry, La Farge, as an expert on Navajos, was asked by the Tenth Circuit Court in Denver in the early 1930s to serve as an expert witness in the court's effort to define the term. Rather than use his own definition, however, he told the court how the consumers he knew defined the term. He reported that consumers carried "a certain feeling toward [the Navajo Indian] which I judge to be a romantic feeling" rooted in their perceptions of Indian labor and traditions. When a consumer held a piece of jewelry, La Farge contended, she wanted to know that the bracelet in her hands was "a product of that [Indian way of] life." Though he acknowledged that silversmithing dated only from the 1870s and that Navajo artisans had used "modern" tools like mechanized buffers and blowtorches from the beginning, La Farge insisted that consumers believed machines played no role in the production of "Indian-made" goods. To white consumers, Navahos—as portrayed by the tourist industry, traders, dealers, and even museums—were a people yet to be touched by modernity, even as they edged toward total assimilation. If they had "borrowed" new technologies to produce their jewelry, they were undermining the authenticity of the items they made. If whites and Navajos used the same technologies in the construction of jewelry, what separated the two groups? And, more importantly, how would commercial interests be able to preserve consumer demand for authentic Navajo-made goods in light of such adaptations?[104]

Codifying the Navaho:
The "Indian-Made" Controversy

In 1930, at the end of his junior year at the Albuquerque Indian school, a Navajo student named Haske Burnside answered a help-wanted ad for experienced silversmiths in the *Albuquerque Morning Journal*. After an initial interview, Burnside was offered a job at Maisel's Indian Trading Post in downtown Albuquerque. He was scheduled to work sixty hours a week and to receive a weekly salary of $6 for hand hammering jewelry—a wage of 10 cents per hour. However, when Maurice Maisel, owner of the store, discovered that Burnside had studied "mechanics and machine work" in high school and knew how to run a lathe, he transferred Burnside to the store's "in-house" machine shop and bumped his salary to $25 per week, or 41 cents per hour. Maisel valued Burnside's proficiency as a machine operator more than his abilities as a hand craftsman. Burnside's work was so valuable that at the end of the summer, as the young man prepared to go back to school, Maisel asked him to return the following year—promising to increase his pay by $15 per week. The proprietor also pledged to find the silversmith a wife—a Navajo woman who would weave in the store while Burnside worked in the back.[1] Aside from Maisel's offer to act as a matchmaker, the proposed arrangement mirrored the formula that the Harvey Company had established three decades earlier: hire Indian artisans to perform craft work in carefully coordinated displays in order to sell Indian-made products to tourists and consumers. With Maisel's promises of an increased salary and domestic security,

Burnside returned to work at the trading post the following year. However, when Burnside resumed his position at the lathe, Maisel did not increase his salary to $40. Nor did he find Burnside a wife.[2] When Maisel failed to fulfill his promises, Burnside became increasingly dissatisfied with his employer.

In many ways, Burnside's response to Maisel's unfulfilled promises demonstrates how differently the two men interpreted their relationship. For Burnside, Maisel's proposal was probably a sign that their relationship transcended the wage-labor system. Traditionally, uncles, brothers, or trusted family members or friends helped arrange marriages between Navajos. Thus, in Burnside's mind, Maisel was showing disregard for their personal relationship when he reneged.

Maisel's initial offer, in contrast, almost certainly had more of an economic rationale than a personal one: he knew that Navajo weavers were popular tourist attractions and would make his store more appealing to white consumers. His failure to provide Burnside with a wife may have stemmed from withering economic conditions or the fact that culturally it was not his place to do so. Or perhaps he could not find a weaver who was willing to work in his store and marry Burnside. Whatever the case, tension over these issues hurt the men's relationship, and as Burnside became increasingly unsatisfied with the conditions of his employment, he began to question the wider implications of Maisel's business practices for other artisans.

To add injury to insult, one day while Maisel was away, Burnside almost sliced his finger off working the lathe. By the time Maisel returned, the silversmith was nursing various wounds. Burnside informed Maisel that he was quitting because Maisel had not honored his word and Burnside did not want to work for someone with so little integrity.[3] In support of Burnside's actions, fellow silversmith Herbert Brown—an Acoma Indian who had witnessed the entire course of events—quit as well. Immediately after their confrontation with Maisel, Burnside and Brown walked to a local restaurant to plan how to reveal the dishonesty of Maisel's advertising practices, given that the trader did not openly acknowledge that Indians worked on a sort of mechanized assembly line at the shop. In relating the circumstances of his departure to anthropologist John Adair, Burnside explained what they did next. For the steep fee of $37, Burnside and Brown decided to "insert an add [*sic*] in the Albuquerque paper telling about how Maisel's silver was machine made" rather than

wholly crafted by Indian hands. Not ones to back down from a fight, the two men signed their names.[4]

Shortly after the silversmiths' ad appeared in print, Burnside was contacted by "a man from Washington" named Eugene Burr. Usually, being singled out by an official from Washington was an ominous sign for a Navajo. In this case, however, Burr, who worked for the Federal Trade Commission (FTC), was interested in Maisel's misleading advertising practices. According to Burnside, the ad led Burr to investigate the veracity of Maisel's claims that the jewelry he sold was handmade by Indians. In 1932, after looking into the matter, the FTC ordered Maisel to "cease and desist" using the label "Indian-made" on the grounds that the goods made in Maisel's store were partially machine made. The 1932 order led to a series of legal appeals and rulings hashing out the exact meaning of the term *Indian-made*, the production methods the term should represent, and its legitimate use in promotional campaigns. As a skilled Navajo craftsman, a student at a Bureau of Indian Affairs (BIA) school, and a wageworker, Burnside represented a few of the parties interested in the production, common understanding, and legal definition of the term *Indian-made*. Along with others from a variety of economic, educational, and racial backgrounds, Burnside supported the FTC's efforts to clarify and codify the term.

The FTC entered the fray not just because of Burnside's complaints but because its primary purpose was to protect businesses from unfair interstate commerce. Maisel willingly acknowledged that he engaged in interstate commerce, employing between six and twelve salesmen to travel the United States selling the goods made in his store to a host of retailers. Thus, the FTC had to prove that the methods of production he used gave him an unfair advantage. Toward that end, the FTC and a collection of Indian traders asserted that because the items made in his shop were produced with the aid of machinery, they could be produced in less time than handmade goods, lowering his overhead and enabling him to undersell his competitors. Although his approach enabled consumers to buy lower-priced goods, the FTC contended that because the public so closely associated the terms *Indian-made* and *handmade*, Maisel's use of the term was actively misleading.

Consumers were familiar with the images evoked by the phrase *Indian-made*. For at least three decades, they had seen myriad advertisements and promotional literature, store and hotel displays, photographs and

paintings, novels and plays, and museum exhibitions and ethnographic displays that featured Navaho artisans producing goods by hand. FTC lawyers made the case that the resulting consumer perceptions were not simply an important component of the market for Indian-made goods; they defined the market itself.

By reviewing the Maisel case in this chapter, we can explore the effects of the representation of the Navaho on Indian producers, traders, and consumers alike. Did the term *Indian-made,* when coupled with the imagery surrounding the Navaho, function as a brand name—as the FTC contended—that signified primitivism and preindustrialism to non-Indians? Could the products of artisans still be considered "Indian-made" if their producers used machinery and worked for wages? Could Indians who used machines still represent their traditional culture, or were they members of a modern workforce? How should the marketplace value goods produced by Indians using machines, to whom would such products appeal, and who benefited from their sale? The Maisel case brought before a federal court a set of concerns that had great import for many Navajo producers, Navajo traders, federal regulators, anthropologists, ethnologists, and white consumers in the 1930s. Moreover, it highlighted the ambiguous place of Navajo producers in modern America.

The case demonstrates that the production of Navajo-made goods, and all they came to represent, was not immune from the larger social, cultural, and economic developments of the era. Several historical trends combined to draw attention to Maisel's commercial endeavors. First, as middle- and upper-class white American consumers grappled with the economic constraints of the 1930s, they became increasingly aware of both the benefits and the pitfalls of mass production and mass consumption. At the same time, the needs of Navajo craft producers and consumers gained cultural, social, and economic importance as the Great Depression ravaged the Navajo Reservation. Also during this period, the federal government instituted a policy of stock reduction that drastically diminished the number of sheep, goats, and horses on the reservation. This action devastated the income-earning potential of Navajos and traders from 1932 to 1936.[5]

Amid these pressures, one cannot be surprised that Navajo Indian artisans like Burnside became more conscious of their status within the market economy as the producers of a particular kind of product. The conflation of product and producer marked a crucial point: the ongoing

social construction of the Navaho converged with the meaning of the "Indian-made" label within the marketplace. Primitivism was both marketable and malleable. The dispute between Maisel and Burnside, and the subsequent legal battle, demonstrates that the contest between the concept of the Navaho and Navajo subjectivity took place not only in advertisements, hotels, newspapers, retail shops, reservation-based trading posts, living rooms, museums, and public venues throughout the country, but it also played out in courts of law. The U.S. Court of Appeals for the Tenth Circuit (hereafter Tenth Circuit Court) received the task of defining the "secondary meanings" of the term *Indian-made*. If after defining the term, the court found that Maisel's practices did indeed mislead the public and provide him with an unfair advantage, it would have to determine whether the FTC's regulation of the sale of such goods was fair and enforceable. But before either district court or circuit court judges could make such determinations, they had to get a sense of the operations at Maisel's Indian Trading Post and determine why so many people objected to Maisel's practices.

The Representation of "Indian-Made" Goods at Maisel's

What made Maisel's representation of "Indian-made" goods so contentious? The controversy over Maisel's use of the term *Indian-made* arose not from what the public or consumers saw when they patronized the store but from what was subtly concealed or obscured in printed advertisements and wholesale catalogs. Located directly across from the popular Alvarado Hotel in Albuquerque, the Maisel Indian Trading Post emulated some features of the Harvey Company's retail endeavors. First, by placing his store near the busy Atchison, Topeka & Santa Fe railway terminal, Maisel knew he could count on a steady stream of curious travelers and cost-conscious shoppers searching for entertainment, authenticity, and souvenirs. Next, although Maisel's shop was not as ornate as the Alvarado's Indian Room, visitors could still see Indian silversmiths making jewelry. Yet, at Maisel's, only the lower-paid Indians who were doing "hand" work were easily visible to the public. If customers asked to see the entire shop, Maisel would show it to them. But in his displays, catalogs and circulars, Maisel largely relied on a host of obstructionist

strategies to deflect consumers' attention away from the fact that many of the twelve to sixty Indian silversmiths he employed to produce jewelry used machinery in their work.[6]

Maisel attempted to capitalize on the spectacle of "primitive" Indian production by shielding his industrial workforce from public view.[7] In his retail space, in weekly newspaper ads, and in the approximately 20,000 catalogs he mailed out to consumers and curio-store owners across the United States, Maisel routinely promised visitors that his employees put on the "greatest Indian show." He also proclaimed that his was one of the few shops where consumers could see "the Indian silversmith at work" and then purchase goods from one of the largest selections of stock in the region.[8] At Maisel's, silversmithing was as much a performance of "primitive" Indian life as of indigenous occupation. Thus, when Burnside and his peers worked for Maisel, they became actors in the drama surrounding the consumption of "Indian-made" goods, and Maisel's shop became yet another stage to showcase a specific image of the Navaho in the interest of commerce. Bracelets, rings, concha belts, and letter openers were made there, but so too were characterizations of silversmiths and the Navaho—despite the fact that many of the Indian silversmiths who worked at Maisel's were not Navajos.

Like the shell-game operator who wants to draw attention away from his sleight of hand, Maisel directed consumer perceptions. Whereas the Alvarado emphasized the production of goods to mirror an ethnographic encounter with "primitive" artisans making their wares, Maisel's operated on the assumption that goods had a market value not wholly dependent upon specific production methods. Maisel adopted this stance less to compete with reservation-based traders and independent silversmiths than to draw a share of the market away from urban manufacturers of machine-made "Indian-style" jewelry for the mass market. For instance, in his promotional newsletter for June 27, 1931, Maisel attempted to entice Bernice Hunter of the Dee Tahquitz Hotel in Palm Springs, California, along with tens of thousands of other curio-store owners and dealers in American Indian artifacts, to sell "Maisel's genuine coin-silver, Indian-made jewelry." The bottom line, according to the circular, was simply that "MAISEL'S COSTS NO MORE" than similarly styled goods that had been made by non-Indians using modern machinery—and, by extension, the store's goods cost much less than goods made by reservation-based Indians strictly engaged in hand labor.[9]

This newsletter offers a useful place to begin unraveling the threads of race and regulation, production and consumption, and borrowing and tradition that had become attached to the concept of the Navaho. In its pages, Maisel clearly wanted to forestall criticism and gloss over problematic issues that the use of machinery might raise among particular groups of consumers, silversmiths, anthropologists, market observers, and Indian traders. As a result, he directed consumer attention beyond the finished products to the kind of raw materials that went into them as well as the characteristics of his Indian employees. As part of his agenda, Maisel needed to convince buyers that the producers of his goods, simply by being Indian, endowed the items with authenticity and value and that no one production method conferred these traits. He offered the appearance, disposition, and work habits of the Indian silversmiths he employed as proof of their authenticity and to enhance the appeal of the "Indian-made" jewelry he sold in his store.

Because Maisel's employees were central to his portrayal of his goods, he devoted the whole of the widely circulated newsletter to introducing his Indian workforce to the public. In the top quarter of the newsletter was a triptych photograph, and in the first of the three panels stood four Indians who were "just in from the reservation" as well as "one of our Indian workers who brought them in to join our crowd."[10] As testimony to the workers' Indian-ness, they were wrapped in stylized Pendleton blankets, their arms hidden beneath the folds of the blankets, and their heads were uncovered. Just below the "new recruits," in the second panel, was a photograph of the initiates alongside eighteen other unnamed Indian silversmiths. The majority of these employees wore uniforms of dark-colored pants and white work shirts with their sleeves rolled up to their elbows. All of the smiths, experienced and inexperienced alike, now wore the distinctive head wrap associated with Navajo silversmiths.[11] The differences between the two groups of smiths—the old and the new—had already started to fade. All now bore the markers of a Navaho silversmith. But, in case the newsletter did not make the connection clear, Maisel hammered the point home by placing the familiar image of a "lone" Navaho silversmith on the banner of the newsletter.[12]

In the third and final panel of the newsletter's photograph, the key image in the newsletter's photo series, was a portrait of Maisel's "force of non-Indian workers." Careful to point out that these individuals were not involved in the production of jewelry, Maisel described them as the

MAISEL'S *Indian Trading Post*

ALBUQUERQUE
NEW MEXICO

June 27, 1931.

At the top of this picture --

you see four Indians just in from the reservation, with one of our Indian workers who brought them in to join our crowd of Indian silversmiths. In the center you see them grouped together, and at the bottom of the picture you see our force of non-Indian workers who are not actively engaged in making the jewelry, but who as clerical, sales, office and shop workers help us to get the Indians' work to you.

Last month we wrote you that we were enlarging our workshops. This work is completed and we are increasing our force of Indian workers. (We now have what we believe to be the largest establishment in America devoted to producing and selling genuine coin-silver, Indian-made jewelry.)

We wish you could have an opportunity to go through our shop. Tourists are always dropping in to see our Indians at work, and buyers of our wares are always invited to go all through our establishment. Many of our Indians do not speak English, and it is like a trip through the reservation to see them and hear them singing as they work.

Excerpt from the "Maisel Newsletter," June 27, 1931. Maurice Maisel used his newsletter as a form of advertising. Like Hubbell, who also wrote personal notes to curio-store owners, Maisel personalized his correspondence. Records of the Federal Trade Commission, FTC Archives, National Archives and Records Administration, College Park, Maryland.

"clerical, sales, office and shop workers" who helped only to manage and distribute the efforts of Indian labor.[13] Thus, he made a clear distinction between the Indian silversmiths and white employees. Indeed, the triptych nicely illustrates what was actually happening in Maisel's shop: reservation Indians were transformed into a workforce, albeit a "primitive" one, whereas white employees oversaw the production and sale of the jewelry they made. The difference between the final photo and the previous two also supported Maisel's overall strategy: he wanted customers to see that silversmiths were different from whites even when they worked for wages.

Maisel even tried to liken his establishment to an Indian reservation rather than to a modern factory. In the newsletter, he noted that he took pride in his shop, which he described as the largest of its kind in the United States, but he also pointed out characteristics that made the Indian silversmiths, and the conditions under which they labored, similar to those of Navajos on the reservation. Despite the size of the shop, Maisel insisted that he was not running a thoroughly modern business. The Indian silversmiths in his store did not speak English, and customers visiting the shop could hear the silversmiths singing while they worked as they might on "a trip to the reservation."[14] And, as the top two panels of the triptych illustrated, he directly compared the silversmiths he employed to those one might see, or hear about, on an unnamed Indian reservation. However, because he presented his employees wearing a head wrap commonly associated with Navajo men, and silversmithing was so closely associated with Navajos by the 1930s, he was clearly referring to the Navajo Indian reservation. He went even further to link the production methods of his shop to those on that reservation: the "use of Mexican pesos as a source of the silver has almost died out and the reservation silversmiths now use flat coin-silver." By drawing a straight line from the reservation to his store, he could maintain the idea of the primitive qualities of the work: "We, too, supply our Indians with coin-silver sheets to save the time-consuming hammering, which is not a skilled-labor process to begin with."[15]

Even as Maisel worked to lessen the distance between shop and reservation, he recognized that space was not the only obstacle he had to transcend if he wanted his customers to think of the goods made in his store as worthy of the "Indian-made" label. He also had to emphasize the distance between "primitive" producers and "civilized" consumers. To do so,

he directed the reader's attention to the craftsmanship that went into the production of goods in his shop, inverting the categories of "skilled" and "unskilled" work in the process. "Some of our Indians operate punches to supply the hand workers with [silver] blanks," but other silversmiths "are skilled in making the little hand punches that the silversmiths use to hammer in most of the symbolic designs." In an attempt to obscure the meaning of the term blanks—the prefabricated sheets or bracelet-sized strips of precut and machine-pressed silver—he focused on the quality of the materials rather than the processes of production, assuring possible patrons that he did not permit anything other than the use of "genuine coin-silver, and no settings but genuine turquoise" in the jewelry produced at the shop. The admission that a few Indians in his service used a machine to press and roll out silver blanks to speed the task of shaping the silver for the true artisan rhetorically turned machine work into unskilled labor. Once rolled, blanks were handed off to other craftsmen who did the majority of design work by hand. In Maisel's shop, the products of the skilled workers, who in this case applied designs by hand, rested on the labor of those who did the supposedly "unskilled" work with machines.[16] Maisel's definitions of "skilled" and "unskilled" work demonstrate how carefully he crafted his narrative to fit consumer-driven perceptions of Navaho producers. But such inversions were not reflected in the paychecks of the Indians who performed handwork. They received significantly less than did the workers operating machines.

Not only did Maisel attempt to divert attention from the use of machinery at his shop, but he also downplayed his own interest in the production of goods by focusing on other features that supposedly denoted and preserved Indian authenticity. According to Maisel, the use of machinery provided silversmiths with "the white man's tools to help" preserve an Indian craft. Moreover, as he repeated many times in newsletters and advertisements, the goods he sold were made from coin silver, by which he meant the kind of silver used in the silver dollars or pesos that the first Navajo silversmiths had molded into jewelry. In Maisel's advertising strategy, "white man's tools" and modern materials combined to salvage a "primitive" art form. His role in saving the craft of silversmithing was especially important, Maisel argued, as a bulwark against unscrupulous industrialists such as the H. H. Tammen Company of Denver and the Arrow Novelty Company of New York City, which had begun mass-producing "Indian-style" jewelry in urban factories. Around 1930, the FTC had

required Tammen and others to advertise and sell goods under the label "Indian-design" or "Indian-style."[17]

By focusing on certain markers that consumers would equate with Navaho identity—such as workers' not speaking English, singing while working, hand hammering metal, or using coin silver in the production of "Indian-made" jewelry—Maisel accentuated the divide between the Indians who transformed silver coins into jewelry and the consumers who used their silver dollars to purchase it. In Maisel's ads, these differences of expression and behavior demonstrated that the products had value because of the qualities of their Indian producers, not only the production methods they used. In many ways, Maisel's strategy mirrored that of an earlier generation of reservation traders who had used the narrative of frontier commerce to perpetuate the idea that the Navaho were not centrally located within the modern market economy. Though Maisel wanted customers to believe that a visit to his store was like a trip to the reservation, he could not deny that the Indians at his store worked under the supervision of a white foreman in a machine shop and produced goods directly for a retail outlet. Because his Indian employees did not work on a remote "frontier," he could not draw upon frontier commerce as a marketing tool.

This ambiguity created a bind for Maisel. On the one hand, he had to admit that both the shop floor and the store floor were vital to the burgeoning modern marketplace. On the other, he had to distance Indians from that marketplace to maintain his claim of the goods' "authenticity" because of the "primitivism" of their producers. Within the shop or in the limited space of advertisements, he could simply attempt to divert customers' attention from the fact that silversmiths were using machinery. In his newsletter, however, he adopted another tactic. There he attempted to distance whites and Indians from each other by focusing on the inherent differences between his Indian employees and his white employees, and by extension, between his Indian employees and the white consumers he was courting. In this sense, Maisel was doing something that had become standard practice among traders, tourist purveyors, and dealers. To sell goods, he molded a vision of the Navaho that placed the concept in opposition to whiteness.

Maisel crafted his business strategy to draw a share of the market away from retailers like Tammen. He realized that if his business as a wholesaler and retailer of "Indian-made" (as opposed to "Indian-style") goods

were to flourish, he would have to find a way to cut costs and production time while maintaining the integrity and authenticity of the items he sold. To be competitive, Maisel decided upon a relatively simple plan: he hired Navajo, Pueblo, and Apache Indians to use modern machinery to produce a specific style of Indian-made jewelry. In this way, not only could he compete with mass manufacturers by selling large quantities of virtually identical jewelry to curio stores, he could sell the jewelry for significantly less than could individual silversmiths or traders on the reservation. However, he also unleashed a storm of criticism and controversy that would eventually force a legal definition of the "Indian-made" label. Maisel may not have been the first or only "trader" to make Indian production practices adhere to contemporary manufacturing methods, but he was one of the most open practitioners of the approach, and he was successful at it at a time when the income from, and value of, such products was increasingly important to producers, dealers, and consumers.[18]

Consumers and the "Indian-Made" Label

As an astute businessman, Maisel carefully crafted his portrait of Navaho labor to appeal to consumers. As whites became more discerning consumers in the early part of the twentieth century, they invested specific sentiments in the act of shopping for certain goods, and their quest for Navajo Indian-made jewelry and rugs reflected this fact. For years, consumers had been aware of the supposedly primitive qualities of Indian-made goods. Michael Harrison, witness for the FTC in the Maisel case and lecturer on Indian arts, asserted that over a nine-year period, he had personally come into contact with over 18,000 Americans who conflated the terms *Indian-made* and *handmade.* The FTC used such testimony to assert that hand production was the key element separating "primitive" goods from those made by Indians using machinery.[19]

Harrison may have known thousands of consumers, but the Justice Department sought additional testimony from a more qualified and famous expert. It called Oliver La Farge to testify about Indian production methods as well as to inform the court about consumers' motivations for purchasing Indian-made goods. La Farge's expertise derived from his training as an anthropologist and the publication of his widely read and Pulitzer Prize–winning 1929 novel on the Navajo, *Laughing Boy.*[20] The celebrated

author claimed that consumers of Navajo silverwork frequently sought his opinion. First and foremost, according to La Farge, buyers attached "a great deal of importance" to the "hand-hammering" process. Hand-work had been "built up by the many stories that have been published, [and] the propaganda of the Santa Fe Railroad," which commonly "used any primitive angle," especially that the "soul" of craft work was derived from the hand-hammering process to promote Indian-made goods.[21] This handwork was a key characteristic that all American consumers associated with Navajo-made goods. La Farge said that buyers of the "first class" or those who "spend large sums of money on Indian products, who know about them and who exercise their own careful selection" wanted to buy only handmade goods. Tourists and sightseers—or the "second class" of consumers—spent less money and knew less about the ways of Navajo Indians, but they were also "particularly anxious to learn what is Indian[-made]" and sought out goods that bore the label.[22] Consumers had a sentimental and "romantic feeling" about "the Indian way of work" and wanted jewelry that represented the Navahos they had come to envision. Invoking the discourse of primitivism—especially the distance between "primitive" producers and "civilized" consumers, La Farge asserted that purchasers believed that the artistic inspiration for hand-crafted Indian materials came from an "instinct in our civilization" to be attracted to supposedly "less civilized" goods. He knew of a "great many" people who purchased Indian-made jewelry not because they found it aesthetically pleasing. Rather, he said, when people spend "a great deal of money on" Indian jewelry, they "will not wear it" because "they buy it for other [romantic] value, as the association is an extremely important one."[23]

The court also heard the testimony of M. L. Woodard, editor of the regionally circulated *Southwest Tourist News*. A promoter of Navajo goods and culture and a former trader, Woodard informed the court that consumers thought that Indian-made jewelry was made almost exclusively by Navajo Indians, that it was "distinctive" because it was a product of hand labor, and as a result, that no two pieces were alike. He was positive that "the use of machinery in any form" destroyed "the primitive art of the Indian" and that consumers' sentiments and beliefs influenced their purchases and therefore had an economic impact on Navajos and traders alike. "During the last several decades," stated Woodard, the art of silver-smithing "grew in leaps and bounds until the manufacture of Indian jewelry became next to the raising of wool, the chief industry of the [Navajo]

Indians, and constitutes one of their chief sources of revenue." According to the trader turned newspaperman, any decrease in the sales of such items was the direct result of Maisel's inundation of the retail market with imitation Indian-made jewelry.[24] It was not simply the fear that consumers would buy the cheaper goods that haunted Woodard. It was the fact that consumers might lose all interest in Indian-made goods if they came to view the items as simply another form of machine-made jewelry.

Woodard had considerable experience with white consumers. Not only could he speak on their behalf, but he had helped mold the very sentiments he was there to explain. Just one year before his testimony for the FTC, Woodard wrote about the Navajos at the Exhibition of Craftsmen and Work he had organized in Boston, telling readers of the *New Mexico Highway Journal* that the event created a phenomenon. Contradicting La Farge's assertion about consumers' lack of aesthetic appreciation, Woodard claimed that every afternoon and evening, as Navajo artisans wove rugs, made sandpaintings, and turned out silver jewelry in their "stoical manner," Bostonians "marveled" at "the remarkable artistic ability of this primitive tribe."[25] Woodard even went so far as to have Navajo artists pose with white women dressed as Pilgrims as a means of connecting the Navajos to a key moment in American history as set forth in national myths of progress. In staging and describing such events, Woodard helped potential consumers interpret a variation of "primitivism" that was simultaneously specific to Navahos and representative of all American Indians. Indians—be they Navajos, Pequots, or Assiniboine Sioux—were depicted as part of the past, especially in relation to the myths of American cultural and national development.

Woodard was hardly alone in using representations of the preindustrial Navaho to reflect the historical experience of first contact. The court also heard how American consumers imparted lessons about Indians of the past, and their role in American society, to school-age children. Lucille Smith, a consumer of Indian-made wares and a lecturer in the Illinois school system, told the judges that her collection of Navajo jewelry allowed her to present a particular lesson to children. In her testimony in the Maisel case, she contended that her lectures conjured both important national myths and cultural preservation. "Along about Thanksgiving time," began Smith, "we always talk about the Pilgrims and the Indians." When she lectured, Smith encouraged children to bring Indian artifacts to class so "instead of spending so much time on the historical part of it,

they [the children] bring to the room many things they have gotten during their vacation time throughout the West." Books lent legitimacy to Smith's lesson plans, and she told officials that grade-school "readers" had "many little stories about Indians and pictures of Indians." These pictures showed a lone "silversmith just squatting on the ground with just those little crude tools and no machinery."[26]

Smith reported, however, that her students' relatives or friends who had traveled to the Southwest could undermine an entire lesson by relating the "truth" about Indian-made jewelry, informing children that the jewelry was "machine made" or "made in a workshop and there are many workers."[27] She said that knowledge of Navajos working in machine shops, or with civilized tools, interfered not only with the children's perception of Indians but also with their view of themselves. The concept of the Navaho allowed whites to express beliefs about time, race, and history that were external to Navajos themselves. When Woodard, Smith, and other consumers collapsed the temporal and cultural distance between Navajo Indians and the American Indians who supposedly ate with the Pilgrims at Plymouth, they could see the Navaho as representatives of a static "primitive" past and themselves as "civilizers."

Maisel's attorney, John Simms, disagreed with this reasoning because it fixed Navajos in the past and made their culture appear unchanging. Although the defense called no consumers to testify on Maisel's behalf, Simms claimed that consumers understood that Indian culture was continually evolving and progressive: "We do not believe that the public regards the making of Indian jewelry as static." To prove this assertion, he argued that the public "would not purchase articles such as letter openers, cigarette trays, pen holders and things of that kind which have no Indian background whatsoever" if they did not consider Navajo culture to be adaptive.[28] For Maisel and his lawyers, the "borrowing" and adaptive Navajos and the "primitive" and preindustrial Navaho were one and the same. In this case, borrowing was not the threat to Navaho primitiveness that it had been in Stewart Culin's scenario. Instead, the two features could coexist—as long as the industrialized Indian was not fully on display.

We might ask, then, what really motivated consumers and how their motivations affected Indians. Celebrating one of America's foundational myths or basking in the romance of hand production were only two of the reasons consumers purchased Indian-made goods. As we saw in Chapter 4, American consumers had long engaged in buying Navajo rugs or jewelry

because it enabled middle-class women, among other things, to emulate the style of the wealthiest Americans, while paying only a fraction of the price. These consumers' bargain hunting had an immediate impact on Navajos and traders. In 1907, Marion Moore, wife of Navajo trader J. B. Moore of Crystal, New Mexico, told dealer Grace Nicholson that middle-class eastern consumers were cost conscious to the point of exploiting producers. For instance, Moore noted that as Navajo-made goods became popular additions to living rooms and cozy corners, organizations such as the Navajo Indian League in Boston, which had its own store, attempted to "pick up everything they can find that is cheap or that the indians [*sic*] have been jewed down on." Moore's anti-Semitism revealed her own prejudices, and her use of this language dramatizes the exploitative aspects of the relationship she believed existed between white consumers, Navajo Indians, and the traders who mediated the exchanges. According to Moore, consumers did not want to pay, and had not in the past paid, "a living price" for goods. The shoppers who rankled Moore, and the producers whom Burnside sought to protect, clearly differed in their views of the meaning of Indian-made goods. For men like Burnside, creating Indian-made products was a way to make a living in the modern marketplace. Consumers, according to Moore's self-serving statement, believed that "Indian-made" signaled production by primitives who existed outside of the market economy and did not therefore need or even value money.[29]

Consumers' pursuit of the thrill of bargain hunting was central to Maisel's model. According to Maisel, American consumers demanded "something cheap," and most wanted a "beautiful bracelet for a dollar or two or three or four, a pin for 50 cents." Where others, like Moore, feared the erosion of income, Maisel envisioned profit. "I saw an opportunity for the Indian to meet the demand by putting him [the Indian] in my shop and producing jewelry."[30] In testimony, Maisel affirmed the suggestion that consumers believed Navahos had only recently emerged from a "more or less wild state" and thus had a primitive understanding of the market.[31] For white consumers, haggling was an essential part of purchasing goods manufactured by "primitive" people. Not only was bartering cast as an inherently primitive economic behavior, but it was an act that enabled them to mesh the dual ideals of living on a budget and creating an expressive and stylish decorative scheme in the middle-class household.[32] In fact, these aspects of primitivism were precisely why modern consumers found bargaining to be appropriate and entertaining, whether

they bargained with Maisel or with Moore—or imagined them bargaining with Indians. In many ways, the consumption of Indian-made goods corresponded to and reinforced the emergence of race-conscious modern American "consumer citizens," who steadily gained power in the 1930s.[33] But, as Marion Moore's quote about cheap consumers demonstrates, the consolidation of white American identity around the practices of consumption, had significant consequences for those on the far side of the transaction. Because those who testified about middle-class white consumers did not recognize American Indians as part of the modern, urban, industrialized marketplace, we can see one more way that Indian labor was not measured according to marketplace standards. Consequently, silversmiths struggled in a system in which their pay was not necessarily representative of their labor.

Wage Work and Silversmithing

Even as whites devalued Indians' labor, income from silversmithing was becoming an increasingly important part of the reservation household economy—especially in the southeastern part of the Navajo Reservation. By 1931, as Clinton Bortell, manager of the Kiva and Curio Shop in Albuquerque, told FTC field representatives, "Indian jewelry is the medium of exchange and represents the Indians [sic] purchasing power" in trading posts across the reservation. He estimated that the trade in such goods generated $10 million annually.[34] In 1932, S. F. Staker, the superintendent of the Eastern Navajo Agency, noted that approximately one of every ten Navajos employed on the reservation worked as a silversmith.[35] Although we have no way to verify this statistic, a large majority of working silversmiths did in fact provide essential support to their families. As a result, in the Maisel case, the FTC charged that the livelihood of thousands of silversmiths and their families "is threatened with extinction by the respondent's [Maisel's] trade terms which destroy their sales and goodwill."[36]

Although it is difficult to ascertain exactly how many Navajos received income from their craft, silversmiths and their families did rely on the income from the tourist and curio market. In 1937, Haske Burnside's brother, John, documented that half his yearly income of $1181 derived from silversmithing.[37] A survey of fifty-two smiths in 1938 supports Bortell's main assertion that jewelry provided smiths with necessary income.

At that time, the average annual income from piece-goods silverwork, in which an individual trader commissioned a silversmith to produce a particular number of goods, was $383. The silversmiths produced most such goods between November and April, when income from other family businesses, like tending to sheep, was minimal. In addition, silversmiths reported the value of jewelry they made for themselves as income.[38] Navajos used cash and credit from pawned goods to purchase sheep, food, tools, or supplies. As with weaving, reservation trading posts were the primary locations at which Navajos sold or pawned jewelry and traders purchased the jewelry for resale to the public. If Bortell's numbers are correct, however, we can also see that though silversmiths earned some much-needed income from their labor, they did not earn nearly as much as the traders, wholesalers, and retailers did.

Even as traders turned a profit, silverwork continued to serve an important social function, reaffirming familial ties, kinship networks, the value of cultural expression, and clan alliances among Navajos. Entire families commonly helped in the production of goods for the marketplace, often for a trader who supplied tourist-related industries. Two of silversmith John Burnside's sons, for instance, helped him produce jewelry. His wife also contributed to the family income by grinding turquoise and "doing some of the silver work" in addition to selling her weavings to traders for approximately $150 per year. Wives, sisters, daughters, mothers, or cousins often helped with the tasks of producing jewelry. In some cases, like that of Haske Burnside's sister, Mary, they even worked as silversmiths themselves. Extended family ties were also important because parents routinely sent their children to relatives to learn the craft. Thus, families and clans were linked through apprenticeships.[39] Items made either for family members or for the market could be pawned or traded for credit, scrip, or cash at the trading posts.

The introduction of wage work at Maisel's remade a system that had emerged in the 1920s when reservation-based traders dominated the silver trade. As the demand for silverwork expanded in the 1910s and 1920s, silversmiths and traders began to work in tandem. Some reservation traders, mostly in the southeastern part of the reservation, established and maintained semiexclusive trade relationships with specific groups of Navajo silversmiths and select retailers. Traders provided or "lent" silver, turquoise, and other supplies to artisans, who in turn supplied traders with a steady stream of goods. Traders usually paid silversmiths a flat rate

for their labor for every ounce of silver they used.[40] In turn, large retailers, like the Harvey Company, purchased such goods for their venues. Some silversmiths worked for wages within shops near the reservation. Others took home supplies and returned to the trader with finished goods.

As inexpensive Indian-style jewelry gained in popularity, however, reservation-based Indian silversmiths and Navajo traders struggled to compete not only with each other but with companies like Tammen and Arrow as well. When reservation-based traders began hiring as many Indian silversmiths as they could find to make jewelry on-site, the independent silversmiths were the first to feel the pinch. In the 1930s, for instance, a single high-quality handmade Navajo bracelet could take an individual craftsman (and his or her family) between ten and twelve hours to produce and could be sold to a trader for approximately $6. In such a case, the silversmith made between 50¢ and 60¢ per hour. By comparison, the Tammen Company could make a dozen machine-made products of similar design in less than an hour.[41]

In the early 1930s, however, the "lending-out" system, and its underlying philosophy, was challenged by off-reservation traders, like Maisel, who found the system of "giving out silver" too risky and too slow to produce dividends. Before opening his store in Albuquerque, Maisel had tried and failed to make this system work for him. Sometime in the 1920s, he operated a shop close to the reservation, and he claimed he had "lost" 1,200 ounces of silver to Navajo silversmiths who used his silver to make goods for his competitor, A. J. Merrill of the McAdams Trading Post. As a former employee of Maisel's, McAdams had been able to lure silversmiths away from Maisel. At this point, Maisel's attorney, Simms, had told Maisel to "go into a business that was more to the jewish [sic] temperament."[42] Such advice, along with Maisel's failure to keep his business "in-house," fueled his decision to abandon the lending system so that he could directly oversee production.[43] Under a new setup in Albuquerque, Maisel paid wages to Navajo, Pueblo, and Apache silversmiths for their employment in his workshops, making it difficult for the majority of traders who depended on the piece- goods system to stay competitive. Critics charged that wage work also decreased the quality of the goods the Indians produced. Such shifts forced the involved parties to consider the role of wage work in the production of Navajo-made goods.

The court sought the testimony of Indian artisans to determine how work conditions at Maisel's differed from Indians' "traditional" practices.

Within Maisel's shop, according to the Indians' testimony, one silver-smith used a lathe to cut forms, the next worked the rolling machine, another pounded out and shaped the jewelry, a fourth stamped a design onto the piece, and a fifth finished and polished the piece with the aid of a machine buffer. With more than one craftsman working on a single piece of jewelry, Maisel's shop could produce jewelry faster than could single silversmiths working in their homes on the reservation.[44]

Witnesses on both sides of the case compared the work practices at Maisel's with those on the reservation. Witnesses for Maisel noted that reservation silversmiths rarely, if ever, fashioned silver jewelry from start to finish exclusively with the use of "primitive" hand tools. They also said that the Indian silversmiths at Maisel's—even those who operated machinery—used hand tools at various stages of production just as did those working on the reservation. Indians pointed out that their ances-tors had a history of using machine-pressed silver; they had never mined silver, instead using copper wire, machine-minted pesos, or silver dollars as a base metal. More importantly, even Indians who made so-called ex-clusively handmade goods used certain "civilized" tools. Even Joe Abeita from Isleta Pueblo, a witness the prosecution called to testify as a tradi-tional silversmith, supported the above arguments: "When I make silver jewelry pieces in my own home, I use a charcoal fire with a blowtorch to melt the silver. I use a gas blowtorch . . . I use Mexican pesos."[45]

Whatever side they took in the Maisel case, the silversmiths who testi-fied saw remuneration as the key issue. Charlie Petsoe, a twenty-seven-year-old Navajo silversmith, worked for Maisel because he needed the $12 per week he could earn there. But he, like Haske Burnside, eventu-ally quit because he thought he deserved a higher wage.[46] The problem for Petsoe was not that the goods he made in Maisel's store violated some sort of artisanal integrity or white consumer sensibility; rather his main objection was that he did not receive a fair wage for his hourly labor. Haske Burnside, who by 1932 was working as an instructor at the U.S. Indian School in Albuquerque, made the most comprehensive claim by linking the larger market to the financial viability of silversmiths as a whole. He argued that Maisel's employment practices were destructive to the Navajo economy. "With regard to the manufacture of Indian jewelry by . . . Maisel's," Burnside stated that his former employer's practices not only forced silversmiths, their wives, and their children to starve, he also claimed "he [is] disgracing our silversmith trade" as well. Maisel's use of

machinery and machinists, according to Burnside, was "putting the [traditional reservation] silversmith out of business."[47]

The insertion of wage work into silversmithing, however, called attention to some of the key differences between the market-oriented transactions on the reservation and those off it. As historian Colleen O'Neill has shown, wage work was not new to the reservation, nor was it inherently objectionable to Navajos.[48] Yet Burnside had come to realize that though wage work might provide employment in Albuquerque, it also threatened the earning potential of individual smiths working on the reservation, like Isadore Burnside, who supplied specific traders with piece goods. Even traders like Mike Kirk, who ran posts on the periphery of the reservation, saw a difference between wage work on and off the reservation. Like Maisel, Kirk paid silversmiths wages, but unlike Maisel—whose main customers were tourists, curio-shop owners, and dealers in Indian arts and crafts—he depended on Navajos for business. Off-reservation businessmen, such as Maisel, were better able to survive economic downturns because they did not depend upon Navajos for business, nor were they drawn into the practice of overstocking.

Indian Education and Silversmithing

In many ways, Maisel's business practices reflected a widespread belief that the transition of silversmiths from pieceworkers to wageworkers was a natural step in the assimilation of Navajo Indians. In this regard, the most powerful and influential agents of change on the reservation were the Bureau of Indian Affairs schools that actively promoted an assimilationist agenda from the 1910s through the early 1930s. The BIA placed particular importance on wage work, viewing it as a necessary step in the evolution of the Navajo—if not a key mechanism for assimilation.[49] At the Burke Indian School in Fort Wingate, New Mexico, the curriculum focused on educating Navajos to be good wageworkers and emphasized the qualities they would need, including "diligence, reliability, initiative, and technical skill (when called for)."[50] Administrators at the Burke Indian School also encouraged students to participate directly in the market as an expression of American citizenship. Mirroring the dominant anthropological view, they believed that Navajos were especially inclined to soak up such lessons because they were cultural borrowers or "a product

of contacts with other cultures" that had in the past, "and will continue to absorb cultural elements as the need arises."[51] Turning Navajos into wage earners was one way school administrators believed Navajos could come to live and work more like other working-class Americans.

In the 1930s, when Indian activist John Collier became the commissioner of Indian affairs, he challenged the more drastic assimilationist policies by promoting the inherent value of indigenous cultures, crafts, and skills. Although school administrators did not abandon the idea of assimilation, they began to extol the value of Navajo culture in school curricula. As a result, assimilationist ideas were somewhat tempered by Collier's belief in cultural pluralism. The concurrent debacle of stock reduction destroyed Collier's reputation among Navajos, but the curriculum at bureau schools during his tenure did change. For instance, in 1935, in addition to the typical Indian school curriculum of vocational training, the Burke Indian School offered courses that recognized the worth of traditional Navajo family life, including marriage and divorce customs and the role of the Navajo family as an economic institution. These courses represented a departure from earlier BIA educational standards, which forcefully discouraged or prohibited Indians from learning about, expressing, or appreciating their cultures.[52]

Still, to foster the development of community-minded, market-oriented citizens, school officials outlined the skill sets that Navajo boys and girls should learn to become what we might call Americans of Navajo origin. At BIA schools, for instance, girls learned to make "satisfactory yarns, to dye them, to combine them into artistic patterns, and to weave them into acceptable products." They also studied poultry management and sewing. Boys were encouraged to develop specific skills as well, including carpentry, building, and "common ranch blacksmithing," which required proficiency in "shaping and soldering sheet metals."[53] In many ways, the schools' educational strategies were bolstered by, and complementary to, the practices of traders on and off of the reservation.

There was considerable overlap between BIA education policy and open market practice. Indian curio-store owner Julius Gans, who hired Indian silversmiths to work in an open atmosphere in his shop, explained the connection between silversmithing and BIA school policy: "The United States Indian School at Santa Fe, when it started a department to teach Indian silversmithing chose as an instructor an Indian who had learned his craft with us, and the silversmithing department at the local school was

laid out according to the arrangement of our shop." By the mid-1930s, the BIA also hired former Gans employees as instructors in other bureau schools. Gans reasoned that this policy was prudent because it allowed silversmiths to teach others how to compete with "machine made articles."[54] Haske Burnside also benefited from such educational objectives. He practiced working with silver at a BIA school and later worked as an instructor at the Albuquerque Indian school from 1931 to 1934.[55] Thus, the BIA was an active player in the modern production of arts and crafts—and by extension it unintentionally challenged the predominant image of the Navaho silversmith. The BIA put its weight behind the development of a curriculum that placed indigenous culture alongside machine work and wage labor and did not see the two as mutually exclusive.

Initially, the tension between machine work and Indian handwork did not concern BIA educators. For instance, they encouraged students and instructors to apply the principles of general metalwork to the trade of silversmithing. In the 1936 edition of the Burke Indian School newspaper, *Shus Be' Tok News* (Bear Springs News), Navajo student reporter Felix Baldwin noted, "The boys are getting to the point of knowing what silversmithing really means." For Baldwin, silversmithing meant having a marketable skill. With the help of Navajo silversmithing instructor Dooley Shorty, Navajo boys learned how to make and repair silver jewelry.[56] Burke school administrators also hoped that students would learn how to cut dies and stamps; work with copper, brass, and silver; and cut and polish stones so that they would have a host of marketable skills when they graduated. Baldwin's reporting revealed that at school, young Navajos received training in both machine work and handwork and were expected to use both skills once they graduated to help support themselves. Did such training make boys less "primitive" or more "civilized"? Clearly, the BIA hoped for the latter, yet when pressed, it chimed in to promote the preservation of an "Indian-made" label whose value derived, supposedly, from the more "primitive" elements of the handwork closely associated with the Navaho.

Either way, Maisel's attorney was quick to argue that both Maisel and the BIA believed that wage labor had an economically transformative impact on Indians. Whereas BIA schools prepared Indians to compete in the market while preserving their culture, Simms argued that Maisel had enabled Indian silversmiths to break free of the anachronistic economic relationship that dominated the trading-post system. There, Indians were tied to a cyclical system of barter, trade, and credit. At Maisel's, "Indians

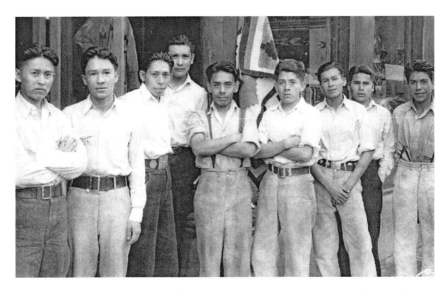

Boys working at Julius Gans's shop. Gans employed a number of silversmiths. By dressing them in a uniform of khakis and white shirts, he showed them as modern workers, not "ancient" Indians. This practice was consistent with his belief that Indians could assimilate and retain their traditions. Frasher Foto Collection, Pomona Public Library, Pomona, California.

work[ed] for wages" and enjoyed the benefits of a straightforward market exchange. In a bold statement, Simms claimed that the silversmiths who worked for Maisel had tasted economic freedom and would "no longer submit to the privations, inadequate pay and uncertainty of employment which the reservation Indian accepts as a matter of course."[57] Burnside expressed more than his desire for "economic freedom" when he quit. His actions also reflected a general suspicion of Maisel's business practices.

When Burnside quit his job and decided to testify against his former employer, his voice was just one of many expressing discontent with the practices and contradictory messages that Maisel used and BIA schools promoted. Although Navajos had incorporated new metalsmithing techniques into their jewelry making throughout their history, and places like the Burke Indian School sought to encourage this practice, local museum curators, ethnologists, and wealthy collectors like Mary C. Wheelwright strongly disapproved of this embrace of technology.[58] In 1934, Mary Russell F. Colton, curator of art and ethnology at the Northern Arizona Society for Art and Science, outlined her own curriculum for public and

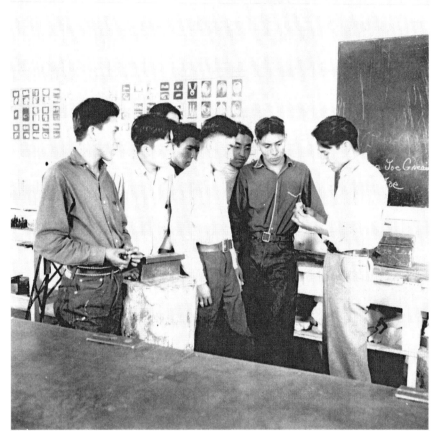

"Dooley Shorty Instructing Class in Silversmithing, 1938," by John Adair. Wheelwright Museum of the American Indian, Santa Fe, New Mexico.

Indian schools throughout the Southwest. Colton proposed that Indian schools hire "a silversmith of real ability" to teach younger Navajos how to make silver jewelry. She was emphatic that "the modern type" of smith, like Dooley Shorty, who used machinery or other "short cuts" should not be hired to teach in Indian schools. For her, the "charm" of Navajo silver jewelry rested in the fact that "it is evidentially all worked by hand, with crude tools." She wanted to preserve hand production at all costs. "As soon as the mechanical appliances are used and the surfaces are polished by an electric 'buffer,' and the turquoise cut and polished mechanically," she argued, "it is no longer real Navajo jewelry and you had just as well buy any other silver work made by machine."[59] Colton's choice of words

"Boys at the School at Silvershop Bench, 1938," by John Adair, showing Navajos working with silver at school under Dooley Shorty's direction. Wheelwright Museum of the American Indian, Santa Fe, New Mexico.

highlights the prevailing dichotomy between the "primitive" and the "civilized." Indians and machinery were incompatible ideas. Colton was, like the FTC, passionate about this issue in her desire to protect American shoppers, their expectations, and the integrity of the Navaho.

According to Colton, consumers' interest in Navajo Indian-made goods stemmed from their trust in the authenticity of the goods in question. Thus, her view placed authenticity at odds with assimilation. Authenticity, and thus consumer interest, derived from the mysterious "charm" of handwork, as long as the hands in question belonged to a Navajo. Yet Colton's publication alerts us to the fact that this issue had come to the forefront not simply because of Maisel's or Gans's practices but because Indian

students were being trained in the "mechanical arts" at BIA schools just as consumers were beginning to question the label of "Indian-made."

Regulatory Efforts: Phase One

For decades, the connection between handwork, primitivism, and the Navaho had been a useful conceit for the southwestern tourist industry, Navajo traders, dealers in arts and crafts, museums, ethnologists, and publications like Colton's hammered home the idea. As non-Indians invested in Navajo arts and crafts, those in favor of preserving the focus on hand labor in defining Indian goods argued that consumers had come to associate Navajo-made goods with a particular set of "primitive" qualities. Such associations were neither new nor insignificant.

Twenty years before the FTC filed its case against Maisel, members of the U.S. Congress debated whether to regulate the market for Indian-made goods. The legislators' interest grew out of activity at the Department of the Interior to invigorate the "Indian-made" market. Whether consumers wanted "handmade" goods, goods that signified inalienable characteristics, or simply souvenirs, as early as the 1910s, the Department of the Interior believed that most people who purchased Indian-made goods had at least some appreciation of the people who manufactured the goods. In fact, the first attempt to regulate the sale of Navajo-made goods sought to assist Indian producers and to ensure that consumers had a steady supply of high-quality goods to purchase. In the 1910s, the congressional Commission on Indian Affairs (CIA) asserted that the popularity of Navajo textiles and silverwork, even if it grew out of false ideas about Navajo labor, affected entire Navajo families. The CIA reported that in just one year, 1912, blankets that Navajo weavers made from Navajo wool had earned weavers, their families, and Indian traders $675,000.[60] The CIA also noted that 843,750 pounds of "native wool are annually worked into blankets by Navajos" and that an additional $36,000 worth of textiles made from commercially-dyed Germantown wool had also been sold. As a result, the CIA began to plan "for the preservation of . . . native industries."[61] Thus, the CIA's primary effort to regulate the sale of Navajo-made goods was spurred by consumer demand and aimed to help the entire Navajo population.

That first official attempt to oversee and "authenticate" the sale of "genuine" Navajo-made items occurred in 1914. In that year, the CIA initiated a labeling scheme to verify the authenticity of Navajo blankets. Charles H. Davis, supervisor of farming in the Indian Office, believed that labels would enhance the popularity of such goods. Hence, he began to investigate the Navajo blanket industry and eventually used his findings in developing the Davis Plan. The aim of the Davis Plan was to guarantee "the genuineness of the article" and to highlight the "unique and exceptional value" of Navajo rugs. The CIA stated that the tagging system was necessary because the market for Indian industries was routinely "exploited."[62]

In 1914, the CIA undertook an effort to protect Navajo weavers and traders from the uncertainties of the market by creating a "more certain and better market with comparatively satisfactory prices." One way to accomplish this goal, according to CIA documents, was to sell Navajo goods in larger department stores. CIA Annual Reports reveal that unnamed merchants from "populous centers" in the East supported the program in the hope that the Davis Plan would provide a "dependable and standardized supply of native Indian industries" for resale to the public. The CIA believed that weavers, traders, dealers, retailers, and consumers would all benefit from the regulation.[63] As we know, traders made attempts in the 1900s to sell Navajo goods in department stores like Bullock's, Macy's, and Wanamaker's. Yet department stores alone could not solve the economic problems of weavers or of the "Indian-made" market in general. Besides, even when stores went to great lengths to create lavish displays that evoked the frontier, consumers still valued the processes of hunting down Navajo-made blankets and jewelry either by visiting tourist destinations or by bartering with traders who worked directly with remotely located and "primitive" Indians.[64] Expanding the number of rugs for sale at set prices in department stores was not the answer. Despite Davis's intentions, his plan failed only a short time after it was introduced, perhaps partly because he seemed to recognize Navajo weavers as market-oriented actors.

Further, by 1917, the most influential Navajo traders reported that the tags would not help them sell textiles. Traders also claimed that the wholesalers and retailers to whom they sold goods removed the informative tags for "commercial reasons." Retailers feared that customers might contact the traders named on the tags.[65] In addition, the Davis Plan's own

restrictions undermined its success. Under the plan, only those blankets for which traders paid more than 75 cents per pound could bear an official linen tag reading "This blanket is the product of Navajo Indians of this Reservation and made from native Navajo wool." Those who lamented the failure of the plan claimed that wholesalers and retailers simply purchased more Navajo blankets in the less expensive category to avoid the tagging system.[66]

More important, almost all retailers set their own prices and feared standardization by the government. Some large and popular retailers, like the Fred Harvey Company, already attached their own seals of authenticity. Because Davis Plan tags would tell consumers what weavers had initially been paid, they threatened to curtail retail markups, which could run as high as 600 percent. Thus, the tagging scheme also endangered the ability of dealers and retailers to set prices. The Fred Harvey Company, for instance, had a complicated and secretive way of pricing blankets. It used codes to obscure prices from consumers, and only trained salesmen could read both wholesale and retail prices. This system gave the Harvey sales staff leeway in pricing rugs and bartering with customers. CIA tags would have limited their ability to do so. Whatever the reason, the CIA abandoned its attempt to regulate the market for Navajo blankets three years after the plan's inception.[67]

Despite, or perhaps because of, the failure of the Davis Plan, American Indian crafts remained popular throughout the 1920s. In 1920 alone, the CIA reported nationwide sales of $1,869,907 for goods made by American Indians.[68] Yet the fashionableness of Indian-made goods was all but ignored by Charles Burke, the commissioner of Indian affairs in the 1920s. Burke made no attempts to regulate, standardize, or facilitate the sale of Navajo-made products.[69]

Burke's lack of interest in Indian arts and crafts did not reflect a corresponding lack of interest among consumers and activists. Throughout the 1920s and into the 1930s, consumers in New York City, Brooklyn, Philadelphia, Providence, Boston, Chicago, Phoenix, Denver, and Los Angeles continued to buy Navajo-made rugs and silverware, read articles on Navajo life, and attend exhibitions featuring Navajo artisans. Because the market had so much potential, Dr. Lewis Meriam, author of a congressional report on the state of Indians in the United States in 1928, found that contrary to Commissioner Burke's beliefs, government intervention in the Indian art market would greatly help American Indians in the United

States, including the Navajos.[70] When John Collier assumed Burke's position, he took Meriam's charge seriously and worked for the creation of an Indian Arts and Crafts Board and altered BIA school curricula accordingly. Along with the Meriam report, and after years of failed attempts to "standardize" the terms of trade for Indian-made blankets, the contested meaning of primitivism sparked Collier's successful intervention.

Regulatory Efforts: Phase Two

Two additional governmental attempts to control the market for Indian-made goods occurred in the 1930s: one legislative and the other regulatory. Because of continued interest in American Indians and the popularity of their arts and crafts, the question of craft regulation resurfaced in the 1930s. Congressman Scott Leavitt of Montana introduced a bill aimed at "the safeguarding and improvement of quality as a means to the increase of quantity of 'Indian-made' goods." The Indian Arts and Crafts Cooperative Marketing Board Bill (Frazier-Leavitt bill) sought to widen the market for Indian-made goods and called for penalties of up to $5,000 or six months in jail for the misrepresentation of Indian arts and crafts.[71] Senator Lynn Joseph Frazier of North Dakota introduced similar legislation in the Senate. The bill's supporters noted the need to protect Indian arts and feared that, with the exception of Navajo arts and crafts, these arts were in danger of disappearing altogether. Frazier and Leavitt also argued that the development of new markets for Indian goods could bring much-needed revenue to Indian reservations and ease the miserable economic conditions that had descended on all American Indians with the onset of the Great Depression. Three years before becoming the commissioner of Indian affairs, activist John Collier agreed that the bill would "rule out machine-made imitations of Indian goods" and "reach toward an indefinitely widened market for Indian made goods of best quality."[72]

Certain segments of the public were skeptical. The Eastern Association of Indian Affairs (EAIA), whose members included authors Oliver La Farge, Mary Austin, and Mabel Dodge Luhan, objected to the bill's design to expand the market for Indian arts and crafts. EAIA members believed that the quality of goods made by Indians disintegrated when large quantities of them were produced. The EAIA wanted to find a way to save existing craft skills and established markets without expanding markets, as

the bill proposed.[73] They feared that wider markets would prompt the production of more low-grade, lightweight commercial goods—like jewelry and blankets—for middle- and working-class Americans and fewer "authentic" ones for existing connoisseurs. The reality was that since the early 1900s, the market for Indian-made goods had been infused with the kind of commercialism the EAIA found objectionable.

Navajo traders flip-flopped in their support of the bill. Initially, they believed that the creation of new markets and the promotion of Indian-made goods could help them sell overstocked rugs and blankets.[74] In 1931, however, fearing that a federally appointed board that bought, sold, and dealt in Indian-made products would invade their markets, Navajo traders withdrew their support.[75] The bill had other powerful opponents. Herman Schweizer of the Harvey Company told Lorenzo Hubbell Jr., "The Indian stands a better chance in the hands of the traders than in the hands of three or four theorists."[76] Schweizer then asked Hubbell to help kill the Frazier-Leavitt bill. Hubbell did his best, and throughout the early 1930s, the Frazier-Leavitt bill remained stalled in Congress.

As the Great Depression took its toll and economic conditions on the Navajo Reservation worsened, the government pursued another regulatory effort to quell the proliferation of imitation Indian jewelry. Like Tammen, the Jeffery Jewelry Company of Illinois faced charges of flooding the market and driving down the prices of individual bracelets, rings, and belts. In 1932, the FTC cracked down on the Jeffery Jewelry Company for selling "Navajo" and "Indian" jewelry that was "manufactured or fabricated by machinery" by non-Indians "in mills or factories" in Chicago. Not only did such practices deceive the public, they also diverted much-needed trade from Navajo Indians engaged in hand production and from injured traders and smiths—like Mike Kirk, Julius Gans, and perhaps even Maurice Maisel—who had to compete with mass-produced goods in the marketplace.[77]

Meanwhile, observers and traders decided that continued action was necessary to protect the markets for Indian-made goods and the income they generated. Two years before the FTC action in the Jeffery case, the American Indian Defense Association "predicted that the Navajos would suffer acutely during the winter ahead and that even the reservation traders who were indispensable to the Navajo economy would face extreme difficulties."[78] This prediction came true. The more depressed the U.S. economy became, the more important was the sale of blankets and

jewelry to Navajo Indians and Indian traders. The superintendent of the Eastern Navajo Agency even suggested to the BIA that the bureau ask civic organizations such as the Boy Scouts, Red Cross, 4-H clubs, and Campfire Girls to buy Navajo rugs as a way of helping the Navajos survive the winter. In the early 1930s, one-third of all Navajo income "derived from craft objects, principally blankets and jewelry."[79]

Over the years, traders learned that working for a legislative solution like the Frazier-Leavitt bill was time-consuming and inefficient, so they began to favor direct action. Thus, a group of 144 Navajo traders met in Gallup, New Mexico, at the Intertribal Ceremony in 1931 to "organize for the protection of their Indian merchandise," especially "the Navajo rug." The newly formed United Indian Traders Association (UITA) advocated "certain standards" in workmanship and material in the production of Indian goods.[80] Eventually, like other powerful business interests, they turned to the FTC. However wedded the traders were to the rhetoric of primitivism and the narrative of frontier commerce, their turn to the regulatory state reveals their awareness that Navajos and their "Indian-made" products existed within the modern market economy.

Defining "Indian-Made"

At this moment, in the shifting context of economic insecurity, the importance of consumer-oriented activity spurred the UITA, FTC, and, eventually, the Committee on Indian Arts and Crafts (CIAC) to create a legally binding definition of the "Indian-made" label. Although Burnside may have attracted Eugene Burr's attention, the UITA was the one to press for FTC investigation into the matter. The case against Maisel first went before an FTC examiner and then, by way of appeal, made its way to the Tenth Circuit Court in Denver, Colorado. After the FTC charged Maisel in May 1932 with "making and selling jewelry . . . produced by Indian workmen by means of modern equipment and machinery" that was "made by (Navajo) Indians through the primitive methods of hand production," the court finally decided the matter in May 1935.[81] Not only did the judges rule that the commission had adequately demonstrated that Maisel's employees used some machinery in the process of manufacture, they ruled that as "a corollary to this proposition it must follow that the adjudged deceit of the public is on account of the Indian not having

spent . . . time in pounding the basic silver into the desired shape and thickness." To come to their decision, the judges had relied heavily on La Farge's testimony. According to "several witnesses . . . principally the anthropologists," it was "through the pounding process the Indian puts something of himself into the article." The court acknowledged, however, that "no Indian supports this theory." Indeed, "so far as the Indian is concerned, the shortest route to the desired remuneration is his chief objective." In the end, the Court ruled that "the theory of the anthropologist must be sustained."[82]

The involvement of silversmiths like Burnside and Petsoe in the Maisel case introduces us to the complexities surrounding the production of goods bearing the "Indian-made" label. The one-dimensional portrait of the primitive Navaho ascribed to Navajos roles that they did not always wish to—or in this case, would willingly—play. Instead, Navajos produced Indian-made goods for a number of reasons. As artists, silversmiths valued the creation of beauty. As skilled workers, they wanted the opportunity to ply their trade. As wageworkers, they needed the money their skills brought in. Although various marketing ploys had led consumers to believe that the image of the "primitive" silversmith was forever fixed, in reality, Navajo silversmiths represented a wide range of skills, modern market interests, and personal motivations, ranging from the economic need for wages to the cultural imperatives of *hózhó* through artistic creations.

In listening to La Farge, the court openly ignored a host of other issues relevant to the silversmiths. The perception of the Navaho—or what La Farge referred to as "propaganda"—had been produced, marketed, commodified, consumed, and then codified into law. This final decision marked an important moment for Navajo workers during the Great Depression. On one hand, it offered potential employers—the reservation traders—protection from "unfair" competition. On the other, it linked silversmiths, and their work, to an unfair and limiting stereotype of Navajos as Navaho primitives. The tension between what consumers expected (low-cost items that authentically represented the preindustrial past) and what producers deserved (recognition of their skills through just compensation) would continue throughout the twentieth and into the twenty-first century. Eventually, that tension would tie Navajos and the branding of their culture to the international marketplace in a host of complex ways.

The struggles among Indians, traders, collectors, and others interested in Indian-made objects came to a head in the Maisel case. However, Burnside's success in helping to bring the court case did not carry through to give Navajos' greater influence on the market. When the Tenth Circuit Court met in Denver to determine whether goods made by Indians using modern equipment could be labeled "Indian-made," it announced that Indians themselves favored the "shortest route to remuneration." The court did not let the views of the Indians who testified on Maisel's behalf sway its decision. Instead, it ruled that the "theory of the anthropologists must be sustained."[83] That theory, perpetuated by Oliver La Farge and others, held that it was "through the pounding process" that the Indian put "something of himself into" a piece of jewelry. If consumers were to continue to buy the image of Navaho Indians through their Indian-made goods, then use of large industrial machines was not acceptable.

A number of powerful actors had developed strong vested interests in the images of the "primitive" Indian producing authentic rugs and jewelry in time-honored, preindustrial fashion. The Navaho provided an object of study for anthropologists, added value to goods sold by traders, and offered status to collectors. The Navaho even offered something to some Navajos, who could parlay their mastery of "traditional" techniques to gain status and money. When the court gave the force of law to the equation conflating "Indian-made" and "primitive," it satisfied, at least in part, each of these groups.[84] However, it did so at the cost of oversimplifying the past and present of the Navajo people, who were living complicated lives in the real world, on the disadvantaged fringes of the modern American economy.

Branding, Borders, and Beyond

The "Indian-made" controversy of the 1930s did not close the story. Tensions over the authenticity and appropriation of Indian culture have persisted, and in recent years, as anthropologist Michael Brown notes in *Who Owns Native Culture?*, have intensified.[1] Questions about authenticity have simultaneously broadened, by going global, and receded, by narrowing the criteria for defining products as authentically Indian and determining where they can legitimately be made. By the late twentieth century, demand for Navajo blankets, for instance, had spawned an extensive market that, through its manipulation by American dealers, pitted Navajo Indians, as Americans, against Zapotec Indians, as Mexicans. National boundaries have given additional value to some goods and undercut others, casting goods as expressions of different national identities. In no case, however, have external forces alone—either political developments or cultural appropriations of primitivism—completely controlled the way artisans engage with the market.

To understand the role of national politics in these contemporary controversies, we need to revisit the United States' conquest of the Southwest in the 1840s. The integration of the Southwest into the nation, which occurred during the "classic period" of Navajo textiles and continued into its "transitional period," separated Mexico and the United States and divided the indigenous peoples of Mexico and the United States into different national populations: Americans and Mexicans. These geopolitical

forces created specific regional economies that were governed by federal regulatory entities and answerable to national laws governing trade between Navajos and white Americans, as well as trade between Americans and Mexicans in general.

Within the boundaries of the United States, Navajos had become the Navaho by 1930—a unique population supposedly doomed to one form of vanishing or another. The Navaho were depicted as creative, industrious, and as more than one observer noted, adept "cultural borrowers." As with other "outsider" populations, their ultimate demise seemed unavoidable. They would either assimilate, with the guidance of whites, or they would slowly die out. As early as 1887, the idea began to circulate that Navajos would either develop into civilized beings or would remain "demons or brutes" doomed to extinction if they were left without the improving influence of education.[2] President Grover Cleveland concurred with this idea and urged the Bureau of Indian Affairs to support assimilationist agendas in Indian boarding schools.[3] By the early 1900s, others, like Stewart Culin, were predicting that the Navajo would assimilate as a natural part of their evolution.[4]

Images like Edward Curtis's "The Vanishing Race," which depicted a line of Navajos slowly plodding toward the sun-drenched buttes, reinforced the idea of the Navajos' extinction. In the photo, Navajos, their backs to the camera, trudge away from, not toward, civilization. Promoters of "Indian-made" goods folded this type of highly staged tableau of disappearance into the standard marketing ploy that imparted a sense of urgency to American consumers. Consumers should not lose what might be their final chance to take home part of the mythologized West; this appeal helped persuade consumers to buy millions of dollars' worth of Navajo-made textiles and jewelry from traders, dealers, and curio-store owners. Advertising campaigns conveniently ignored the fact that the Navajo population was actually growing and focused on the mythologized Navahos instead of real people.

While dealers helped consumers invest in "scarce" goods, traders hoped that white consumers would view the popular and stylized Navajo rugs and jewelry as novelties that evoked the "frontier" and reaffirmed their racial status as civilized consumers. As with other "exoticized" populations in other tourist destinations, material representations of Navaho culture became popular souvenirs.[5] The Navahos, and the goods that Navajos made, came to represent a place—the Southwest; a time—the

past; and an ideology of racialized national pride—the triumph of white "civilized" American democracy. Yet even as Navajo artists created their goods with the American marketplace in mind, they sought to stay true to their cultural imperatives. The sale of their goods could strengthen their kinship networks and support the larger community.

Beyond demonstrating their agency in the marketplace, Navajo artists differentiated themselves from other Americans by creating rugs or jewelry for American consumers. Navajos weavers, for instance, integrated new yarns, color schemes, and designs into their textiles, never losing sight of Spider Woman, *hóhzó,* or the marketplace. Even as traders took credit for such innovations, weavers took pride in the creation of specific styles, such as the subtle Wide Ruins rugs, the dramatic Ganado Reds, the symbolic Storm Patterns, and the religiously inspired Yei Bi Chi designs. These designs soon came to represent both a general product—if not a brand—and specific regions, because they were associated with weavers from across the Navajo reservation. Although not all weavers made rugs that signified specific parts of the reservation, the highly stylized and differentiated Navajo-made rugs gradually assumed a general trademark status that persists today, simultaneously fostering cultural, regional, and national specificity. As Rosemary Coombe has pointed out, trademarks can be "logos, brand names, characteristic advertising images, or other (usually visual) forms that condense and convey meaning in commerce."[6] She contends that the "ubiquity of trademarks in *national social arenas* and their currency both as culture and as private property create generative conditions for struggles over significance."[7] As consumers came to associate Navajo rugs with specific images of Navahos created by individuals like Curtis and Harvey Company managers, Navajos struggled to gain control over the Navajo brand.

By the 1930s, conditions in post-Fordist America were ripe for a struggle over the meaning of Navajo "Indian-made" goods. During this decade, the state intervened not only by regulating Indian affairs, long an arena of government activism, but also by codifying markers of Navaho identity, further entrenching the cultural trademark of "Indian-made" goods. In the mid-1930s, the United Indian Traders Association attempted to protect the market for Navajo rugs from large-scale manufacturers. Although the Federal Trade Commission (FTC) ruled that only handmade goods could bear the label "Indian-made," it also sought to protect white consumers from buying goods that had been mass-produced in white-owned

factories to resemble Navajo Indian jewelry or rugs or by southwestern Indians in machine shops. Coming on the heels of the FTC's regulatory efforts, Congress established the Indian Arts and Crafts Board in 1935 to police the sale of "Indian-made" products, including those made by Navajos. The intent of this act was twofold: to preserve indigenous craft cultures and economies, and to protect consumers from retailers who used deceptive marketing practices.[8]

By the 1940s, the Navajo Nation decided to take matters into its own hands by starting the Navajo Arts and Crafts Guild in Fort Wingate, New Mexico. The guild's first director, a Navajo silversmith named Ambrose Roanhorse, helped the organization expand across the reservation. Avoiding the tourist market, Roanhorse focused on producing "the finest type of Navajo handcrafts." As the guild grew, more and more Navajos across the reservation began producing Navajo textiles and silver jewelry. By 1972, the guild had reorganized as the Navajo Arts and Crafts Enterprise (NACE). At that point, demand for Navajo jewelry peaked, and paradoxically NACE began mass-producing Navajo Jewelry to fill orders placed by larger retailers like Sears and Montgomery Ward. As silversmiths made more and more goods, and silver prices spiked from $4 to $50 per ounce, quality deteriorated, and the tribe lost over $1 million.[9] In this moment of crisis, Navajo Raymond Smith took over the "wobbly enterprise," reestablishing its commitment to quality and rebuilding its national reputation and profit margin. In creating Nace, the Navajo Nation claimed the authority to regulate goods on its own terms. In so doing, Navajos contributed to consumer confidence in Navajo-made goods, and after some difficulties in the late 1970s, trust in the Navajo brand itself. The Navaho had not completely disappeared. Tourists and consumers still harbored outdated ideas about the Navaho, but Navajos began publicly and forcefully to assert their agency. For decades, Navajos had actively participated in the marketplace. As such, they declared their dual identity as Navajos and as Americans; rather than seeing these identities as separate categories, Navajos lived them as one. When another threat to the market for "Indian-made" goods arose in the 1980s and 1990s, the focus was not strictly on mass manufacturing or on definitions of "Indian-made." Instead, Navajos now encountered market competition from another indigenous population and faced questions about who qualified as an authentic Indian.

Recent debates about Navajo-made goods no longer focus exclusively on the mass production of goods. Instead, they often focus on the national

identity of the producers.[10] Observers of Navajo craft industries in the 1980s and 1990s reported that the brisk expansion of foreign textiles with Navajo designs was putting pressure on the market for Navajo rugs and blankets (and other Indian arts and crafts), which had been relatively strong since the early twentieth century. Sociologist Kathy M'Closkey and other critics of foreign producers believe that the importation of "fake" textiles fundamentally harms the Navajo weavers and the larger Navajo community.[11] Consumer advocates worry that the sale of Navajo reproductions misleads consumers who want authentic Navajo-made rugs as ethnic art or as emblems of America's frontier heritage and nationality.

Navajos recognized the complexity of this situation. On April 8, 1998, *USA Today* featured a front-page article on the economic crisis caused by the flood of faux "Indian-made" goods coming into the American market. The headline warned, "Indian Art: Buyer Beware, Artisans Pay Price of Counterfeiting." The newspaper informed its readers that each year, hundreds of thousands of tourists traveled to the Southwest and spent more than a billion dollars on American Indian arts and crafts. "Increasingly," reported John Shiffman, "much of what's for sale isn't handmade or crafted by [American] Indians." As a result, American Indian craftsmen and women lost up to 90 percent of the trade and the income generated from it to foreign production. The article quoted Lee Yazzie, a Navajo silversmith from Gallup, New Mexico: "When you rob people of their design and take it overseas (for production) and get another people there to do it for peanuts, then two groups of people are being taken advantage of." Echoing the FTC's initial concern in 1932, Yazzie added that when consumers unwittingly purchased faux "Indian-made" goods, they were the victims of deception and fraud.[12]

The most commonly noted "threat" to the Navajo textile market has come from the Zapotec Indians. M'Closkey reports that "sophisticated copies" of Navajo rugs "are created by thousands of Zapotec weavers active in cottage industries" and that the entrepreneurs "who appropriated Navajo patterns to this region [and] import the finished products into the United States" mark up the prices of the rugs from 200 to 1,000 percent.[13] Anthropologist William Warner Wood has reported that the once-distinctive "Zapotec textiles are no longer sold as Zapotec textiles but as Southwestern U.S. textiles" or rather "as inexpensive, vaguely ethnic or Native American textiles" that have specific "Navajo-like" patterns.[14] Wood sees this competition as part of an expansion of local production

and trade networks that have allowed the Zapotecs to become produc-
ers of products connoting the distinctive regional, southwestern style. In
contrast, M'Closkey believes that the producers of these rugs place little
cultural meaning on their manufacture. Because Zapotec rugs sell for sig-
nificantly lower prices than do rugs made by Navajo weavers, even with
a high retail markup, M'Closkey and others fear that escalating sales of
the Zapotec-made goods in hotel gift shops, curio stores, ethnic-art gal-
leries and through websites will further undermine the economic well-
being of weavers on the Navajo reservation and destroy a "way of life" in
the process.[15]

Lee Yazzie's statement about the exploitation of two groups of people
directs our attention to the complexity of the marketplace and the ubiq-
uity of culture. As the market for Navajo-made goods grew, early deal-
ers and traders exported representations of Navajo-made goods to distant
communities. In some ways, this process has been replicated among the
Zapotec. Like the Navajos, the Zapotecs have been weaving since before
the arrival of the Spanish. Like Navajos during the early period, Zapotecs
initially manufactured textiles to trade with surrounding communities,
but their trade networks were not as extensive as those in the North. They
also worked with intermediaries, as the Navajos did with the early Navajo
traders, to connect stores in the United States with weavers in Teotitlán.
Since 1970, Zapotecs have experienced their own "transitional period" and
have seen many changes in the production of their goods, including the
expansion of Zapotec craft industries, the emergence and growth of a mer-
chant class, and the mass export of rugs.

This process was possible in part because of deepening national con-
sciousness in Mexico. Just as Navajo culture became an expression of
national culture and Navajo-made products connoted American national
pride, Mexican nationalists promoted Zapotec textiles during a key pe-
riod in Mexican history. In the postrevolutionary period in Mexico, after
the 1910s, many intellectuals and politicians "worked to create a sense
of Mexican national identity in which indigenous culture was a prom-
inent feature" and helped to develop both ethnic pride and tourism.[16]
Government-sponsored programs featured Zapotec textiles to highlight
indigenous crafts, viewing the native industry as a matter of Mexican
pride. Responding to this interest and drawing on their tradition of tex-
tile production, Zapotec weavers wove rugs with their own geometric
designs. Their unique designs became popular expressions of Mexico's

indigenous and Aztecan past. Yet by the 1970s and 1980s, Zapotecs were making textiles not only for tourists within Mexico but also for export to the American Southwest, where the goods are still sold.[17]

Exporting Zapotec rugs required a high degree of coordination among U.S. retailers, Mexican middlemen, and Zapotec weavers, all of whom wanted to take advantage of the mania for southwestern style that flourished in the 1970s. By 1980, American wholesale buyers of Zapotec rugs were bringing books and museum catalogs with photos of Navajo rugs to Oaxaca. Retailers and middlemen told the weavers what to make for specific markets in Santa Fe and Taos.[18]

The organization of the Zapotec weaving industry has again changed since the 1990s. Because of high demand among American consumers for Zapotec textiles, the rugs are no longer produced exclusively in Teotitlán by Zapotec weavers for local intermediaries. The rugs have become part of a larger global process. Zapotec weavers now reproduce Navajo designs, while American businesses coordinate production and trade. In today's globalized world, the production of a Zapotec textile starts with an order from a business in the United States.[19] Like Navajos, Zapotecs have kept their textile traditions alive by heeding international market demands in the production of their goods. They have been able to keep families together and to stay employed by working to meet the demands of the ever-growing market for southwestern-style goods.

Navajos are affected by the import of so-called fake rugs, yet so too are the Zapotec artisans who manufacture the Navajo-style rugs. As Wood suggests, when Zapotec textiles enter the marketplace, "the various 'traditions' for woolen 'serape style' textiles on both sides of today's U.S./ Mexico border are so completely intertwined that they are neither products of Mexico nor the United States exclusively."[20] Instead, the hybrid indigenous designs are "the product of a set of distinct but interconnected weaving traditions that . . . span an international border."[21]

Wood's assessment forces us to wonder whether participation in the global marketplace has changed local Navajo and Zapotec weaving communities and cultures. Are global influences intervening in Zapotec culture just as frontier commerce forever changed the Navajos? After all, for a brief period around 1900, white middle-class consumers valued Navajo textiles as unique items produced only by a "primitive" population and viewed them as cheaper versions of Persian rugs. The intermediaries (traders and dealers) encouraged weavers' use of new patterns

and designs (Persian rugs), facilitated the use of new dyes and materials (Germantown yarns), and then marketed Navajo textiles to middle-class American consumers as representations of the frontier-era "vanishing race" of American Indians. They highlighted the skill of weavers—who worked only with their hands—as the key to the authenticity of the product. Just as Navajo weavers reproduced design elements from Persian rugs to meet consumer tastes, Zapotecs have created rugs that are popular down-market tourist items because they mimic Navajo styles. An interesting difference exists, however: Marketers have downplayed Zapotec Indian identity in this process of exchange, unlike the traders in Navajo goods 100 years ago, who promoted the concept of the Navaho to stimulate demand.

Consumers have recently conflated the ethnicity and national identity of Zapotec Indians to assert the inauthenticity of Zapotec rugs. U.S. law requires the labeling of Zapotec rugs sold in the country as "made in Mexico." Yet some Zapotecs would prefer to sell them as "Indian-made" goods. In 1992, a Zapotec weaver named Antonio attempted to sell rugs directly to consumers in Santa Fe during the popular and lucrative Indian Market week. As Antonio carried the rugs around Santa Fe's plaza, trying to catch the attention of potential buyers, an elderly customer approached him and asked, "What tribe are you from?" He answered that he was a Zapotec Indian. "Oh . . . Zapotec," the man responded. "And where is that reservation located?" When the seller replied that his village was in Mexico, the prospective buyer retorted, "Mexico, no . . . I'm not interested in a Mexican blanket," and walked away.[22] As this episode reveals, the Zapotecs have been drawn into an international market for a locally manufactured and nationally symbolic product in which their own ethnicity has little or no value. In contrast, Navajo-made rugs have value in part because they have become a brand embodying the qualities ascribed to Navajos over the years and because Navajos and consumers have continued to attach value to them.

As federally recognized Native Americans, Navajos are citizens of their own nation—the Navajo Nation—and of the United States. This dual nationality indicates both that Navajos have maintained their culture in the face of shifting political borders and that cultural distinctions can be slippery and malleable. Cultural traditions separate groups, but so too do national borders. Borders matter, especially when the regulation of trade affects the marketing of products that convey meaning about nationalism

and identity to buyers. American shop owners who sell Zapotec rugs find ways to make these goods appealing to American consumers who are largely interested in goods made by American Indians, not Mexicans. They do so by cleverly emphasizing the generic "Indian-ness" of the weavers or the "primitive nature" of the hand-woven textiles. In a sense, then, they evoke the Navaho brand without mentioning Navajos. They find creative ways to slide over the fact that the rugs are made in Mexico by the Zapotecs. As the elderly gentleman in our example reveals, American consumers still consider Zapotec textiles "not worthy of purchase in their own right as Native American crafts but as cheaper substitutes for the 'real thing': a Navajo textile."[23] For this reason, shops downplay Zapotec identity and Mexican nationality.

This strategy has paid off for dealers. As Antonio's story reveals, it places Zapotec weavers in a weak position if they want to influence the market. Intermediaries and consumers play an important role in constructing variations of Navajo and Zapotec identity in the global market. This image-making schema almost wholly obscures the history of local craft industries, the transformation of local economies, and the cultural importance of the artisans' skills to the community.

Navajo representatives have tried to publicize these issues by proposing the use of an official trademark for their cultural products. Contemporary Navajo weavers want to preserve market opportunities while maintaining the cultural importance of the goods they make. At the same time, they want to protect non-Navajo weavers and consumers from being "taken advantage of." As a result, they acknowledge the necessity of passing on the craft to subsequent generations, the need for effective state regulation— even though they are suspicious of the federal government—and the value of improving marketing strategies. At a 1998 meeting of the Navajo Arts and Crafts Forum, Ferdinand Notah, executive director of the Navajo Division of Economic Development, noted the importance of marketing Navajo arts and crafts as expressions of the Navajo Nation in order to emphasize the Navajos' role in the world.[24] Navajo silversmith Ray Tracey even advocated marketing Navajo culture, much like Air Jordan basketball shoes, Perrier bottled water, and Levi's Jeans. "Name recognition is vital in business," he said at the 1998 meeting.[25] Andy Abeita, an activist who works "to protect and promote authentic Indian arts and crafts," emphasized "the importance of artwork for education and the preservation of culture." Abeita reminded the other artisans in attendance that

their primary "communication" with the world at large "is through arts." Edward P. Howard, a lawyer from the Center for Law and Public Interest, told forum members that he was committed to "solving once and for all the problem of fraudulent competition" of Indian arts and crafts. He charged audience members to bring him a case he could prosecute, so that the courts could establish a precedent in law.[26]

As the discussion at the Arts and Crafts Forum illustrates, Navajos are aware of the economic and cultural importance of their arts and crafts as markers of their identity. Although Congress passed the Arts and Crafts Act in 1990 to provide a mechanism to stem the import of "fakes" or goods manufactured by people outside the United States and sold under false pretenses, artisans seldom make use of it because of lax enforcement and cultural attitudes towards the law. Audience members told Howard, for instance, that "suing someone in a court of law is against the ways of traditional Navajo society," while admitting that this approach sounded like an effective way of stemming the flow of Navajo knockoffs into the marketplace.[27] Clearly, Navajo culture maintains a key role in Navajo society.

The 1990 act was the culmination of several earlier attempts to regulate the trade in "Indian-made" goods and it specifies which indigenous group or groups can sell products using the "Indian-made" label. Consumers look for such indications of authenticity when they purchase Indian-made products—and an official label is therefore appealing.[28] Unfortunately for the Zapotecs and other indigenous peoples outside the United States, a product has to be handmade by a member of a federally recognized tribe to carry the "Indian-made" label. The law also discourages Indians like Antonio and members of other non-recognized groups, who are proud of their heritage and products of their labor, from selling goods as products of their culture. Ethnic-art dealers skirt these regulations in creative ways. Some dealers do not tag Zapotec rugs at all and simply place them in close proximity to certified Navajo weavings. Others attach tags with the names of specific weavers—many of whom are invented by dealers—without mention of a tribal or national identity. Others simply claim that a rug is made of 100 percent wool and dyed with natural vegetable dyes—features that consumers have associated with Navajo textiles since the turn of the twentieth century. An additional strategy is to emphasize the "primitiveness" of the Zapotec Indians while minimizing the fact that the weavers live, work, and weave in Mexico. All

these strategies seek to reinforce the images of "Indian-ness" that have developed within "the particular social and cultural space of the Southwest, images that have been successfully manipulated in the marketing of arts and crafts of the past."[29]

Since the beginning of the twentieth century, consumer demand has fueled retailers' efforts to control perceptions of the Navaho and increase the market for Indian-made goods. Yet when consumers buy Zapotec reproductions of Navajo rugs in the United States, real Navajo weavers—not romanticized ones—feel the pinch. This fact highlights a fascinating theme in the relationship between representation, economics, and politics: before the establishment of the modern border between the United States and Mexico, the flow of trade between the two nations was largely unhindered by state intervention. Yet contemporary political intervention (in part on behalf of Navajos and their marketing strategies) has sought to assert cultural ownership and certify the authenticity of products, even though these goods may carry different meanings for different groups. By 2000, Navajo artists were asserting that they have made a trade name for themselves that needs to be protected, whether or not it is a legally registered trademark. We might wonder, then, if the concept of the Navaho from one era, which codified craft products while misrepresenting Navajos, could be reappropriated and updated in the contemporary era to accurately represent real people, craft processes, and tribal identity. In this scenario, three questions remain unanswered. Does global competition strengthen Navajo identity? What will be the fate of local Zapotec textile producers now that the forces of international free trade have expanded the market for their rugs? Finally, what are we to make of an economy that valued a culturally specific understanding of Navaho identity but still has a difficult time acknowledging the full worth of Navajo craftsmanship and labor?

The ability to sell Navajo-made rugs and jewelry to Westerners, who have a tendency to locate "beauty in things" rather than in the production of them, shows that Navajos, whom whites saw as outsiders in a more centralized domestic market (that is, as Navahos), were able to maintain their supposedly peripheral cultural traditions in the face of the dominant society's potentially hegemonic power. Navajos would have produced beautiful goods even if outsiders had not bought them, but they were also able to trade the goods while retaining the items' value as cultural expressions.

In this sense, culture and economics were, and continue to be, inter-twined. Thus, even as weavers—or silversmiths—have incorporated new materials and technologies into the design and production of their goods, they have not sacrificed their cultural identities. By selling the goods they make, weavers and their families have maintained and strengthened the core cultural beliefs, like those surrounding Spider Woman and weaving, that were trade oriented from their inception.[30] Navajos have not simply responded to outside influences, nor have they relinquished their culture. Instead, they have struggled, and continue to struggle, to maintain their cultural traditions as they create and sell their products.[31]

NOTES

Introduction. Navajos, the Navaho, and the Market for Indian-Made Goods

1. The use of the words *Navajo* and *Navaho* are intentional. See the explanation in subsequent paragraphs.
2. Rinehart took the photograph of Chief Wets It in 1898 in Omaha, Nebraska. The Goodwins used Navajo-sounding words to describe their guests. *Hostine,* for instance, is the Navajo word for "man" or "Mr.," and *klish (tl'iish)* means "snake." On indigenous dress, see Josephine Paterek, *Encyclopedia of American Indian Costume* (Denver: ABC-CLIO, 1994), 93–96.
3. On Laura Sedgwick Collins as a composer, see "For Arts Club Library," *New York Times,* April 24, 1906, 11; on Marie Penfield, see "A Process Server's Nerve," *New York Times,* December 21, 1900; M. R. Harrington, "'Finds' on Long Island," *New York Times,* September 28, 1902.
4. Frank McNitt, *Richard Wetherill: Anasazi* (Albuquerque: University of New Mexico Press, 1966); James E. Snead, *Ruins and Rivals: The Making of Southwest Archaeology* (Tucson: University of Arizona Press, 2001).
5. Hyde Exploring Expedition activity and holdings, *Holsinger Report,* December 5, 1901, file no. 1902-11158-1, National Archives and Records Administration, Washington, D.C. The term *Navajo trader* refers to non-Indians licensed to trade with Navajos on the reservation.
6. "Navajo Indian Fiesta," Warshaw Collection of Business Americana, Indians, box 2, Archives Center, National Museum of American History, Smithsonian Institution, Washington, D.C.
7. Colleen O'Neill, *Working the Navajo Way: Labor and Culture in the Twentieth Century* (Lawrence: University Press of Kansas, 2005); Kathy M'Closkey, *Swept under the Rug: A Hidden History of Navajo Weaving* (Albuquerque: University of New Mexico Press, 2002); Alice Littlefield and Martha Knack, eds., *Native Americans and Wage Labor: Ethnohistorical Perspectives* (Norman: University of Oklahoma Press, 1996); Brian Hosmer, *American Indians in the Marketplace: Persistence and Innovation among the Menominees and Metlakatlans, 1870–1920* (Lawrence: University Press of Kansas, 1999).
8. Robert F. Berkhoffer Jr., *The White Man's Indian: Images of American Indians from Columbus to the Present* (New York: Vintage, 1979); Leah Dilworth, *Imagining Indians in the Southwest: Persistent Visions of a Primitive Past* (Washington, D.C.: Smithsonian Institution Press, 1996); Philip Deloria, *Playing Indian* (New Haven, Conn.: Yale University Press, 1998); Sherri Smith, *Reimagining Indians: Native Americans through Anglo Eyes, 1880–1940* (New York: Oxford University Press, 2000); Shari M. Huhndorf, *Going Native: Indians in the American Cultural Imagination* (Ithaca, N.Y.: Cornell University Press, 2001); Molly Mullin, *Culture in the Marketplace: Gender, Art, and Value in the American Southwest* (Durham, N.C.: Duke University Press, 2001). Although Mullin is not writing about whites "playing Indian," she does demonstrate that whites supported the sale of "authentic"

Indian arts and crafts both to help indigenous peoples and to bolster the creation of specific gendered identities. Alan Trachtenberg, *Shades of Hiawatha: Staging Indians, Making Americans, 1880–1930* (New York: Hill and Wang, 2004); Paige Raibmon, *Authentic Indians: Episodes of Encounters from the Late-Nineteenth Century Northwest Coast* (Durham, N.C.: Duke University Press, 2005); Jennifer Nez Denetdale, *Reclaiming Diné History: The Legacies of Navajo Chief Manuelito and Juanita* (Tucson: University of Arizona Press, 2007); Martin Padget, *Indian Country: Representations of Travel in the Southwest, 1840–1935* (Albuquerque: University of New Mexico Press, 2004).

9. Pierre Bourdieu, *The Field of Cultural Production* (New York: Columbia University Press, 1993), 7.

10. Elazar Barkan and Ronald Bush, *Prehistories of the Future: The Primitivist Project and the Culture of Modernism* (Stanford, Calif.: Stanford University Press, 1995), 2. Barkan and Bush define modernism as "a mixture of violence and aestheticism; the difficulties of placing and displacing the modern and the primordial; the conflation of the past and the future" (2).

11. T. J. Jackson Lears, *No Place of Grace: Antimodernism and the Transformation of American Culture, 1880–1920* (Chicago: University of Chicago Press, 1994), xvi.

12. Ibid., xi.

13. Marianna Torgovnick, *Gone Primitive: Savage Intellects, Modern Lives* (Chicago: University of Chicago Press, 1990).

Chapter 1. Creating the Navaho

1. H. A. Belt, quoting Herman Schweizer in a letter to Gladys Reichard, May 27, 1939, Gladys Reichard Collection, Museum of Northern Arizona, Flagstaff.

2. J. F. Huckle to J. L. Hubbell, July 20, 1905, October 27, 1905, and 1906 letters about Indian work agreements and authorization of salary agreements, Fred Harvey Company folder, box 37, Juan Lorenzo Hubbell Collection (JLHC), University of Arizona Special Collection, Tucson, Arizona; Gladys Reichard, *Navajo Medicine Man: Sandpaintings and Legends of Miguelito* (New York: J. J. Augustin Publisher, 1939), 5.

3. H. A. Belt to Gladys Reichard, May 27, 1939, Reichard Collection. On staged authenticity, see Dean MacCannell, *The Tourist: A New Theory of the Leisure Class* (New York: Schocken Books, 1989), 94; John A. Jackle, *The Tourist: Travel in Twentieth Century North America* (Lincoln: University of Nebraska Press, 1985), 30. On the Harvey Company's creation of a primitivist spectacle, see Leah Dilworth, *Imagining Indians in the Southwest: Persistent Visions of a Primitive Past* (Washington D.C.: Smithsonian Institution Press, 1996), 82–95.

4. Reichard, *Navajo Medicine Man,* 5.

5. J. T. Swively, Fred Harvey Manager, to Hubbell, May 24, 1905, box 37, JLHC. For Navajos, burying the umbilical cord in Navajo country is important to one's spiritual development because it symbolizes the shift from maternal sustenance to spiritual nurturing by the Earth. Maureen Trundell Schwartz, *Molded in the Image of Changing Woman: Navajo Views on the Human Body and Personhood* (Tucson: University of Arizona Press, 1997), 138–140.

6. Huckle to Hubbell, July 1, 1905, JLHC.

7. Ibid., July 20, 1905, October 27, 1905, JLHC.

8. Ibid., October 24, 1905, JLHC.

9. Ibid., May 24, 1905, to September 13, 1905. Quote from Huckle to Hubbell, June 9, 1905, JLHC; Belt to Reichard, May 27, 1939, Reichard Collection.

10. Huckle to Hubbell, July 1, 1905, JLHC. Navajos have strong taboos against death. Alexander H. Leighton and Dorothea C. Leighton, *The Navajo Door: An Introduction to Navajo Life* (Cambridge, Mass.: Harvard University Press, 1945), 57–58.

11. Traders commonly refer to Navajo death taboos in their memoirs, interviews, and autobiographies. For an example, see Will Evans, *Along Navajo Trails: Recollections of a Trader*, ed. Susan E. Woods and Robert S. McPherson (Logan: Utah State University Press, 2005), 228–229; Kathryn Gabriel, ed., *Marietta Wetherill: Recollections on Life with the Navajo in Chaco Canyon* (Boulder: Johnson Books, 1993), 192–194. Philip Reed Rulon, ed., *Gladwell Richardson: Navajo Trader* (Tucson: University of Arizona Press, 1986), 16–17, 78–79; Reichard, *Navajo Medicine Man*, 5.

12. John Frederick Huckle to Herman Schweizer, July 20, 1905, box 37, JLHC.

13. Leighton and Leighton, *The Navajo Door*, 57–58. Navajos rarely trusted the treatment of family members to outsiders. The Leightons write, "When a man or woman gets sick, the family takes over the direction of treatment. . . . The family decides whether to call the Singer" (58). Miguelito, as a medicine man, probably would have been particularly opposed to the hospitalization of his wife. Harvey Company and Hubbell correspondence, May–September 1905, JLHC. On Adjiba's death, see the letter dated July 24, 1905, which provides some indication that the baby survived. Oral history, Marie Curley, 1977, Hubbell Trading Post National Historic Site, U.S. National Park Service, Ganado, Arizona.

14. Marta Weigle and Barbara A. Babcock, eds., *The Great Southwest of the Fred Harvey Company and the Santa Fe Railway* (Phoenix: Heard Museum, 1996); Dilworth, *Imagining Indians in the Southwest*.

15. The date is currently contested by anthropologists, archaeologists, and Navajo oral tradition. Peter Iverson, *Diné: A History of the Navajos* (Albuquerque: University of New Mexico Press, 2002), 12–19. Jennifer Nez Denetdale, *Reclaiming Diné History: The Legacies of Navajo Chief Manuelito and Juanita* (Tucson: University of Arizona Press, 2007).

16. Kelli Carmean, *Spider Woman Walks This Land: Traditional Cultural Properties and the Navajo Nation* (Walnut Creek, Calif.: AltaMira Press, 2002), 6.

17. Iverson, *Diné*, 24–29. James Brooks, *Captives and Cousins: Slavery, Kinship and Community in the Southwest Borderlands* (Chapel Hill: University of North Carolina Press, 2001), 95. Ronald H. Towner and Jeffery S. Dean, "Questions and Problems in Pre–Fort Sumner Navajo Archaeology," in *The Archaeology of Navajo Origins*, ed. Ronald H. Towner (Salt Lake City: University of Utah Press, 1996), 8; Marsha Weisiger, "The Origins of Navajo Pastoralism," *Journal of the Southwest* 46, no. 2 (Summer 2004): 253; Denetdale, *Reclaiming Diné History*, 11.

18. Peter Iverson, *The Navajos: Indians of North America* (New York: Chelsea House, 1990), 42.

19. Ibid., 43. Iverson reports that as many as 2,000 Navajos escaped the Long Walk by fleeing into the isolated canyons of Arizona and to Black Mesa, a remote area in Cañon de Chelly.

20. Ibid., 47. Denetdale, *Reclaiming Diné History*.

21. Peter Iverson, *The Navajo Nation* (Westport, Conn.: Greenwood Press, 1976), 11. Today the Navajo Nation is the most populous Indian nation in the United States with over 250,000 members. In addition, the Navajo reservation is the largest in the United States, spanning more than 19 million acres in Utah, New Mexico, and Arizona.

22. The four sacred mountain ranges are Dook'o'oosłíí in Arizona, Tsoodzil in New Mexico, and Dibé ntsaa and Sis Naajíní in Colorado.

23. Jennifer Nez Denetdale, "Representing Changing Woman: A Review Essay on Navajo Women," *American Indian Culture and Research Journal* 25, no. 3 (2001): 1–26; Gladys Reichard, *Spider Woman: A Story of Navajo Weavers and Chanters* (Glorieta, N. Mex.: Rio Grande Press, 1934).

24. Carmean, *Spiderwoman Walks This Land,* xix.

25. On the history of weaving, see Nancy J. Blomberg, *Navajo Textiles: The William Randolph Hearst Collection* (Tucson: University of Arizona Press, 1988), 5; Kathy M'Closkey, *Swept under the Rug: A Hidden History of Navajo Weaving* (Albuquerque: University of New Mexico Press, 2002); Garrick Bailey and Roberta Glenn Bailey, *A History of the Navajos: The Reservation Years* (Santa Fe: School of American Research Press, 1986), 51–53; Colleen O'Neill, *Working the Navajo Way: Labor and Culture in the Twentieth Century* (Lawrence: University Press of Kansas, 2005), 58–59. Quote from Tyler Cowen, *Creative Destruction: How Globalization Is Changing the World's Cultures* (Princeton, N.J.: Princeton University Press, 2002), 43.

26. Cowen, *Creative Destruction,* 43.

27. Blomberg, *Navajo Textiles,* 5.

28. Ibid., p. 6; Erika Marie Bsumek, "Making 'Indian-made': The Production, Consumption and Construction of Navajo Ethnic Identity, 1880–1935" (Ph.D. diss., Rutgers University, 2000); M'Closkey, *Swept under the Rug,* 152–153.

29. Jane Schneider, "The Anthropology of Cloth," *Annual Review of Anthropology* 16 (1987): 429–430. I use the term *Navajo traders* to describe non-Navajos who traded with the Navajos on the reservation.

30. On the influence of "oriental" designs, see Blomberg, *Navajo Textiles,* 6; M'Closkey, *Swept under the Rug,* 146.

31. John Adair, *The Navajo and Pueblo Silversmiths* (Norman: University of Oklahoma Press, 1944), 3–5.

32. Gary Witherspoon, *Language and Art in the Navajo Universe* (Ann Arbor: University of Michigan Press, 1977), 151–154.

33. John Adair, "Journal Notes," June–July 1938, 64–65, John Adair Papers (JAP), Wheelwright Museum of the American Indian, Santa Fe, New Mexico.

34. Ibid., 65; Robert W. Volk, "Barter, Blankets, and Bracelets: The Role of the Trader in the Navajo Textile and Silverwork Industries, 1868–1930," *American Indian Culture and Research Journal* 12, no. 4 (1988): 53.

35. Adair, "Journal Notes," 63, JAP. Some evidence exists that traders began buying Indian jewelry to sell to tourists as early as 1885. John Adair "Field Notes," 15, Saturday, June 29, 1940, JAP.

36. Mark Simmons, *New Mexico: An Interpretive History* (Albuquerque: University of New Mexico Press, 1988), 133.

37. Charles Montgomery, *The Spanish Redemption: Heritage, Power, and Loss on New Mexico's Upper Rio Grande* (Berkeley: University of California Press, 2002); John Nieto Philips, *The Language of Blood: The Making of Spanish American Identity*

in New Mexico, 1850–1940 (Albuquerque: University of New Mexico Press, 2004).

38. Richard White, *"It's Your Misfortune and None of My Own": A New History of the American West* (Norman: University of Oklahoma Press, 1993), 255–257. According to White, "The railroads created the infrastructure for the emerging western economy and set the patterns for its development." He reports that the railroads built this infrastructure in two ways. First, they acted as agents of economic development: their building, maintenance, and demand for fuel stimulated western markets. Second, railroads enlarged access to eastern and European markets. Alexandra J. Roberts, "The Alvarado Hotel: A Reflection of the Railroad Years in Albuquerque," April 1, 1980, Center for Southwest Research (CSWR), University of New Mexico, Albuquerque. The population of Albuquerque increased from 1,307 in 1880 to 12,000 in 1893, and most of this increase was due to an influx of Anglo immigrants, who worked for the railroads and Albuquerque schools, hospitals, and the telephone exchange and electric company.

39. During the reorganization, the Atchison, Topeka & Santa Fe (AT&SF) Railroad became the AT&SF Railway. Sandra D'Emilio and Suzan Campbell, *Visions and Visionaries: The Art and Artists of the Santa Fe Railway* (Salt Lake City, Utah: Peregrine Smith Books, 1991), 8; Keith L. Bryant, *History of the Atchison, Topeka and Santa Fe Railway* (Lincoln: University of Nebraska Press, 1974), 153–182.

40. By 1915, the AT&SF Railway had spent over $1 million to construct an exhibit on the peoples and natural wonders of New Mexico and Arizona at the Panama-Pacific Exposition in San Diego, California. This project, which the company called the Painted Desert, was part of an extensive advertising campaign to attract passenger travel. See "The Big Fair Ready at San Diego with Many Special Features," *Santa Fe Magazine*, December 1914, 21–23.

41. Edward Hungerford, "A Study in Consistent Railroad Advertising," *Santa Fe Magazine*, March 1923, 44. William Allen White worked as the editor of the *Emporia Gazette* and was a self-appointed, and powerful, spokesperson for the middle class.

42. Marsha Weisiger, "The Origins of Navajo Pastoralism," *Journal of the Southwest* 46, no. 2 (Summer 2004): n37.

43. Marjorie Helen Thomas (1885–1983). D'Emilio and Campbell, *Visions and Visionaries*, 85.

44. D'Emilio and Campbell, *Visions and Visionaries*, 85.

45. The term *savage* was synonymous with "dangerous," "barbarous," "wild," and "noncivilized." Whites used the term to justify placing Navajos, and other Native Americans, below them on a hierarchical scale of evolution. Centuries of hostility between the Navajos and other New Mexican groups further entrenched the idea that the Navajos were especially savage. Navajo, Comanche, and Apache raids on Puebloan and New Mexican villages continued until the mid-nineteenth century. See Francis Paul Prucha, *The Great Father: The United States Government and the American Indians* (Lincoln: University of Nebraska Press, 1995), 366–367; Ramón Gutierrez, *When Jesus Came, the Corn Mothers Went Away: Marriage, Sexuality and Power in New Mexico, 1500–1846* (Stanford, Calif.: Stanford University Press, 1991), 281–282.

46. D'Emilio and Campbell, *Visions and Visionaries*, 12; Fred Harvey quote from "How Fame Has Been Won for the Harvey Service by Devotion to a Business Principle," *Santa Fe Magazine*, February 1916, 35.

47. *The Indian and Mexican Building* (Albuquerque: Fred Harvey Publisher, circa 1920), CSWR.

48. Dilworth, *Imagining Indians,* 79–80; D'Emilio and Campbell, *Visions and Visionaries,* 9, 16–21; Alta Edmonson, "E. Irving Crouse, Painter of Indians," *Panhandle-Plains Historical Review* 42 (1969): 12; T. C. McLuhan, *Dream Tracks: The Railroad and the American Indian, 1890–1930* (New York: Harry Abrahams, 1985). AT&SF advertisements compared the Southwest to other centers of ancient civilizations like Greece and Turkey. C. P. Holliday Papers, Huntington Library, San Marino, California. Marta Weigle and Barbara Babcock, *The Great Southwest of the Fred Harvey Company and the Santa Fe Railroad* (Phoenix: Heard Museum, 1996). On the emergence of middle-class travelers, see Dona Brown, *Inventing New England: Regional Tourism in the Nineteenth Century* (Washington, D.C.: Smithsonian Institution Press, 1995); Hal Rothman, *Devil's Bargains: Tourism in the Twentieth Century American West* (Lawrence: University Press of Kansas, 1998); Dean Mac-Cannell, *Empty Meeting Grounds: The Tourist Papers* (London: Routledge, 1992), 159. By 1916, the New Mexican Museum in Santa Fe reported hosting almost 30,000 out-of-state visitors each year. See "New Mexico Field Work in 1915," *El Palacio,* January 1916, 59.

49. Adair, "Journal Notes," unnumbered page in section on Stewart before entry dated July 16, 1938, JAP.

50. Adair, "Journal Notes," July 12, 1940, 35–39, JAP. On paying silversmiths by the ounce, see Margery Bedinger, *Indian Silver: Navajo and Pueblo Jewelers* (Albuquerque: University of New Mexico Press, 1973), 115–116.

51. Adair, "Journal Notes," July 12, 1940, 35–39, JAP.

52. Author interview with Vidal Chavez, March 15, 2006.

53. Oliver La Farge to Miss A[melia] E. White, Coconut Grove, Florida, April 18, 1935, Indian Arts and Crafts Folders, American Association on Indian Affairs Records, Mudd Manuscript Library, Princeton University, Princeton, New Jersey; interview with Vidal Chavez, March 15, 2006. Chavez stated that Julius Gans paid him a salary of $20 per month. Chavez still works as a silversmith in a Santa Fe tourist shop three days a week.

54. In 1931, John G. Hunter told Burnside, "If you have any kind of job I would urge you to hang on to it even though you may not be able to make much more than a living, for there are thousands and thousands of people all over the country who would be delighted with the opportunity of just making enough to live on." John G. Hunter, superintendent, Southern Navajo Agency, Fort Defiance to Mr. Johnson H[aske] Burnside, Albuquerque Indian School, July 22, 1931, Haske Burnside file, Jonathan Batkin Collection, Wheelwright Museum of the American Indian, Santa Fe, New Mexico.

55. Oliver La Farge to Miss White, Santa Fe, May 23, 1935, Martha and Amelia Elizabeth White Papers, School for Advanced Research, Santa Fe, New Mexico.

56. Washington Matthews, "Navajo Silversmiths," *Second Annual Report of the Bureau of Ethnology to the Secretary of the Smithsonian Institution, 1880–1881* (Washington, D.C.: Government Printing Office, 1883), 167–178.

57. On the southwestern "intelligentsia," see Lois Palken Rudnick, *Utopian Vistas: The Mabel Dodge Luhan House and the American Counterculture* (Albuquerque: University of New Mexico Press, 1996), 70–144; Molly H. Mullin, *Culture in the Marketplace: Gender, Art, and Value in the American Southwest* (Durham, N.C.:

Duke University Press, 2001); Margaret Jacobs, "Uplifting Cultures: Encounters between White Women and Pueblo Indians" (Ph.D. diss., University of California, Davis, 1996), 288; Mary Austin, *Taos Pueblo* (San Francisco: Grabhorn Press, 1930).

58. Oliver La Farge to Miss White, Santa Fe, May 23, 1935, p. 2, White Collection, School of Advanced Research.

59. Ruth F. Kirk, "Southwestern Indian Jewelry," *El Palacio*, February/March 1945, 21–32, 41–50.

60. Huckle to Hubbell, November 20, 1902, JLHC.

61. Adair, "Journal Notes," 41, JAP. Schedule 6, July 26, 1939, 22–26, and Schedule 10, July 28, 1939, 42–48, Soil Conservation Survey Schedules (SCS), National Archives Records Administration, Laguna Niguel, California.

62. SCS Schedule 53, Gallup/Two Wells Area, September 2, 1939, 16–60. See also record nos. 375–401, September 22, 1939, SCS Survey.

63. O'Neill, *Working the Navajo Way*, 70.

64. Bruce Bernstein, "The Marketing of Culture: Pottery and Santa Fe's Indian Market" (Ph.D. diss., University of New Mexico, 1993), 66.

65. Reichard, *Navajo Medicine Man*, 6.

66. Ibid., 7.

67. J. F. Huckle to H. Schweizer, September 4, 1924, MS 7-3-1, Wheelwright Collection.

68. Belt to Reichard, May 27, 1939, Reichard Collection.

69. Roman Hubbell to Gladys Reichard, October 11, 1936, Reichard Collection.

70. Diana F. Pardue, "Marketing Ethnography: The Fred Harvey Indian Department and George A. Dorsey," in Weigle and Babcock, eds. *The Great Southwest*, 102–109.

Chapter 2. Negotiating the Navajo Trading Post, Navigating the National Economy

1. Louisa Alcott to Lorenzo Hubbell Jr., November 27, 1935, box 124, John Lorenzo Hubbell Collection (JLHC), University of Arizona Special Collection, Tucson.

2. David Murray, *Indian Giving: Economies of Power in Indian-White Exchanges* (Amherst: University of Massachusetts Press, 2000); Daniel H. Usner Jr., *Indians, Settlers, and Slaves in a Frontier Exchange Economy: The Lower Mississippi Valley before 1783* (Chapel Hill: University of North Carolina Press, 1992); Richard White, *The Middle Ground: Indians, Empires, and Republics in the Great Lakes Region, 1650-1815* (Cambridge: Cambridge University Press, 1991); James H. Merrell, *Into the American Woods: Negotiators on the Pennsylvania Frontier* (New York: W. W. Norton, 2000).

3. Willow Roberts, *Stokes Carson: Twentieth Century Trading on the Navajo Reservation* (Albuquerque: University of New Mexico Press, 1987), xviii; Laura Graves, *Thomas Varker Keam: Indian Trader* (Norman: University of Oklahoma Press, 1998). Numerous books have popularized, romanticized, and mythologized the lives of Indian traders. See, for example, Mary Jeanette Kennedy, *Tales of a Trader's Wife: Life on the Navajo Indian Reservation, 1913-1938* (Albuquerque: Valliant Co., 1965); Franc Johnson Newcomb, *Navajo Neighbors* (Norman: University of Oklahoma Press, 1966); Maurine S. Fletcher, ed., *The Wetherills of the Mesa Verde: Autobiography of Benjamin Alfred Wetherill* (Lincoln: University of Nebraska Press,

1977); Sallie Wagner, *Wide Ruins: Memories from a Navajo Trading Post* (Albuquerque: University of New Mexico Press, 1997). These texts are only a few of many published firsthand accounts and autobiographies of Navajo traders. Such books continue to attract a wide readership and to romanticize the lives of early Navajo traders. Scholars have yet to place these texts within a historical framework. The few scholars who have examined traders include Roberts, *Stokes Carson;* Elizabeth Vibert, *Traders' Tales: Narratives of Cultural Encounters on the Columbia Plateau, 1807–1846* (Norman: University of Oklahoma Press, 1997); and Frank McNitt, *The Indian Traders* (Norman: University of Oklahoma Press, 1962).

4. Richard White, *The Roots of Dependency: Subsistence, Environment, and Social Change among the Choctaws, Pawnees, and Navajos* (Lincoln: University of Nebraska Press, 1988), 244; James Brooks, *Captives and Cousins: Slavery, Kinship, and Community in the Southwest Borderlands* (Chapel Hill: University of North Carolina Press, 2002); Garrick Bailey and Roberta Bailey, *A History of the Navajos: The Reservation Years* (Santa Fe: School of American Research Press, 2002), 142–147. Navajo raiding was not indiscriminate. Like other methods of acquisition, it was regulated by Navajo tradition. See Bernard Haile, "Property Concepts of the Navajo Indians," *Catholic University of America Anthropological Series* 17 (Washington D.C.: Catholic University of America Press, 1954), 1, 5, 28, 48, 51.

5. On the springtime market for wool, see J. L. Hubbell to his son Lorenzo at Keams Canyon, March 21, 1912, JLHC. On seasonal trade, see Roberts, *Stokes Carson,* 61; and oral history interview with YaNaBa Winker by David Brugge, November 2, 1971, HUTR, 27; Marsha Weisiger, "The Origins of Navajo Pastoralism," *Journal of the Southwest* 46, no. 2 (Summer 2004), 253–282.

6. B. Youngblood, "Navajo Trading," in *Survey of Conditions of the Indians of the United States, Part 34: Navajo Boundary and Pueblos in New Mexico.* U.S. Senate, Subcommittee of the Committee on Indian Affairs, 75th Congress, 1st session, Washington, D.C.: Government Printing Office, 1937, 5–7; Human Census Records, 1936–37, Soil Conservation Survey Schedules, National Archives and Records Administration, (NARA), Laguna Niguel, California.

7. Youngblood, "Navajo Trading," 8, 105.

8. Clyde Kluckhohn and Dorothea Leighton, *The Navajo* (Cambridge, Mass.: Harvard University Press, 1946), 79. Clyde Kluckhohn was a professor of anthropology at Harvard University. He started his study of Navajos in 1923 and worked for the Office of Indian Affairs during the 1940s.

9. Kluckhohn and Leighton, *The Navajo,* 80.

10. Vibert, *Traders' Tales;* see also the following works by Richard White: *Roots of Dependency;* "Ecological Change and Indian-White Relations," in *History of Indian-White Relations,* ed. Wilcomb E. Washburn, vol. 4 of *Handbook of North American Indians,* ed. W. C. Sturtevant (Washington, D.C.: Smithsonian Institution, 1988); and *The Middle Ground.* And see Haile, "Property Concepts," 40.

11. Kluckhohn and Leighton, *The Navajo,* 38; Francis Paul Prucha, *American Indian Policy in the Formative Years: The Indian Trade and Intercourse Acts, 1790–1834* (Lincoln: University of Nebraska Press, 1962).

12. Frank McNitt, *Indian Traders,* 68–115; Roberts, *Stokes Carson,* 15; Nancy Peake, "Trading Post Tales" (master's thesis, University of New Mexico, 1992), 4.

13. U.S. Congress, "Session on Indian Traderships," in *Reports of Committees of the Senate of the United States for the Second Session of the Fiftieth Congress, 1888–1889* (Washington, D.C.: Government Printing Office, 1889); McNitt, *Indian Traders*, 45.

14. *The 1834 Indian Trade Act,* section 5, amended by Congress August 15, 1876; and section 2136, revised February 14, 1873.

15. On October 26, 1865, George Richardson received his license to trade at Fort Sumner from Indian Agent Theodore H. Dodd. The traders that followed included Thomas V. Keams at Fort Defiance, 1867; and Joseph Alexander La Rue and Oscar M. Brown at Fort Sumner, 1866–1867; and Lehman Spiegelberg, who was licensed to trade throughout the reservation in 1868. The government later limited trading to a specific location and discontinued reservation-wide licenses. McNitt, *Indian Traders*, 46.

16. David F. Aberle, "Navajo Economic Development," in *Handbook of North American Indians of the Southwest,* ed. William C. Sturtevant and Alfonso Ortiz (Washington, D.C.: Smithsonian Institution Press, 1983), 642; White, *Roots of Dependency,* 242. The Navajo population in 1849 was 5,000, and in 1868, it was 8,000. By 1891, the population was reportedly more than 16,000. McNitt, *Indian Traders,* 50.

17. Department of Indian Affairs, *Reports of the Commissioner of Indian Affairs,* House Executive Document 1, part 5, (Washington, D.C.: Government Printing Office, 1886), 115. On traders' profits, see Frank D. Reeve, "The Government and the Navajo," *New Mexico Historical Review* 18 (1943): 40–43. The trader at Sweetland grossed $10,000, and the trader at Fort Defiance grossed $4,000.

18. Department of Indian Affairs, *Annual Report, Commissioner of Indian Affairs* (Washington, D.C., 1890). From 1889 to 1972, approximately 240 trading posts had served the Navajo Reservation. Willow Roberts, "Index of Trading Posts," in *The Trader Project,* report compiled for the Chaco Canyon National Monument, 1979, Chaco Collection, U.S. National Park Service, Museum Collection, University of New Mexico, Albuquerque, 1–9.

19. White, *Roots of Dependency,* 242.

20. Charlotte Johnson Frisbie, *Navajo Medicine Bundles or Jish* (Albuquerque: University of New Mexico Press, 1987); Roberts, *Stokes Carson,* 47. Almost all trader accounts emphasize the importance of establishing strong ties with local medicine men. Anthropologists also document this element of the trade encounter. Gladys Reichard, *Spider Woman: A Story of Navajo Weavers and Chanters* (Glorieta, N.Mex.: Rio Grande Press, 1934), 144–153. On other relationships between medicine men and traders, see Franc Johnson Newcomb, *Hosteen Klah: Navajo Medicine Man and Sand Painter* (Norman: University of Oklahoma Press, 1964). Newcomb and her family operated the Pesh-do-clish Trading Post, and Klah and the Newcombs became friends. Klah allowed Newcomb to document the designs of ceremonial sandpaintings. The relationship was important both for Klah and for the Newcombs' trading business (116–117).

21. Roberts, *Stokes Carson,* 32.

22. Herman Schweizer to Jesse Nubaum, April 19, 1930, Mary Austin Papers, Huntington Library, San Marino, California. Schweizer claimed that Wetherill was killed as a result of "illadvised" business practices. Frank McNitt, *Richard Wetherill: Anasazi* (Albuquerque: University of New Mexico Press, 1966), 5–7, 274–279. Marietta Wetherill, Richard Wetherill's wife, documented additional violence

between Navajos and whites. Marietta Wetherill oral history, Chaco Canyon Archives, tape 452, August 31, 1953. Marietta Wetherill reported that Navajos disliked, and sometimes killed, whites and that, for instance, two white traders were killed just five years before Marietta's marriage to Richard. She also reported a conversation with an old Navajo woman, who supposedly said, "Well, one time a man came here . . . he had two black mules and the bay horse that Anasazi [the trader R. Wetherhill] bought . . . Well he was eating his supper and he had a little campfire and the [Navajo] man . . . shot him in the back" (11). This murder was committed, according to Marietta, because it "wasn't any harm to kill a white man, it was a victory." She continued, "They (Navajos) were proud of the fact that they had done it" (12). Navajo-white tension also led to the death of a man named Welch in 1894 at Hogback; he was killed by a Navajo boy, and Apache slave, named Neskahay (13). Marietta Wetherill wrote the following in the margins of a book by Byron Cummings about a trip he took with a Navajo man named Glad Hand to Long Canyon in 1918: "In that day and age he [Cummings] was lucky to be alive. I am surprised John Wetherill would let Dear Cummings go out alone with one Dene, can't understand it." Byron Cummings, *Indians I Have Known* (Tucson: Arizona Silhouettes, 1952), 36 (in a copy that Wetherill donated to the Huntington Library); Dennis Boyd, "Trading and Weaving: An American-Navajo Symbiosis" (master's thesis, University of Colorado, 1979). Other accounts of violence on the reservation: oral history interview of Father Demanuel Trockure, OFM, May 25, 1976, St. Michael's, Arizona, Day Family Collection, Cline Library, Northern Arizona University, Flagstaff.

23. Ruth Underhill, *The Navajos* (Norman: University of Oklahoma Press, 1956), 180–181. See oral histories, 1970–1971; trader interviews, Hubbell National Trading Post, Ganado, New Mexico; trader interviews, Day Family Collection; Willow Roberts Powers, *Navajo Trading: The End of an Era* (Albuquerque: University of New Mexico Press, 2001).

24. Edward T. Hall, *West of the Thirties: Discoveries among the Navajo and Hopi* (New York: Doubleday, 1994), 158; oral history interview of Ailema Benally, May 25, 1976, Day Family Collection.

25. Oral history interview of Sam Edward Day III, May 26, 1976, Day Family Collection.

26. Edward T. Hall describes the Lippencotts as "well educated and good willed" people who were looking to anchor themselves in a "magic" land. "Newcomers themselves, as well as literate and outgoing, they were the ideal people to tell the outside world the story of trading with the Navajos." Hall, *West of the Thirties*. See Wagner, *Wide Ruins*, ix. Sallie Lippencott Wagner and her husband, Bill Lippencott, met in the Anthropology Department at the University of Chicago. Bill Lippencott was pursuing his master's degree and Sallie was working toward her bachelor's degree. She states up front, "My interest in anthropology grew out of a romantic interest in the Indians" (1).

27. J. L. Hubbell to Mrs. G. G. Trask, New York, New York, April 17, 1915, letterbook, vol. 100, JLHC. On ceremonies, see David Brugge's oral history interview with YaNaBa Winker on November 2, 1971, HUTR. YaNaBa states that Hubbell and his son Roman hosted chicken pulls at the trading post.

28. Interview 15, Mrs. Stella Preston, January 19, 1972, HUTR. Hubbell's trading post served as "home base" because it was a day's ride to Keams Canyon to see the dance.

29. Oral history, John Charlie, tape 197, Navajo transcripts, American Indian Oral History Collection, Center for Southwest Research, University of New Mexico, Albuquerque.

30. White, *Roots of Dependency*, 242. See also W. W. Hill, "Navajo Trading and Trading Ritual," *Southwestern Journal of Anthropology* 4 (Winter 1948): 374–376, 379–383, 388–390.

31. Wagner, *Wide Ruins*, 50.

32. Ibid., 51.

33. Underhill, *The Navajos*, 182–183; William Y. Adams, "Shonto: A Study of the Role of the Trader in A Modern Navajo Community," *Bureau of American Ethnology*, Bulletin 188 (Washington, D.C.: Government Printing Office, 1963), 152–153.

34. Hall, *West of the Thirties*, 150.

35. Lorenzo Hubbell, 1909 ledger book, box 348; profit total, box 347; business records, box 95, JLHC; Kathy M'Closkey, "Some Ruminations on Textile Production by the Navajo and the Inuit," *Papers from the Third and Sixth Navajo Studies Conferences* (Window Rock, Ariz.: Navajo Nation Historic Preservation Department), 379–389. See also 1926 internal trading post correspondence, box 97, JLHC.

36. Lorenzo Hubbell Sr. to commissioner of Indian affairs, Mr. E. K. Miller, superintendent, Keams Canyon, Arizona. May 24, 1926, JLHC. My research indicates that traders underreported the value of items they purchased from Indians. Unfortunately, a more systematic study of trader reports does not exist.

37. *Commission of Indian Affairs Annual Reports*, 1914, 34. On the number of weavers see table 17 in the 1912 annual report, 154. The 1913 annual report states that only 128 Navajo Indians worked for either the U.S. Indian Service or private parties during fiscal year 1913. It also reports that 1,000 weavers (although I suspect this is a gross understatement) brought in a total of $700,000 in income to the reservation. This figure demonstrates both the importance of weavers and the importance of the traders who ultimately sold the blankets, rugs, and textiles for the final figure.

38. M'Closkey, "Weavers Fleeced Again," chart: "Wool and Blanket Shipment from Hubbell Trading Post, Ganado," unpublished paper, author's collection.

39. Lorenzo Hubbell to Charles Hubbell at Oraibi, Arizona, trading post, March 21, 1912, box 97, JLHC.

40. Lorenzo Hubbell Jr. to J. L. Hubbell Sr., March 15, 1913, box 99, JLHC.

41. Lorenzo Hubbell to Charles Hubbell, March 21, 1912, JLHC.

42. Kluckhohn and Leighton, *The Navajo*, 38. Author interview with Elijah Blair, March 16, 2005, Page, Arizona.

43. Lorenzo Hubbell to Simeon Schwemberger at Cedar Springs trading post, March 21, 1912, box 97, JLHC.

44. Lorenzo Hubbell Sr. to Lorenzo Hubbell Jr., March 21, 1912, box 97, JLHC (italics added).

45. Ibid.

46. Hubbell to Schwemberger, March 21, 1912, JLHC.

47. On the market value of wool in 1912 and 1913, see box 97, JLHC. Hubbell refers to the retail price of the wool throughout his correspondence. This quote also verifies that Navajos could, at different times, get more for 10 pounds of raw wool than they could for a woven rug of the same weight if one deducts labor costs.

48. C. N. Cotton to J. L. Hubbell, June 5, 1913, box 20, JLHC.

49. Lester Williams, *C. N. Cotton and His Navajo Blankets: A Biography of C. N. Cotton, Gallup, New Mexico Indian Traders and Reprinting of Three Mail Order Catalogues of Navajo Indian Blankets and Rugs Originally Printed between 1896 and 1916* (Albuquerque: Avanyu Publishing, 1989), 11.

50. Oral history interview with YaNaBa Winker by David Brugge, November 2, 1971, HUTR.

51. Louis Hieb, "John Lorenzo Hubbell," *American National Biography,* ed. John A. Barraty and Mark C. Carnes (New York: Oxford University Press, 1999), 392.

52. Oral history interview with YaNaBa Winker, November 2, 1971, HUTR.

53. John Bowman, Indian agent for the Navajo Reservation stationed at Fort Defiance, Arizona, to the commissioner of Indian affairs, February 22, 1886, reprinted in Williams, *C. N. Cotton and His Navajo Blankets,* 1.

54. Hall, *West of the Thirties,* 147.

55. J. L. Hubbell to Nelson Gorman, January 17, 1913, box 97, JLHC.

56. McNitt, *Indian Traders,* 54; Roberts, *Stokes Carson,* 46–48.

57. McNitt, *Indian Traders,* 57; Powers, *Navajo Trading,* 212.

58. Mary Baily, Trader Oral History Collection, Cline Library, Northern Arizona University, Flagstaff.

59. Sallie Wagner used to be Sallie Lippencott. Wagner, *Wide Ruins,* 11. The Lippencotts ran a trading post at Wide Ruins during the 1930s and 1940s. On the seasonal nature of pawn, see McNitt, *Indian Traders,* 54, and Roberts, *Stokes Carson,* 46.

60. Wagner, *Wide Ruins,* 11–14, 93. Roberts reports that Stokes Carson held goods for "safekeeping," *Stokes Carson,* 47.

61. Ibid., 92.

62. Roberts, *Trader Project,* 8.

63. Father Bernard Haile reported that pawnbroking was an "early institution" set up by "inexorable" lenders. He said that some interest rates for "short term" pawn loans were as high as 200 percent. Bernard Haile, OFM, "Property Concepts of the Navajo Indians," *The Catholic University of America Anthropological Series,* no. 17 (Washington, D.C.: Catholic University of American Press, 1954).

64. On trading posts' operating as banks, see Roberts, *Trader Project,* 9.

65. Roberts, *Trader Project,* 10–13; "Brother" to Hubbell, Lorenzo, October 9, 1911, box 96, JLHC; oral history interview with YaNaBa Winker, November 2, 1971, HUTR.

66. Hall, *West of the Thirties,* 150. On Navajos' distrust of trader bookkeeping, see Roberts, *Trader Project,* 13.

67. Oral history interview with YaNaBa Winker, 9, 15, HUTR. On high prices at trading posts, see, Roberts, *Trader Project,* 11.

68. Haile, "Property Concepts," 53.

69. Roberts, *Trader Project,* 7.

Chapter 3. Marketing the Navaho through Frontier Commerce

1. Kay Bennett, *Kaibah: Recollection of a Navajo Girlhood* (Los Angeles: Westernlore Press, 1964), 17–19. Weavers have told similar stories of the social and economic aspects of the trading experience in oral histories. See interviews with Asdzaa Bekashi, November 8, 1971, and Marie Curley, September 10, 1970, Doris Duke

Oral History Project, Navajo Weavers from Ganado, directed by David Brugge, Hubbell Trading Post National Historic Site, U.S. National Park Service, Ganado, Arizona.

2. Ibid.

3. Billie Williams Yost, *Bread upon the Sands* (Caldwell, Idaho: Caxton Press, 1958), 48–49.

4. Ibid.

5. The images of Indians' "frontier commerce" mirrored many of the eighteenth- and nineteenth-century discussions of trading with Indians. Robert W. Berkhoffer Jr., *The White Man's Indian: Images of the American Indians from Columbus to the Present* (New York: Vintage Books, 1979); James H. Merrell, *Into the American Woods: Negotiators on the Pennsylvania Frontier* (New York: W. W. Norton, 1999); Claudio Saunt, *A New Order of Things: Property, Power, and the Transformation of the Creek Indians, 1733–1816* (Cambridge: Cambridge University Press, 1999).

6. On Morgan's thoughts on evolution, see Lewis H. Morgan, *Ancient Society; or, Researches in the Lines of Human Progress from Savagery through Barbarism to Civilization,* ed. Eleanor Burke Leacock (Cleveland: Meridian Books, 1963 [1877]), 3, 13. Brian Dippie, *The Vanishing American: White Attitudes and U.S. Indian Policy* (Lawrence: University Press of Kansas, 1982), 105–106; Alan Trachtenberg, *Incorporation of America: Culture and Society in the Gilded Age,* 25th anniversary ed. (New York: Hill and Wang, 2007).

7. Frederick Jackson Turner, "The Significance of the Frontier in American History," first presented at the Historical Congress in Chicago at the World's Columbian Exhibition of 1893, originally printed in *Annual Report of the American Historical Association for the Year 1893* (Washington, D.C: Government Printing Office, 1894), here referenced from Martin Ridge, ed., *History, Frontier, and Section: Three Essays by Frederick Jackson Turner* (Albuquerque: University of New Mexico Press, 1993).

8. Robert M. Utley, *The Indian Frontier of the American West, 1846–1890* (Albuquerque: University of New Mexico Press, 1984), 230.

9. Jeffrey Ostler, *The Plains Sioux and U.S. Colonialism from Lewis and Clark to Wounded Knee* (Cambridge: Cambridge University Press, 2004), 36; Kerwin Klein, *Frontiers of Historical Imagination: Narrating the European Conquest of Native America, 1890–1990* (Berkeley: University of California Press, 1997), 129–143. On Indian lands and frontier lands at the end of the century, see Elliott West, *The Contested Plains: Indians, Gold Seekers and the Rush to Colorado* (Lawrence: University Press of Kansas, 1998).

10. George B. Bowra, "Glimpse of the Navajo Indian," *National Republic,* November 1933, 7.

11. T. J. Jackson Lears, *Fables of Abundance: A Cultural History of Advertising in America* (New York: Basic Books, 1994), 199; Susan Strasser, *Satisfaction Guaranteed: The Making of the American Mass Market* (Washington, D.C.: Smithsonian Institution Press, 1989), 18.

12. J. B. Moore, *The Navajo: A Reprint in Its Entirety of a Catalogue Published by J. B. Moore, Indian Trader, of the Crystal Trading Post, New Mexico, 1911* (Albuquerque: Avanyu Publishing, 1986); J. B. Moore, *Collector, Wholesale and Retail: Fine Navajo Blankets* (Crystal, N.Mex.: J. B. Moore Trader, ca. 1905), Wheelwright Museum of the American Indian, Santa Fe, New Mexico. Moore's catalogs featured expensive

color plates and are still in print and used by collectors of Navajo rugs. J. L. Hubbell, *Hubbell Trading Post Catalogue* (Chicago: Hollister Press, ca. 1903), Grace Nicholson Collection (GNC), Huntington Library, San Marino, California. J. L. Hubbell to Miss Nicholson, GNC, October 15, 1903.

13. Hubbell, *Hubbell Trading Post Catalogue,* GNC.

14. Ibid.

15. Moore, *The Navajo,* 3.

16. Sallie Lippencott Wagner also claimed to have influenced the creation of the Wide Ruins style. In fact, she begins the chapter of her biography titled "Rugs for Trade or Cash" by stating, "[A] friend of mine persists in telling people that I taught the Navajos how to weave." Wagner, *Wide Ruins: Memories from a Navajo Trading Post* (Albuquerque: University of New Mexico Press, 1997), 49. On the scholarly interpretation of traders' influence over weavers, see Kathy M'Closkey, "Marketing Multiple Myths: The Hidden History of Navajo Weaving," *Journal of the Southwest* 36 (Autumn 1994): 185; Gary Witherspoon, *Navajo Weaving: Art in Its Cultural Context,* Research Paper 36, Museum of Northern Arizona, Flagstaff, 1987, 71; Kathy Howard, "'A Most Remarkable Success': Herman Schweizer and the Fred Harvey Indian Department," in *The Great Southwest of the Fred Harvey Company and the Santa Fe Railway,* ed. Marta Weigle and Barbara A. Babcock (Phoenix: The Heard Museum,1996), 87; Nancy J. Blomberg, *Navajo Textiles: The William Randolph Hearst Collection* (Tucson: University of Arizona Press, 1994), 19.

17. *Franciscan Missions of the Southwest (FMSW)* was an annual journal published by the Franciscan Fathers of St. Michael's Arizona. Hubbell as well as traders Matchin and Boardman of Lukachukai, Arizona; M. E. Kirk of Chin Lee; C. D. Deadman of Ganado; and C. C. Mannin and Company of Gallup all frequently advertised in *FMSW. FMSW* 8 (1920), University of Arizona, Tucson. A. F. Spiegelberg, former trader turned merchant, published articles on Navajo rugs. See *Outwest,* May 1904; "Navajo Blankets," *El Palacio,* June 1925, 223–229. For other articles featuring the role of traders and the use of rugs in homes, see "A Legend of the Navajos," *Cosmopolitan,* November 1896, 73; "Vanishing Indian Types," *Scribner's,* 1906, 513–529; "Bedouins of the Desert," *Outwest* 35, 1912, 107–116; "The Loom in the New World," *American Museum of Natural History Journal* 16 (1926): 381; "Primitive American Hand-Made Rugs," *Good Furniture Magazine* 28, 1 (1927): 14–19; "Glimpse of the Navajo Indian," *National Republic,* November 1933; "Navajo Weaving," *Indians at Work,* December 15, 1934: 22–25; "Indian Fair," *Art and Archeology* 18 (1925): 215–224; "Wild Indians of the Four Corners," *Travel,* January 1924, 20–23.

18. Hubbell, *Hubbell Trading Post Catalogue,* GNC.

19. Hazel Cumin, "The Bayeta of the Navaho," *House Beautiful,* May 1929, 644–669.

20. John L. Cowan, "Bedouins of the Southwest," *Outwest,* February 1912, 61, 107–116.

21. Fr. Leopold Ostermann, OFM, "The Navajo Indian Blanket," *FMSW* 6 (1918): 1–6.

22. *FMSW* 5 (1917): 11.

23. "Advertisement" section, *FMSW* 8 (1920), capitalization as in the original.

24. Ibid.; Index, *FMSW* 6 (1918) and 5 (1917).

25. Leah Dilworth, *Imagining Indians in the Southwest: Persistent Visions of a Primitive Past* (Washington, D.C.: Smithsonian Institution Press, 1996), 54–62; Jackson

Rushing, *Native American Art and the New York Avant-Garde* (Austin: University of Texas Press, 1995). According to Rushing, "Primitivist texts on Native American art reveal a concern, indeed, a fear shared by many of the writers about the increasing secularization of modern American life. Their sustained physical presence in the Southwest was itself a critique of urbanism and its attendant psychic dislocations" (39). On primitivism in general, see Marianna Torgovnick, *Gone Primitive: Savage Intellects, Modern Lives* (Chicago: University of Chicago Press, 1990), 8–11.

26. Alan Trachtenberg, *Shades of Hiawatha: Staging Indians, Making Americans, 1880–1930* (New York: Hill and Wang, 2004), 216.

27. On bargaining culture among immigrants, see Elizabeth Ewen, *Immigrant Women in the Land of Dollars: Life and Culture on the Lower East Side, 1890–1925* (New York: Monthly Review Press, 1985), 166–169; Susan Strasser, *Waste and Want: A Social History of Trash* (New York: Owl Books, 1999), 77–80, 106–109.

28. Richard T. Ely, *An Introduction to Political Economy* (New York: Chautauqua Press, 1889). Turner, "Significance of the Frontier"; Kerwin Klein, *Frontiers of Historical Imagination: Narrating the European Conquest of Native America, 1890–1990* (Berkeley: University of California Press, 1997), 139. In his discussion of frontiers and economic theory, Klein argues that social evolutionism worked its way into social theory as well as economic theory. Klein gracefully paraphrases Ely: "Savages/barbarians do not engage in commerce, they do not command a concept of private property, they do not have a cash economy, and they do not exhibit the typical features of nineteenth century capitalism" (139).

29. Leonard Helfgott, *Ties That Bind: A Social History of the Iranian Carpet* (Washington, D.C.: Smithsonian Institution, 1994). "Consumerism," Helfgott states, "entwined with cultural appropriation expressed simultaneously both a confidence in expanding production and global control and a growing sense of malaise resulting from the social, economic, and psychic upheavals endemic to maturing capitalism" (85). Joanne Boles, "The Development of the Navajo Rug, 1890–1920 as Influenced by Trader J. L. Hubbell" (Ph.D. diss., Ohio State University, 1977), 95.

30. Hubbell, *Hubbell Trading Post Catalogue,* ca. 1903, GNC.

31. Boles, "Development of the Navajo Rug," 95.

32. Garrick Bailey and Roberta Glenn Bailey, *A History of the Navajos: The Reservation Years,* rev. ed. (Santa Fe: School of American Research Press, 1986).

33. Philip Deloria, *Indians in Unexpected Places* (Lawrence: University Press of Kansas, 2005), 145.

34. Sherry Clayton Taggett and Ted Schwarz, *Paintbrushes and Pistols: How the Taos Artists Sold the West* (Santa Fe: John Muir Publications, 1990); Patricia Trenton, *Independent Spirits: Women Painters of the American West* (Berkeley: University of California Press, 1995); D'Arcy McNickle, *Indian Man: A Life of Oliver La Farge* (Indianapolis: Indiana University Press, 1971); Rushing, *Native American Art.*

35. Trader Oral History Collection (TOHC), Cline Library, Northern Arizona University, Flagstaff; James C. Faris, *Navajo and Photography: A Critical History of the Representation of an American People* (Albuquerque: University of New Mexico Press, 1996), 255–264. In Faris's book, figures 191–201 all feature Navajo women weaving either alone or with their children, from 1884 to 1936. Figures 198 and 199 feature two women weaving side by side, but each is weaving a unique rug. Jennifer Nez Denetdale, "'One of the Queenliest Women in Dignity, Grace, and

Character I Have Ever Met': Photography and Navajo Women—Portraits of Juanita, 1868–1902," *New Mexico Historical Review* 79, no. 3 (Summer 2004): 289–318.

36. George Wharton James, *Indian Blankets and Their Makers* (Chicago: A. C. McClurg and Co., 1914). On traders' payments to James, see the Juan Lorenzo Hubbell Collection (JLHC), box 353, p. 3, Special Collections, University of Arizona, Tucson.

37. Brian Dippie, *The Vanishing American*; Coll Thrush, *Native Seattle: Histories from the Crossing Over Place* (Seattle: University of Washington Press, 2007). On population numbers, see Bailey and Bailey, *History of the Navajos*, 27, 231.

38. Erik Krezen Trump, "The Indian Industries League and Its Support of American Indian Arts, 1893–1922: A Study of Changing Attitudes toward Indian Women and Assimilationist Policy" (Ph.D. diss., Boston University, 1996); Margaret D. Jacobs, *Engendered Encounters: Feminism and Pueblo Cultures, 1879–1934* (Lincoln: University of Nebraska Press, 1999); Carter Jones Meyer, "Saving the Pueblos: Commercialism and Indian Reform in the 1920s," in *Selling the Indian: Commercializing and Appropriating American Indian Cultures* (Tucson: University of Arizona Press, 2001), 199.

39. Hubbell, *Hubbell Trading Post Catalogue,* ca. 1915; box 545, p. 2, JLHC.

40. J. B. Moore, *Catalogue of Navajo Baskets* (Crystal, New Mexico, ca. 1903–1911), 4.

41. J. L. Hubbell, "Catalogue and Price List, Navajo Blankets and Indian Curios," ca. 1915, box 545, p. 2, JLHC.

42. Julius Gans, "The Indian as Artist," Southwest Arts and Crafts, Santa Fe, New Mexico, ca. 1920, box 2, 6, Warshaw Collection of Business Americana, Indians, Archives Center, National Museum of American History, Smithsonian Institution, Washington, D.C. Similarly, Ruth Underhill, who conducted her anthropological fieldwork among the Navajos in the 1930s and 1940s, reported in *The Navajos* that Navajos purchased machine-woven blankets at trading posts rather than make them for themselves.

43. Robert W. Kapoun and Charles J. Lohrmann, *Language of the Robe: American Indian Trade Blankets* (Salt Lake City: Peregrine Smith Books, 1992), 51–55.

44. Colleen O'Neill, *Working the Navajo Way: Labor and Culture in the Twentieth Century* (Lawrence: University Press of Kansas, 2005), 12–13.

45. Bernard Haile, OFM, "Property Concepts of the Navajo Indians," *Catholic University of America Anthropological Series,* no. 17 (Washington, D.C.: Catholic University of American Press, 1954), 48–49. Richard White, *The Roots of Dependency: Subsistence, Environment and Social Change among the Choctaws, Pawnees, and Navajos* (Lincoln: University of Nebraska Press, 1988), 247.

46. Author interviews with traders Elijah Blair, March 16, 2005, and Bruce Burnham, March 14, 2005, about Arbuckle's coffee and Pet Milk. See also Manuscript Collection no. 299, United Indian Trader's Association Collection and Collection PH.98.20.1.1-6.451, Finding Aid, TOHC; Kapoun and Lohrmann, *Language of the Robe,* 35. On calico cloth, see Underhill, *The Navajos,* 192.

47. Interview with Tobe Turpen, December 12, 1998, p. 54, TOHC.

48. Interviews with Bruce Burnham and Elijah Blair, March 15–18, 2006. Edith Kennedy listed Coleman fuel as a desired brand; TOHC. Trader Grace Herring mentions Wheaties cereal in a February 11, 1998, interview, p. 8, TOHC.

49. Human Census Records, Soil Conservation Survey Schedules, 1930s, box 20, National Archives and Records Administration (NARA), Laguna Niguel, California.

50. Human Census Records, 1930s, hogan 12, group F, area Red Lake, box 20, NARA.

51. Human Census Records, hogan 3, group B, area Red Lake, box 20, NARA. Although the women are listed as the income earners, the men undoubtedly contributed to the household economy.

52. Louis A. Hieb, "John Lorenzo Hubbell," in *American National Biography,* ed. John A. Barraty and Mark C. Carnes (Oxford: Oxford University Press, 1999), 392.

53. J. L. Hubbell, "Fifty Years an Indian Trader," *Touring Topics,* December 1930, 24.

54. Ibid.

55. Interviews with Mrs. Dorothy Hubbell, May 1, 1972, and Philip Hubbell, May 16, 1972, Frank McNitt Collection, State Records and Archives, Santa Fe, New Mexico.

56. Lester L. Williams, *C. N. Cotton and His Navajo Blankets: A Biography of C. N. Cotton Gallup, New Mexico Indian Traders and Reprinting of Three Mail Order Catalogues of Navajo Indian Blankets and Rugs Originally Printed between 1896 and 1919* (Albuquerque: Avanyu Publishing, 1989); David M. Brugge, *Hubbell Trading Post: National Historic Site* (Tucson: Southwest Parks and Monuments Association, 1993), 28. Also see Frank McNitt, *The Indian Traders* (Norman: University of Oklahoma Press, 1962), 142–154; H. L. James, *Rugs and Posts: The Story of Navajo Weaving and Indian Trading* (West Chester, Pa.: Schiffer Publishing, 1988), 63–70.

57. Charles Avery Amsden, *Navaho Weaving: Its Technic and Its History* (Santa Ana, Calif.: Fine Arts Press, 1934; repr., Glorieta, N.Mex.: Rio Grande Press, 1990), 179. Page reference is to the 1990 edition.

58. Williams, *C. N. Cotton,* 12–13.

59. Brugge, *Hubbell Trading Post,* 32. Keam retired with an estate of $55,000, whereas Wetherill was killed by a Navajo. In general, the economics of trading posts differed. McNitt, *Indian Traders,* 124–142.

60. "Sir Thomas Lipton," *Dictionary of National Biography,* ed. Wickham Legg (Oxford: Oxford University Press, 1941), 538–540.

61. The fact that Hubbell compared himself to Lipton is significant, showing that he was trying to claim ties with other traders and successful businessmen. On self-made men, see Martin Summers, *Manliness and Its Discontents: The Black Middle Class and the Transformation of Masculinity* (Durham: University of North Carolina Press, 2003); Gail Bederman, *Manliness and Civilization: A Cultural History of Gender and Race in the United States, 1880–1917* (Chicago: University of Chicago Press, 1996).

62. J. L. Hubbell to Nas-Wab-Quay [Curio Store], St. Ignace, Michigan, April 8, 1930, box 106, JLHC. Hubbell also corresponded with people and businesses in, among other states, New York, Minnesota, California, New Jersey, Arizona, New Mexico, Pennsylvania, Montana, Wisconsin, and Kansas. See a sample of one of Hubbell's mass-mailing letters, box 545, JLHC.

63. J. L. Hubbell to Mr. Connolly, January 16, 1930, box 106, JLHC.

64. Box 331, p. 245, JLHC; Kathy M'Closkey, *Swept under the Rug: A Hidden History of Navajo Weaving* (Albuquerque: The University of New Mexico Press, 2002), 98.

65. Martha Blue, *Indian Trader: The Life and Times of J. L. Hubbell* (Walnut, Calif.: Kiva Publishing, 2000), 145.

66. J. L. Hubbell to Mandel Bros. Dept Store, Chicago, Illinois, March 1, 1913, box 97, JLHC.

67. Ibid.
68. J. L. Hubbell to C. B. Fenton, [M]ackinac, Michigan, May 13, 1909, box 96, JLHC.
69. Alfred Hardy to Lorenzo Hubbell, June 15, 1916, box 36 JLHC (my italics).
70. Blomberg, *Navajo Textile,* 15.
71. J. L. Hubbell to the Franklin Motor Car Co., Syracuse, New York, May 5, 1925, box 104, JLHC.
72. Deloria, *Indians in Unexpected Places,* 143.
73. Moore, *The Navajo,* 3, 26.
74. T. J. Jackson Lears, *No Place of Grace: Antimodernism and the Transformation of American Culture, 1880–1920* (Chicago: University of Chicago Press, 1994), 92, 108; Torgovnick, *Gone Primitive,* 8–11; Rushing, *Native American Art,* 39.
75. J. B. Moore, *The Navajo* (catalog), 1911, 25.
76. Edwin Wade, "The Ethnic Art Market in the American Southwest, 1880–1980," in *Objects and Others: Essays on Museums and Material Culture,* ed. George W. Stocking (Madison: University of Wisconsin Press, 1985), 167–191; Molly Mullin, "The Patronage of Difference: Making Indian Art 'Art, Not Ethnology'" in *The Traffic in Culture: Prefiguring Art and Anthropology,* ed. George E. Marcus and Fred R. Myers (Berkeley: University of California Press, 1995), 166–198; Dilworth, *Imagining Indians.*
77. Robert W. Volk, "Barter, Blankets and Bracelets: The Role of the Trader in the Navajo Textile and Silverwork Industries, 1868–1930," *American Indian Culture and Research Journal* 12, no. 4 (1988): 46. On growth of the market, see James, *Indian Blankets,* viii; and U.S. Department of the Interior, *Annual Reports of the Commissioner of Indian Affairs* (Washington, D.C.: Government Printing Office, 1890), 162. Interestingly, just as other markets for Indian-made goods were declining, the market for Navajo-made goods took off. See Douglas Cole, *Captured Heritage: The Scramble for Northwest Coast Artifacts* (Norman: University of Oklahoma Press, 1985), 212–243.
78. Rug Ledger Books 1–15, Fred Harvey Collection, Museum of International Folk Art, Santa Fe, New Mexico; Hubbell Rug Books, JLHC; Blomberg, *Navajo Textiles,* 23–25.
79. Lorenzo Hubbell to Charlie [Hubbell], August 27, 1931, box 106, JLHC.
80. Warren I. Susman, "Personality and the Making of Twentieth Century Culture," in *Culture as History: The Transformation of American Society in the Twentieth Century* (New York: Pantheon Books, 1984), 271–285.

Chapter 4. Dealing in and Consuming the Navaho, 1890–1940

1. Forrest Parker to Lorenzo Hubbell, May 4, 1921, box 43, Juan Lorenzo Hubbell Collection (JLHC), Special Collections, University of Arizona, Tucson.
2. Forrest Parker to Lorenzo Hubbell, May 6, 1921, box 43, JLHC.
3. "The Stirring Story of Mankind's Rise," in *Official Guide Book of the Fair 1933: A Century of Progress Chicago* (Chicago: A Century of Progress Administration, 1933), 59, 66.
4. The term *domestic imperialism* is mine. However, the concept is linked to Laura Ann Stoler's and Laura Wexler's work. Stoler suggests, "To study the intimate is not to turn away from colonial dominations, but relocate their conditions of

possibility and relations and forces of production." Laura Ann Stoler, "Matters of Intimacy as Matters of State: A Response," *Journal of American History* 88, no. 3 (2001): 894. Also by Stoler in this issue, see "Tense and Tender Ties: The Politics of Comparison in North American History and (Post) Colonial Studies," 829–865. Whereas Stoler focuses much of her attention on bodies and selves in intimate spaces, I focus on the relationship between people and objects in personal space. See also Laura Wexler, *Tender Violence: Domestic Visions in an Age of U.S. Imperialism* (Chapel Hill: University of North Carolina Press, 2000). Mary Louise Pratt's work has also influenced my thinking about domestic imperialism. Whereas she explores how Europeans produced the non-European world, ideologically and culturally, through travel narratives, I explore how consumption produced a conception of Navahos for white, well-off shoppers. Mary Louise Pratt, *Imperial Eyes: Travel Writing and Transculturation* (London: Routledge, 1992), 4. I am also building on Nicholas Thomas's idea that the collection of "curiosities in some way stood as an objectification of the culturally and historically specific form of intellectual and experiential desire which 'curiosity' alluded to." Nicholas Thomas, *Entangled Objects: Exchange, Material Culture, and Colonialism in the Pacific* (Cambridge, Mass.: Harvard University Press, 1991), 122. On intimacy and imperialism in the West, see Albert Hurtado, *Intimate Frontiers: Sex, Gender, and Culture in Old California* (Albuquerque: University of New Mexico Press, 1993).

5. Neil Harris, *Cultural Excursions: Marketing Appetites and Cultural Tastes in Modern America* (Chicago: University of Chicago Press, 1990); 66. Simon Bronner, "Reading Consumer Culture," in *Consuming Visions: Accumulation and Display of Goods in America, 1880–1920*, ed. Simon J. Bronner (New York: W. W. Norton, 1989), 13–54; T. J. Jackson Lears, *No Place of Grace: Antimodernism and the Transformation of American Culture, 1880–1920* (Chicago: University of Chicago Press, 1994), 7–47; Simon J. Bronner, *Grasping Things: Folk Material Culture and Mass Society in America* (Lexington: University of Kentucky Press, 1986), 119; Mary Louise Roberts, "Gender, Consumption and Commodity Culture," *American Historical Review* 3 (June 1998): 817–844.

6. Susan Strasser, *Waste and Want: A Social History of Trash* (New York: Owl Books, 1999), 69–110, 161–202; Thomas Dublin, *Women at Work: The Transformation of Work and Community in Lowell, Massachusetts, 1826–1860* (New York: Columbia University Press, 1979), 5.

7. Lizabeth Cohen, *A Consumers' Republic: The Politics of Mass Consumption in Postwar America* (New York: Vintage Books, 2003); Jürgen Habermas, *The Structural Transformation of the Public Sphere: An Inquiry into a Category of Bourgeois Society*, trans. Thomas Burger (1962; repr., Cambridge, Mass.: MIT Press, 1991); Richard Wightman Fox and T. J. Jackson Lears, eds., *The Culture of Consumption: Critical Essays in American History, 1880–1980* (New York: Pantheon Books, 1983), ix–xvii; T. J. Jackson Lears, *Fables of Abundance: A Cultural History of Advertising in America* (New York: Basic Books, 1994); Frank Mort, *Cultures of Consumption: Masculinities and Social Space in Late Twentieth-Century Britain* (London: Routledge, 1996); Erika Diane Rappaport, *Shopping for Pleasure: Women and the Making of London's West End* (Princeton, N.J.: Princeton University Press, 2000); Marguerite Shaffer, *See America First: Tourism and National Identity, 1880–1940* (Washington, D.C.: Smithsonian Institution Press, 2001).

8. Nina Collier to J. L. Hubbell, September 4, 1934, JLHC.

9. John Wanamaker Company, *Golden Book of the Wanamaker Stores: Jubilee Year, 1861–1911* (Philadelphia: John Wanamaker Company, 1911–1913), 242; Richard Lindstrom, "Not from the Landside but from the Supply Side: Native American Responses to the Wanamaker Expedition," *Journal of Social History* 30, no. 1 (Autumn 1996): 209–227.

10. Lears, *No Place of Grace,* 60–61. As Lears has shown, consumerism did provide some "liberation." But it could not level the economic and cultural playing field, as social theorists had imagined. The rejuvenation of Arts and Crafts, and the development of Arts and Crafts ideologies came "from among the business and professional people who felt most cut off from 'real life'" (61). Bronner, *Grasping Things,* 117; Lee Glazer and Susan Key, "Carry Me Back: Nostalgia for the Old South in Nineteenth Century Popular Culture," *Journal of American Studies* 30 (1996): 1–24. Steven Gelber attributes the rise of the "do-it-yourself" movement, in part, to nostalgia. Men especially refused to buy things for the home that their fathers had made. Steven M. Gelber, "Do-It-Yourself," *American Quarterly* 49, no. 1 (March 1997): 67–101.

11. Stewart Culin, "Primitive American Art and Ornament," *University Bulletin* 4 (1900): 192. Stewart Culin worked as a museum director and lectured on the material culture of American Indians and Chinese and European "peasants." Simon Bronner, "Stewart Culin, Museum Magician," *Pennsylvania Heritage* 11 (Summer 1985): 4–11.

12. Diana Pardue, "Marketing Ethnography: The Fred Harvey Indian Department and George A. Dorsey," in *The Great Southwest of the Fred Harvey Company and the Santa Fe Railway,* ed. Marta Weigle and Barbara A. Babcock (Phoenix: Heard Museum, 1996), 105. When Indians would not sell Culin original material, he commissioned reproductions.

13. Culin, "Primitive American Art and Ornament," 192.

14. Culin's contemporaries included Gustave Stickley, George Wharton James, and Otis T. Mason. All claimed that "primitive" handicraft had a "moral force" that commercial efficiency lacked. Yet each warned consumers against feeling too much sympathy for "primitives." Simon Bronner, ed., *Folk Life Studies from the Gilded Age: Object, Rite and Custom in Victorian American* (Ann Arbor: UMI Research Press, 1987), 172.

15. Nicholson Biographical Information, "Finding Aid," Grace Nicholson Collection (GNC), Huntington Library, San Marino, California.

16. Elizabeth Cromley, "Masculine/Indian," *Winterthur Porfolio* 31 (Winter 1996): 265. On Nicholson's rejection of weapons and Sitting Bull's buckskin coat, see E. F. Kiessling to Grace Nicholson, July 19, 1915, GNC.

17. Nicholson's male clients included Joseph Dixon, William Henry Holmes, F. W. Hodge, Lawrence W. Jenkins, Alfred Kroeber, and Charles Lummis. One female anthropologist, Matilda Cox Stephens, also purchased goods from Nicholson.

18. Cromley, "Masculine/Indian," 277; Philip J. Deloria, *Playing Indian* (New Haven, Conn.: Yale University Press, 1998), 97.

19. Navajo rugs were popular decorative items. Middle-class women used them in their living rooms to express identity. On transition from parlor to living room and the use of accessories, see Karen Halttunen, "From Parlor to Living Room: Domestic Space, Interior Decoration, and the Culture of Personality," in Bronner,

ed., *Consuming Visions,* 157–189; Katherine C. Grier, *Culture and Comfort: Parlor Making and Middle-Class Identity, 1850–1930* (Washington, D.C.: Smithsonian Institution Press, 1988).

20. In 1925, Nicholson donated a collection of Indian-made items to the Denver Art Museum. She also corresponded with and sold items to other museums, including the Peabody Museum at Harvard, the Southwest Museum in Los Angeles, and the natural history museum in Berkeley. On Nicholson's success, see Joan M. Jenson, *One Foot in the Rockies: Women and Creativity in the American West* (Albuquerque: University of New Mexico Press, 1995), 61–66.

21. Hyde Exploring Expedition Folder, October 30, 1902, GNC. On George Pepper's participation in marketing goods, see "Chief Wets-It Assinniboine: Navajo Indian Fiesta," March 14, 1901, Warshaw Collection of Business Americana, Indians, box 2, Archives Center, National Museum of American History, Smithsonian Institution, Washington, D.C.

22. The Hyde Exploring Expedition's investment in trade with the Navajos was significant. By 1901, the HEE had collected over 10,000 pieces of pottery, 50,000 pieces of turquoise, 5,000 stone implements, 1,000 bone and wooden objects, and numerous other pieces. When the HEE went bankrupt in 1903, accounts indicate that it had between $125,000 and $175,000 worth of goods out on credit to area Navajos. In 1901, J. S. Holsinger, special agent for the General Land Office, went to investigate the Chaco Canyon ruins to determine the need for preservation. He summarized HEE activity and holdings in his *Holsinger Report,* December 5, 1901 (National Archives and Records Administration, Washington, D.C., file no. 1902-11158-1), 70; David Brugge, *A History of the Chaco Navajos* (Albuquerque: U.S. National Park Service, 1980), 172; Robert Hill Lister and Florence Lister, *Chaco Canyon: Archaeology and Archaeologists* (Albuquerque: University of New Mexico Press, 1981), 41; Richard White, *The Roots of Dependency: Subsistence, Environment, and Social Change among the Choctaws, Pawnees, and Navajos* (Lincoln: University of Nebraska Press, 1988), 247; Herman Schweizer to Jesse Nasbaum, April 9, 1930, enclosed in Herman Schweizer to Mary Austin, April 8, 1930, Mary Austin Papers, Huntington Library, San Marino, California.

23. George Wharton James to Grace Nicholson, December 16, 1902, and March 13, 1903, GNC; Martin Padget, *Indian Country: Representations of Travel in the Southwest, 1840–1935* (Albuquerque: University of New Mexico Press, 2004).

24. Joseph Henry Sharp to Grace Nicholson, September 12, 1918, Taos, New Mexico, GNC. Sharp was one of the artists working in the famed Santa Fe Art Colony. On the display of Sharp's collection at Nicholson's shop, see "Current Art Exhibitions Reviewed," *Los Angeles Times,* March 21, 1937.

25. Mrs. A. J. Comstock to Grace Nicholson, Ventura, California, 1901–1904, GNC.

26. Mrs. W. F. Dermont, Berkeley, California, to Grace Nicholson, 1916, GNC.

27. P. K. T. (?) to Grace Nicholson, dated 1914, GNC.

28. Ibid.; Ina Selby to Grace Nicholson, June 28, 1908, GNC.

29. Bertha Little to Grace Nicholson, December 3, 1909, GNC.

30. Ibid., October 5, 1908.

31. Ibid., December 3, 1909.

32. Candice Volz, "The Modern Look of the Early Twentieth Century House: A Mirror of Changing Lifestyles," in *American Home Life, 1880–1930,* ed. Jessica Foy and Thomas J. Schlereth (Knoxville: University of Tennessee Press, 1992), 33;

Richard Ohmann, *Selling Culture: Magazines, Markets, and Class at the Turn-of-the-Century* (London: Verso, 1996), 140–144.

33. "Primitive American Hand-made Rugs," in *Good Furniture Magazine* 28, no. 1 (1927): 14–19; "Redman's Last Stand," *Harper's Weekly*, May 1913; "Indians at Work," *Survey Graphic*, June 1934; "Bayeta of the Navajo," *House Beautiful*, May 1929; "Among the Navajo," *Outlook* 76:349–359, 1904. Many more articles appeared on the use of Navajo rugs, baskets, and silverwork as decorative accessories.

34. Ohmann, *Selling Culture*, 148; Halttunen, "From Parlor to Living Room," 164–165, 177 (on the living room as an expression of female personality). On the household décor as a communicating medium, see Grier, *Culture and Comfort*, 7.

35. Summary Report, GNC. Nicholson's home and shop in Pasadena has been turned into the Pacific Asia Museum. Nicholson traveled to Asia and began collecting items from Japan and China when consumers began to desire such goods. Volz, "The Modern Look," 33.

36. Mary C. Jones to Grace Nicholson, 1918, GNC.

37. Jones's Indian collection was impressive, filling two large display cases. Ibid., GNC.

38. Anita Baldwin to Grace Nicholson, February 4, 1921, box 1, GNC.

39. Mary Jones to Grace Nicholson, 1918, GNC.

40. Grace Nicholson to Lorenzo Hubbell, October 12, 1903, box 63, JLHC; Hubbell to Nicholson, October 15, 1903, GNC.

41. Information from this study comes primarily from Nicholson's letterbooks (volumes in which she kept carbon copies of all the letters she wrote to clients). On married and single women's experiences outside the home, see Nancy Cott, *The Grounding of Modern Feminism* (New Haven, Conn.: Yale University Press, 1987), 179–211; and Brigitt Georgi-Findlay, *The Frontiers of Women's Writing: Women's Narratives and the Rhetoric of Westward Expansion* (Tucson: University of Arizona Press, 1996).

42. Nicholson Letterbooks, 1912, 79–84, GNC.

43. "Miss Nicholson Theme of Writer," *Pasadena Star*, November 9, 1915, clipping in Grace Nicholson Collection, correspondence file, Museum of the American Indian, Research Office, Bronx, New York.

44. Mrs. Jesse Metcalf Correspondence, October 21, 1913, letterbook 99, GNC. Mrs. Metcalf was delighted with Nicholson's work and purchased an additional $251.50 worth of Indian goods in 1913. One of the items Nicholson sent to Metcalf was an "old Spanish shawl for $150.00." This purchase bumped up the total cost of the goods Metcalf purchased to $361.50.

45. Grace Nicholson to Mrs. Radeke, 32 Prospect St., Providence, Rhode Island, November 1, 1912, 1912 letterbook, 107, GNC.

46. Nicholson carefully built her career and reputation by maintaining relationships with some of the most influential members of the museum world. She corresponded with Alfred Kroeber, head of the University of California, Berkeley's anthropology department; William Henry Holmes of the Smithsonian; George Gustav Heye, who later donated his collection to the Museum of the American Indian; and many others. She also was a voracious reader of Indian myths and lore published by ethnographers and ethnologists. She interviewed other collectors and trekked out to find remote Indian groups from whom she could purchase goods. In many respects, she interacted with American Indians more than some anthropologists did at the time.

47. Mrs. Lang was a cofounder of this museum. She gave $50,000 to the building fund. Florence Osgood Rand Lang Papers, Montclair Art Museum, Montclair, New Jersey.

48. Carol Hartman to Grace Nicholson, August 20, 1902, GNC.

49. Grace Nicholson to Miss Livermore, Morristown, New Jersey, May 14, 1940, Grace Nicholson Collection, Museum of the American Indian.

50. Carol Hartman to Grace Nicholson, September 20, 1902, GNC; author interviews with Elijah Blair and Bruce Burnham, March 14, 2006, Page, Arizona; Francis L. Fugate, *Arbuckles: The Coffee That Won the West* (El Paso: Texas Western Press, 1994).

51. Boxes in the Juan Lorenzo Hubbell Collection contain over 1,000 letters from individuals planning to visit the Hubbell Trading Post at times of ceremonials, dances, and tours.

52. Grace Nicholson to Alice Phromm, August 26, 1912, box 7, GNC. Nicholson may have wanted to hide news of disease on the reservation because clients were prone to return goods and feared the spread of disease via objects.

53. Ibid.

54. Greg Dening, *Performances* (Chicago: University of Chicago Press, 1996), 111. The most explicit example of this relationship between dealers and their clients is in correspondence between Nicholson and Mary C. Jones of Pittsburgh, Pennsylvania. In this letter, Jones tells Nicholson that she wants to use the excuse of a religious convention to get away from Mr. Jones.

55. Alice Kessler Harris, *New Viewpoints in Women's History: Working Papers from the Schlesinger Library 50th Anniversary Conference, March 4–5, 1994* (Cambridge, Mass.: Arthur and Elizabeth Schlesinger Library, 1994), 23.

56. Objects from exotic peoples represented the people themselves. See James Clifford, *The Predicament of Culture: Twentieth Century Ethnography, Literature and Art* (Cambridge, Mass.: Harvard University Press, 1988).

57. Historian Lawrence Levine has demonstrated that middle- to upper-class individuals had a vested interest "unconscious though it may have been—in welcoming and maintaining the widening cultural gaps" that worked to separate Americans of different races and classes. Lawrence Levine, *Highbrow, Lowbrow: The Emergence of Cultural Hierarchy in America* (Cambridge, Mass.: Harvard University Press, 1988), 227.

58. M. L. Woodard, "The Navajo Goes East," *New Mexico Highway Journal*, March 1931, 14–15, 20.

59. Ibid., 20. After the Boston excursion, Mr. Staples, "coordinator of the event, continued with three other Navajos on another jaunt which included four days at Marshall Field and Company in Chicago."

60. Most scholarship focuses on connections between the cultural elite and primitivism. Molly Mullin, "The Patronage of Difference: Making Indian Art 'Art, Not Ethnology,'" in *The Traffic in Culture: Refiguring Art and Anthropology*, ed. George E. Marcus and Fred R. Myers (Berkeley: University of California Press, 1995), 166–200; Curtis M. Hinsley and David R. Wilcox, eds., *The Southwest in the American Imagination: The Writings of Sylvester Baxter, 1881–1889* (Tucson: University of Arizona Press, 1996); Lois Palken Rudnick, *Utopian Vistas: The Mabel Dodge Luan House and the American Counterculture* (Albuquerque: University of New Mexico Press, 1996); Patricia R. Everett, *A History of Having a Great Many Times*

Not Continued to Be Friends: The Correspondence between Mabel Dodge and Gertrude Stein, 1911–1934 (Albuquerque: University of New Mexico Press, 1996); Sylvia Rodriquez, "Art, Tourism and Race Relations in Taos," in *Discovered Country: Tourism and Survival in the American West,* ed. Scott Norris (Albuquerque: Stone Ladder Press, 1994), 161; Sherry Clayton Taggett and Ted Schwarz, *Paintbrushes and Pistols: How the Taos Artists Sold the West* (Santa Fe: John Muir Publications, 1990); James W. Byrkit, ed., *Charles Lummis: Letters from the Southwest* (Tucson: University of Arizona Press, 1989); Padget, *Indian Country.*

61. For figures on the sale of blankets, see U.S. Department of the Interior, *Annual Reports of the Commissioner of Indian Affairs* (Washington, D.C.: Government Printing Office, 1890), 162. In 1904, the commissioner of Indian affairs reported, "In the neighborhood of $500,000 is derived from" sheep, goats, and the sale of Navajo blankets. *Annual Reports of the Commissioner of Indian Affairs* (Washington D.C.: Government Printing Office, 1904), 141. On the trade in blankets reaching the $1 million mark, see Robert W. Volk, "Barter, Blankets, and Bracelets: The Role of the Trader in the Navajo Textile and Silverwork Industries, 1868–1930," *American Indian Culture and Research Journal* 12, no. 4 (1988): 46. Collector George Wharton James reported that the sale of Navajo rugs exceeded $1 million in 1923; James, *Indian Blankets and Their Makers* (Chicago: A. C. McClurg and Co, 1914). For a general discussion of consumer demand for goods made by southwestern Indians, see Edwin L. Wade, "The Ethnic Art Market in the American Southwest, 1880–1980," in *Objects and Others: Essays on Museums and Material Culture,* ed. George W. Stocking (Madison: University of Wisconsin Press, 1985).

62. "The Emergency in Indian Arts and Crafts," November 10, 1930, American Indian Defense Association, box 2, JLHC; Robert Fay Schrader, *The Indian Arts and Crafts Board: An Abstract of New Deal Indian Policy* (Albuquerque: University of New Mexico Press, 1983), 44.

Chapter 5. Authenticating the Navaho

1. Sherry Smith, *Reimagining Indians: Native Americans through Anglo Eyes, 1880–1940* (New York: Oxford University Press, 2000), 146–147; George Wharton James, *The Indians of the Painted Desert Region; Hopis, Navahoes, Wallapais, Havasupais* (New York: Little, Brown, and Company, 1903); George Wharton James, *In and Around the Grand Canyon: The Grand Canyon of the Colorado River in Arizona* (New York: Little, Brown, and Company, 1900); George Wharton James, *Indian Blankets and Their Makers* (Chicago: A. C. McClurg and Co., 1934). James wrote extensively about the Southwest and the indigenous people who lived there.

2. "Chief Wets-It Assinniboine," Warshaw Collection. The use of the term *Pellicana* lent authority to James as an expert on Navajo culture. As the invitation parenthetically noted, "Pellicana" meant "white person." The word is probably a variation of the Navajo term for a white person, *biligana.*

3. Ibid., last page of invitation.

4. On the sale of James's personal collection, see G. W. James to Grace Nicholson, February 16, 1902, and February 18, 1903, Grace Nicholson Collection, Huntington Library, San Marino, California. George Pepper claimed to have influenced the style of rugs that Navajo weavers made, taking credit for the invention of

the Navajo pillow cover, an item that became a staple of the Navajo textile trade. George Pepper, "The Making of the Navajo Blanket," *Everybody's Magazine,* January 1902; *Pueblo Bonito Anthropological Papers of the American Museum of Natural History* 27 (New York: American Museum of Natural History, 1920); Frank McNitt, *Richard Wetherill: Anasazi* (Albuquerque: University of New Mexico Press, 1966), 199–200. To sell Navajo blankets and jewelry, the Hyde Exploring Edition opened a store on 23rd Street in New York City in 1899. Herman Schweizer to Jesse Nasbaum, April 9, 1930, enclosed in Herman Schweizer to Mary Austin, April 8, 1930, Mary Austin Papers, Huntington Library, San Marino, California.

5. Wick Miller to Jess[e] Nusbaum, "Prospectus of Exhibit of Indian Craftsmen at Work," August 9, 1932, Laboratory of Anthropology Collection, Museum of Indian Arts & Culture, Santa Fe, New Mexico.

6. Jean Reed, "Navajo and Pueblo Indian Crafts," *Brooklyn Museum Quarterly* 19 (1932): 67.

7. Hubert Howe Bancroft was probably one of the first scholars to use the term *diffusion* in relation to Navajo language grouping. Hubert Howe Bancroft, *The Native Races of the Pacific States of North America,* vol. 3 (New York: Appleton, 1875): 583. In 1897, Washington Matthews described the "modern houses" of Navajos as "imitative" of those of non-Indians. Washington Matthews, *Navajo Legends* (New York: Houghton Mifflin, 1897; repr., Salt Lake City: University of Utah Press, 1994), 17. Citations are to the University of Utah edition. George Dorsey, of the Field Columbian Museum, explained the history of Navajo "infusion" in his booklet *Indians of the Southwest,* published in the same year that Culin went on his second collecting trip to the Southwest. George A. Dorsey, *Indians of the Southwest* (Topeka: Atchison, Topeka & Santa Fe Railway System Publisher, 1903), 166–167.

8. Neil Harris, "Museums, Merchandising, and Popular Taste: The Struggle for Influence," in *Cultural Excursions: Marketing Appetites and Cultural Tastes in America* (Chicago: University of Chicago Press, 1990), 65.

9. The Brooklyn Museum was just one of thirty-three locations across America that booked Miller and the Indian craftsmen. "List of Towns to Be Visited," reprint from the *Amos Parrish Magazine,* ca. 1933, Jonathan Batkin Collection, Wheelwright Museum of the American Indian, Santa Fe, New Mexico.

10. Leah Dilworth, *Imagining Indians: Persistent Visions of a Primitive Past* (Washington, D.C.: Smithsonian Institution Press, 1996); Margaret D. Jacobs, *Engendered Encounters: Feminism and Pueblo Cultures, 1879–1934* (Lincoln: University of Nebraska Press, 1999); Eliza McFeely, *Zuni and the American Imagination* (New York: Hill and Wang, 2001); Robert A. Trennert, "Fairs, Expositions, and the Changing Image of Southwestern Indians, 1876–1904," *New Mexico Historical Review* 62, no. 2 (Spring 1987): 127–150.

11. William H. Lyon, "The Navajos in the American Historical Imagination, 1868–1900," *Ethnohistory* (Spring 1998): 239. Frederick Webb Hodge, ed., *The Handbook of American Indians North of Mexico* (New York: Greenwood Press, 1910), 41–45.

12. William Edwardy, "The Navajo Indians," *Harper's Weekly,* July 1890, 530.

13. M. J. Riordan, "The Navajo Indians," *Overland Monthly,* October 1890, 373. Michael Riordan's brother, Denis, was probably the source of this information. Denis Matthew Riordan was a Navajo agent who worked at Fort Defiance in 1882

and 1883. See William H. Lyon, "The Navajos in the American Historical Imagination, 1868–1900," *Ethnohistory* (Spring 1998): 241.

14. Riordan, "The Navajo Indians," 380. Riordan makes no mention of Navajos as "borrowers."

15. Hazel E. Cumin, "The Bayeta of the Navaho: Examples of a Vanished Art, the Memory of Which Is Fast Disappearing," *House Beautiful,* May 1929, 644. She also asserted that Navajos had since become better craftsmen than the Puebloan peoples. Other articles also suggest that the Navajos borrowed the art of weaving from the Pueblos. See John L. Cowan, "Bedouins of the Southwest," *Outwest,* February 1912, 113.

16. Stewart Culin, "Guide to the Southwestern Indian Hall," *Museum News,* April 1907, 106.

17. Culin, "Guide," 107.

18. Jean Reed, "Navajo and Pueblo Indian Crafts," *Brooklyn Museum Quarterly* 19 (1932): 67.

19. Ibid.

20. Herbert Spinden, "Indian Art on Its Merits," *Parnassus* 3 (November 1931): 12.

21. Richard White, *The Roots of Dependency: Subsistence, Environment, and Social Change among the Choctaws, Pawnees, and Navajos* (Lincoln: University of Nebraska Press, 1988), 311.

22. Regna Darnell, *Invisible Genealogies: History of Americanist Anthropology* (Lincoln: University of Nebraska Press, 2001); David Hurst Thomas, *Skull Wars: Kennewick Man, Archaeology, and the Battle for Native American Identity* (New York: Basic Books, 2000), 48.

23. Thomas, *Skull Wars,* 65.

24. Ibid., 67; Frederick Hoxie, *A Final Promise: A Campaign to Assimilate the Indians* (Lincoln: University of Nebraska Press, 1984); Lewis Henry Morgan, *Systems of Consanguinity and Affinity of the Human Family* (Washington, D.C.: Smithsonian Institution Press, 1870).

25. Franz Boas, "The History of Anthropology," *Science* 20 (October 21, 1904): 515. See also Ira Jacknis, "Franz Boas and Exhibits: On the Limitations of the Museum Method of Anthropology," in *Objects and Others: Essays on Museums and Material Culture,* ed. George Stocking (Madison: University of Wisconsin Press, 1985), 75–111.

26. Boas, "History," 513.

27. Ibid., 522.

28. Darnell, *Invisible Genealogies;* Thomas, *Skull Wars,* 69.

29. Boas, "History," 522.

30. Louise Lamphere, "Gladys Reichard among the Navajo," *Frontiers: A Journal of Women Studies* 12 (1992): 82.

31. Franz Boas, American Museum of Natural History, Department of Anthropology, quoted in Jacknis, "Franz Boas and Exhibits," 100.

32. Frederick Ward Putnam, quoted in Curtis M. Hinsley, "The World as Marketplace: Commodification of the Exotic at the World's Columbian Exposition, Chicago, 1893," in *Exhibiting Cultures: The Poetics and Politics of Museum Display,* ed. Ivan Karp and Steven D. Levine (Washington, D.C.: Smithsonian Institution Press, 1991), 347.

33. David Jenkins, "Object Lessons and Ethnographic Displays: Museum Exhibitions and the Making of American Anthropology," *Comparative Studies in Society and History* 36 (April 1994): 250.

34. Robert E. Bieder, *Science Encounters the Indian: The Early Years of American Ethnology* (Norman: University of Oklahoma Press, 1986), 14.

35. Ira Jacknis, "The Road to Beauty: Stewart Culin's American Indian Exhibitions at the Brooklyn Musuem," in *Objects of Myth and Memory: American Indian Art at the Brooklyn Museum,* ed. Diana Fane, Ira Jacknis, and Lise M. Breen (Seattle: University of Washington Press, 1991), 29–44. According to Deborah Wythe, former archivist of the Brooklyn Museum and now head of Digital Collections and Services, "The Brooklyn Institute of Arts and Sciences was founded in 1823 as the Brooklyn Apprentices' Library. It was reorganized in 1843 as the Brooklyn Institute. In 1890, it was renamed the Brooklyn Institute of Arts and Science which became the parent organization of the Brooklyn Museum of Art, Botanic Garden, Academy of Music, Children's Museum, and Department of Education. The Institute was dissolved between 1970 and 1980 leaving the various divisions independent" (e-mail to author, July 24, 2003).

36. Stewart Culin to Franklin Hooper, October 28, 1903, Brooklyn Museum Archives, Culin Archival Collection, Department of Ethnology [3.1.004], Brooklyn, New York (hereafter Culin Collection); Eliza McFeely, *Zuni and the American Imagination* (New York: Hill and Wang, 2001), 111; Diana Fane, "The Language of Things: Stewart Culin as Collector," in Fane et al., eds., *Objects of Myth and Memory,* 13–27.

37. Daniel Brinton was professor of ethnology at the Academy of Natural Sciences, Philadelphia, and of American archaeology and linguistics. Robert E. Bieder, "Anthropology and the History of the American Indian," *American Quarterly* 33 (1981): 314. On the relationship between Culin and Brinton, see Fane, "The Language of Things," 15, 24.

38. Fane, "The Language of Things,"13–25; McFeely, *Zuni and the American Imagination,* 118; Jacknis, *Road to Beauty,* 38.

39. William Leach, *Land of Desire: Merchants, Power, and the Rise of a New American Culture* (New York: Vintage, 1993), 169–170.

40. George Dorsey, "Stewart Culin," *American Magazine,* June 19, 1913, Culin Collection [5.2.016]; Stewart Culin, "Games of the North American Indians," in *24th Annual Report of the Bureau of American Ethnology, 1902-1903* (Washington, D.C., 1907; repr., New York: Dover, 1975).

41. Eliza McFeely reports that Culin's first exhibit on southwestern Indians "featured a full-length portrait of Frank Hamilton Cushing by Thomas Eakins" that looked out over Culin's displays. McFeely, *Zuni and the American Imagination,* 113–114.

42. Stewart Culin, *Brooklyn Museum Annual Report* (1904), 21, Culin Collection.

43. The pottery collection included 176 pieces of prehistoric pottery or "specimens, from Arizona, Colorado, New Mexico and Utah"; 350 "specimens, in part collected from a ruined pueblo near Santa Fe" and "in part derived from various existing Indian towns in New Mexico"; and 55 "specimens of prehistoric and modern Hopi, Zuni, and other Indian pottery from the Southwestern United States." Culin, *Brooklyn Museum Annual Report* (1904), 19.

44. Dorsey, "Stewart Culin."

45. On Vanderwagen, see Frank McNitt, *The Indian Traders* (Norman: University of Oklahoma Press, 1962), 241; Stewart Culin to Franklin Hooper, August 15, 1903, Culin Collection [3.1.006].

46. Stewart Culin, *Report on a Collecting Expedition among the Indians of New Mexico and Arizona, 4–9/1903* (1903), 101–102, Culin Collection [2.1.002].
47. Stewart Culin to Franklin Hooper, August 15, 1903, Culin Collection [3.1.006].
48. Franklin Hooper to Stewart Culin, October 28, 1903, Culin Collection [3.1.004].
49. Culin, "Guide," 107.
50. *Report on a Collecting Expedition* (1903), 10, Culin Collection [2.1.002].
51. Ibid. (1902), 3 [2.1.001].
52. Ibid.
53. Day Family Collection, box 3, folder 91, Cline Library, Northern Arizona University.
54. Culin traveled for 178 days and covered 7,026 miles on this expedition. He reported that the bones and household items from Cañon del Muerto had been collected by Charles, Willie, and Sam Day on March 9, 1903, only one month before Culin's arrival in the area. *Report on a Collecting Expedition* (1903), 14, Culin Collection [2.1.002].
55. Ibid.
56. Ibid. (1903), 15 [2.1.002].
57. Campbell Grant, *Canyon de Chelly: Its People and Rock Art* (Tucson: University of Arizona Press, 1978), 81–87. Culin dates the raid to approximately 1803, or "something like a hundred years ago, the date is fixed a year or two years before Manuelito Viego was born, a band of Navajo were living in the Canon." Artifacts in the collection included "loom sticks, spindles, a piece of blue woolen fabric and a bag of quills," as well as a "small bow, apparently one sinew backed was accompanied with some fragments of cane arrows" and "a number of large black pottery mush pots, precisely like those used by the Navajos to-day." Culin wrote that the broken skulls showed "that the Indians were clubbed to death." *Report on a Collecting Expedition* (1903), 14 [2.1.002].
58. On relating the tale to museum visitors, see Culin, "Guide," 108.
59. Stewart Culin, "The Indians of the Southwest," 1904 lecture, 57–58, Culin Collection [5.2.005].
60. Culin, "Guide," 108.
61. *Report on a Collecting Expedition* (1903), 106, Culin Collection [2.1.002].
62. Ibid., 69.
63. Ibid.
64. Charlotte Johnson Frisbie, *Navajo Medicine Bundles or Jish: Acquisition, Transmission, and Dispossession in the Past and Present* (Albuquerque: University of New Mexico Press, 1987), 108.
65. *Report on a Collecting Expedition* (1903), 69, Culin Collection [2.1.002].
66. Culin learned that the "buckskin wrappings were all made from deer that had been captured without injury. . . . So much care and time had been made necessary to collect these materials" that Sandoval asserted that these "objects were very valuable." Ibid.
67. Ibid., 70.
68. Ibid.
69. Ibid., 69.
70. Ibid.
71. Ibid., 71–72.

72. In his expedition journal, Culin gives the trader's name as Joe Wilkin. *Report on a Collecting Expedition* (1903), 71–72 [2.1.002]. The correct name is probably Robert L. Wilken, the author of a text on Father Weber: *Anselm Weber, O.F.M., Missionary to the Navajo, 1898–1921* (Milwaukee: Bruce Publishing Company, 1955), 129. Charlotte Frisbie notes a connection between the men. Frisbie, *Navajo Medicine Bundles*, 232.
73. *Report on a Collecting Expedition* (1903), 69–74, Culin Collection [2.1.002]. Culin pursued these items even though he'd already purchased one from Charles Day. Ibid., 16.
74. Ibid., 12–16.
75. Ibid., 16.
76. Ibid.
77. Ibid. (1902), 24 [2.1.001].
78. Given such analysis, the community that Culin is referring to in the previous quote is likely the larger nation, the United States. Ibid.
79. Ibid.
80. Ibid. (1903), 117 [2.1.002].
81. Ibid.
82. Ibid.
83. Ibid., 122.
84. Ibid.
85. Ibid.
86. On forced assimilation in the early twentieth century, see David Wallace Adams, *Education for Extinction: American Indians and the Boarding School Experience, 1875–1928* (Lawrence: University Press of Kansas, 1995), 263–269.
87. Jacknis, "The Road to Beauty," 31.
88. Culin, "Guide," 107.
89. Darnell chronicles the changes in anthropological theory at the turn of the century in *Invisible Genealogies*, 33–40; Culin, "The Indians of the Southwest," (1904 lecture), 1, Culin Collection [5.3.007].
90. Ibid.
91. Ibid.
92. Ibid., 11.
93. Fane, "The Southwest," 47.
94. Culin, "The Indians of the Southwest" (1904 lecture), 6, Culin Collection [5.3.007].
95. Ibid., 2.
96. Ibid., 10.
97. Ibid.
98. Ibid.
99. Ibid., 35.
100. Ibid.
101. Ibid., 24. On the use of the word *Anasassi* in Culin's expedition report, see *Report on a Collecting Expedition* (1903), 61, Culin Collection [2.1.002]. On different adaptations and borrowings that Culin observed among the Navajos, see ibid., 9, 69, 72, 77, 83, 84, 90. Culin made only two notations of Zuni "adaptations": use of "American clothing" (93) and the desire of a Zuni silversmith to upgrade his forge and buy new tools (92).
102. Culin, "Guide," 107.

103. Wick Miller to Jess[e] Nusbaum, August 9, 1932, Laboratory of Anthropology Collection.

104. Oliver La Farge testimony, *Federal Trade Commission v. Maisel Trading Post, Inc.,* 77F.2d 246 (10th Cir. 1935), case 976, T15, 104, FTC Archives, National Archives and Records Administration, College Park, Maryland.

Chapter 6. Codifying the Navaho: The "Indian-Made" Controversy

1. John Adair, "Journal Notes," June–July 1938, 83–87, John Adair Papers (JAP), Wheelwright Museum of the American Indian, Santa Fe, New Mexico.

2. Ibid.

3. Ibid.

4. Ibid., 55. In 1938, Burnside told anthropologist John Adair that he and Brown had decided to fight their former employer.

5. Richard White, *The Roots of Dependency: Subsistence, Environment, and Social Change among the Choctaw, Pawnees, and Navajos* (Lincoln: University of Nebraska Press, 1988).

6. Robert Fay Schrader, *The Indian Arts and Crafts Board: An Aspect of New Deal Indian Policy* (Albuquerque: University of New Mexico Press, 1983), 54–57.

7. George Nelson testimony, *Transcript of Record, United States Circuit Court of Appeals, Tenth Circuit, No. 976, Federal Trade Commission v. Maisel Trading Post, Inc., Respondent, Application for Enforcement of Order to Cease and Desist, Issued by Petitioner, Docketed October 23, 1933,* 135, 77 F.2d 246 (10th Cir. 1935), FTC Archives II, National Archives Trust, FTC Archives, National Archives and Records Administration, College Park, Maryland (hereafter *FTC v. Maisel*).

8. Maisel testimony, *FTC v. Maisel,* FTC docket 2037; advertisement in *Albuquerque Morning Journal,* August 21, 1929, 1.

9. *Maisel's Indian Trading Post,* Albuquerque, New Mexico, June 27, 1931, *FTC v. Maisel,* D13.

10. Ibid.

11. Josephine Paterek, *Encyclopedia of American Indian Costume* (Denver: ABC-CLIO, 1994), 171.

12. *Maisel's Indian Trading Post,* D13. Maisel's use of images, in Jennifer Nez Denetdale's words, "reinforce[s] reductionist representations" of Navajos. As Denetdale points out, this strategy was common and did more than misrepresent Navajos. It masked "the unimaginable traumas Navajos have survived." Jennifer Nez Denetdale, *Reclaiming Diné History: The Legacies of Navajo Chief Manuelito and Juanita* (Tucson: University Press of Arizona, 2007), 88.

13. *Maisel's Indian Trading Post,* D13.

14. Ibid.

15. Ibid.

16. Ibid.

17. Ibid.; Jonathan Batkin, "Some Early Curio Dealers of New Mexico," *American Indian Art Magazine,* Summer 1998, 74.

18. In a 1940 interview with John Adair, Maisel told the anthropologist that he did not think his trade in silver jewelry exceeded $1 million. Adair estimated the amount to be closer to $1.5 million. Although these figures are not verifiable,

they indicate that a great deal of money was at stake. Adair, "Journal Notes," November 14, 1940, JAP.

19. *FTC v. Maisel,* memorandum for Commissioner Humphrey, docket 2037, D3.

20. Oliver La Farge testimony, *FTC v. Maisel,* T14; Oliver La Farge, *Laughing Boy: A Navajo Love Story* (New York: Houghton Mifflin, 1929).

21. Oliver La Farge, Records of the Federal Trade Commission, *Transcript of Record for the U.S. Court of Appeals for the Tenth Circuit,* box 92, 72/14/3:2, 27, National Archives Trust, FTC Archives, National Archives and Records Administration, Denver, Colorado (hereafter FTC *Transcript*).

22. Oliver La Farge, FTC, T4, 101–104.

23. Oliver La Farge testimony, *FTC v. Maisel;* FTC *Transcript,* box 92, loc.72/14/3:2, 26, T4, 104; 276.

24. M. L. Woodard, editor of *Southwest Tourist News,* Gallup, New Mexico, *FTC v. Maisel,* FTC Field Report, file no. c-12108, July 4, 1931, D13.

25. M. L. Woodard, "The Navajo Goes East," *New Mexico Highway Journal,* March 1931, 15.

26. Lucille Smith, *Transcript of Record,* 37, *FTC v. Maisel.*

27. Ibid. Smith claimed to have lectured to 5,000 children.

28. Ibid., 21.

29. Marion Moore to Grace Nicholson, August 29, 1907, Grace Nicholson Collection, Huntington Library, San Marino, California. On anti-Semitism and exploitative relationships, see Kerwin Klein, *Frontiers of Historical Imagination: Narrating the European Conquest of Native America, 1890–1990* (Berkeley: University of California Press, 1997). Gail Bederman documents a similar tone in Teddy Roosevelt's explanation of the conquest of Native Americans. Gail Bederman, *Manliness and Civilization: A Cultural History of Gender and Race in the United States, 1860–1917* (Chicago: University of Chicago Press, 1996).

30. Maurice Maisel, testimony, September 3, 1932, *FTC v. Maisel,* docket 2037.

31. Eugene Burr to M. Maisel, testimony, September 3, 1932, *FTC v. Maisel,* docket 2037.

32. Daniel Horowitz, "Frugality or Comfort: Middle-Class Styles of Life in the Early Twentieth Century," *American Quarterly* (Summer 1985): 239–259. Horowitz describes the duality of middle-class philosophies of shopping and economizing.

33. Lizabeth Cohen, *A Consumers' Republic: The Politics of Mass Consumption in Postwar America* (New York: Vintage Books, 2003), 18–61.

34. P. Clinton Bortell, Field Report, June 29, 1931, *FTC v. Maisel.*

35. S. F. Staker, witness, FTC *Transcript, Docketed October 23, 1933,* 114.

36. *FTC v. Maisel, Writ of Certiorari,* D5, 19A. The total population of Navajos at this time was approximately 50,000.

37. Adair, "Journal Notes," June–July 1938, 21, JAP.

38. John Adair, *The Navajo and Pueblo Silversmiths* (Norman: University of Oklahoma Press, 1944), 112–113. On income from silversmithing, see also Nathaniel K. Fairbank, "Handcraft: An Investigation of the Present and Potential Market for Noncompetitive Handcraft in the United States," *Division of Self-Help Cooperatives, Federal Emergency Relief Administration,* box 65, folder 1, 10–12, American Association on Indian Affairs Records (AAIA), Mudd Manuscript Library, Princeton University, Princeton, New Jersey. Fairbank claimed that southwestern Indians, in particular, relied on the income they earned from handcrafts, even though it

was fairly low. Income from "Indian" handcrafts amounted to $266,000 in 1933. Notably, $122,720 of that amount came from the sale of Navajo textiles. An additional $47,475 came from sale of "Indian" silverwork. In sum, the sale of Navajo-made goods represented a good proportion of Indian-made goods produced and sold in the United States. Fairbank also figured that an individual Indian silversmith working in the Santa Fe region earned approximately $300 a year. By comparison, the 1,453 individual members of the League of New Hampshire Arts and Crafts guild made approximately $6.50 per year from the sale of their handmade objects. Given this information, Fairbank seemed to parrot La Farge when he asserted that craft production among American Indians might be the "perfect non competitive handcraft"—meaning "goods of such character or catering to such a market that price is not the determining factor."

39. White, *Roots of Dependency*, 238–239; Adair, *Navajo and Pueblo Silversmiths*, 113. On family members' learning the craft of silver, see John Adair, "Journal Notes," July 2, 1938, JAP. Adair notes, "Haske says he learned silver from John . . . they are brothers . . . he says his sister also works silver as well as weaves."

40. Adair, *Navajo and Pueblo Silversmiths*, 114. On the flat rate paid to silversmiths, see Charlie Bitsui, John Peshlakai, and Robert Pino, interview sheets 1938–1939, MS18-11-414, Wheelwright Museum of the American Indian, Santa Fe, New Mexico.

41. Adair, "Journal Notes," June–July 1938, 12, JAP. Although Adair did his fieldwork in 1938, his methodology for determining how long a skilled silversmith would take to make an "old-style" Navajo bracelet is still useful in determining the amount of time that went into the production of such goods. He also reports that artisans could make bracelets and other goods of lesser quality faster.

42. John Adair, "Interview with Maisel," November 15, 1940, JAP.

43. Maurice Maisel testimony, September 3, 1932, *FTC v. Maisel*, docket 2037, 814. A. J. Merrill told the FTC field representative how the plan worked: "They [the traders] furnish the Indian with turquoises [sic] and silver pesos or squares but never furnish the pattern. They direct the Indian to make so many bracelets, rings, belts . . . of certain sizes, which can sell for a certain price, but the design, shape . . . are left to the individual judgement of the Indian" (2).

44. *FTC v. Maisel*, docket section, file 2037-3-12. Correspondence, Amicus Curiae and Attorneys, *FTC v. Maisel*, 570:16:10, RG 122, box 1149, D10, Lyle to Burr, May 13, 1935. Lyle refers to the assembly-line approach that Maisel used to speed up production and to rob the jewelry of its value as a personal expression of the individual silversmith. On the 144 traders involved in the lawsuit, see Lyle, D10, Brief of Amicus Curaie.

45. Joe Abeita testimony, *FTC v. Maisel*, T13, 121.

46. Charlie Petsoe testimony, *FTC v. Maisel*, T9, 334.

47. Haske Burnside (Navajo) to Eugene Burr, September 30, 1933. D9. While working as a silversmithing instructor at the Albuquerque U.S. Indian School in Albuquerque, Burnside wrote to Burr, "I have four brothers, they do the silversmithing and also they are starving on account of Maisel's Machine made Indian imitation Jewelry." On the number of Navajos on the reservation (4,500), see *FTC v. Maisel*, D1-5. On the support of the commissioner of Indian affairs, see *FTC v. Maisel*, 570:16:10, RG 122, box 1149. Docket Section, file 2037-3-12 includes correspondence from Harold L. Ickes, secretary of the interior, and John Collier, among others.

48. Colleen O'Neill, *Working the Navajo Way: Labor and Culture in the Twentieth Century* (Lawrence: University Press of Kansas, 2005).

49. David Wallace Adams, *Education for Extinction: American Indians and the Boarding School Experience, 1875–1928* (Lawrence: University Press of Kansas, 1995); Frederick E. Hoxie, *A Final Promise: The Campaign to Assimilate the Indians, 1880–1920* (Lincoln: University of Nebraska Press, 1984; repr., Lincoln: University of Nebraska Press, 2001), 67.

50. *Educational Objectives to Serve Tentatively as a Basis for a Navajo Curriculum at the Charles Burke Indian School,* February 15, 1935, 5, LeRoy Jackson Collection, Huntington Library, San Marino, California.

51. Ibid., 5–6.

52. Adams, *Education for Extinction,* 335.

53. *Educational Objectives,* 5–6.

54. Julius Gans, letter to the editor, *Southwest Tourist News,* February 19, 1935, 2.

55. Haske Burnside Personal File, Albuquerque Indian School, letter from L. McKinney to potential consumers, June 21, 1939. The letter gives the dates of Haske's employment at the Albuquerque Indian School as 1931–1934. Jonathan Batkin Collection, Wheelwright Museum of the American Indian, Santa Fe, New Mexico.

56. *Shush Be' Tok News,* Fort Wingate, New Mexico, vol. 5, March 16, 1936, Jackson Collection.

57. *FTC v. Maisel,* 570:16:10, RG 122, box 1149; quote from page 1.

58. Molly Mullin, *Culture in the Marketplace: Gender Art and Value in the American Southwest* (Durham, N.C.: Duke University Press, 2001); Mary C. Wheelwright testimony, *FTC v. Maisel,* T8.

59. Mary Russell F. Colton, *Art for the Schools of the Southwest: An Outline for the Public and Indian Schools,* Bulletin 6, February 1934 (Flagstaff: Northern Arizona Society of Science and Art), 30.

60. U.S. Department of the Interior Commissioner of Indian Affairs, *Annual Reports, Department of the Interior,* 1912, 38, CIA/BIA Annual Reports, Bureau of Indian Affairs Collection, Special Collections, University of California, Santa Barbara.

61. Ibid., 38.

62. Ibid., 38. The Commission of Indian Affairs documented that Navajo blankets were "the most important native industry" between 1914 and 1917. See CIA, *Annual Reports* 1914, 14; 1915, 11; 1916, 32. CIA, *Annual Reports,* 1916, 32.

63. CIA, *Annual Report,* 1916, 32. Museum directors from the Commercial Museum and the University Museum, both of Philadelphia, supported the program and agreed to give the CIA floor space and assistance "in setting up exhibits in conspicuous places properly marked to direct the public to the Indian source of supply" (32). Schrader has also documented the existence of the tagging program in *Indian Arts and Crafts Board,* 9.

64. After a successful Christmas display in 1934, Macy's decided to make an Indian rug department a permanent part of its store. See U.S. Secretary to the Commissioner of Indian Affairs, Marion Hall, to Oliver La Farge, January 24, 1935, box 65, AAIA Records. The endeavor seemed to end sometime in 1936. Macy's placed only two orders with Hubbell, for approximately 280 rugs. See R. H. Macy's and Company to Lorenzo Hubbell, February 8 and 26, 1936, box 53, Juan Lorenzo Hubbell Collection (JLHC), Special Collections, University of Arizona, Tucson.

By April 1936, Oliver La Farge had accused Macy's of trying to cut corners by sell-
ing "Indian-style" rugs as opposed to Navajo rugs. Oliver La Farge to John Collier,
April 20, 1936, box 65, AAIA Records.

65. Schrader, *Indian Arts and Crafts Board,* 9.

66. Ibid., 8.

67. On the failure of the Davis Plan, see CIA, *Annual Reports,* 1917, 39. Fred Har-
vey's complicated pricing system is explained in Nancy J. Blomberg, *Navajo Tex-
tiles: The William Randolph Hearst Collection* (Tucson: University of Arizona Press,
1988), 23–25. The company used three price codes. For instance, each letter in
the code name HYDRAULICS stood for a number from 1 to 10: H stood for 1, Y stood
for 2, and so on. When needed, X represented zero. The retail markup on rugs
could be as much as 600 percent depending on style, color, and size. For example,
in the first decade of the twentieth century, a rug that the Harvey Company pur-
chased from J. L. Hubbell for $12 might retail for $60–$85 at the Fred Harvey gift
shop. See Harvey Rug Books, no. 3, 1905–1906, sheet 9, rugs 126–156, Museum of
International Folk Art, Santa Fe, New Mexico. On prices lower than 75 cents, see
C. N. Cotton to Roman Hubbell, April 26, 1912, box 20, JLHC. Cotton reported in
1912 that he rarely paid even 75 cents a pound for a blanket. He mostly paid be-
tween 50 and 60 cents per pound. The highest price paid that year was 75 cents,
but other traders reportedly paid up to $1.30.

68. CIA, *Annual Report,* 1920, 113, as reported in Schrader, *Indian Arts and Crafts
Board,* 11. The CIA reported that native industries bought in $177,169 nationwide
in 1900; $847,556 in 1911; $1,316,298 in 1914; and $1,315,112 in 1917. The com-
mission lists Navajos' income from crafts for only one year: $247,000 in 1917.
See "Income of Indians (by Reservations), Including Tribal Incomes, Fiscal Year
Ending June 30, 1917," CIA, *Annual Report,* 1917. The total number of Native
Americans living on reservations in 1920 was 355,901. The total population of
Navajos was between 20,000 (1900) and 70,000 (1947). These figures are from
Clyde Kluckhohn and Dorothea Leighton, *The Navaho* (Cambridge, Mass.: Har-
vard University Press, 1946).

69. Schrader, *Indian Arts and Crafts Board,* 14–15. Burke's only attempt to promote
Indian arts and crafts was to sponsor an Indian arts and crafts booth at the Travel
Club of America in New York City. During the 1920s, many Americans feared
that native arts would disappear, despite their contemporary popularity, because
elder craftsmen were dying and the CIA was not encouraging the preservation
of traditional arts and crafts. See Lewis Meriam et al., *The Problem of Indian Ad-
ministration,* Institute for Government Research, Studies in Administration (Bal-
timore: Johns Hopkins Press, 1928), 646–648.

70. Roger L. Nichols, *Indians in the United States and Canada: A Comparative History*
(Lincoln: University of Nebraska Press, 1998). Dr. Lewis Meriam headed a staff
of expert researchers. His staff found that Indian schools were underfunded and
overcrowded, that poverty was a common problem, and that U.S. Indians' per
capita income was one-sixth that of U.S. residents. Inadequate health care was
also a problem, and disease affected many Indians. The report blamed the BIA
for the general state of Indians. The researchers found that one-quarter of reser-
vation Indians earned less than $100 per year. Some 71.4 percent had incomes of
less than $200, and only about 2 percent of all reservation Indians earned $500
or more. The report suggested that the marketing of Indian artifacts would help

bring needed income to reservation Indians. Meriam et al., *The Problem of Indian Administration*, 533, 651–652.

71. Frazier-Leavitt bill, February 13, 1930, box 2, JLHC. See also Schrader, *Indian Arts and Crafts Board*, 22–43. Opponents of the Frazier-Leavitt bill included the Eastern Association of Indian Affairs, Mary Austin, and Mabel Dodge Luhan. They objected on the grounds that Collier, who pushed for the bill, had not sought their input. In addition, many people believed that the legislation would destroy old styles of arts and crafts and that it encouraged the mass production of Indian art. Traders also objected to the bill, because it did not clearly define their role (35). The bill was held up in the Bureau of the Budget, which eventually determined that the program should be funded by external organizations. This recommendation was consistent with President Hoover's belief in voluntary, corporate action.

72. "The Emergency in Indian Arts and Crafts," AIDA [American Indian Defense Association] file, box 2, JLHC. The emergency was a serious drop in wool prices, blanket prices, and jewelry prices as a result of the Depression; Collier was also concerned that imitation jewelry was becoming more common. See also Schrader, *Indian Arts and Crafts Board*, 33. For the Collier quote, see AIDA to Roman Hubbell, February 13, 1930, AIDA file, box 2, JLHC.

73. On saving Indian arts and crafts see, Margaret Davis Jacobs, "Uplifting Cultures: Encounters between White Women and Pueblo Indians, 1890–1935" (Ph.D. diss., University of California, Davis, 1996), 258.

74. Amelia E. White to Charles James Rhoads, April 10, 1930, box 1203, file 900, BIA Collection. White was AAIA secretary of Indian affairs, and she forwarded the unsigned traders' letters to Rhoads and Leavitt, supporters of the bill, in an effort to show that traders were only after profit and therefore disingenuous in their support. Many traders did change their mind about the bill, claiming they had not read a copy of it before signing it. See also Schrader, *Indian Arts and Crafts Board*, 36. On the practice of overstocking blankets, see Chapter 2.

75. John Collier to Lorenzo Hubbell Jr., September 19, 1931, AIDA file, box 2, JLHC. Collier tried to quell Hubbell's fears by stating that the presidential board would only attempt to start new markets in cities such as Paris and London. He reassured Hubbell the board would not infiltrate established markets.

76. Herman Schweizer to Lorenzo Hubbell Jr., Oraibi, Arizona, March 10, 1930, JLHC.

77. *Federal Trade Commission v. Jeffery Jewelry Company*, docket 2004, September 21, 1932, box 64, AAIA Records.

78. "The Emergency in Indian Arts and Crafts," November 10, 1930, file 900, box 1203, BIA Records; and AIDA file, box 2, JLHC. Schrader, *Indian Arts and Crafts Board*, 41–44, reports that those familiar with the Navajo Reservation saw conditions worsen and devised several plans to stimulate the market for Indian-made goods.

79. "Emergency in Indian Arts and Crafts," JLHC; John Collier to Mr. Parker, Hubbell Trading Post, March 27, 1933, AIDA file, box 2, JLHC. On stock reduction, see White, *Roots of Dependency*, 250–261.

80. Among other things, the United Indian Traders Association (UITA) objected to the sale of partially or wholly machine-processed rugs, jewelry, basketry, and pottery under the "Indian-made" label. The UITA proposed regulating and standardizing hand production methods, the materials used in Indian industries, and the

kinds of marketing techniques traders could use. The association also introduced its own labeling and stamping scheme. As the formation of the UITA illustrates, use of a label that informed consumers that a rug or bracelet was certifiably Indian-made was a central feature of trade in Indian industries in the 1930s. UITA devised the following official standard for Navajo rugs: "Material used shall be virgin wool or virgin angora wool, the same shall be hand-washed, hand-carded and hand-dyed, the warp shall be all wool and hand-spun, the wool shall be all wool and hand-spun and the blanket shall be hand-woven by an Indian." Charles Avery Amsden, *Navaho Weaving: Its Technic and Its History* (Santa Ana, Calif.: Fine Arts Press, 1934; repr. Glorieta, N.Mex.: Rio Grande Press, 1990), 203. Page number from 1990 edition. See also *FTC v. Maisel,* UITA position paper, D10. Note that UITA's definition specifies hand processes, including dyeing, whereas many traders—Cotton, Hubbell, and Moore among them—had been providing weavers with commercially dyed wool for many years. Amsden reports that the UITA allowed non-Indian dyed wool "provided it was done by hand" (203).
81. Memorandum of the Commission, *FTC v. Maisel,* docket 2037, D3.
82. *FTC v. Maisel,* May 1, 1935 Ruling.
83. Two subsequent amendments were issued in 1936, but the basic elements of the 1935 case were upheld, albeit without any significant mechanism for enforcement.
84. *FTC v. Maisel.* Maisel submitted a series of labels to the court to prove he was in compliance with the law.

Conclusion. Branding, Borders, and Beyond

1. Michael Brown, *Who Owns Native Culture?* (Cambridge, Mass.: Harvard University Press, 2003).
2. "Ramona Days," no. 1, March 1, 1887, 6, Indian Department, Center for Southwest Research (CSWR) University of New Mexico.
3. Ibid.; letter from Grover Cleveland, unnumbered page, call number E97.6 R3 V1 #1, (CSWR), University Libraries, University of New Mexico, Albuquerque.
4. Discourses about the civilization or extinction of Native Americans became especially heated during the Jeffersonian and Jacksonian eras. The debate continued into the twentieth century, taking on new meaning in the hands of ethnographers like Stewart Culin. Erika Bsumek, "The Navajos as Borrowers," *New Mexico Historical Review* 79, no. 3 (Summer 2004): 319–347; Anthony Wallace, *Jefferson and the Indians: The Tragic Fate of the First Americans* (Cambridge, Mass.: Belknap Press, 2001); Michael Paul Rogin, *Fathers and Children: Andrew Jackson and the Subjugation of the American Indian* (New York: Knopf, 1975).
5. George Lipsitz, *Possessive Investment in Whiteness: How White People Profit from Identity Politics* (Berkeley: University of California Press, 1998); A. G. Hopkins, "Globalization With and Without Empires: From Bali to Labrador," in *Globalization in World History,* ed. A. G. Hopkins (New York: W. W. Norton, 2002), 221–243, esp. 230; Brown, *Who Owns Native Culture?;* Hal Rothman, *Devil's Bargains: Tourism in the Twentieth Century American West* (Lawrence: University Press of Kansas, 1998); Sarah H. Hill, "Marketing Traditions: Cherokee Basketry and Tourist

Economies," in *Selling the Indian: Commercializing and Appropriating American Indian Cultures,* ed. Carter Jones Meyer and Diana Royer (Tucson: University of Arizona Press, 2001), 212–235.

6. Rosemary Coombe, "Embodied Trademarks: Mimesis and Alterity on American Commercial Frontiers," *Cultural Anthropology* 1, no. 2 (1996): 203.

7. Ibid. (emphasis mine).

8. Robert Faye Schrader, *The Indian Arts and Crafts Board: An Aspect of New Deal Indian Policy* (Albuquerque: University of New Mexico Press, 1983).

9. Lenora Begay Trahant and Monty Roessel, *The Success of the Navajo Arts and Crafts Enterprise* (New York: Walker and Company, 1996), 13–15.

10. According to Kathy M'Closkey, "The appropriation of popular Navajo patterns is not just a pilfering of pretty designs. It is theft of a way of life." Moreover, "it threatens the destruction of activities vital to Navajo culture. And it is one of the more recent threats that perpetuate processes begun more than a century ago." Kathy M'Closkey, *Swept under the Rug: A Hidden History of Navajo Weaving* (Albuquerque: University of New Mexico Press, 2002), 15.

11. Ibid.; William Warner Wood, "Rapport Is Overrated: Southwestern Ethnic Art Dealers and Ethnographers in the 'Field,'" *Qualitative Inquiry* 7 (2001): 484–503; Wood, "Flexible Production, Households, and Fieldwork: Multisited Zapotec Weavers in the Era of Late Capitalism," *Ethnology* 39 (2000): 133–148.

12. John Shiffman, "Indian Art: Buyer Beware, Artisans Pay Price of Counterfeiting," *USA Today,* April 8, 1998, 1A–2A.

13. M'Closkey, *Swept under the Rug,* 196.

14. Wood, "Flexible Production," 137.

15. "Even the Experts Are Being Duped," *USA Today,* April 8, 1998, 2A. This fear stems from the fact that a high percentage of the Navajo Nation's 200,000 (or more) members "are involved in the trade" of selling rugs and other "Indian-made" goods.

16. William Warner Wood, "Stories from the Field, Handicraft Production, and the Mexican National Patrimony: A Lesson in Translocality from B. Traven," *Ethnology* 39 (2000): 184; Lynn Stephen, *Zapotec Women* (Austin: University of Texas Press, 1991), 91–93, 133.

17. William Warner Wood, "Oaxacan Textiles, 'Fake' Indian Art, and the Mexican 'Invasion' of the Land of Enchantment" (unpublished paper, Natural History Museum, Los Angeles, n.d.), 4–5.

18. Ibid., 5.

19. Wood, "Flexible Production," 135.

20. Wood, "Oaxacan Textiles," 12.

21. Ibid.

22. Wood, "Rapport Is Overrated," 491–492.

23. Ibid., 493.

24. "Tourism Office Hosts Unique Forum to Examine Arts and Crafts Issues," *Navajo Times,* May 14, 1998.

25. Ibid.

26. Ibid.

27. Ibid.

28. Gail Sheffield, *The Arbitrary Indian: The Indian Arts and Crafts Act of 1990* (Norman: University of Oklahoma Press, 1997), 102–120.

29. Wood, "Rapport Is Overrated," 494.
30. The fact that weavers have maintained their culture does not necessarily mean that they have been fairly compensated. Jennifer Nez Denetdale, "Review Essay," *New Mexico Historical Review* (Fall 2004): 478.
31. Ibid., 471–479; M'Closkey, *Swept under the Rug*, 234–255.

BIBLIOGRAPHY

Manuscript Collections and Archives

John Adair Papers (JAP), Wheelwright Museum of the American Indian, Santa Fe, New Mexico.

American Association on Indian Affairs Records (AAIA), Mudd Manuscript Library, Princeton University, Princeton, New Jersey.

Mary Austin Papers, Huntington Library, San Marino, California.

Jonathan Batkin Collection, Wheelwright Museum of the American Indian, Santa Fe, New Mexico.

Bureau of Indian Affairs Collection (BIA), Special Collections, Donald C. Davidson Library, University of California, Santa Barbara.

Haske Burnside Papers, Collection of Jonathan Batkin, Wheelwright Museum of the American Indian, Santa Fe, New Mexico.

Center for Southwest Research, University Libraries, University of New Mexico, Albuquerque.

Chaco Collection, University of New Mexico, Albuquerque, with U.S. National Park Service.

Culin Archival Collection, Brooklyn Museum Archives, Department of Ethnology, Brooklyn, New York.

Day Family Collection, 1858–1977, Cline Library, Northern Arizona University, Flagstaff.

American Indian Oral History Collection, Center for Southwest Research (CSWR), University Libraries, University of New Mexico, Albuquerque.

Doris Duke Oral History Project, Hubbell Trading Post National Historic Site (HUTR), U.S. National Park Service, Ganado, Arizona.

Federal Trade Commission v. Maisel Trading Post, Inc., 77 F.2d 246 (10th Cir. 1935), case 976, FTC Archives II, National Archives and Records Administration, College Park, Maryland.

Records of the Federal Trade Commission, U.S. Court of Appeals for the Tenth Circuit, National Archives Trust, FTC Archives, National Archives and Records Administration, Denver, Colorado.

Franciscan Missions of the Southwest (FMSW), Special Collections, University of Arizona, Tucson.

Fred Harvey Collection, Special Collections, University of Arizona, Tucson.

Fred Harvey Rug Books, Museum of International Folk Art, Santa Fe, New Mexico.

C. P. Holliday Papers, Huntington Library, San Marino, California.

Juan Lorenzo Hubbell Collection (JLHC), Special Collections, University of Arizona, Tucson.

Lorenzo Hubbell Papers, Hubbell Trading Post National Historic Site (HUTR), U.S. National Park Service, Ganado, Arizona.

Human Census Records, Soil Conservation Survey Schedules, National Archives and Records Administration (NARA), Laguna Niguel, California.

Laboratory of Anthropology Collection, Museum of Indian Arts & Culture, Santa Fe, New Mexico.

Florence Osgood Rand Lang Papers, Montclair Art Museum, Montclair, New Jersey.
Charles Lummis Papers, Southwest Museum, Los Angeles, California.
Frank McNitt Papers, State Records Center and Archives, Santa Fe, New Mexico.
Grace Nicholson Collection (GNC), Huntington Library, San Marino, California.
Grace Nicholson Collection, Museum of the American Indian, Research Office, Bronx, New York.
Gladys Reichard Collection, Museum of Northern Arizona, Flagstaff.
Soil Conservation Survey Schedules (SCS), National Archives and Records Administration (NARA), Laguna Niguel, California.
Trader Oral History Collection (TOHC), Cline Library, Northern Arizona University, Flagstaff.
Warshaw Collection of Business Americana, Archives Center, National Museum of American History, Smithsonian Institution, Washington, D.C.
Martha and Amelia Elizabeth White Papers, School for Advanced Research, Santa Fe, New Mexico.

Interviews

Blair, Elijah. Page, Arizona, March 14, 2006.
Burnham, Bruce. Gallup, New Mexico, March 14, 2006.
Chavez, Vidal. Santa Fe, New Mexico, March 15, 2006.

Books and Periodicals

Aberle, David F. "Navajo Economic Development." In *Handbook of North American Indians of the Southwest,* vol. 9, eds. William C. Sturtevant and Alfonso Ortiz, 641–658. Washington, D.C.: Smithsonian Institution Press, 1983.
Adair, John. *The Navajo and Pueblo Silversmiths.* Norman: University of Oklahoma Press, 1944.
Adams, David Wallace. *Education for Extinction: American Indians and the Boarding School Experience, 1875–1928.* Lawrence: University Press of Kansas, 1995.
Adams, William Y. "Shonto: A Study of the Role of the Trader in a Modern Navajo Community." *Bureau of American Ethnology Bulletin* 188: 152–153. Washington, D.C.: Government Printing Office, 1963.
Albrecht, Dorothy E. "John Lorenzo Hubbell, Navajo Indian Trader." *Arizoniana: The Journal of Arizona History* 4 (Fall 1963): 33–40.
Almaguer, Tomás. *Racial Fault Lines: The Historical Origins of White Supremacy in California.* Berkeley: University of California Press, 1994.
"Among the Navajo." *Outlook* 76 (1904): 349–359.
Amsden, Charles Avery. *Navaho Weaving: Its Technic and Its History.* Santa Ana, Calif.: Fine Arts Press, 1934. Reprint, Glorieta, N.Mex: Rio Grande Press, 1990.
"Arizona History from Newspaper Accounts." *Arizoniana: The Journal of Arizona History* 4 (Fall 1963): 47–48.
Austin, Mary. *Taos Pueblo.* San Francisco: Grabhorn Press, 1930.
Babcock, Barbara A. "'A New Mexican Rebecca': Imaging Pueblo Women." *Journal of the Southwest* 32, no. 4 (1990): 400–437.

Bailey, Garrick, and Roberta Glenn Bailey. *A History of the Navajos: The Reservation Years.* Santa Fe: School of American Research Press, 1986.

Bancroft, Hubert Howe. *The Native Races of the Pacific States of North America,* vol. 3. New York: D. Appleton, 1875.

Barkan, Elazar, and Ronald Bush. *Prehistories of the Future: The Primitivist Project and the Culture of Modernism.* Stanford, Calif.: Stanford University Press, 1995.

Batkin, Jonathan. "Some Early Curio Dealers of New Mexico." *American Indian Art Magazine* 23 (Summer 1998): 74.

Baudrillard, Jean. *Le Système des Objets.* Paris: Denoel-Gontheir, 1968.

Bederman, Gail. *Manliness and Civilization: A Cultural History of Gender and Race in the United States, 1880-1917.* Chicago: University of Chicago Press, 1996.

Bedinger, Margery. *Indian Silver: Navajo and Pueblo Jewelers.* Albuquerque: University of New Mexico Press, 1973.

"Bedouins of the Desert." *Outwest* 35 (1912): 107-116.

Benedict, Ruth. *Patterns of Culture.* Boston: Houghton Mifflin Company, 1934.

Bennett, Kay. *Kaibah: Recollection of a Navajo Girlhood.* Los Angeles: Westernlore Press, 1964.

Berkhoffer, Robert F., Jr. *The White Man's Indian: Images of the American Indians from Columbus to the Present.* New York: Vintage Books, 1979.

Bernstein, Bruce. "The Marketing of Culture: Pottery and Santa Fe's Indian Market." Ph.D. diss., University of New Mexico, 1993.

Bieder, Robert E. "Anthropology and the History of the American Indian." *American Quarterly* 33 (1981): 314.

———. *Science Encounters the Indian, 1820-1880: The Early Years of American Ethnology.* Norman: University of Oklahoma Press, 1986.

"The Big Fair Ready at San Diego with Many Special Features." *Santa Fe Magazine,* December 1914, 21-23.

Blomberg, Nancy J. *Navajo Textiles: The William Randolph Hearst Collection.* Tucson: University of Arizona Press, 1988.

Blue, Martha. *Indian Trader: The Life and Times of J. L. Hubbell.* Walnut, Calif.: Kiva Publishing, 2000.

Boas, Franz. "The History of Anthropology." *Science,* October 21, 1904, 515.

Boles, Joanne. "The Development of the Navajo Rug, 1890-1920 as Influenced by Trader J. L. Hubbell." Ph.D. diss., Ohio State University, 1977.

Bourdieu, Pierre. *The Field of Cultural Production.* New York: Columbia University Press, 1993.

Bowra, George B. "Glimpse of the Navajo Indian." *National Republic,* November 1933, 7.

Boyd, Dennis. "Trading and Weaving: An American-Navajo Symbiosis." Master's thesis, University of Colorado, 1979.

Bronner, Simon J., ed. *Folk Life Studies from the Gilded Age: Object, Rite and Custom in Victorian America.* Ann Arbor, Mich.: UMI Research Press, 1987.

———. *Grasping Things: Folk Material Culture and Mass Society in America.* Lexington: University Press of Kentucky, 1986.

———. "Reading Consumer Culture." In *Consuming Visions: Accumulation and Display of Goods in America, 1880-1920,* ed. Simon J. Bronner, 13-54. New York: W. W. Norton, 1989.

———. "Stewart Culin, Museum Magician." *Pennsylvania Heritage,* Summer 1985, 4-11.

Brooks, James. *Captives and Cousins: Slavery, Kinship and Community in the Southwest Borderlands.* Chapel Hill: University of North Carolina Press, 2002.

Brown, Dona. *Inventing New England: Regional Tourism in the Nineteenth Century.* Washington, D.C.: Smithsonian Institution Press, 1995.

Brown, Michael. *Who Owns Native Culture?* Cambridge, Mass.: Harvard University Press, 2003.

Brugge, David M. *A History of the Chaco Navajos.* Albuquerque: U.S. National Park Service, 1980.

——. *Hubbell Trading Post: National Historic Site.* Tucson: Southwest Parks and Monuments Association, 1993.

Bryant, Keith L. *History of the Atchison, Topeka and Santa Fe Railway.* Lincoln: University of Nebraska Press, 1974.

Bsumek, Erika Marie. "Making 'Indian-Made': The Production, Consumption and Construction of Navajo Ethnic Identity, 1880–1935." Ph.D. diss., Rutgers University, 2000.

——. "The Navajos as Borrowers." *New Mexico Historical Review* 79, no. 3 (Summer 2004): 319–347.

——. "Value Added in the Production and Trade of Navajo Textiles: Local Culture and Global Demand." In *Global History: Interactions between the Universal and the Local,* ed. A. G. Hopkins, 39–65. London: Pelgrave, 2006.

——. "Exchanging Places: Virtual Tourism, Vicarious Travel and the Consumption of Southwestern Indian Artifacts," in *The Culture of Tourism, The Tourism of Culture,* ed. Hal Rothman, 118–139. Albuquerque: University of New Mexico Press, 2003.

Byrkit, James W., ed. *Charles Lummis: Letters from the Southwest.* Tucson: University of Arizona Press, 1989.

Carmean, Kelli. *Spider Woman Walks This Land: Traditional Cultural Properties and the Navajo Nation.* Walnut Creek, Calif.: AltaMira Press, 2002.

Chambers, John Whiteclay. *The Tyranny of Change: America in the Progressive Era, 1890–1920.* 2nd ed. New York: St. Martin's Press, 1992.

Clifford, James. *The Predicament of Culture: Twentieth Century Ethnography, Literature and Art.* Cambridge, Mass.: Harvard University Press, 1988.

Cohen, Lizabeth. *A Consumers' Republic: The Politics of Mass Consumption in Postwar America.* New York: Vintage Books, 2003.

Cole, Douglas. *Captured Heritage: The Scramble for Northwest Coast Artifacts.* Norman: University of Oklahoma Press, 1985.

Colton, Mary Russell F. *Art for the Schools of the Southwest: An Outline for the Public and Indian Schools.* Bulletin no. 6 (February 1934): 30. (Published by the Northern Arizona Society of Science and Art, Flagstaff.)

Coombe, Rosemary. "Embodied Trademarks: Mimesis and Alterity on American Commercial Frontiers." *Cultural Anthropology* 1, no. 2 (1996): 202–224.

Cott, Nancy. *The Grounding of Modern Feminism.* New Haven, Conn.: Yale University Press, 1987.

Cowan, John L. "Bedouins of the Southwest." *Outwest* (February 1912): 61, 107–116.

Cowen, Tyler. *Creative Destruction: How Globalization Is Changing the World's Cultures.* Princeton, N.J.: Princeton University Press, 2002.

Cromley, Elizabeth. "Masculine/Indian." *Winterthur Portfolio* 31 (Winter 1996): 265–280.

Cronon, William, ed. *Under an Open Sky: Rethinking America's Western Past.* New York: W. W. Norton, 1992.

Culin, Stewart. *Brooklyn Museum Annual Report,* 1904.

———. "Games of the North American Indians." In *24th Annual Report of the Bureau of American Ethnology, 1902–1903.* Washington, D.C., 1907. Reprint, New York: Dover, 1975.

———. "Guide to the Southwestern Indian Hall." *Museum News,* April 1907, 106.

———. "Primitive American Art and Ornament." *University Bulletin* 4 (1900): 191–196.

Cumin, Hazel E. "The Bayeta of the Navaho: Examples of a Vanished Art, the Memory of Which Is Fast Disappearing." *House Beautiful,* May 1929, 644–669.

Cummings, Byron. *Indians I Have Known.* Tucson: Arizona Silhouettes, 1952.

"Current Art Exhibitions Reviewed." *Los Angeles Times,* March 21, 1937, C4.

Curtis, Edward. "Vanishing Indian Types." *Scribner's* 39, no. 5 (1906): 513–529.

Cvetkovich, Ann. *Mixed Feelings: Feminism, Mass Culture and Victorian Sensationalism.* New Brunswick, N.J.: Rutgers University Press, 1992.

Darnell, Regna. *Invisible Genealogies: History of Americanist Anthropology.* Lincoln: University of Nebraska Press, 2001.

de Angulo, Gui. *Jaime in Taos: The Taos Papers of Jaime de Angulo.* San Francisco: City Lights Books, 1985.

de Grazia, Victoria, ed. *The Sex of Things: Gender and Consumption in Historical Perspective.* Berkeley: University of California Press, 1996.

Deloria, Philip. *Indians in Unexpected Places.* Lawrence: University Press of Kansas, 2005.

———. *Playing Indian.* New Haven, Conn.: Yale University Press, 1998.

DeMark, Judith Boyce, ed. *Essays in Twentieth Century New Mexico History.* Albuquerque: University of New Mexico Press, 1994.

D'Emilio, Sandra, and Suzan Campbell. *Visions and Visionaries: The Art and Artists of the Santa Fe Railway.* Salt Lake City: Peregrine Smith Books, 1991.

Denetdale, Jennifer Nez. "'One of the Queenliest Women in Dignity, Grace, and Character I Have Ever Met': Photography and Navajo Women—Portraits of Juanita, 1868–1902." *New Mexico Historical Review* 79, no. 3 (Summer 2004): 289–318.

———. *Reclaiming Diné History: The Legacies of Navajo Chief Manuelito and Juanita.* Tucson: University of Arizona Press, 2007.

———. "Representing Changing Woman: A Review Essay on Navajo Women." *American Indian Culture and Research Journal* 25, no. 3 (2001): 1–26.

———. "Review Essay." *New Mexico Historical Review* (Fall 2004): 478.

Dening, Greg. *History's Anthropology: The Death of William Gooch,* vol. 2. Association for Social Anthropology in Oceania, ed. Ivan Brady. Lanham, Md.: University Press of America, 1988.

———. *Islands and Beaches: Discourses on a Silent Land, Marquesas, 1774–1880.* Honolulu: University of Hawaii Press, 1980.

———. *Mr. Bligh's Bad Language: Passion, Power and Theatre on the Bounty.* Cambridge: Cambridge University Press, 1992.

———. *Performances.* Chicago: University of Chicago Press, 1996.

Deutch, Sarah. "Landscape of Enclaves: Race Relations in the West, 1865–1990." In *Under an Open Sky: Rethinking America's Western Past,* ed. William Cronon, 110–132. New York: W. W. Norton, 1992.

Deverell, William. *Railroad Crossing: Californians and the Railroad, 1850–1910.* Berkeley: University of California Press, 1994.

Dilworth, Leah. *Imagining Indians in the Southwest: Persistent Visions of a Primitive Past.* Washington, D.C.: Smithsonian Institution Press, 1996.

Dippie, Brian. *The Vanishing American: White Attitudes and U.S. Indian Policy.* Lawrence: University Press of Kansas, 1982.

Dixon, Joseph K. *The Vanishing Race: The Last Great Indian Council.* New York: Doubleday, Page and Company, 1913.

Dorsey, George A. *Indians of the Southwest.* Topeka: Atchison, Topeka and Santa Fe Railway System Publisher, 1903.

———. "Stewart Culin." *American Magazine,* June 19, 1913.

Dublin, Thomas. *Women at Work: The Transformation of Work and Community in Lowell, Massachusetts, 1826–1860.* New York: Columbia University Press, 1979.

Dyk, Walter. *A Navaho Autobiography.* New York: Viking, 1947.

Edmonson, Alta. "E. Irving Crouse, Painter of Indians." *Panhandle-Plains Historical Review* 42 (1969): 12.

Edwards, Elizabeth. *Anthropology and Photography, 1860–1920.* New Haven, Conn.: Yale University Press, 1992.

Edwardy, William. "The Navajo Indians." *Harper's Weekly,* July 1890, 530.

Elliott, Michael A. "Ethnography, Reform and the Problem of the Real: James Mooney's *Ghost Dance Religion.*" *American Quarterly* 50 (June 1998): 201–233.

Elsner, John, and Roger Cardinal, eds. *The Cultures of Collecting.* London: Reaktion Books, 1994.

Ely, Richard T. *An Introduction to Political Economy.* New York: Chautauqua Press, 1889.

Evans, Will. *Along Navajo Trails: Recollections of a Trader,* ed. Susan E. Woods and Robert S. McPherson. Logan: Utah State University Press, 2005.

"Even the Experts Are Being Duped." *USA Today,* April 8, 1998, 2A.

Everett, Patricia R. *A History of Having a Great Many Times Not Continued to Be Friends: The Correspondence between Mabel Dodge and Gertrude Stein, 1911–1934.* Albuquerque: University of New Mexico Press, 1996.

Ewen, Elizabeth. *Immigrant Women in the Land of Dollars: Life and Culture on the Lower East Side, 1890–1925.* New York: Monthly Review Press, 1985.

Fane, Diana. "The Language of Things: Stewart Culin as Collector." In *Objects of Myth and Memory: American Indian Art at the Brooklyn Museum,* ed. Diana Fane, Ira Jacknis, and Lise M. Breen. Seattle: University of Washington Press, 1991.

Faris, James, C. "Laura Gilpin and the 'Endearing' Navajo." *History of Photography* 21 (Spring 1997): 60–66.

———. *Navajo and Photography: A Critical History of the Representation of an American People.* Albuquerque: University of New Mexico Press, 1996.

Fletcher, Maurine S., ed. *The Wetherills of the Mesa Verde: Autobiography of Benjamin Alfred Wetherill.* Lincoln: University of Nebraska Press, 1977.

"For Arts Club Library." *New York Times,* April 24, 1906, 11.

Fox, Richard Wightman, ed. *The Power of Culture: Critical Essays in American History.* Chicago: University of Chicago Press, 1993.

Fox, Richard Wightman, and T. J. Jackson Lears, eds. *The Culture of Consumption: Critical Essays in American History, 1880–1980.* New York: Pantheon Books, 1983.

Fox, Robin. *The Violent Imagination.* New Brunswick, N.J.: Rutgers University Press, 1989.

Fox, Stephen. *John Muir and His Legacy: The American Conservation Movement.* Boston: Little, Brown and Company, 1981.

———. *The Mirror Makers: A History of American Advertising and Its Creators.* New York: William Morrow and Company, 1984.

Frisbie, Charlotte Johnson. *Navajo Medicine Bundles or Jish: Acquisition, Transmission, and Dispossession in the Past and Present.* Albuquerque: University of New Mexico Press, 1987.

Fugate, Francis L. *Arbuckles: The Coffee That Won the West.* El Paso: Texas Western Press, 1994.

Gabriel, Kathryn, ed. *Marietta Wetherill: Reflections on Life with the Navajos in Chaco Canyon.* Boulder, Colo.: Johnson Books, 1992.

Gacs, Ute, and Aisha Kahn, eds. *Women Anthropologists: A Bibliographical Dictionary.* Westport, Conn.: Greenwood Press, 1988.

Garcia, Mario T. *Desert Immigrants: The Mexicans of El Paso, 1880–1920.* New Haven, Conn.: Yale University Press, 1981.

Garroutte, Eva Marie. *Real Indians: Identity and Survival of Native America.* Berkeley: University of California Press, 2003.

Garvey, Ellen Gruber. *The Adman in the Parlor: Magazines and the Gendering of Consumer Culture, 1880–1910s.* New York: Oxford University Press, 1996.

Gelber, Steven M. "Do-It-Yourself." *American Quarterly* 49, no. 1 (March 1997): 67–101.

——. *Hobbies: Leisure and the Culture of Work in America.* New York: Columbia University Press, 1999.

Georgi-Findlay, Brigitt. *The Frontiers of Women's Writing: Women's Narratives and the Rhetoric of Westward Expansion.* Tucson: University of Arizona Press, 1996.

Gitlin, Jay. "On the Boundaries of Empire: Connecting the West to Its Imperial Past." In *Under an Open Sky: Rethinking America's Western Past,* ed. William Cronon, 71–90. New York: W. W. Norton and Company, 1992.

Glaser, Jane, ed. *Gender Perspectives: Essays on Women in Museums.* Washington, D.C.: Smithsonian Institution Press, 1994.

Glazer, Lee, and Susan Key. "Carry Me Back: Nostalgia for the Old South in Nineteenth Century Popular Culture." *Journal of American Studies* 30 (1996): 1–24.

"Glimpse of the Navajo Indian." *National Republic,* November 1933.

Goody, Jack. *The East in the West.* Cambridge: Cambridge University Press, 1996.

Grant, Campbell. *Canyon de Chelly: Its People and Rock Art.* Tucson: University of Arizona Press, 1978.

Grattan, Virginia L. *Mary Colter: Builder upon the Red Earth.* Flagstaff, Ariz.: Northland Press, 1992.

Graves, Laura. *Thomas Varker Keam: Indian Trader.* Norman: University of Oklahoma Press, 1998.

Grier, Katherine C. *Culture and Comfort: Parlor Making and Middle-Class Identity, 1850–1930.* Washington, D.C.: Smithsonian Institution Press, 1988.

Gutierrez, David. *Walls and Mirrors: Mexican Americans, Mexican Immigrants and the Politics of Ethnicity.* Berkeley: University of California Press, 1995.

Gutierrez, Ramón. *When Jesus Came, the Corn Mothers Went Away: Marriage, Sexuality and Power in New Mexico, 1500–1846.* Stanford, Calif.: Stanford University Press, 1991.

Habermas, Jürgen. *The Structural Transformation of the Public Sphere: An Inquiry into a Category of Bourgeois Society,* trans. Thomas Burger. Cambridge, Mass.: MIT Press, 1991. First published 1962.

Haile, Bernard. "Property Concepts of the Navajo Indians." *Catholic University of America Anthropological Series* no. 17. Washington, D.C.: Catholic University of America Press, 1954.

Hall, Edward T. *West of the Thirties: Discoveries among the Navajo and Hopi.* New York: Doubleday, 1994.

Hall, Jacquelyn Dowd. "Open Secrets: Memory, Imagination and the Refashioning of Southern Identity." *American Quarterly* 50 (March 1998): 109–124.

Halpern, Katherine Spences, and Susan Brown McGreevy. *Washington Matthews: Studies of Navajo Culture, 1880–1894.* Albuquerque: University of New Mexico Press, 1997.

Halttunen, Karen. "From Parlor to Living Room: Domestic Space, Interior Decoration, and the Culture of Personality." In *Consuming Visions: Accumulation and Display of Goods in America, 1880–1920,* ed. Simon J. Bronner, 157–189. New York: W. W. Norton, 1989.

Haraway, Donna. *Primate Visions: Gender, Race and Nature in the World of Modern Science.* New York: Routledge, 1989.

Harrington, M. R. "'Finds' on Long Island." *New York Times,* September 28, 1902.

Harris, Alice Kessler. *New Viewpoints in Women's History: Working Papers from the Schlesinger Library 50th Anniversary Conference, March 4–5, 1994.* Cambridge, Mass.: Arthur and Elizabeth Schlesinger Library, 1994.

Harris, Neil. *Cultural Excursions: Marketing Appetites and Cultural Tastes in Modern America.* Chicago: University of Chicago Press, 1990.

———. "Museums, Merchandising, and Popular Taste: The Struggle for Influence," chapter 3 of *Cultural Excursions: Marketing Appetites and Cultural Tastes in Modern America.* Chicago: University of Chicago Press, 1990.

Helfgott, Leonard M. *Ties That Bind: A Social History of the Iranian Carpet.* Washington, D.C.: Smithsonian Institution Press, 1994.

Helm, June. "Social Contexts of American Ethnology, 1840–1984." In *1984 Proceedings of the American Ethnographic Society in New York City,* ed. Stuart Plattner. American Ethnological Society, 1984.

Hieb, Louis. "John Lorenzo Hubbell." In *American National Biography,* ed. John A. Barraty and Mark C. Carnes. New York: Oxford University Press, 1999.

Hill, Sarah H. "Marketing Traditions: Cherokee Basketry and Tourist Economies." In *Selling the Indian: Commericializing and Appropriating American Indian Cultures,* ed. Carter Jones Meyer and Diana Royer, 212–235. Tucson: University of Arizona Press, 2001.

Hill, W. W. "Navajo Trading and Trading Ritual." *Southwestern Journal of Anthropology* 4 (Winter 1948): 371–396.

Hinsley, Curtis. "Authoring Authenticity." *Journal of the Southwest* 32, no. 4 (1990): 462–478.

———. *Savages and Scientists: The Smithsonian Institution and the Development of American Anthropology, 1846–1910.* Washington, D.C.: Smithsonian Institution Press, 1981.

———. *The Smithsonian and the American Indian: Making a Moral Anthropology in Victorian America.* Washington, D.C.: Smithsonian Institution Press, 1981.

———. "The World as Marketplace: Commodification of the Exotic at the World's Columbian Exposition, Chicago, 1893." In *Exhibiting Cultures: The Poetics and Politics of Museum Display,* ed. Ivan Karp and Steven D. Lavine, 344–365. Washington, D.C.: Smithsonian Institution Press, 1991.

Hinsley, Curtis M., and David Wilcox. *The Southwest in the American Imagination: The Writings of Sylvester Baxter, 1881–1889.* Tucson: University of Arizona Press, 1996.

Hodge, Frederick Webb, ed. *The Handbook of American Indians North of Mexico.* New York: Greenwood Press, 1910.

Hopkins, A. G. "Globalization With and Without Empires: From Bali to Labrador." In *Globalization in World History*, ed. A. G. Hopkins, 221–243. New York: W. W. Norton, 2002.

Horgan, Paul. *The Centuries of Santa Fe*. Albuquerque: University of New Mexico Press, 1956.

Horowitz, Daniel. "Frugality or Comfort: Middle-Class Styles of Life in the Early Twentieth Century." *American Quarterly* (Summer 1985): 239–259.

Hosmer, Brian. *American Indians in the Marketplace: Persistence and Innovation among the Menominees and Metlakatlans, 1870–1920*. Lawrence: University Press of Kansas, 1999.

Hosmer, Brian, and Colleen O'Neill. *Native Pathways: American Indian Culture and Economic Development in the Twentieth Century*. Boulder: University of Colorado Press, 2004.

Howard, Kathy. "A Most Remarkable Success: Herman Schweizer and the Fred Harvey Indian Department." In *The Great Southwest of the Fred Harvey Company and the Santa Fe Railway*, ed. Marta Weigle and Barbara A. Babcock. Phoenix: Heard Museum, 1996.

"How Fame Has Been Won for the Harvey Service by Devotion to a Business Principle." *Santa Fe Magazine*, February 1916, 35.

Hoxie, Frederick. *A Final Promise: A Campaign to Assimilate the Indians*. Lincoln: University of Nebraska Press, 1984. Reprint, Lincoln: University of Nebraska Press, 2001.

Hubbell, J. L. "Fifty Years an Indian Trader." *Touring Topics*, December 1930, 24.

——. *Hubbell Trading Post Catalog*. Chicago: Hollister Press, ca. 1903.

Huhndorf, Shari M. *Going Native: Indians in the American Cultural Imagination*. Ithaca, N.Y.: Cornell University Press, 2001.

Huizer, Gerrit, and Bruce Mannheim, eds. *The Politics of Anthropology: From Colonialism and Sexism toward a View from Below*. World Anthropology. The Hague: Mouton, 1979.

Hungerford, Edward. "A Study in Consistent Railroad Advertising." *Santa Fe Magazine*, March 1923, 44.

Hurtado, Albert. *Intimate Frontiers: Sex, Gender, and Culture in Old California*. Albuquerque: University of New Mexico Press, 1993.

Hyde, Ann Farrar. *American Vision: Far Western Landscape and National Culture, 1820–1920*. New York: New York University Press, 1990.

Ickingrill, Stephen, and Stephen Mills, eds. *Victorianism in the United States: Its Era and Its Legacy*. Vol. 24, *European Contributors to American Studies*. Amsterdam: VU University Press, 1992.

The Indian and Mexican Building. Albuquerque: Fred Harvey Publisher, ca. 1920.

"Indian Fair." *Art and Archeology* 18 (1925): 215–224.

"Indians at Work." *Survey Graphic* 23, no. 6 (June 1934): 261.

Iverson, Peter. *Diné: A History of the Navajos*. Albuquerque: University of New Mexico Press, 2002.

——. *The Navajo Nation*. Westport, Conn.: Greenwood Press, 1976.

——. *The Navajos: Indians of North America*. New York: Chelsea House, 1990.

Jackle, John A. *The Tourist: Travel in Twentieth Century North America*. Lincoln: University of Nebraska Press, 1985.

Jacknis, Ira. "Franz Boas and Exhibits: On the Limitations of the Museum Method of Anthropology." In *Objects and Others: Essays on Museums and Material Culture*, ed. George Stocking, 75–111. Madison: University of Wisconsin Press, 1985.

————. "The Road to Beauty: Stewart Culin's American Indian Exhibitions at the Brooklyn Musuem." In *Objects of Myth and Memory: American Indian Art at the Brooklyn Museum*, ed. Diana Fane, Ira Jacknis, and Lise M. Breen. Seattle: University of Washington Press, 1991.

Jacobs, Margaret D. *Engendered Encounters: Feminism and Pueblo Cultures, 1879-1934.* Lincoln: University of Nebraska Press, 1999.

————. "Uplifting Cultures: Encounters between White Women and Pueblo Indians." Ph.D. diss., University of California, Davis, 1996.

James, George Wharton. *In and Around the Grand Canyon: The Grand Canyon of the Colorado River in Arizona.* New York: Little, Brown, 1900.

————. *Indian Blankets and Their Makers.* Chicago: A. C. McClurg and Co., 1914.

————. *The Indians of the Painted Desert Region; Hopis, Navahoes, Wallapais, Havasupais.* New York: Little, Brown, 1903.

James, H. L. *Rugs and Posts: The Story of Navajo Weaving and Indian Trading.* West Chester, Pa.: Schiffer Publishing, 1988.

Jenkins, David. "Object Lessons and Ethnographic Displays: Museum Exhibitions and the Making of American Anthropology." *Comparative Studies in Society and History* 36 (April 1994): 250.

Jenson, Joan M. *One Foot in the Rockies: Women and Creativity in the American West.* Albuquerque: University of New Mexico Press, 1995.

John Wanamaker Company. *Golden Book of the Wanamaker Stores: Jubilee Year, 1861-1911.* Philadelphia: John Wanamaker Company, 1911-1913.

Kabat, Sally G. "Home away from Home: The Architectural Geography of Hotels in the American Southwest, 1880-1920." Ph.D. diss., University of New Mexico, 1994.

Kaplan, Amy, ed. *Cultures of United States Imperialism.* Durham, N.C.: Duke University Press, 1993.

Kapoun, Robert W., and Charles J. Lohrmann. *Language of the Robe: American Indian Trade Blankets.* Salt Lake City: Peregrine Smith Books, 1992.

Karp, Ivan, and Steven D. Lavine, eds. *Exhibiting Cultures: The Poetics and Politics of Museum Display.* Washington, D.C.: Smithsonian Institution Press, 1991.

Kellner, Douglas, ed. *Baudrillard: A Critical Reader.* Oxford: Blackwell, 1994.

Kennedy, Mary Jeanette. *Tales of a Trader's Wife: Life on the Navajo Indian Reservation, 1913-1938.* Albuquerque: Valliant Co., 1965.

Kirk, Ruth F. "Southwestern Indian Jewelry." *El Palacio*, February/March 1945, 21-32, 41-50.

Klein, Kerwin L. "Frontier Products: Tourism, Consumerism and the Southwestern Public Lands, 1890-1990." *Pacific Historical Review* 62, no. 1 (February 1993): 39-71.

————. *Frontiers of Historical Imagination: Narrating the European Conquest of Native America, 1890-1990.* Berkeley: University of California Press, 1997.

Kluckhohn, Clyde. *To the Foot of the Rainbow: A Tale of Twenty-Five Hundred Miles of Wandering on Horseback through the Southwest Enchanted Land.* Albuquerque: University of New Mexico Press, 1992. First published London: Eveleigh, Nash and Grayson, 1927.

Kluckhohn, Clyde, and Dorothea Leighton. *The Navaho.* Cambridge, Mass.: Harvard University Press, 1946.

Kropp, Phoebe. *California Vieja: Culture and Memory in a Modern American Place.* Berkeley: University of California Press, 2006.

———. "'There Is a Little Sermon in That': Constructing the Native Southwest at the San Diego Panama-California Exposition of 1915." In *The Great Southwest of the Fred Harvey Company and the Santa Fe Railway,* ed. Marta Weigle and Barbara A. Babcock, 36–46. Phoenix: Heard Museum, 1996.

Kuklick, Henrika. *The Savage Within: The Social History of British Anthropology, 1885–1945.* New York: Cambridge University Press, 1991.

La Farge, Oliver. *Laughing Boy.* New York: Houghton Mifflin, 1957. First published in 1929 by Houghton Mifflin.

Lamphere, Louise. "Gladys Reichard among the Navajo." *Frontiers: A Journal of Women Studies* 12 (1992): 82.

Lange, Patricia Fogelman. "The Spiritual World of Franc Johnson Newcomb." *New Mexico Historical Review* 73 (July 1998): 253–271.

Leach, William. *Land of Desire: Merchants, Power, and the Rise of a New American Culture.* New York: Vintage, 1993.

Lears, T. J. Jackson. *Fables of Abundance: A Cultural History of Advertising in America.* New York: Basic Books, 1994.

———. *No Place of Grace: Antimodernism and the Transformation of American Culture, 1880–1920.* Chicago: University of Chicago Press, 1994.

———. "Sherwood Anderson: Looking for the White Spot." In *The Power of Culture,* ed. Richard Wightman Fox and T. J. Jackson Lears, 13–39. Chicago: University of Chicago Press, 1993.

"A Legend of the Navajos." *Cosmopolitan,* November 1896, 73.

Leighton, Alexander H., and Dorothea C. Leighton. *The Navajo Door: An Introduction to Navajo Life.* Cambridge, Mass.: Harvard University Press, 1945.

Levine, Lawrence. *Highbrow, Lowbrow: The Emergence of Cultural Hierarchy in America.* Cambridge, Mass.: Harvard University Press, 1988.

Limerick, Patricia Nelson. *The Legacy of Conquest: The Unbroken Past of the American West.* New York: W. W. Norton, 1987.

Lindstrom, Richard. "Not from the Landside but from the Supply Side: Native American Responses to the Wanamaker Expedition." *Journal of Social History* 30, no. 1 (Autumn 1996): 209–227.

Lipsitz, George. *Possessive Investment in Whiteness: How White People Profit from Identity Politics.* Berkeley: University of California Press, 1998.

Lister, Robert Hill, and Florence Lister. *Chaco Canyon: Archaeology and Archaeologists.* Albuquerque: University of New Mexico Press, 1981.

Littlefield, Alice, and Martha Knack, eds. *Native Americans and Wage Labor: Ethnohistorical Perspectives.* Norman: University of Oklahoma Press, 1996.

"The Loom in the New World." *American Museum of Natural History Journal* 16 (1926): 381.

Lopez, Ian F. Haney. *White by Law: The Legal Construction of Race.* New York: New York University Press, 1996.

Lutz, Catherine A. *Reading National Geographic.* Chicago: University of Chicago Press, 1993.

Lynes, Russell. *The Taste Makers.* New York: Harper and Brothers, 1955.

Lyon, William H. "The Navajos in the American Historical Imagination, 1868–1900." *Ethnohistory* (Spring 1998): 237–275.

MacCannell, Dean. *Empty Meeting Grounds: The Tourist Papers.* London: Routledge, 1992.

———. "Reconstructed Ethnicity: Tourism and Cultural Identity in Third World Communities." In *Empty Meeting Grounds: The Tourist Papers,* ed. Dean MacCannell. London: Routledge, 1992.

——. *The Tourist: A New Theory of the Leisure Class.* New York: Schocken Books, 1989.

Maithen, Joan. "Women of Chaco: Then and Now." In *Rediscovering Our Past: Essays on the History of American Archeology,* ed. J. Reyman, 103–130. Brookfield, Vt.: Avebury Press, 1992.

Marshall, James. *Santa Fe: The Railroad That Built an Empire.* New York: Random House, 1945.

Matthews, Washington. *Navajo Legends.* Salt Lake City: University of Utah Press, 1994. First published 1897 by Houghton Mifflin.

——. "Navajo Silversmiths." In *Second Annual Report of the Bureau of Ethnology to the Secretary of the Smithsonian Institution, 1880–1881,* 167–178. Washington, D.C.: Government Printing Office, 1883.

Mauss, Marcel. *The Gift: The Form and Reason for Exchange in Archaic Societies,* trans. Mary Douglas. London: Routledge, 1990.

McFeely, Eliza. *Zuni and the American Imagination.* New York: Hill and Wang, 2001.

M'Closkey, Kathy. "Marketing Multiple Myths: The Hidden History of Navajo Weaving." *Journal of the Southwest* 36 (Autumn 1994): 185–220.

——. "Some Ruminations on Textile Production by the Navajo and the Inuit." *Papers from the Third and Sixth Navajo Studies Conferences,* 379–389. Window Rock, Ariz.: Navajo Nation Historic Preservation Department. Third conference: November 2–5, 1988, sixth conference: March 11–14, 1992.

——. *Swept under the Rug: A Hidden History of Navajo Weaving.* Albuquerque: University of New Mexico Press, 2002.

McLuhan, T. C. *Dream Tracks: The Railroad and the American Indian, 1890–1930.* New York: Harry Abrams, 1985.

McNickle, D'Arcy. *Indian Man: A Life of Oliver La Farge.* Indianapolis: Indiana University Press, 1971.

McNitt, Frank. *The Indian Traders.* Norman: University of Oklahoma Press, 1962.

——. *Richard Wetherill: Anasazi.* Albuquerque: University of New Mexico Press, 1966.

McWilliams, Carey. *North from Mexico: The Spanish-Speaking People of the United States.* New York: Greenwood, 1948.

——. *Southern California: An Island on the Land.* Layton, Utah: Gibbs Smith, 1973.

Meek, Ronald L. *Social Science and the Ignoble Savage.* Cambridge: Cambridge University Press, 1976.

Meriam, Lewis, Ray Brown, Henry Roe Cloud, Edward Everett Dale, Emma Duke, Herbert R. Edwards, Fayette Avery McKenzie, Mary Louise Mark, W. Carson Ryan Jr., and William Spillman. *The Problem of Indian Administration,* Institute for Government Research, Studies in Administration. Baltimore: Johns Hopkins Press, 1928.

Merrell, James H. *Into the American Woods: Negotiators on the Pennsylvania Frontier.* New York: W. W. Norton, 2000.

Meyer, Carter Jones. "Saving the Pueblos: Commercialism and Indian Reform in the 1920s." In *Selling the Indian: Commercializing and Appropriating American Indian Cultures,* ed. Carter Jones Meyer and Diana Royer, 190–211. Tucson: University of Arizona Press, 2001.

Miller, Daniel. *A Theory of Shopping.* Oxford: Polity Press, 1998.

Montgomery, Charles. *The Spanish Redemption: Heritage, Power, and Loss on New Mexico's Upper Rio Grande.* Berkeley: University of California Press, 2002.

Moore, J. B. *Catalogue of Navajo Baskets.* Crystal, N.Mex.: ca. 1903–1911.

———. *The Navajo: A Reprint in Its Entirety of a Catalogue Published by J. B. Moore, Indian Trader, of the Crystal Trading Post, New Mexico, 1911.* Albuquerque: Avanyu Publishing, 1986.

Morgan, Lewis H. *Ancient Society; or, Researches in the Lines of Human Progress from Savagery through Barbarism to Civilization,* ed. Eleanor Burke Leacock. Cleveland: Meridian Books, 1963. First published in 1877.

———. *Systems of Consanguinity and Affinity of the Human Family.* Washington, D.C.: Smithsonian Institution Press, 1870.

Mort, Frank. *Cultures of Consumption: Masculinities and Social Space in Late Twentieth-Century Britain.* London: Routledge, 1996.

Mullin, Molly H. *Culture in the Marketplace: Gender, Art, and Value in the American Southwest.* Durham, N.C.: Duke University Press, 2001.

———. "The Patronage of Difference: Making Indian Art 'Art, Not Ethnology.'" In *The Traffic in Culture: Prefiguring Art and Anthropology,* ed. George E. Marcus and Fred R. Myers. Berkeley: University of California Press, 1995.

Murray, David. *Indian Giving: Economies of Power in Indian-White Exchanges.* Amherst: University of Massachusetts Press, 2000.

Myrick, David F. *New Mexico's Railroads: A Historical Survey,* rev. ed. Albuquerque: University of New Mexico Press, 1990.

"Navajo Blankets." *El Palacio,* June 1925, 223–229.

"Navajo Weaving." *Indians at Work,* December 15, 1934, 22–25.

Newcomb, Franc Johnson. *Hosteen Klah: Navajo Medicine Man and Sand Painter.* Norman: University of Oklahoma Press, 1964.

———. *Navajos Neighbors.* Norman: University of Oklahoma Press, 1966.

"New Mexico Field Work in 1915." *El Palacio,* January 1916, 43–59.

Nichols, Roger L. *Indians in the United States and Canada: A Comparative History.* Lincoln: University of Nebraska Press, 1998.

Norris, Scott, ed. *Discovered Country: Tourism and Survival in the American West.* Albuquerque: Stone Ladder Press, 1994.

Ohmann, Richard. *Selling Culture: Magazines, Markets, and Class at the Turn-of-the-Century.* London: Verso, 1996.

O'Kane, Walter Collins. *Sun in the Sky.* Norman: University of Oklahoma Press, 1950.

O'Neill, Colleen M. *Working the Navajo Way: Labor and Culture in the Twentieth Century.* Lawrence: University Press of Kansas, 2005.

Ostler, Jeffrey. *The Plains Sioux and U.S. Colonialism from Lewis and Clark to Wounded Knee.* Cambridge: Cambridge University Press, 2004.

Padget, Martin. *Indian Country: Representations of Travel in the Southwest, 1840–1935.* Albuquerque: University of New Mexico Press, 2004.

Padilla, Genaro. *My History, Not Yours: The Formation of Mexican American Biography.* Madison: University of Wisconsin Press, 1993.

Pardue, Diana. "Marketing Ethnography: The Fred Harvey Indian Department and George A. Dorsey." In *The Great Southwest of the Fred Harvey Company and the Santa Fe Railway,* ed. Marta Weigle and Barbara A. Babcock, 102–109. Phoenix: Heard Museum, 1996.

Parezo, Nancy, ed. *Hidden Scholars: Women Anthropologists and the Native American Southwest.* Albuquerque: University of New Mexico Press, 1992.

———. "A Multitude of Markets." *Journal of the Southwest* 32, no. 4 (1990): 563–575.

Parman, Donald L. *Indians and the American West in the Twentieth Century.* Bloomington: Indiana University Press, 1994.

———. *The Navajos and the New Deal*. New Haven, Conn.: Yale University Press, 1976.

Pascoe, Peggy. "Miscegenation Law, Court Cases, and Ideologies of 'Race' in Twentieth Century America." *Journal of American History* 83 (June 1996): 44.

Paterek, Josephine. *Encyclopedia of American Indian Costume*. Denver: ABC-CLIO, 1994.

Peake, Nancy. "Trading Post Tales." Master's thesis, University of New Mexico, 1992.

Pease, Donald E. "New Perspectives on U.S. Culture and Imperialism." In *Cultures of United States Imperialism*, ed. Amy Kaplan. Durham, N.C.: Duke University Press, 1993.

Pepper, George. "The Making of the Navajo Blanket." *Everybody's Magazine*, January 1902.

Philips, John Nieto. *The Language of Blood: The Making of Spanish American Identity in New Mexico, 1850–1940*. Albuquerque: University of New Mexico Press, 2004.

Plattner, Stuart. "Markets and Marketplaces." In *Economic Anthropology*, ed. Stuart Plattner. Stanford, Calif.: Stanford University Press, 1989.

Powers, Willow Roberts. *Navajo Trading: The End of an Era*. Albuquerque: University of New Mexico Press, 2001.

Pratt, Mary Louise. *Imperial Eyes: Travel Writing and Transculturation*. London: Routledge, 1992.

"Primitive American Handmade Rugs." *Good Furniture Magazine* 28, no. 1 (1927):14–19.

"A Process Server's Nerve." *New York Times*, December 21, 1900.

Prucha, Francis Paul. *American Indian Policy in the Formative Years: The Indian Trade and Intercourse Acts, 1790–1834*. Lincoln: University of Nebraska Press, 1962.

———. *A Bibliographical Guide to the History of Indian-White Relations in the United States*. Chicago: University of Chicago Press, 1977.

———. *The Great Father: The United States Government and the American Indians*. Lincoln: University of Nebraska Press, 1995.

Pueblo Bonito: Anthropological Papers of the American Museum of Natural History, vol. 27. New York: American Museum of Natural History, 1920.

Raibmon, Paige. *Authentic Indians: Episodes of Encounters form the Late-Nineteenth-Century Northwest Coast*. Durham, N.C.: Duke University Press, 2005.

Rappaport, Erika Diane. *Shopping for Pleasure: Women and the Making of London's West End*. Princeton, N.J.: Princeton University Press, 2000.

"Redman's Last Stand." *Harper's Weekly*, May 1913, 18.

Reed, Jean. "Navajo and Pueblo Indian Crafts." *Brooklyn Museum Quarterly* 19 (1932): 67.

Reeve, Frank D. "The Government and the Navajo." *New Mexico Historical Review* 18 (1943): 40–43.

Reichard, Gladys. *Navajo Medicine Man: Sandpaintings and Legends of Miguelito from the John Frederick Huckle Collection*. New York: J. J. Augustin Publisher, 1939.

———. *Social Life of the Navajo Indians with Some Attention to Minor Ceremonies*. New York: Columbia University Press, 1928.

———. *Spider Woman: A Story of Navajo Weavers and Chanters*. Glorieta, N.Mex.: Rio Grande Press, 1934.

Ridge, Martin, ed. *History, Frontier, and Section: Three Essays by Frederick Jackson Turner*. Albuquerque: University of New Mexico Press, 1993.

Riordan, M. J. "The Navajo Indians." *Overland Monthly*, October 1890, 373.

Roberts, Mary Louise. "Gender, Consumption and Commodity Culture." *American Historical Review* 3 (June 1998): 817–844.

Roberts, Willow. *Stokes Carson: Twentieth Century Trading on the Navajo Reservation*. Albuquerque: University of New Mexico Press, 1987.

——. *The Trader Project*. Report compiled for the Chaco Canyon National Monument, 1979, Chaco Collection, U.S. National Park Service, Museum Collection, University of New Mexico, Albuquerque.

Rodriquez, Sylvia. "Art, Tourism and Race Relations in Taos." In *Discovered Country: Tourism and Survival in the American West,* ed. Scott Norris. Albuquerque: Stone Ladder Press, 1994.

Rogin, Michael Paul. *Fathers and Children: Andrew Jackson and the Subjugation of the American Indian*. New York: Knopf, 1975.

Rollins, Peter C., and John E. O'Conner, eds. *Hollywood's Indian: The Portrayal of the Native American in Film*. Lexington: University Press of Kentucky, 1998.

Rosaldo, Renato. *Culture and Truth: The Remaking of Social Analysis*. Boston: Beacon Press, 1989.

———. "A Note on Geertz as a Cultural Essayist." *Representations* 59 (Summer 1997): 30–35.

Rosenberg, Rosalind. *Beyond Separate Spheres: Intellectual Roots of Modern Feminism*. New Haven, Conn.: Yale University Press, 1982.

Rothman, Hal. *Devil's Bargains: Tourism in the Twentieth Century American West*. Lawrence: University Press of Kansas, 1998.

Rudnick, Lois Palken. *Mabel Dodge Luhan: New Woman, New Worlds*. Albuquerque: University of New Mexico Press, 1984.

——. *Utopian Vistas: The Mabel Dodge Luhan House and the American Counterculture*. Albuquerque: University of New Mexico Press, 1996.

Rulon, Philip Reed, ed. *Gladwell Richardson: Navajo Trader*. Tucson: University of Arizona Press, 1986.

Runte, Alfred. *Trains of Discovery: Western Railroads and the National Parks*. Niwot, Colo.: Roberts Rinehart, 1990.

Rushing, Jackson. *Native American Art and the New York Avant-Garde: A History of Cultural Primitivism*. Austin: University of Texas Press, 1995.

Rydell, Robert W. *All the World's a Fair*. Chicago: University of Chicago Press, 1984.

——. *World of Fairs: The Century-of-Progress Expositions*. Chicago: University of Chicago Press, 1993.

Said, Edward W. *Culture and Imperialism*. New York: Random House, 1993.

Saldivar, Ramon. *Chicano Narrative: The Dialectics of Difference*. Madison: University of Wisconsin Press, 1990.

Saunt, Claudio. *A New Order of Things: Property, Power, and the Transformation of the Creek Indians, 1733–1816*. Cambridge: Cambridge University Press, 1999.

Scanlon, Jennifer. *Inarticulate Longings: The Ladies' Home Journal, Gender and the Promises of Consumer Culture*. New York: Routledge, 1995.

Scharff, Virginia. *Taking the Wheel: Women and the Coming of the Motor Age*. Albuquerque: University of New Mexico Press, 1991.

Schneider, Jane. "The Anthropology of Cloth." *Annual Review of Anthropology* 16 (1987): 409–448.

Schrader, Robert Fay. *The Indian Arts and Crafts Board: An Abstract of New Deal Indian Policy*. Albuquerque: University of New Mexico Press, 1983.

Schwartz, Maureen Trundell. *Molded in the Image of Changing Woman: Navajo Views on the Human Body and Personhood*. Tucson: University of Arizona Press, 1997.

Scott, James C. *Domination and the Arts of Resistance: Hidden Transcripts*. New Haven: Yale University Press, 1990.

Shaffer, Marguerite S. *See America First: Tourism and National Identity, 1880–1940.* Washington, D.C.: Smithsonian Institution Press, 2001.

Sheffield, Gail. *The Arbitrary Indian: The Indian Arts and Crafts Act of 1990.* Norman: University of Oklahoma Press, 1997.

Shiffman, John. "Indian Art: Buyer Beware, Artisans Pay Price of Counterfeiting." *USA Today,* April 8, 1998, 1A–2A.

Signal, Daniel Joseph. "Towards a Definition of American Modernism." *American Quarterly* 39 (September 1987): 7–27.

Simmons, Mark. *New Mexico: An Interpretive History.* Albuquerque: University of New Mexico Press, 1988.

"Sir Thomas Lipton." In *Dictionary of National Biography,* ed. Wickham Legg. Oxford: Oxford University Press, 1941.

Smith, Sherry. *Reimagining Indians: Native Americans through Anglo Eyes, 1880–1940.* New York: Oxford University Press, 2000.

Smith-Rosenberg, Carroll. *Disorderly Conduct: Visions of Gender in Victorian America.* Oxford: Oxford University Press, 1985.

Snead, James E. *Ruins and Rivals: The Making of Southwest Archaeology.* Tucson: University of Arizona Press, 2001.

Spicer, Edward H. *Cycles of Conquest: The Impact of Spain, Mexico and the United States on the Indians of the Southwest, 1533–1960.* Tucson: University of Arizona Press, 1962.

Spinden, Herbert. "Indian Art on Its Merits." *Parnassus* 3 (November 1931): 12.

Stephen, Lynn. *Zapotec Women.* Austin: University of Texas Press, 1991.

"The Stirring Story of Mankind's Rise." In *Official Guide Book of the Fair 1933: A Century of Progress Chicago.* Chicago: A Century of Progress Administration, 1933.

Stocking, George W., ed. *Colonial Situations: Essays on the Contextualization of Ethnographic Knowledge.* Vol. 7, *History of Anthropology.* Madison: University of Wisconsin Press, 1991.

———, ed. *Observers Observed: Essays on Ethnographic Fieldwork.* Vol. 1, *History of Anthropology.* Madison: University of Wisconsin Press, 1983.

———. *Race, Culture and Evolution: Essays in the History of Anthropology.* New York: Collier-Macmillan, 1968.

———, ed. *Romantic Motives: Essays on Anthropological Sensibility.* Vol. 6, *History of Anthropology.* Madison: University of Wisconsin Press, 1989.

Stoler, Laura Ann. "Matters of Intimacy as Matters of State: A Response." *Journal of American History* 88, no. 3 (December 2001): 894.

———. "Tense and Tender Ties: The Politics of Comparison in North American History and (Post) Colonial Studies." *Journal of American History* 88, no. 3 (December 2001): 829–865.

Strasser, Susan. *Satisfaction Guaranteed: The Making of the American Mass Market.* Washington, D.C.: Smithsonian Institution Press, 1989.

———. *Waste and Want: A Social History of Trash.* New York: Owl Books, 1999.

Summers, Martin. *Manliness and Its Discontents: The Black Middle Class and the Transformation of Masculinity.* Chapel Hill: University of North Carolina Press, 2003.

Susman, Warren I. "Personality and the Making of Twentieth Century Culture." In *Culture as History: The Transformation of American Society in the Twentieth Century.* New York: Pantheon Books, 1984.

Swann, Brian, and Arnold Krupat, eds. *Rediscovering the Word: Essays on Native American Literature.* Berkeley: University of California Press, 1987.

Taggett, Sherry Clayton, and Ted Schwarz. *Paintbrushes and Pistols: How the Taos Artists Sold the West.* Santa Fe: John Muir Publications, 1990.

Thomas, David Hurst. *Columbian Consequences: The Spanish Borderlands in Pan-American Perspective,* vols. 1–3. Washington, D.C.: Smithsonian Institution Press, 1991.

——. *Skull Wars: Kennewick Man, Archaeology, and the Battle for Native American Identity.* New York: Basic Books, 2000.

——. *The Southwestern Indian Detours: The Story of the Fred Harvey/Santa Fe Railway Experiment in 'Detourism.'* Phoenix: Hunter Publishing, 1978.

Thomas, Nicholas. *Entangled Objects: Exchange, Material Culture, and Colonialism in the Pacific.* Cambridge, Mass.: Harvard University Press, 1991.

Thompson, Eleanor McD., ed. *The American Home: Material Culture, Domestic Space and Family Life.* Hanover, N.H.: University Press of New England, 1998.

Thrush, Coll. *Native Seattle: Histories from the Crossing Over Place.* Seattle: University of Washington Press, 2007.

Tobias, Henry J. *A History of the Jews in New Mexico.* Albuquerque: University of New Mexico Press, 1990.

Tomlinson, John. *Cultural Imperialism: A Critical Introduction.* Baltimore: Johns Hopkins University Press, 1991.

Torgovnick, Marianna. *Gone Primitive: Savage Intellects, Modern Lives.* Chicago: University of Chicago Press, 1990.

"Tourism Office Hosts Unique Forum to Examine Arts and Crafts Issues." *Navajo Times,* May 14, 1998.

Towner, Ronald H., and Jeffery S. Dean. "Questions and Problems in Pre–Fort Sumner Navajo Archaeology." In *The Archaeology of Navajo Origins,* ed. Ronald H. Towner. Salt Lake City: University of Utah Press, 1996.

Trachtenberg, Alan. *Incorporation of America: Culture and Society in the Gilded Age,* 25th anniversary ed. New York: Hill and Wang, 2007.

——. *Shades of Hiawatha: Staging Indians, Making Americans, 1880–1930.* New York: Hill and Wang, 2004.

Trahant, Lenora Begay, and Monty Roessel. *The Success of the Navajo Arts and Crafts Enterprise.* New York: Walker and Company, 1996.

Trennert, Robert A. "Fairs, Expositions, and the Changing Image of Southwestern Indians, 1876–1904." *New Mexico Historical Review* 62, no. 2 (Spring 1987): 127–150.

Trenton, Patricia. *Independent Spirits: Women Painters of the American West.* Berkeley: University of California Press, 1995.

Trump, Erik Krezen. "The Indian Industries League and Its Support of Indian Arts, 1893–1922: A Study of Changing Attitudes toward Indian Women and Assimilationist Policy." Ph.D. diss., Boston University, 1996.

Turner, Frederick Jackson. "The Significance of the Frontier in American History." Presented at the Historical Congress in Chicago at the World's Columbian Exhibition of 1893. First published in *Annual Report of the American Historical Association for the Year 1893.* Washington, D.C.: Government Printing Office, 1894.

Turner, Victor. *The Ritual Process: Structure and Anti-structure.* Chicago: Aldine Publishing Company, 1969.

Underhill, Ruth M. *The Navajos.* Norman: University of Oklahoma Press, 1956.

——. *Red Man's America: A History of Indians in the United States.* Chicago: University of Chicago Press, 1953.

U.S. Congress. "Session on Indian Traderships." In *Reports of Committees of the Senate*

of the United States for the Second Session of the Fiftieth Congress, 1888–1889. Washington. D.C.: Government Printing Office, 1889.

U.S. Department of the Interior. *Annual Reports of the Commissioner of Indian Affairs.* Washington, D.C.: Government Printing Office, 1890 and 1904.

Usner, Daniel H., Jr. *Indians, Settlers, and Slaves in a Frontier Exchange Economy: The Lower Mississippi Valley before 1783.* Chapel Hill: University of North Carolina Press, 1992.

Utley, Robert M. *The Indian Frontier of the American West, 1846–1890.* Albuquerque: University of New Mexico Press, 1984.

Vibert, Elizabeth. *Traders' Tales: Narratives of Cultural Encounters on the Columbia Plateau, 1807–1846.* Norman: University of Oklahoma Press, 1997.

Volk, Robert W. "Barter, Blankets, and Bracelets: The Role of the Trader in the Navajo Textile and Silverwork Industries, 1868–1930." *American Indian Culture and Research Journal* 12, no. 4 (1988): 39–63.

Volz, Candice. "The Modern Look of the Early Twentieth Century House: A Mirror of Changing Lifestyles." In *American Home Life, 1880–1930,* ed. Jessica Foy and Thomas J. Schlereth. Knoxville: University of Tennessee Press, 1992.

Wade, Edwin L. "The Ethnic Art Market in the American Southwest, 1880–1980." In *Objects and Others: Essays on Museums and Material Culture,* ed. George W. Stocking. Madison: University of Wisconsin Press, 1985.

Wagner, Roy. *The Invention of Culture.* Englewood Cliffs, N.J.: Prentice-Hall, 1975.

Wagner, Sallie. *Wide Ruins: Memories from a Navajo Trading Post.* Albuquerque: University of New Mexico Press, 1997.

Wallace, Anthony. *Jefferson and the Indians: The Tragic Fate of the First Americans.* Cambridge, Mass.: Belknap Press, 2001.

Waters, L. L. *Steel Trail to Santa Fe.* Lawrence: University Press of Kansas, 1950.

Weigle, Marta. "Exposition and Mediation: Mary Colter, Erna Fergusson, and the Santa Fe/Harvey Popularization of the Native Southwest, 1902–1940." *Frontiers* 12, no. 3 (1992): 116–150.

———. *Santa Fe and Taos: The Writer's Era, 1916–1941.* Santa Fe: Ancient City Press, 1994.

Weigle, Marta, and Barbara A. Babcock, eds. *The Great Southwest of the Fred Harvey Company and the Santa Fe Railway.* Phoenix: Heard Museum, 1996.

Weisiger, Marsha. "The Origins of Navajo Pastoralism." *Journal of the Southwest* 46, no. 2 (Summer 2004): 253–282.

West, Elliott. *The Contested Plains: Indians, Gold Seekers and the Rush to Colorado.* Lawrence: University Press of Kansas, 1998.

Wexler, Laura. *Tender Violence: Domestic Visions in an Age of U.S. Imperialism.* Chapel Hill: University of North Carolina Press, 2000.

White, Richard. "'Although I Am Dead, I Am Not Entirely Dead. I Have Left a Second for Myself': Constructing Self and Persons on the Middle Ground of Early America." In *Through a Glass Darkly: Reflections on Personal Identity in Early America.* Chapel Hill: University of North Carolina Press, 1997.

———. "Ecological Change and Indian-White Relations." In *History of Indian-White Relations,* ed. Wilcomb E. Washburn, vol. 4 of *Handbook of North American Indians,* ed. W. C. Sturtevant. Washington, D.C.: Smithsonian Institution, 1988.

———. *The Frontier in American Culture.* Berkeley: University of California Press, 1994.

———. *"It's Your Misfortune and None of My Own": A New History of the American West.* Norman: University of Oklahoma Press, 1993.

——. *The Middle Ground: Indians, Empires, and Republics in the Great Lakes Region, 1650–1815.* Cambridge: Cambridge University Press, 1991.

——. *The Roots of Dependency: Subsistence, Environment, and Social Change among the Choctaws, Pawnees, and Navajos.* Lincoln: University of Nebraska Press, 1988.

"Wild Indians of the Four Corners." *Travel,* January 1924, 20–23.

Wilken, Robert L. *Anselm Weber, O.F.M., Missionary to the Navajo, 1898–1921.* Milwaukee: Bruce Publishing Company, 1955.

Williams, Lester L. *C. N. Cotton and His Navajo Blankets: A Biography of C. N. Cotton, Gallup, New Mexico Indian Traders and Reprinting of Three Mail Order Catalogues of Navajo Indian Blankets and Rugs Originally Printed between 1896 and 1919.* Albuquerque: Avanyu Publishing, 1989.

Witherspoon, Gary. *Language and Art in the Navajo Universe.* Ann Arbor: University of Michigan Press, 1977.

——. *Navajo Weaving: Art in Its Cultural Context.* Research Paper, no. 36. Flagstaff: Museum of Northern Arizona, 1987.

Wolf, Eric. *Envisioning Power: Ideologies of Dominance and Crisis.* Berkeley: University of California Press, 1999.

Wood, William Warner. "Flexible Production, Households, and Fieldwork: Multisited Zapotec Weavers in the Era of Late Capitalism." *Ethnology* 39 (2000): 133–148.

——. "Rapport Is Overrated: Southwestern Ethnic Art Dealers and Ethnographers in the 'Field.'" *Qualitative Inquiry* 7 (2001): 484–503.

——. "Stories from the Field, Handicraft Production, and the Mexican National Patrimony: A Lesson in Translocality from B. Traven." *Ethnology* 39 (2000): 184.

Woodard, M. L. "The Navajo Goes East." *New Mexico Highway Journal,* March 1931, 14–15, 20.

Wunder, John. R. *"Retained by the People": A History of American Indians and the Bill of Rights.* New York: Oxford University Press, 1994.

Yost, Billie Williams. *Bread upon the Sands.* Caldwell, Idaho: Caxton Press, 1958.

Youngblood, B. "Navajo Trading." In *Survey of Conditions of the Indians of the United States, Part 34: Navajo Boundary and Pueblos in New Mexico.* U.S. Senate, Subcommittee of the Committee on Indian Affairs, 75th Congress, 1st session. Washington, D.C.: Government Printing Office, 1937.

Zuckert, Catherine H. *Natural Right and the American Imagination.* Savage, Md.: Rowman and Littlefield, 1990.

INDEX